Hans Haacke: Unfinished Business

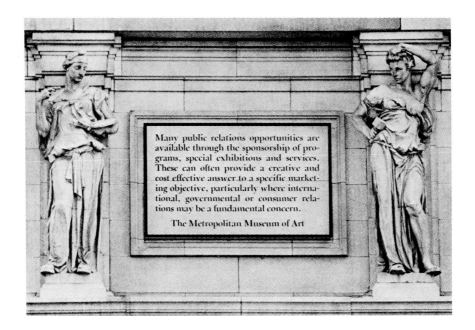

Many public relations opportunities are available through the sponsorship of programs, special exhibitions and services. These can often provide a creative and cost effective answer to a specific marketing objective, particularly where international, governmental or consumer relations may be a fundamental concern.

The Metropolitan Museum of Art

Hans Haacke: Unfinished Business

Essays by

Rosalyn Deutsche

Hans Haacke

Fredric Jameson

Leo Steinberg

Brian Wallis

Edited by

Brian Wallis

The New Museum of Contemporary Art, New York

M.I.T. Press, Cambridge, Massachusetts; London, England

 Cartier

Hans Haacke: Unfinished Business

December 12, 1986—February 15, 1987

Library of Congress Cataloguing-in-Publication Data

Hans Haacke: Unfinished Business

 Exhibition catalog.
 Bibliography: p. 288
 1. Haacke, Hans, 1936- —Exhibitions. 2. Conceptual
art—Germany (West)—Exhibitions. I. Haacke, Hans,
1936- . II. Wallis, Brian, 1953- . III. New
Museum of Contemporary Art (New York, N.Y.)
N6888.H22A4 1987 700′.92′4 86-62735
ISBN 0-262-23129-8 (cloth)
ISBN 0-262-73079-0 (pbk.)

This catalogue has been organized by Brian Wallis, Marcia
Landsman, and Phil Mariani; typeset by Phil Mariani;
designed by Bethany Johns, Homans Design Inc.; and
printed by Arcata Graphics.

Frontispiece: Invitation for one-person exhibition at John
Weber Gallery, New York, May 1985.

This exhibition is supported by the National Endowment for
the Arts, Institute of Museum Services, the New York State
Council on the Arts, and the New York City Department of
Cultural Affairs.

Table of Contents

Director's Foreword

Marcia Tucker

Hans Haacke's work raises issues which, when first publicly addressed on the occasion of his canceled Guggenheim Museum exhibition in 1971, were extremely controversial. These issues remain trenchant questions today. To what extent can art exist outside of history and politics? For those artists like Haacke whose work has been loosely termed "socially concerned," where does "politics" begin and "aesthetics" leave off? What is the nature and responsibility of a museum—to its governing body, its staff, and to its public and the community of artists that it ostensibly serves?

In the more than fifteen years since that time, critical and public definitions of what constitutes art and art practice in general have changed dramatically, in significant measure due to Haacke's work itself. Like Haacke, increasing numbers of artists are committed to the idea that works of art are products of a specific time and place, can act as critiques of institutions and as catalysts of social change, and are subject to the same kinds of critical analysis as are other modes of production.

This exhibition and catalogue examine various aspects of this shifting cultural situation. The catalogue essays make clear that art has never been autonomous or separate from society at large. Indeed, this critical disavowal of "the autonomy of art" (Jameson) and of "modernist assumptions about the museum's status as a neutral arena" (Deutsche) are central to any debate today about the value of art and the institutions that house it; they suggest that there is an effective means by which art can reach beyond aesthetics with relevance both to the individual viewer and to a wider social context.

Haacke's work also challenges the role of museums as arbiters of taste. For The New Museum of Contemporary Art, this exhibition challenges our own perceptions of art, art institutions, and society in general. We accept the difficulties and contradictions inherent in presenting the Hans Haacke exhibition and firmly believe that the dialogue that may ensue is essential to us and to our audience, and hope that it is welcomed by both.

My thanks to Hans Haacke, to Brian Wallis, who organized the exhibition, to our board of trustees as well as the National Endowment for the Arts Aid to Special Exhibitions Program which generously supported it, and to those private, corporate, and state and federal agencies and foundations which have continued to underwrite The New Museum's programs in appreciation of differing voices and dissenting points of view.

Acknowledgments

Brian Wallis

One of the least apparent, though most politically expedient, aspects of Hans Haacke's work is the way in which it addresses and challenges its audience. For while the ostensible subjects of Haacke's works are the specific social and economic conditions he bares, the real political consequence is the education and transformation of the viewer. This passage which Haacke's work enfolds—from passive viewer to active reader and participant—makes particularly relevant the presentation of his work in a critical catalogue.

It also makes particularly meaningful the process of working with Hans Haacke on this exhibition. The same intelligence, incisive wit, meticulous attention to detail, and prescient political observations which animate his works, made working with Hans a rewarding and pleasurable experience. We thank him for the opportunity to present this work and to share with us his thoughts and ideas.

We are honored in this catalogue by a distinguished group of essayists. Leo Steinberg, Rosalyn Deutsche, and Fredric Jameson have each provided an eloquent and spirited argument for a particular reading of Haacke's work. For their efforts I am tremendously grateful.

At the Museum I would like to thank most of all, Marcia Tucker, who has supported this exhibition from its inception. In addition, my colleagues on the curatorial staff, Bill Olander, Lynn Gumpert, Lisa Parr, Karen Fiss, Alice Yang, and Portland McCormick, have all provided essential assistance, advice, and encouragement. Cindy Smith and Marion Kahan ably coordinated the details of shipping and installation of the exhibition.

This catalogue owes its realization to the work and dedication of three extraordinary individuals: Marcia Landsman, publications coordinator, who organized the project; Phil Mariani, who edited and typeset the book, and honed its conceptual framework; and Bethany Johns, of Homans/Salsgiver, who created the handsome design. My special thanks to Katy Homans and the staff of Homans/Salsgiver for their wholehearted support; thanks also to Mark Rakatansky of MIT Press. Others who assisted at various stages were Claire Dannenbaum, Eugene Mosier, Jennifer Freda, Sarah Baldwin, Page Rhinebeck, and Maud Lavin.

Insofar as this exhibition has been a collaborative effort—that is, a social as well as a business transaction—it has made clear that the process of social transformation to which Haacke's work is dedicated can be advanced. Yet it is also evident that this larger project remains, for now, unfinished business.

Some of Hans Haacke's Works Considered as Fine Art

Leo Steinberg

As young Roy Lichtenstein put the case in a famous interview, the problem for a hopeful scene-making artist in the early sixties was how best to be disagreeable. What he needed was to find a body of subject matter sufficiently odious to offend even lovers of art. And as everyone knows, Lichtenstein opted for the vulgarity of comic book images. Here's what he said to Gene Swenson in November 1963:

It was hard to get a painting that was despicable enough so that no one would hang it—everybody was hanging everything. It was almost acceptable to hang a dripping paint rag, everyone was accustomed to this. The one thing everyone hated was commercial art; apparently they didn't hate that enough either.

That last reflection sounds faintly rueful, as if Lichtenstein thought he had failed. Indeed, he had missed his declared objective. If he'd been looking for what no one would hang, he had quite underestimated his public. And his subsequent career has progressively deepened his "failure" (though perhaps not beyond consolation). Meanwhile, just eight years later, success came to Hans Haacke, who, upon invitation, produced three unacceptable pieces, which the Guggenheim Museum refused to install.

Chief among the rejected works was Haacke's now famous Manhattan project: gray matter all over and a slow, plodding title—*Shapolsky et al. Manhattan Real Estate Holdings, a Real-Time Social System, as of May 1, 1971*. Obviously, neither the title nor the aspect nor the size of Haacke's huge documentary were meant to delight. Like a good realist, the artist was putting factuality first, and like a conscientious designer, he was making form follow function; you can't quarrel with that. What caused the alarm was the function itself: the delivery, to the wrong address, as it were, of information gathered on New York streets and in the County Clerk's Office, itemizing the buildings controlled by one major Manhattan landlord. The proposed exhibit was a wall-sized chart composed of a marked city plan and small architectural photographs accompanied by typed data sheets. No selectivity, such as one wants in a work of art; rather an overplus, more than the eye could take in; and that, presumably, was the point, since each of these plots and tenements stood for a source of income. Now, in works of art, as in living organisms, "more" is not necessarily an unqualified good—excess may spell glut and surfeit. But where money talks, plethora is an absolute blessing, always preferable to somewhat less; so that here the normal creative procedure of culling a

representative sample to avoid the drag of a full inventory would be mere depletion, spoiling the total. The owner of these prolix properties—142 buildings, including a generous portfolio of slums—was evidently a man of substance, probably a philanthropist, a donor perhaps to this very museum. If so, the visiting art buff, profiting from the squalid rents of the poor, would find himself in connivance with social conditions which, from an aesthetic perspective, are not in good taste.

But as they say in New York—"And what else is new?" The motif of morally tainted money has had its day; it was intriguing when socialism was the *dernier cri*, and before one had learned to make and sell art for art's sake. Think of old Ibsen. Or read George Bernard Shaw's "Unpleasant Plays," written when he first tried his hand as a dramatist. Shaw, however, never used real names. His characters were archetypal and their actions symbolic. It is one thing for the dainty suitor in Shaw's *Widowers' Houses* (1892) to learn with dismay that the money his bride would inherit was being made by rent gouging; it is quite another to be informed by a museum exhibit how Mr. Shapolsky and his troop of seventy corporations came by their money "as of May 1, 1971." In the view of the museum director who cancelled the show, Haacke's piece, being essentially a "muckraking venture," had forfeited "its status, or at least its immunity, as a work of art."

The argument was not unreasonable, but it backfired. For if Haacke discovered what Lichtenstein had searched for in vain, to wit, what could not be hung and where the limit of the acceptable runs; if he had located one inhibition that art must not violate, then he had (with assistance from the museum) implanted a significant moment in the history of art. He had created an object that was making art history. Isn't that what most artists hope to bring off?

The question "Is it Art?" usually comes in the rhetorical mode, as if there were a categorical answer. Yet with its built-in assumption that the area covered by "art" is prefixed and foreknown, it's an odd question to be asking these days. Do Duchamp's famous readymades now exist as anything but works of art—the store-bought snow shovel, the bottle rack, and the rest? As exhibits on museum display they embody an artist's choice whether to fabricate something or make a decision. And they have come to be regarded as art because they were a) accommodated in art galleries and art books; b) taken no notice of by anyone on the outside; and c) addressed to questions hotly discussed by insiders. And since Duchamp's day, "when [as Joyce pointed out] we were jung and easily freudened," we have

admitted under the heading of art grosser improbabilia—artifacts whose aesthetic presence was as nothing compared to their unforgettable impact as facts.

Would someone please write the history of "The Box" in latter twentieth-century art? Frank Lloyd Wright despised rooms with four walls and could think of no grosser insult than calling them "boxes." And how that degraded thing has been exalted in sculpture! The plain wooden box accompanied by a playback of the noises made in producing it; the minimal cubes, uncertainly solid or hollow; Haacke's own *Condensation Cubes*; Brillo boxes indistinguishable from their prototypes in the supermarket. Et cetera.

Remember how the canvas became its own worthy subject? The canvas of solid color, introducing Inaction Painting; the canvas scored by a single knife slash; a two-backed pair of them mated like kissers—in privacy before any visitation by paint. Was it the idea of privacy that furnished the subject? And what about the idea of scale, scale as such: an immense clothespin, straddling the urban scene like a colossus; a mile's stretch of rocky coast temporarily wrapped in cloth at a staggering cost defrayed by the artist with project-engendered funds; followed by art works that ran on for miles and miles. Some of these exploits had to be seen; others traveled by rumor. Deeds once performed, they exist sufficiently in recall. What matters is that they happened, and that one remembers. Who could forget the self-destructing machine that broke down on a rainy night at the Modern twenty-five years ago?

Harold Rosenberg's famous fantasy that the works of the Abstract Expressionists were not pictures but "action painting," encounters in an arena, had made a whole generation sit up. Younger artists concluded that if what mattered was the encounter, then why corner it within the "arena" of a stretched canvas? They went on to produce in fact what Rosenberg had heralded in a figure of speech, that is to say, they staged actions as art. Hence the happenings and performance pieces throughout the land—events that distilled from foregoing art the variables of decision and doing.

Let whoever lives in the aftermath of the sixties relish their own anthology: here one artist serves his time in the gallery by sitting on a live horse with a mask held to his face; another, under a sloping plank, masturbates to defeat shame and fear; a third hangs himself on a gallery wall, suspended inside a sack between Old Master paintings; or, with supreme economy, puts a bullet through his arm (biceps replacing canvas as the "arena"). Lastly, the artist reduced to a voice at the other end of a telephone, a voice without message, except to entreat you to say something, anything whatsoever, just to say something.

Meanwhile, the emerging conceptualism of the sixties was opening other outlets to action art, among them the divulging of information, not excluding financial accounting. Most of it came deadpan in the formal dress of framed pictures—formalism-formality-mockery. One such piece, a serial called *Money*, entered a 1969 Whitney Museum show. It consisted of eight foolscap sheets of correspondence concerning a sensitive transfer of funds, climaxing in the denouement of a cancelled check. Observe that our teleological construct begins to approach the Haacke aesthetic. But the Whitney work was small-scaled; the funds involved were at the artist's own disposition; and the tang of narcissism, as in most such disclosures, was inescapable. Haacke, in his non-Guggenheim piece that came two years later, gained on all counts by displacing his modest self and shifting to bigger stakes, yet still within a given art context.

From a synoptic viewpoint, those earlier sorties beyond the home limits of art (the 1971 Guggenheim International showed a fair number) seemed to give Haacke all the franchise he needed. His work fitted in. What, then, made his *Real-Time Social System* so welcome-proof, so sure of being cast out? In what sense was he not playing the game? What did he do that was so absolutely forbidden?

It appears that the freedom enjoyed by modernist art in this century was circumscribed after all. Seen from the centers of real power, even the license to *épater le bourgeois* was confined to clowning inside the ring. Because whatever artists did within their profession, whatever they might inflict on themselves or their peers, or on Art itself; whatever fantasy, privacy, or obsession they chose to lay bare, to those at the social controls, these "histrionics of the art world" (Haacke's phrase) were harmless stuff, like the capers formerly permitted to mummers and mountebanks, fire-eaters, sword-swallowers, and their kind. Artists, like fools in motley at the courts of bored princes, had a protected right to their antics—within certain limits. For the old jesters too would take risks and could joke even at their patrons' expense; but never about their patrons' sources of revenue. They could peer into the human heart, but not into ledgers; snoop from under the bed, but keep out of the countinghouse.

Such were the rules of the game; then and now. And Haacke, in breaking them, was not playing fair—not with the rich, nor with the art institutions that compete for their gifts, nor (let's remember the neediest) with the producers of art. He was stepping out of the ring, crossing the barrier of permissible clowning. And we perceive where, for most of us, the forbidden resides. We gladly allow derision, blasphemy, kinkiness, smut; these are—well, keep 'em coming. Our art indulges banter, pastiche, even shameless incompetence. In fact, we proscribe nothing that

merely exposes the artist and that shakes up no more than the inner circle. For us, the one sin that can still be contracted lies in asking how money that might be diverted to art is actually made. Sin of ingratitude. Has the artist forgotten that money wrung from the poor is ennobled when a tithe or pittance of it is turned over to art? Why then revert to its ignoble source? It is here, in the prurient reversion to the sources of wealth, that we recognize the obscene, the unacceptable which Lichtenstein missed. And Haacke has hit upon it. What a felicitous find!

In a climate of growing artistic compliance, with abundant pleasers adorning the lobbies and boardrooms of corporations, Haacke's *Real-Time Social System* prolongs for yet a little while that non-conformist tradition which consists in taking art where it had not previously ventured, i.e., into a factual reality so specific, so unappealing and potentially libelous that one is forced either to refuse it the status of art or, once again, to rethink definitions and erase previous limits. This is what artists committed to realism have always compelled their contemporaries to do. Haacke's piece, then, is art—at least for the present—because it sustains against the odds an important artistic tradition.[1]

To the *Documenta 7* exhibition in Kassel, 1982, Haacke contributed *Oelgemaelde, Hommage à Marcel Broodthaers*. On one gallery wall he hung a hand-painted portrait of President Reagan, done from a photograph and very professional. The facing wall displayed a room-size blow-up from a photographic contact sheet: it showed a crowd of demonstrators hoisting a placard with the rude slogan, "Reagan, Hau Ab" (Get lost!). The visitor found himself middling between the lone leader and the clamorous mob protesting the proposed deployment in Germany of American missiles. (A year later, at the John Weber Gallery, the crowd photograph was that of the 500,000 protesters who had marched against nuclear armament in New York City on June 12, 1982.)

Worlds apart: the overblown news photo was obviously uncomposed, mass-produced, and disposable; not even the marginal sprockets and serial numbers had been masked out to dress it for exhibition. A far cry from the expensive oil picture opposite. Haacke must have spent many hours rummaging for the right image of Mr. Reagan. What he produced was a bust portrait in glamorous contrapposto: head tossed defiantly over one shoulder, like the head of the Emperor Caracalla, or the kingly peruke of Louis XIV in Bernini's marble bust at Versailles—commanding portraits in the heroic vein, their 100-yard stare slightly skyward, o'erleaping remote horizons and assuring the plebs of the leader's superior vision. Nor was this all. Tastefully framed, the portrait of Mr. Reagan had a picture

1. *By calling Haacke's Real-Time Social System "art—at least for the present," I am trying to suggest that its art status is contingent on the continuing validity of the modernist enterprise of the last quarter century. I am not claiming that it is art in some undefined timeless sense; only that it passes under the Duchampian legislation. The analogy with the law is not arbitrary. For a given action, say, an immoral tax dodge, may be illegal under one code, but legal and admirably ingenious under another. And since Duchamp's ascendancy around 1960, we have seen huge puffs settled on objects and actions whose principal gift to us was their imputed art status. For myself, I don't love Haacke's Guggenheim System, as I love the art of Mantegna; but I respect the ingenuity with which it inserts itself in the cracks of modern aesthetics.*

light overhead, a brass label beneath, and before it a velvet rope suspended from shiny stanchions such as museums use to direct visitors to what counts. Finally, on the floor, a red carpet, stopping just short of the rope. In a word: Apotheosis.

The irony here seems broad enough, and the political message could not be clearer. But the question returns—Is it Art?

Well, we could call it art by analogy. In the great church of Sant'Andrea in Mantua, in the Saint Sebastian chapel (third on the right), a sixteenth-century follower of Giulio Romano, Rinaldo Mantovano by name, engaged—just like Haacke—the two lateral walls of his exhibition space in a single confrontational set. As the visitor enters, he sees the pincushion saint on his right, bound to a tree. On the left-hand wall are the archers, aiming, as it were, across the space of the chapel. And the beholder has stumbled into the firing zone. Which side is he on?

Unfortunately, we know little about this Rinaldo of Mantua. Like some of his fellow Mannerists, he may have intended only a playful titillation of fright. On the other hand, he may have meant to imply, symbolically, that every Christian lives in the line of fire, either siding with, or exposed to, the barbs of Christ's enemies. The contrived staging dramatizes an enduring predicament. Space becomes danger-fraught, not because we'll be shot by the picture, but as an existential dilemma. And the analogy with Haacke's installation in Kassel (or at John Weber's, New York) is irresistible, since here too the terrain between facing walls is under fire. Granted that Haacke's iconography differs, and that the victimized in his installation have the advantage of number. But the arrangement, you must admit, is very close. That arrangement—in the way it crosscuts the room, in the tension it generates between opposed walls and wills, between the multitude and the one, between diffused impotence and personified power, the news photo up against the precious oil picture, and the burden of self-definition thrust on the innocent in the middle—all this, to say nothing of the art-historical dignity of the Mantuan precedent, is enough, I should think, to make the work art.

2. The exhibition was organized by Artists Call Against U.S. Intervention in Central America.

In January 1984, in an exhibition held at the public mall of the Graduate Center of the City University of New York, Haacke showed *U.S. Isolation Box, Grenada, 1983*.[2] There wasn't much to it: an unpainted cube, hastily hammered up, about eight feet high; narrow window slits near the top, some small ventilation holes here and there, and, on one of its sides, in large stenciled letters, the words: "Isolation Box As Used by U.S. Troops at Point Salines Prison Camp in Grenada."

Writing in *The New Criterion* (April 1984, p. 71), Hilton Kramer commented: "A parody of the Minimalist sculpture of Donald Judd, perhaps? Not at all. This

was a solemn statement . . . attacking President Reagan. Such works are not only devoid of any discernible artistic quality, they are pretty much devoid of any discernible artistic existence."

So it's not art. But perhaps the formal resemblance of *Isolation Box* to the art cubes of Judd and Tony Smith, and to Haacke's own weather cubes of the sixties, should not be dismissed out of hand. During the 1960s, you remember, those Minimalist works lodged themselves firmly within twentieth-century art, making other sculpture appear needlessly fussy; for as T. S. Eliot warned long ago, new work continually changes our perception of earlier art. And now comes Haacke, not to parody Judd (a notion Kramer rightly rejects), but to accuse those Minimalist box sculptures of lacking airholes and labels, that is, of being hermetic—the blind, deaf-mute icons of a reductive aestheticism. By way of invidious comparison, their autotelic stance is made more ineloquent than their producers intended.

Haacke's *Isolation Box* is an accusing object, and, as befits its foursquare presence, it levels its broadsides four ways: at the U.S. Army for violating the Geneva Convention on Human Rights; at the complicit silence of public opinion; at the know-nothing aloofness of those Minimalist works ensconced in the safety of art; and finally at the discerning critic. For if Haacke's piece—despite its stylistic kinship with Minimalism—is classified as non-art on the grounds that the lettering on it betrays a propagandistic intention, then the critic stands self-accused of being wholly distracted by subject matter, and thus *ipso facto* disqualified from aesthetic judgment.

Or look at it this way. Had Haacke's piece lacked the stenciled inscription, it would have been a Minimalist sculpture of a late academic sort—art, yes, but wanting the charm of originality. With the label displayed, it becomes, you say, not even bad art—merely crude anti-government propaganda. But if it was an art event when Judd and Smith inducted plain cubes into art, then it is likewise an art event when another specimen of the class solicits its own expulsion from art by reminding us that just such minimal boxes are used by U.S. invasion forces to confine enemy prisoners. The reminder proceeds from the legend on one side of the cube. Well, then, suppose we whitewash the legend, or (as the CUNY administration at the Mall tried to do) turn it face to the wall. Have we thereby converted a non-art object (a piece of mere propaganda) into a passable sculpture? What an ingenious, user-friendly device for instant art Haacke will have invented! Think of it: an artist fashions a non-art object which any member of the Art Handlers Union may win for art by rotating it through 180 degrees. Why, it's a magic box!

The consequences of this "magic" for the most similar-seeming genres of

twentieth-century art could be deadly, though Haacke avows no unfriendly intention. "When I read about the isolation boxes used in Grenada in the *New York Times*," he said in an interview, "I immediately recognized their striking similarity to the standard minimal cube." Then, referring to the piece inspired by the report, he added: "You see, one can recycle 'minimalism' and put it to a contemporary use."

But Haacke was not merely "recycling minimalism"; he was implicitly chiding its uselessness, for if Minimalism lacked "contemporary use," what other use could it offer? Haacke confesses to having "always been sympathetic to so-called minimal art," yet he reserves his insider's right to criticize "its determined aloofness, which, of course, was also one of its greatest strengths." But will those "standard minimal cubes" retain their untested strengths in the presence of their politically engaged kin? What once looked aloof may come to look catatonic. Is not Haacke perhaps reversing the movement initiated by Duchamp? Where the earlier ironist, working from within art, had dared the art world to spurn his pisspoor readymades, Haacke, working again from inside, and with an irony no less deep, double-dares that same world to persist in worshiping hardware.

And what if we should come to see that the most reductionist, self-referential-minimal-autotelic works of this century—that precisely these were in fact highly politicized in terms of art politics, drawing strength from their posture of militancy in the art world, their validity wholly dependent on the powers of suasion and influence, and intelligible only as exemplars of embattled critical theory? Then the difference is not between apolitical and engaged, but in the chosen engagement. Politics may be played wherever interests clash—in lovers' quarrels, family tiffs, generational conflicts; economic and professional rivalries, in the class struggle, or in preparations for global war. And works of art, however neutral their seeming, may be "political" on any plane.

Haacke's partisan message is clear, and if he had placed it in a normal political context, such as a radical journal, it would have gone by unnoticed, like camouflage. Intruded in the supposed apolitical context of art, and couched in the familiar idioms of late modernism (Constructivist, Minimalist, or Conceptualist), his political message, by dint of dissonance, becomes grating and shrill—but shrill within the art context. And while its political effectiveness is probably minimal, its effect on Minimal art may well be profound. Haacke may be more threatening to the continuance of modernism than any postmodern of the new figuration. For the death-blow to a given tradition is most effectively dealt from within by a master of that tradition who so quickens its means that earlier practitioners in it come to

seem bland and innocuous. In the final account, Haacke's *Isolation Box* will embarrass the Minimalists more than the military, and that's why it's art.

Haacke's recent works have gained in scope, clarity, and economy. Looking back to the 1971 *Real-Time Social System*, one perceives that it was by comparison somewhat murky. Its motives were less than clear. The work had been designed for a solo show at the Guggenheim; but no connection had been drawn between the museum and the city properties itemized. A New York landlord was pilloried, but why he? Was he a benefactor, an accomplice of the museum? Originally, the piece had been conceived as part of a threefold systems analysis. The projected cluster was to juxtapose inorganic systems (e.g., condensation chambers), biological systems (e.g., ant colonies), and a social system exemplified by an empire of slums. But what made the artist finger "Shapolsky et al." rather than, say, Trump (senior) or Helmsley? No doubt, Shapolsky was honored because he ranked at the time as the top private real estate tycoon in the city, with the extra distinction of an indictment for bribing building inspectors and a conviction as a rent gouger. But these personal data were not in the piece, the artist having failed to reflect that folks who had heard of Kandinsky might never have heard of Shapolsky. Yet the name, even if unfamiliar, would resonate. Hearing the ethnic ring in it, some museum-goers might wonder: must one choose a Jew's property to illustrate "social systems"? Did this exposé of a stereotypical Jewish landlord express the old gut reaction that resents a non-Aryan presence among holders of wealth, or was this the updated anti-Semitism of the New Left? When the project was vetoed for citing the actual name of an individual culprit, the artist offered a "compromise." The compromise (which Haacke published in *Studio International*, July-August 1971, p. 33) replaced the name of the real slumlord by a "fictionalized personal name" set off between quotes, a name that retained the initials and the telltale ethnicity of the original. Harry Shapolsky became generic as "Harvey Schwartz," as if to say, any substitute, so long as it's blatantly Jewish, will do. Presumably, Haacke's reasoning here was determined by notions of verifiability and sociological accuracy, as important to him as naming the correct species of ants in his biological system. But in effect, his substitutive "Harvey Schwartz" made Harry Shapolsky's personal culpability recede behind the odium of a collective guilt. Such insistence on ethnic stereotypes, however intended, could have awkward consequences. What if a sedulous reader of Haacke's system observed that a female president of a "Schwartz"-controlled corporation appeared under the made-up name "Peggy Schwartz"? A colluding relative of the infamous Harry Shapolsky gets a given name

that happens also to be the name of the first female Guggenheim relative likely to come to mind. Was the name suggested by the fact that the patriarch of the Guggenheim clan early in 1971 was *Harry* Guggenheim? A subconscious association? Or were these fictive names meant to insinuate an affinity between Guggenheim and "Schwartz"-Shapolsky? Did the fact that the museum bears a Jew's name enter into the iconographic program of this *Real-Time Social System*, or was one supposed to blink it away? In short, was the odor of anti-Semitism here a part of the message? Was it a variable that had got out of control—or what Haacke elsewhere calls "fallout at a secondary level"; or was it entirely unintended, the uncalled-for projection of oversensitive souls?

These unresolved questions are interpretable as stylistic flaws, not uncharacteristic of early works—and Haacke in 1971 was a novice at political art. His subsequent pieces were to be less ambiguous. Though the systems confronted have grown in range and complexity, the focus is sharper now, the control more secure.

MetroMobiltan (1985), is a compact construction requiring some scanning of type, but still intelligible at a glance, like an altarpiece. It deals with the partnership of two major American institutions: The Metropolitan Museum of Art in New York and Mobil Corporation, whose South African subsidiary, we learn, supplies the police and military of its host country with about twenty percent of their fuel needs. Haacke's wall-sized assemblage displays three banners hung over a photomural that records a funeral procession for black victims of the police. The middle banner advertises a Mobil-funded show of ancient Nigerian art at the Met. On the outer banners are statements from the management of the corporation, fending off criticism by explaining a) that Mobil's South African operation represents but a small part of its total sales, and b) that it would be unmannerly not to cooperate with one's host. Since the banners are too narrow to screen the whole field, the gaps in between permit intermittent glimpses of the subtext, the news photo of the cortège; which renders the formal effect somewhat jumpy. Fortunately Mobil's logo, prominent on all three banners, maintains thematic and visual continuity. Furthermore, harmony is assured by the crowning feature—a classical, nicely crested entablature, whose center is solemnized by an inscription. An eight-piece platform in front of the work offers aesthetic distance.

No such distance is granted by the verbal components of the design. The flanking statements mobilize such large reserves of moral obtuseness that one stares helpless into the gap between simple decency and the rationalizations of

multinational enterprise. But the inspirational plaque overhead is the most telling: excerpted from the Met's come-on to industry (a leaflet entitled "The Business Behind Art Knows the Art of Good Business"), it reminds corporations that investment in art exhibitions is cost-effective PR—"particularly where . . . consumer relations may be a fundamental concern." In other words, if some potential clients deplore the company's *de facto* support of apartheid, why not fund a blockbuster to regain their esteem? The cynical drift of this exhortation, set off on the architrave, is both comic and sad, the more so since its certain efficacy far exceeds that of the famous two-word appeal formerly blazoned on the Temple of Apollo at Delphi.

No one is likely to mistake the message of *MetroMobiltan*—that we are facing a tightening interlock between corporate power and dependent art institutions. And the point is made with some visual sophistication, the entablature being an especially happy invention: benign and impartial, its embrace reconciles economic power with culture and a black dirge with the unctuous self-satisfaction of the oilmen.

But it is not such felicities of design that make the work art. That status accrues to it rather by virtue of its certain futility in *Realpolitik* and its effectiveness somewhere else. One might almost call the piece apolitical, since it is hard to conceive any action resulting from it. The artist knows perfectly well that Mobil will not be induced to retreat from its South African market; that its shareholders will continue to expect maximum earnings; that no museum can refuse money, no matter where or how it was made; and that few museum-goers will forego an interesting art exhibition just because it was funded by a corporation whose politics differ from theirs. In short, nothing practical can or will come of it, because Haacke's *MetroMobiltan* is wholly addressed to the mind and eye, to imagination and feeling.

Haacke says his works produce flow and reception of information. But surely the energy of a work like *MetroMobiltan* lies not in the information conveyed, but in forcing an inward desegregation of mental categories. If our mental life is normally organized like the Sunday paper, with "Business and Finance" well removed from the section called "Arts and Leisure," then Haacke's work confounds the sections; the sanitizing partitions are swept away as things insubstantial, deceptive. It is this troubling of the art lover's psychic life that makes his work art.

One ends up wondering whether Haacke will not eventually join Lichtenstein in his "failure"—that failure which the tolerance of our system can still bestow. For those unacceptable Guggenheim pieces are now being shown after all. Interest in

his work—within the art world, that is—continues to rise. I see that someone from an Ivy League university is doing a piece on him; and that a traveling Haacke show is being organized by a New York museum, with scheduled stopovers in seven American cities, for each of which the artist proposes to make something *ad hoc*, attuned to the muck of the place; seven cities in this land of the brave waiting to welcome each its own outrage. And guess who is funding it?

Property Values: Hans Haacke, Real Estate, and the Museum

Rosalyn Deutsche

The present occasion—Hans Haacke's first exhibition in a New York City museum—invites a reconsideration of the circumstances that prompted the cancellation of the artist's scheduled show at the Guggenheim more than fifteen years ago. At issue then was Haacke's proposal to install what he termed "real-time social systems"—his two real estate pieces in particular—which the museum judged to be incompatible with the functions of a prestigious art institution. Shortly afterwards, explicating the interventionist principles governing his new projects, Haacke speculated about the scope of each work's influence and the duration of its effective life: "Works operating in real time must not be geographically defined nor can one say when the work is completed. Conceivably the situation into which a new element was injected has passed when the process unleashed at that moment has gained its greatest potential."[1] Presumably, for the real estate pieces, the process began with the Guggenheim's censorship, intensified in the course of the ensuing controversy, and concluded with the subsequent exhibition of the rejected works in other venues. What, then, can be gained by continuing to extend that situation into the present? Where, on the other hand, are the dangers in such a retrospective investigation? Paramount among the risks is the likelihood that, directed toward art history's traditional ends and undertaken according to the discipline's standard procedures, it will further marginalize, through accommodation, works that were initially cast outside the official boundaries of art by authoritative decree. Conventionally, art-historical reexaminations attempt to vindicate repudiated works by assimilating them to art's ontological norm. If, in this spirit, Haacke's project is submitted to the judgment seat of history by being referred back to normative criteria and stabilized aesthetic categories, it will consequently be withdrawn from the historical conjuncture in which it arose as well as that in which it continues to survive.

Consigned, for instance, to a homogenized lineage of the avant-garde, the real estate pieces might be facilely linked to a chain of nonconformist artistic ventures initiated by nineteenth-century salon scandals. But such a hopelessly untheorized notion, which denies the heterogeneity of avant-garde history and in which the very production of outrage becomes the normalizing standard for a work's eventual canonization, masks the impact of meaningful changes in critical art practice. In equally invariant terms, Haacke's works might be legitimated by absorbing them into a venerable tradition of realistic works of art united, in this case, by their

1. Hans Haacke, "Provisorische Bemerkungen zur Absage meiner Ausstellung im Guggenheim Museum, New York," in Hans Haacke: Werkmonographie, ed. Edward F. Fry (Cologne: Verlag M. Dumont Schauberg, 1972), p. 65.

objective presentations of unidealized, lower-class themes. Indeed, some of Haacke's advocates at the time of the Guggenheim cancellation based their defense of the real estate pieces on the contention that they utilized the fully respectable techniques of nineteenth-century Realism. Whatever its tactical value during the struggle with the museum, this formulation preserves a concept of realism reduced to a mere commitment to subject matter and adheres to a long discredited faith in the transparency of the relationship between realistic representations and the empirical phenomena to which they refer. Today, critical practices claiming the legacy of realism have extensively redefined that heritage; among other pursuits, they explore the mediation of consciousness through representations and the conditions of possibility for what is perceived to be "real" at a given historical moment.

Instead of incorporating them into avant-garde or realist traditions, art historians might authenticate the banned real estate pieces as art by utilizing the discursive form of the monograph and positioning the works within the artist's career. This option, too, severs them from historical determination, for monographic conventions, as Griselda Pollock observes, define works of art primarily as the unique products of sovereign artistic subjects.[2] Although the concreteness of Haacke's work militates against such neutralization, the biographical mode can abstractly accommodate widely divergent practices. In its scenario of individualistic creative development, the real estate pieces might simply be classified as "early political works," their flaws or rhetorical errors indicated; as early works, they would also be perceived to contain the seeds of the artist's eventual stylistic mastery of techniques and materials. In his "mature phase," he emerges, predictably, as an "exemplary political artist," a new version of the "great artist" who is, in fact, the real object produced by monographic study.

These approaches resurrect precisely those transhistorical artistic conditions and idealist aesthetic categories—author, style, oeuvre—that artists such as Haacke challenged beginning in the late 1960s. Against the prevailing dogma that works of art are self-contained entities possessing fixed, transcendent meanings, these artists counterposed an exploration of cultural processes of meaning attribution. They investigated, also, the changing functions of art in relation to the contingencies of history that were previously relegated in both formalist criticism and its purported adversary—mainstream social art history—to a more or less

2. Griselda Pollock, "Artists, Mythologies and Media–Genius, Madness and Art History," Screen 21, no. 3 (1980): 57-96.

3. Jeanne Siegel, "An Interview with Hans Haacke," Arts Magazine 45, no. 7 (May 1971): 19.

distant backdrop. "From the beginning," Haacke has maintained, "the concept of change has been the ideological basis of my work."[3] It is a concern signaled in the title of his real estate pieces: *Shapolsky et al. Manhattan Real Estate Holdings, a Real-Time Social System, as of May 1, 1971*, and *Sol Goldman and Alex DiLorenzo Manhattan Real Estate Holdings, a Real-Time Social System, as of May 1, 1971*. In both captions, the presence of the words "as of" followed by a precisely designated date delineates, first, important qualities of the work's subject matter. The documented real estate operations, it informs us, function elusively, their activities and compositions continually altering. Secondarily, however, the title alludes to the materialist premises that inform Haacke's mode of artistic production: the belief that a work's meaning is always incomplete, changing "as of" different temporal situations; that the work incorporates the responses it evokes and mutates according to the uses to which it is put; and, finally, that this relativity of meaning depends on the position of viewing subjects who are themselves contingent within history.

Haacke assembled his real estate pieces in 1971, several years after minimalist artists had initiated a critique of artistic autonomy by investigating the spatio-temporal conditions of art's perception. The temporary, site-specific installations mounted by minimalists incorporated the place of a work's perception into the work itself and demonstrated that perceptual experience depends on the conditions in which viewers encounter works of art.[4] But formalism reentered minimalist art in the assumption that the places of perception are politically and socially neutral. A more decisive shift in contemporary art occurred when artists broadened the concept of site to embrace not only the aesthetic context of the work's exhibition but the site's symbolic, social, and political meanings as well as the historical circumstances within which art work, spectator, and place are situated. These inquiries led in diverse directions. A small group of artists pursued an investigation of the institutions that mediate between individual works of art and their public reception, eventually exploring appropriate means of intervention in institutional spaces and discourses. Occupying a pivotal position in the development of this critique of institutions, Haacke's real estate pieces—including the official reaction they aroused—interrogated the museum as such a primary mediating agency, foregrounding the manner in which it determines and limits the reading of artistic texts. The works also confronted the broader social functions of the museum: its points of direct intersection with economic or political interests and the role it plays in legitimating political realities in a society structured on relations of oppression and exploitation.

4. For an account of the changing political meanings of site-specific art since the mid-1960s, see Douglas Crimp, "Serra's Public Sculpture: Redefining Site Specificity," in *Richard Serra/Sculpture*, ed. Laura Rosenstock (New York: Museum of Modern Art, 1986), pp. 41-56. A history of contemporary art practices that address the site of artistic display is contained in Benjamin H. D. Buchloh, "Allegorical Procedures: Appropriation and Montage in Contemporary Art," Artforum 21, no. 1 (September 1982): 43-56.

Attempts to remove Haacke's real estate pieces into a realm of sweeping continuities that repress proofs of rupture and multiplicity can only seem a betrayal of the shifts in aesthetic practice the works helped set in motion. Equally, such interpretations distort the results of Haacke's rigorous investigation into the concrete contemporary factors that characterize the works' sites. Alternatively, several imperatives particular to the present moment compel a recollection of the real estate work. Of overarching concern is the desire to engage, through the recovery of a key moment of contextualist art practice, in a struggle for historical memory necessitated by the current climate of artistic reaction and by widely disseminated neoconservative reconstructions of recent art history. Today, a return in the established art world to conventional forms or mediums of artistic production, a cynical embrace of the conditions of the culture industry, and a resurgence of ideologies of aestheticism and self-expression accompany a resurrection of the authority of traditional art institutions. Concomitantly, the critical art practices of the last twenty years and the contemporary art committed to amplifying their principles are ignored, falsified, or subsumed under the rubric of a senseless pluralism that proclaims art's freedom from history and evacuates our past. Understanding the stakes in the Guggenheim Museum's confrontation with Haacke's real estate pieces can help restore the ability to apprehend *genuine* differences in contemporary art, differences with far-reaching ramifications in the political field.

In still another, more determinate, sense Haacke's real estate pieces resonate in current circumstances and can, conversely, be illuminated from the vantage point of the present. This topicality springs from the questions the works raised, by virtue of their subject matter and form, about a specific interface between economic and artistic concerns—the relations between dominant aesthetic discourses and the interests of real estate capital in New York. In the years since the Guggenheim incident, the problems embedded in Haacke's subject matter—real estate dealings, appalling housing conditions, and the role played by the needs of profit in determining New York's landscape—have mounted with redoubled urgency. As a "solution" to the city's fiscal crisis and, more inclusively, as part of late capitalism's reorganization of the domestic and international division of labor, the city entered in the late 1970s a period of accelerated restructuring into a center for international corporations and corporate-related services. The restructuring entails an attendant impoverishment and dispersal of the blue-collar laborers whose jobs in manufacturing industries have been disappearing from the city's economic base since the 1950s. The physical conditions to support the new economic structure

and facilitate corporate domination of the city have been created by city planning policies that promote privatized construction of corporate headquarters, office buildings, and luxury apartments that service white-collar industries and workers. Fostering gross speculation and enriching big real estate developers, this latest phase of urban redevelopment also engineers the destruction of the material conditions of survival—housing and services—for those residents no longer needed in the city's economy. Redevelopment is, then, one aspect of a more extensive crisis for this group, a crisis that includes unemployment, attacks on unions, and cutbacks in socialized services.

In the unfolding of the redevelopment process, New York's cultural apparatus has played, sometimes unwittingly, a variety of instrumental roles. Commercial galleries moving into the Lower East Side, for example, have facilitated gentrification by raising rent levels and improving the area's image for other members of the gentrifying class.[5] Additionally, works of art or entire museum branches are routinely placed in "public" areas of new corporate buildings and luxury apartment complexes. Whether sponsored by the state or the private sector, they elevate property values and legitimate private speculation by presenting an image of new construction as beautification programs that furnish cultural benefits to New York's populace. As Walter Benjamin remarked about another urban context—Haussmann's spatial reorganization of nineteenth-century Paris—such works are deployed largely to "ennoble technical necessities by artistic aims."[6] To a degree this collaboration is made possible because a great deal of the public art produced for New York's redeveloped, corporate spaces is informed by academic notions of site-specificity that lend it a fashionable, even socially responsible, veneer but suppress comprehension of the real nature of the urban site. City spaces are perceived solely as aesthetic, physical, or functionalist environments; economic forces shaping them are obscured because a distinction is enforced between spatial forms and social processes. Haacke's real estate pieces, in contrast, spanned that artificially created gap, expanding the definition of site-specificity in relation to both urban and cultural sites. The works addressed two spaces—the city and the museum—and comprehended each spatial form not as a static physical or aesthetic entity but as the effect and container of *specific* social processes.

The issue of specificity lay at the heart of the Guggenheim's rejection of Haacke's work. Inadequately and contradictorily defined by the museum's spokesperson, the specificity of Haacke's art was nonetheless emphatically cited as

5. Rosalyn Deutsche and Cara Gendel Ryan, "The Fine Art of Gentrification," October, no. 31 (Winter 1984): 91-111.

6. Walter Benjamin, "Paris, Capital of the Nineteenth Century," in Reflections, trans. Edmund Jephcott (New York and London: Harcourt Brace Jovanovich, 1978), pp. 146-162.

the reason for its unacceptability. "It is well understood in this connection," the director wrote to Haacke

that art may have social and political consequences *but these, we believe, are furthered by indirection and by the generalized, exemplary force that works of art may exert upon the environment, not, as you proposed, by using political means to achieve political ends, no matter how desirable these may appear to be in themselves.*[7]

7. *Thomas M. Messer, letter to Hans Haacke of March 19, 1971, in "Gurgles around the Guggenheim,"* Studio International *181, no. 934 (June 1971): 249.*

According to the stipulations of this familiar argument, Haacke's work is positioned, on account of its specificity, as "political" in relation to the "indirect" art authorized by museological discourse and constituted, thereby, as "neutral." The practical implications of this doctrine are readily apparent in New York today where art that addresses the urban environment in aestheticized or narrowly utilitarian terms reverts to its officially designated purposes. In so doing, it evinces a compliance with the demand that artists remain ignorant of the character of the forces determining their works' location and oblivious to their functioning. The blatant usefulness of this work to those powerful forces, however, undermines the credibility of the assertion that art yields purely beneficial consequences. Whereas in 1971, the notion of art's "generalized exemplary force" was rallied to evict real estate from a New York City museum by claiming that Haacke's detailed analysis of its operations was "alien" to artistic purposes, today, the same aesthetic ideas validate the participation of artists, critics, and museums in advancing the interests of the real estate industry and corporate capital in New York. This does not represent a reversal. In both instances, existing economic relations are actively shielded from public exposure by disavowing their direct ties to the conditions of artistic production. They are established instead as a field severed from the domain of art. When Haacke's work attempted to heal this ideological breach in aesthetic thought, the museum unveiled its repressive powers.

The Guggenheim's director, Thomas Messer, canceled the exhibition, *Hans Haacke: Systems,* a few weeks before its planned opening in April 1971. The action followed a brief period of negotiation between Haacke and Messer about the problems the director anticipated with those works in which Haacke dealt with social, as opposed to his previous physical or biological, themes. On April 5, following Haacke's publication of a statement about the cancellation, Messer responded: "I did explain that by trustee directive this museum was not to engage in extra-artistic activities or sponsor social or political causes but was to accept the limitations inherent in the

8. Thomas M. Messer, *statement of April 5, 1971, in "Gurgles around the Guggenheim," p. 249.*

nature of an art museum."[8] Haacke's "extra-artistic" works included a visitors' poll that expanded a format the artist had developed a few years earlier. In 1970, he had conducted such a survey at the Museum of Modern Art's *Information* exhibition. The MoMA poll had directed attention to the conditions of artistic reception by casting the museum audience in an active role. It queried spectators about their opinion on a timely political issue concerning Governor Rockefeller's support of President Nixon's policy in Indochina. Since Rockefeller, his relatives, business, and political associates were integrally connected to the museum as officers or members of the board of trustees, the question, mounted on the museum wall, not only interrogated spectators about their own political leanings but encouraged them to interrogate, in turn, modernist assumptions about the museum's status as a neutral arena. In this way, the white wall of the museum, sign of that supposed innocence, and, purportedly, a mere background for equally pure art objects, became, instead, a component incorporated into this work. The physical frame of art was thus converted into a vehicle for revealing rather than masking the artistic context in a work that provoked public scrutiny of the concealed economic structure of the cultural institution and the interests of those who control it. In his Guggenheim survey a year later, Haacke proposed to tabulate responses to demographic questions that would have, like his earlier *Gallery-Goers' Residence Profile*, yielded sociological information about the status and class composition of the art world. He also planned to query viewers on current social and political issues.

Although Messer expressed reservations about the poll, it was Haacke's other "social systems" works that he specified as the cause of the show's cancellation. These pieces documented, from material freely available in public records, the property holdings and investment activities of two separate real estate groups. One work provided information about various types of buildings owned by the association of Sol Goldman and Alex DiLorenzo and the other displayed the slum properties of the Shapolsky family organization. In a letter of March 19, preceding the final cancellation, Messer stated that the likelihood of legal consequences precluded these works' exhibition:

When we began our joint exhibition project, you outlined a three-fold investigation and proposed to devote several exhibits to physical, biological, and social systems. From subsequent detailed outlines, it appeared that the social category would include a real-estate survey pointing through word and picture to alleged social malpractices. You would name, and thereby publicly expose, individuals and companies whom you consider to be at fault. After consultation with the Foundation's president and with

9. Ibid., p. 248.

10. Hans Haacke, "Editorial: Artists
vs. Museums, Continued," Art News
70, no. 5 (September 1971): 21.

advice from our legal counsel, I must inform you that we cannot go along with such an exhibition outline.[9]

Having also conferred with lawyers who refuted the possibility of legal suits arising from the work, Haacke commented a few months later that Messer had not referred in his written statement to the poll as a reason for refusing to mount the show "because it was impossible to generate a legal smoke-screen for its rejection; in a meeting with the curator and my lawyer, Mr. Messer demanded the elimination of all directly political questions, a demand with which I, naturally, could not comply."[10] Debating the cancellation in art journals and the mass media, the museum's director as well as Haacke's supporters consistently concentrated on the Shapolsky real estate piece. The predominant interest in the Shapolsky work is probably best explained by the compelling social contradictions it addresses and the consequent force of its confrontation with the precepts of the museum.

This confrontation, destined to provoke a scrutiny of the work's institutional frame, was ensured by the sheer magnitude of the purely factual data that comprised the work and by its display in a format unalloyed by expressionistic sentiments or aesthetic arrangement. *Shapolsky et al. Manhattan Real Estate Holdings* gathers together individual photographs of 142 buildings and vacant lots located primarily in New York slum neighborhoods as well as typewritten sheets, charts, diagrams, and maps detailing real estate transactions, and incorporates these documents into a complex ensemble presentation. Had it been installed in the Guggenheim, spectators willing to commit time to viewing the work might have perceived striking physical and sociological contrasts between the buildings in the photographs and the museum building in which the audience and the work were located. Such observations would have been encouraged because the work's combination of pictorial and textual material blocks customary modes of aesthetic escape from the social conditions portrayed in representations that have been elevated to the status of works of art. Similarly, it refuses to supply the means by which attention is commonly distracted from the circumstances in which art is viewed. Engaging its public in an active reading process, the work emphatically rejects the single-image form of the painted, photographic, or sculpted object accompanied by a discrete caption, a form intended to produce a timeless experience of "presentness" and evoke meditative responses from spectators abstracted from historical conditions. Moreover, the deadpan, unrelieved factuality of the Shapolsky piece obstructs attempts to convert the specificity of its subject matter into a tribute to the artist's subjective expressiveness and compassion; the

repetitive arrangement militates against the transformation of its documented reality into an elegant aesthetic composition.

In these ways, the real estate piece departs from the conventions of another representational genre in which similar iconography of lower-class urban neighborhoods has already entered the precinct of the modern art museum—liberal social documentary, or what Allan Sekula labels the "find-a-bum school of concerned photography."[11] Interestingly, Haacke's photographs document the same type of New York tenements that were the object of social reformers' attention for decades. But even though the museum repeatedly referred to the work as a deed of "social reform," Haacke's project differs fundamentally from the humanist photography associated with reformist traditions. "The subjective aspect of liberal esthetics," Sekula remarks about concerned photography, "is compassion rather than collective struggle. Pity, mediated by an appreciation of 'great art,' supplants political understanding."[12] Because of its overwhelmingly subjective or aestheticist ideals, such work can find shelter within the museum where it is united with other aesthetic objects as the product of unique artistic subjects. And through the cultural institution's tribute to the sensibility that transposes wretched social conditions into the register of art, the social documentarian's distinct position of class privilege in relation to his or her subject matter is confirmed. Simultaneously, however, power and privilege are concealed, even as they are reinforced, since the aesthetic realm the work inhabits is proclaimed as a universal public sphere unfissured by class, racial, or gender divisions.

The Shapolsky piece alters to the point of reversal the viewing dynamics of liberal aesthetics. "Political understanding," that is, replaces "pity, mediated by an appreciation of 'great art.'" Initially, at least, installed in the Guggenheim, it would precipitate an inspection not only of Shapolsky's real estate maneuvers, but of the physical space, social position, and ideological tenets of the museum. The Guggenheim, a New York museum originating in a collection of early twentieth-century idealist abstractions and which trades in equally abstracted concepts of spiritual liberation, individual expression, and purified aesthetic experience would be confronted with a work employing the specificity of painstakingly researched and concrete information about the material reality of New York. A museum building renowned as an aesthetic monument of architectural history would house representations of buildings defined solely as economic entities. Other contrasts—between the pristine interior of the museum and the deteriorating tenement facades, between the social status of the viewers' space in a luxury enclave of Manhattan and that of the impoverished minority ghettos pictured—also threatened to erode

11. Allan Sekula, "Dismantling Modernism, Reinventing Documentary (Notes on the Politics of Representation)," in Photography Against the Grain: Essays and Photo Works 1972-1983 (Halifax: The Press of the Nova Scotia College of Art and Design, 1984), p. 62.

12. Ibid., p. 67. On social documentary photography, see also Martha Rosler, "In, Around, and Afterthoughts (On Documentary Photography)," in Martha Rosler: 3 Works (Halifax: The Press of the Nova Scotia College of Art and Design, 1981), pp. 59-86.

the aura of isolationism constructed around the museum and dismantle its pretensions to represent universal interests. Instead, the museum would emerge as a place occupying a position of material privilege in relation to other terrains. Apprehending this, viewers might focus on the character of these spaces and their interrelation. The quickening of the anticipated confrontation between the Shapolsky piece and the museum into an open rupture could, once the incident became publicized, only intensify the work's effects.

But by creating these tensions, the Shapolsky work also suggests a resemblance between the spaces it addresses. Explicitly, it documents the ownership and control of the urban space. Having forced a consideration of the relationship of the two territories and threatened the illusion of universality engendered by the museum, it implicitly introduced the question of how proprietorial interests also affect the cultural space. Thus, in expanding the context of the work beyond the walls of the museum to embrace the city and wider circumstances in which it is situated, Haacke did not simply extend the notion of site-specificity geographically. Nor did he naively attempt to surmount institutional boundaries by placing his art work symbolically "outside" the museum's walls and addressing "real" subject matter. Rather, he permitted a more profound vision of the institutional apparatus by infiltrating the twin fetishisms of two sites: the city, constructed in mainstream architectural and urban discourses as a physical space, and the museum, conceived in idealist artistic discourse as a purely aesthetic realm, each appeared as tangible spatial forms marked by a political economy.

Interested in revealing the concrete operations of calculated modes of power in situations that appear to be neutral or self-evident, Haacke, when confronting the urban context, concentrated on real estate as a determining force shaping New York's environment. This intention, it turned out, constituted a flagrant violation of the museum's rules of aesthetic propriety. Yet it explains why Haacke selected the Shapolsky group as the subject for his work. When extracting information from public records in the office of New York's County Clerk, he located those real estate owners with the most extensive holdings in their respective categories of investment. Far from an arbitrary choice, this decision was crucial to the trenchancy of Haacke's critique and critical to the realization of his goal: revealing the degree to which large-scale real estate interests dominate New York's landscape. As Haacke clarifies in the notes accompanying the presentation, the properties held by the Shapolsky group represented in 1971 the largest concentration of real estate in Harlem and the Lower East Side under the control of a single group. After selecting Shapolsky, who appeared in the Manhattan Real

Estate Directory as the principal of these substantial holdings, Haacke researched the publicly recorded deeds and mortgage agreements for each of Shapolsky's properties. A close scrutiny of the names and addresses of the parties to the real estate transactions divulged that Shapolsky appeared to be the key figure in a family group that possessed even more properties. By tracing further connections, Haacke uncovered 142 parcels owned by the group and for which title was legally held by about seventy different corporations. Frequent sales and exchanges took place among the individuals and corporations comprising the system: properties were sold; mortgages were obtained, assigned, and cross-held.

Haacke also photographed each of the properties and coupled these pictures with an equal number of typewritten sheets providing data about the property: address; block and lot number; size; building type (its official code—predominantly old- and new-law tenements and apartment buildings); the corporation or individual holding title; the corporation's address and officers; date of purchase; former owner; amount of mortgage; rate of interest on mortgage; holders of mortgage; the assessed land value and total assessed value. Haacke then synthesized this material in diagrams charting the business transactions relating to the individual properties over the twenty years prior to 1971. Three charts list the corporations in the left- and right-hand columns and consist of lines tracing frequent connections through the exchange of mortgages or properties. Another reveals the large number of mortgages on Shapolsky properties held by two Baptist organizations. Finally, two charts list the presidents of the corporations and their addresses, as well as the vice-presidents, secretaries, and corporate addresses, revealing how the system is formed by a web of obscured family ties and dummy corporations that veil the identity of principal owners. Completing Haacke's piece are two enlarged details of maps of the Lower East Side and Harlem neighborhoods with the lots owned by the Shapolsky group circled.

The Shapolsky real estate piece comprises, then, a dossier on an individual Manhattan slumlord, his family, and associates. It identifies one level of real estate operations in the city, revealing the mechanics of a particular strategy of investment. The photographs testify to the kinds of property in which the investments are made—housing in impoverished neighborhoods lucratively run at a low level of maintenance. The data sheets and charts exhibit the myriad financial exchanges and the general organization of investment by which the gains accruing from these manipulated properties are increased. The Shapolsky system is open; if its myriad strands are followed by investigating interrelations among individual and corporate components, they lead to the revelation of an even more labyrinthine and

radiating network that includes rental agents, city workers, city agencies, and religious groups, among others. The cooperation and dispersal of functions within this "extended family" masks its interdependent operations. They acquire a random or discrete appearance that renders them difficult to penetrate by tenants or the broader public, enhancing their flexibility and control.

The full extent of the system's control emerged when, in addition to gathering and shaping the data, Haacke pursued research on the group available in newspapers and other public sources of information. The results do not appear in the work itself. They disclose, however, that Shapolsky was repeatedly investigated on a variety of criminal charges. These included concealing bank accounts and acting as a "front" for investments by members of the city's buildings department in properties he operated.[13] In 1959, Shapolsky was found guilty of rent-gouging but was never imprisoned because, according to the judge, of letters testifying to his good character from "very, very responsible people in the community."[14] Numbered among his character witnesses was one of the Baptist organizations revealed in Haacke's work as holding mortgages on numerous Shapolsky properties. In 1966, as the result of an investigation conducted by radio station WMCA, a bill was introduced into the state legislature requiring that the names of slum owners who operated behind "the obscurity of corporate names"[15] be publicized. The station cited Harry Shapolsky as one of about twelve real estate operators who "had controlled 500 tenement buildings housing 50,000 persons buying and selling—or foreclosing—among each other in deals that increased rents and profits."[16] The bill proposed that a list of all the true owners of any property declared "a public nuisance" be published in two newspapers. A liability clause would make these owners—including mortgage holders—personally liable for repairs to buildings.[17]

The information gleaned from news stories clarifies the purpose of two features discernible in Haacke's work as central to Shapolsky's real estate system. The frequent self-dealing maximizes profits; together with the use of multiple corporations as a form of ownership that limits personal liability, it also obscures the identity of the principals of individual buildings. Further, these two modes of investment activity conceal the full extent of the owners' holdings. Thus, in several ways, they limit public knowledge and the owners' accountability for tax payments as well as for the nondelivery of services to tenants in buildings operated according to the imperatives of the market. Utilizing techniques worked out in complex deals by lawyers and accountants, such private speculation is, in reality, publicly supported.

But a knowledge of these facts generates perceptions more significant than the recognition of the mechanics of the Shapolsky strategy or even of the system's more

13. "Ex-Buildings Aid Held in Perjury," The New York Times, April 24, 1958.

14. Jack Roth, "Shapolsky Found as Rent Gouger," The New York Times, May 2, 1959.

15. Peter Kihss, "Liability is Fixed in New Slum Bill," The New York Times, February 10, 1966.

16. Ibid.

17. Ibid.

comprehensive connections. Beyond these, it highlights a fundamental contradiction in a larger real estate system within which the Shapolsky operation is framed: the contradiction between market requirements and the social needs of city residents. Perhaps an awareness of this contradiction emerges most dramatically in the quasi-legal or criminal activities of unscrupulous landlords, yet it arises out of the basic organization of housing as an investment in capitalist society. Indifference to human needs, then, cannot finally be ascribed to the callousness of individual landlords but is, rather, structurally determined. By implying this contradiction—and Haacke has always encouraged viewers to follow his works' implications—Haacke's piece, too, exceeds its investigation of Shapolsky family relations and expands into a critique of relations of property.

In this light, the issue of the real estate pieces' specificity, the target of the Guggenheim's objections, assumes a critical dimension beyond those discussed earlier in this essay. When defining "specificity," the museum's director continuously differentiated the act of naming specific individuals from the representation of an anonymous system. It was, he claimed, the designation of real people, not a social system, that was impermissible in the museum. Repeatedly, however, he stated that social issues should only be engaged artistically through symbolism, generalization, and metaphor, thereby disqualifying specificity about the identity of a system as well as of individuals. Equivocation on this point pervades his comments justifying the cancellation. "Where do we draw the line?" Messer asked.

With the revealed identities of private individuals and the clear intention to call their actions into question, and by a concomitant reduction of the work of art from its potential metaphoric level to a form of photo journalism concerned with topical statements rather than with symbolic expression.[18]

18. Thomas M. Messer, "Guest Editorial," Arts Magazine 45, no. 8 (Summer 1971): 5. (emphasis added)

Questioned by an astute interviewer who tried to untangle the threads of his definition of "particularity," Messer replied:

I don't know that I fully understood you. But I would say that in the motivation again what is acceptable is the general illustration of a system. What is for the purposes of this discussion inacceptable is that it is aimed at a specific situation. In other words, it no longer has a self-contained creative objective, but is something with an ulterior motive.[19]

19. Barbara Reise, interview with Thomas M. Messer, "'Which is in fact what happened,'" Studio International 182, no. 935 (July-August 1971): 37.

From Messer's obfuscating explanations of what constitutes unacceptable specificity—naming individuals *only* and, at the same time, *any* nongeneralized reference to a social situation—it is only reasonable to deduce that the real estate

pieces contained, in fact, two kinds of thematic specificity that were objectionable to the museum. First, the detailed identification of the activities of a landlord whose rights to operate out of public view were to be protected, and, second, the implied designation of a broader framework for this system in a concrete structure of property relations.

Several elements of Haacke's work permit viewers to initiate a line of questioning about this second system. The condition and disposition of the photographed buildings obviously appear to be regulated by the financial calculations documented in the data sheets and charts. Clearly neither a natural or random process, these considerations are themselves directed by carefully studied decisions made according to the "logic" of an investment system. The juxtaposition of photographs of deteriorated housing with extensive calculations of large amounts of accumulating capital focuses the viewer's investigation with greater precision. These activities are not in the interests of poor tenants nor does the provision of services to those tenants seem to provide a high rate of return on investment. If the drive for profit through capital accumulation and appropriation of rents is revealed, then, as the principal factor governing the provision and condition of housing, serious doubts arise as to whether the needs of low-income residents can ever be met.[20] In 1959, criticizing the suspension of Shapolsky's sentence for rent-gouging Puerto Rican tenants, New York's Assistant District Attorney stated that Shapolsky had "ruthlessly exploited the shortage of housing."[21] Without minimizing the importance of this charge, it is crucial to recognize that the formulation of the housing problem exclusively in terms of a desire to eliminate the abuse of a condition of scarcity leaves the condition itself unexamined. Scarcity of housing— socially, not naturally defined—is, however, a precondition of the market system, and this fact has special ramifications for ghetto areas like those documented in Haacke's work. Given the institution of private ownership of real estate parcels and the drive to increase profits by appropriating bigger rents, together with the extremely limited choices of the poor in securing access to scarce urban resources, it is difficult to escape the conclusion that, as David Harvey asserts, "the rich can command space whereas the poor are trapped in it."[22] Exploitative behavior by landlords only exacerbates the effects of normal entrepreneurial operations; exploitation and speculation in land and housing appear as inevitable features of capitalist urban development resulting from the forces at the core of our economic system.

Within this system, land and the structures on it assume the form of commodities. They do not, however, necessarily manifest this form with regularity;

20. These doubts are not allayed by the fact that one-third of the 1971 Shapolsky properties are, in 1986, owned by the city of New York. Most city-owned residential buildings are acquired through tax delinquency proceedings. Once these buildings are obtained, the city government's intervention in the housing market has consisted largely in recent years of selling parcels to private developers. This action has helped clear the way for gentrification and the subsequent displacement of large numbers of low-income residents in an unprecedented number of New York neighborhoods. These include the Lower East Side, which has undergone a particularly brutal process of gentrification. This information is based on research by Jennifer Freda.

21. Roth, "Shapolsky Found a Rent Gouger."

22. David Harvey, Social Justice and the City (Baltimore: Johns Hopkins University Press, 1973), p. 171.

real estate is likely to be in use for long periods of time and only rarely exchanged. The dialectical unity of use and exchange value embodied in the commodity appears with greatest frequency in the activities presented in the Shapolsky piece—the operation of rental housing and frequent sale of properties. Haacke's manner of presentation underscores the commodity character of the buildings, neighborhoods, and city on which it reports. The data sheets, for example, initially label each vacant lot or building by the conventional units—block and lot numbers—that classify it as real property. Subdivisions of Manhattan's grid structure, the spatial organization imposed on the city by the Commissioner's Plan of 1811, these units facilitate a maximization of profits, providing the infrastructure for real estate speculation. Haacke's photographs reinforce at the level of individual structures the impression of the city as an economic product. Shot from street level, looking up at the buildings, the photographs' borders coincide with the demarcation of property lines, emphatically refusing compositional considerations that might characterize these buildings as historically or aesthetically interesting urban structures rather than real estate. The two municipal maps represent the city similarly, objectified as an assemblage of blocks with Shapolsky's lots indicated. This is particularly striking in relation to the sociological character of the areas the maps represent—Harlem and the Lower East Side, two working-class sectors of Manhattan. In the past, ethnic and racial minorities have been directed to these ghettos, which retain a strong identity as communities or areas containing a vital network of social institutions. In Haacke's maps, photographs, and data sheets, however, they appear not as communities but as a spatial terrain defined purely by the real estate market, a collection of houses, physical structures, and vacant lots.

Real estate, urban theorists inform us, is a commodity with some unusual features. Among these is its physical immobility. It cannot be moved at will. But fixity does not characterize the social processes that organize land and buildings into particular formations. These processes possess the opposite attribute: as human practices they are transformable within the domain of human practice. While the substantial power of real estate is amply demonstrated in Haacke's Shapolsky piece, the land and buildings do not, in this sense, appear as inanimate. Their permanence is shaken and not merely because they are subject to continual manipulation in the marketplace. Rather, as private property and as commodities, they embody relationships of exploitation and domination which are subject to change. In a similar manner, Haacke's work jolted the fictitious air of stability of the building in which it was to be installed and its claims to represent eternal

values. The work created numerous comparisons with the Guggenheim—analogies between the ownership of properties and culture, houses collected by the Shapolsky family and art collected by the Guggenheim family, the commodity form of housing and of art production, and, especially after the cancellation, between the concealment of power in the city and in the museum. In the end, the work foregrounded the fact that the museum building, too, is not an isolated architectural structure, container of static aesthetic objects, but a social institution existing within a wider system, product and container of mutable relations of power.

Following the cancellation, Haacke elaborated the project initiated in the real estate piece—submitting private actions to public scrutiny—by publicizing the museum's censorship of his exhibition and exposing it to open discussion in newspapers, art magazines, and television and radio programs. Throughout the discussion, the museum's director reiterated his initial explanation for the cancellation but also admitted that, even without the fear of legal reprisal, Haacke's work "posed a direct threat to the museum's functioning within its stated and accepted premises."[23]

23. Messer, "Guest Editorial," p. 4.

Should social malpractices be exposed if the evidence is dependable and reliable? Certainly, but not through the auspices of an art museum. It is freely admitted that this conclusion is self-protective, that is, protective of the museum's function as we currently understand it. Individuals and companies who would have suddenly found themselves the unsuspecting targets of a work of art could be expected to react against the artist as well as his museum sponsor. The possibility of a libel suit resulting from such a situation is therefore not farfetched. But the museum's sponsorship would hardly seem defensible even if the legal effects proved to be containable *through the presumably unassailable nature of the assembled documentation—a rather large assumption on the part of the artist.*

A precedent would, in any case, have been set for innumerable analogous presentations with predictably damaging effects upon the museum's central function. What would, for instance, prevent another artist from launching, again via a work of art, a pictorial documentation of police corruption in a particular precinct? What would stand in the way of a museum-sponsored attack upon a particular cigarette brand which the documentation assembled for this purpose would show to be a national health risk?[24]

24. Ibid. (emphasis added)

What indeed? In a historical period marked in the United States by mass protests against governmental policy, police actions, and corporate endangerment of public safety at home and abroad, these possibilities could hardly have seemed absurd or

undesirable. What, for that matter, would prevent an artist from exposing "via a work of art" the threat to public interests posed by the activities of those who control art institutions? Haacke did just that; in 1974, his *Solomon R. Guggenheim Museum Board of Trustees* specifically extended some of the parallels suggested earlier in the Shapolsky work. Here, Haacke traced the interconnections among members of the Guggenheim family, other museum trustees, and various corporations frequently sharing the same addresses and officers. For the multinational Kennecott Copper Corporation, which listed a Guggenheim family member and two trustees on its board of directors, Haacke displayed information about the company's activities in Chile and included a statement by the country's deposed and murdered president, Salvador Allende, that such transnational corporations were "not accountable to or representing the collective interest" of Chilean citizens.[25] Kennecott was later named in hearings on the destabilization of the Allende democracy by United States interests.[26] Thus, this work, which adopted the typography and layout of official trustee lists, contained a pointed reference to the museum's interest in concealing its relation to the operations of privatized property, and opposition to social ownership, a concealment that parallels the Shapolsky strategy for avoiding public accountability.

Self-protectively, the Guggenheim's director continuously described the museum as a private domain and characterized Haacke's real estate work as an invasion of both the privacy of individual entrepreneurs and of the artistic "sanctuary." Meant to foster private experience, the museum was defined as an inappropriate place to publicly question real estate investors who have committed themselves to limiting public awareness of their activities. "These individuals," Messer asserted, "would have been held up to public scrutiny and condemnation without their knowledge and consent."[27] By attacking their right to seclusion, he believed, Haacke was taking unfair advantage of the museum as a refuge to protect *himself* from repercussions:

Haacke's work implicates certain individuals from the safety of its museum sanctuary. Protected by the armor of art, the work reaches out into the sociopolitical environment where it affects not the large conscience of humanity, but the mundane interest of particular parties. Upon the predictable reaction of society the work, turned weapon, would recede into its immune "art-self" to seek shelter within the museum's temporary custody.[28]

Willing, nonetheless—by canceling the exhibition of the work—to offer the museum's protection to large-scale private property and individual slumlords,

25. *This work is reproduced in this catalogue, pp. 110-117.*

26. *Jeanne Siegel, interview with Hans Haacke, "Leon Golub/Hans Haacke: What Makes Art Political?"* Arts Magazine 58, no. 8 (April 1984): 111.

27. *Thomas M. Messer, statement published in* Studio International 181, no. 934 (June 1971): 250.

28. *Messer, "Guest Editorial," p. 5.*

Messer rehearsed prevalent illusions about the art institution as a natural retreat from the exigencies of society. In doing so, he tacitly invoked a view of the museum consistent with its role as a surrogate for the bourgeois domestic interior. Far from a naturally given entity, however, the interior emerged in the nineteenth century to perform functions necessitated by concrete economic conditions. Analyzing the bourgeois living environment as a prismatic cultural object refracting and illuminating these conditions, Walter Benjamin succinctly reconstructed its origins in the historical demarcation during the bourgeois era of public and private spheres, the latter representing the privilege of seclusion. There, private individuals were guaranteed protection and freedom to pursue their private self-interest. To the considerable extent that this freedom aimed to ensure the liberty of acquiring and disposing of property at will, the private sphere testified to the definitive withdrawal of property from social control and served a crucial function in legitimating the bourgeois view of life. Within the realm of the private, the domestic interior was constituted as a distinct domain where harmony was artificially achieved by expelling the real conflicts that characterized economic society. Dependent for its comforts on gains in the economic domain, the illusions of the interior were necessary precisely because the basis of capitalist society lies in a collision of interests and in the predominance of the private over collective concerns. "The private person," as Benjamin wrote

who squares his accounts with reality in his office demands that the interior be maintained in his illusions. This need is all the more pressing since he has no intention of extending his commercial considerations into social ones. In shaping his private environment he represses both. From this spring the phantasmagorias of the interior.[29]

29. Benjamin, "Paris, Capital of the Nineteenth Century," p. 154.

30. Ibid., p. 155.

"The interior is the retreat of art,"[30] he continued, referring to the doomed attempts of the private owner to obliterate the commodity character of his collected objects. The illusions of the interior as shelter and citadel, transferred to that other retreat of art, the museum, were apparently severely convulsed when Haacke proposed to bring texts and photographs of the exteriors of slum dwellings inside the Guggenheim's cloistered residence. The violent expulsion that this emblematic confrontation provoked suggests that economic and social discord are not, in reality, "alien" to the museum's harmonious space but that—as Benjamin wrote about the interior—they complement and imply each other. At least that is what the museum itself intimated when, in an unusually telling moment, it articulated its ideology of autonomy and privacy through a literal defense of the rights of private property.

Hans Haacke and the Cultural Logic of Postmodernism

Fredric Jameson

Hans Haacke's work has a kind of impersonal necessity and inevitability about it. One is surprised to find that a particular work was produced three years ago, or five years ago, or perhaps just last year, since it seems that this work must already have been there somehow. It would seem surprising for it not already to have been in existence, surprising to think of a time in which the Holbein Reagan did not attract the visitor reverently to the edge of its velvet cord, preexisting both the Reagan presidency itself in some other timeless eternal realm of the American Gothic and the conventions of Renaissance portraiture. Not a gag, exactly—having none of the trivial irreverence of Dada or Mona Lisa's moustache, but with the glacial coldness and impersonality of the messages of dead forms themselves, through which no subject-position speaks, not even in protest. Interesting questions are raised by responses of this kind, not least among them that of periods and breaks—limits beyond which such "texts" and such reactions to them would not have seemed inevitable at all.

The logic of Haacke's works and their sense of necessity can be accounted for, at least initially, by the confluence in them of two powerful "traditions" which emerge from the 1960s: the preoccupation with the whole issue of the autonomy of art and culture (something which only becomes intense after that autonomy is objectively problematized), and the inflection of the critique of ideology in the direction of institutions (I will call this institutional critique or institutional analysis). Although I find myself using the word "traditions" to describe these two intellectual themes, they have little enough to do with existing traditions of cultural production (at least until Haacke himself); instead they relate to traditions of thought or what might be termed intellectual debates. Indeed it might be better to identify these themes as features of a larger cultural situation, features which raise specific problems and must be seen as elements in a new intellectual problematic. But it is also helpful, and indeed essential, to grasp these features in their objective form as modifications of the social totality, modifications which generate unaccustomed new dilemmas in the areas of cultural production and theoretical understanding alike.

These modifications can be seen in terms of what has come to be called postmodernism, provided that that concept is thought in a double way: as a designation of a whole set of aesthetic and cultural features and procedures, but also as the name for that specific mutation of the socioeconomic organization of our

society commonly called late capitalism (this third stage of capitalism has also been called "consumer capitalism," "multinational capitalism," and, even, "postindustrial society"). The advantage of this difficult and sometimes confusing dual use of the term postmodernism—designating both a certain systemic cultural logic, and also a whole socioeconomic period—is that it helps us to avoid the often more sterile debates that arise when postmodernism is given a narrow and specifically stylistic sense, as one contemporary artistic "movement" or current among others. Taken in this second and more restricted way, the temptation is to take sides on these developments and either to attack "postmodernism" as a style on the grounds of its essential frivolousness, its loss of the great transaesthetic mission of high modernism, its decorative character, and its depoliticization; or, on the other hand, to salute in postmodernism the inauguration of some new historical era beyond "reference" and metaphysical or ontological illusion, a new and historically original "poststructural" era in which for the first time we consent to the free play of signifiers as such and leave behind the "intellectual comfort" of representationality in which many of the "great" high modernisms were still locked. For our purposes then, to construe "postmodernism" in this narrow stylistic way would mean attempting to situate Haacke within that style, and "deciding," on the basis of one's own position, whether his work exemplifies the features of a postmodernism one wants to celebrate, or whether it is to be regarded as radically oppositional within the force-field of a postmodernism of which one disapproves. (These kinds of decisions, it should be observed, conveniently prolong older left habits of formulating politico-moralizing judgments, whereby the principal activity of the left critic is conceived as just this "deciding" whether works are progressive or reactionary, contestatory and oppositional or a replication of the system and a reinforcement of its formal ideologies.) To insist, then, on "postmodernism" as a systemic form of capitalism—in other words, as a *situation* in which the artist must work and to which culture is understood as an active response (and often an intervention and a reappropriation)—ought to free us from the more facile solutions of a purely aesthetic debate, and, at the same time, to confront us with the far more difficult and complex problem of grasping the relationship between what is new in contemporary culture and in its (equally new and unparalleled) situation of production and struggle.

The question of the autonomy of the aesthetic and of culture, the argument

that culture exists somehow outside of and above the experience of daily life, provides one of the privileged entry points into any discussion of postmodernism. If we begin with this issue, then, we immediately recognize that it can be staged on at least two levels. In other words, the concept of "autonomy" can be understood either as characterizing aesthetic experience as such, or it can be taken to designate the placement of the sphere of culture within social life and "society." In both of these areas, Haacke's work has something instructive, perhaps even exemplary, to tell us; but it is important to keep the two kinds of issues distinct initially, even if later on we want to explore the determinations that bind those two issues together (these determinations will be found to emerge most dramatically in a third area, that of *ideologies* of the aesthetic and of culture).

Certainly the problem of the autonomy of aesthetic experience is the foundational issue of a whole new philosophical discipline of "aesthetics" which emerges fully blown in the work of Immanual Kant and, in particular, in his *Critique of Judgment*. There Kant's "solution"—the work of art as a "finality without end"—constitutes and secures the field or object of study for all of the philosophical aesthetics which follow, down to our own time. This "solution" is considered normative not in the sense that it is widely adopted, but insofar as the problematic it raises is never itself contested or transgressed (or where it is radically repudiated, we leave the disciplinary terrain of philosophical aesthetics altogether). The function of the Kantian solution was to secure some third space, between the end-oriented domain of ethics and action (which in hindsight can be identified as the whole new world of business and commerce, with its various local teleologies organized around exchange-value), and that other space of nascent science and knowledge, of abstraction and control, and of intellectual systems (which are apparently no less teleological than the activities of the world of practice, but which present themselves as disinterested or objective in various ways and—at least until the emergence of a technocratic science in the service of business corporations today—are predicated on the radical difference of the knowledge-function from the commodity world). Thus, the work of art is seen as uncommodified and disinterested and, at the same time, as a kind of practice or activity in the sense of the world of action. This unstable synthesis, then, also requires us to insist on the closure of the aesthetic experience: in order to enter on it and to be equal to its formal demands, we must somehow leave the baser world of practice behind us, yet pause before the threshold of that scientific realm of abstract truth, of the Idea and of the abstraction of pure reason.

The crisis into which this ideal of aesthetic experience has been propelled in

recent times (along with the very discipline of philosophical aesthetics organized around it) can be grasped in terms of developments in the two neighboring realms—science and economics—from which it borrowed its contradictory attributes. On the one hand, modern science no longer seems appropriately describable in the language of the discovery of eternal truths or laws; increasingly it has characterized itself as a kind of infinite practice (as the production of scientific *text* and as a type of play perhaps not unlike the aesthetic). On the other hand, a prodigious expansion of commodity logic or of commodification in general has today begun to colonize the very utopian realm of the aesthetic itself (as well as the Unconscious). In this way, today—in an era of mass culture and of the commodification of form itself—the suspicion becomes imminent and unavoidable that culture and the work of art can no longer be thought of as a zone beyond the teleological and the basely practical. The work of the Frankfurt School clearly marks the great moment of radical doubt and self-consciousness of aesthetic philosophy. Already it had begun to question its own nature and existence in a profoundly historical fashion. The limits of the theories of the Frankfurt School for us today are drawn by their desperate attempt to resecure a diminished, but even more intense and utopian, place for some last surviving "authentic"—noncommodified and "high modernist"—artistic production, an attempt whose historical failure the emergence of postmodernism signals in a more than symptomatic way.

It may, however, be useful to stage this problem of the closure of aesthetic experience in a more practical way by asking ourselves at what price and in what fashion some contemporary experience of what used to be called the aesthetic is conceivable and describable when the frames and closure of the aesthetic have broken down and culture dissolves into the world itself. In other words, it is not evident that mass literature, the literary subgenres, or commercial film, really abolish the closure of aesthetic experience: we still immerse ourselves in the bestseller, and still consent to the darkness of the movie theater (or roll up our windows at the drive-in). Indeed in this sense, television viewing may involve a historically more advanced form of aesthetic experience since the living room determines a certain dispersal of attention, but in reverse. It is not that we cease to follow the storytelling series in some traditional mode of reading attention, but rather that now the television image has installed itself within the object world of the living room in some far more decisively "inner-worldly" fashion.

With Haacke's "installations," however, we approach an extreme point in which it is no longer clear at all that the rapt attention ideally bestowed on a

traditional art "masterpiece"—whether Holbein or Cézanne—any longer comes into play. And in Haacke's case this seems to be something which greatly exceeds the actual spatial framing of the "object" in question. What happens, I think—and here we anticipate the other dimension of this work that has to do with the critique of institutions—is that the elements of the former work of art now enter the "real" object world around them; they enter a space which is no less narrowly specified and spatially and institutionally differentiated than the living room of the middle-class family: that is, of course, the museum. Yet the mode of this "fall" into the world is in Haacke's work structurally peculiar: related, but not identical, to the phenomenon of the "volatilization" or disappearance of the art object itself, on the one hand, and the inner-worldly decorative fragments of a different kind of postmodernism on the other. Here what survives the extinction of the "work" is not its materials or components, but rather something very different, its *presuppositions*, its *conditions of possibility*. So in *Manet-PROJEKT '74*, only the owners and patrons survive, themselves transformed back, as by an X-ray, into their corporate positions and the history of their own bank accounts; while in the *MetroMobiltan* installation, there never was a work of art in the first place, only its obscene future contours, the "offer" of gratifying cultural pleasures to come.

Discussions of this kind make clear what a conceptual leap is involved when we move from the philosophical question of the autonomy of culture to the more "sociological" issue of the status of culture and cultural activity in our society, where "autonomy" now means both the social value and meaning of the activity in general (for instance, whether "culture" is to be assigned a value in its own right, in socialist as well as capitalist societies, or whether it should be subordinate to more practical ends—e.g., the pursuit of social status or mass education and pedagogy). Viewed from this perspective, the question of autonomy merges into that of the public sphere and of the various spaces of modern society. It would seem at least plausible to describe what has happened in recent times (where the older "sacred" spaces of the theater and the opera, the museum and the concert-hall, still residually survive), less in terms of a dissolution of culture as such than as a prodigious expansion of the cultural sphere generally. In the form of the logic of the image or the spectacle or the simulacrum, everything has become "cultural" in some sense. A whole new house of mirrors of visual replication and of textual reproduction has replaced the older stable reality of reference and of the noncultural "real."

In this context, Haacke poses the political dilemma of a new cultural politics: how to struggle within the world of the simulacrum by using the arms and weapons

specific to that world which are themselves very precisely simulacra? This explicitly political work, which reaffirms a certain continuity with older traditions of political culture, nonetheless draws a strategic conclusion on which there seems to be a generous consensus in the left cultural production of the advanced capitalist countries: namely, that it is no longer possible to oppose or contest the logic of the image-world of late capitalism by reinventing an older logic of the referent (or realism). Instead, at least for the moment, the strategy which imposes itself can best be characterized as *homeopathic:* ever greater doses of the poison—to choose and affirm the logic of the simulacrum to the point at which the very nature of that logic is itself dialectically transformed. Such a strategy—even conceived provisionally—has little of the vigorous self-confidence and affirmation of older political and even proto-political aesthetics, which aimed at opening and developing some radically new and distinct revolutionary cultural space within the fallen space of capitalism. Yet, as modest and as frustrating as it may sometimes seem, a homeopathic cultural politics seems to be all we can currently think or imagine.

But even here it is essential to specify some features of Haacke's strategy which are not normally present in a political art which sees its basic task as the contestation of an image—or simulacrum—society. In Haacke's art, it is as though we do not "work through" the images in the Freudian sense, but short-circuit and neutralize them in advance by substituting a rather different kind of attention. (In saying this, I should note that I am marking a certain distance from Rosalind Krauss's very interesting reading of Haacke's work in terms of the Freud-Bataille theme of repetition.) Whatever the inner logic and dynamic of this image content, it seems to me that the most politically operative feature of these installations—*MetroMobiltan* again comes to mind—is rather their raising the issue of the possibilities of representation against the whole new framework of a global multinational system, whose coordinates can as yet not enter the content of any of our older representational systems. Haacke foregrounds this crisis of "mapping," as I have called it elsewhere, by severing the links between the impoverished icons and dead cult objects of an older high culture and the "facts" and "background statistics" of the newer world system (which have not found their own aesthetic system of representation, which are not yet "proper content" for aesthetic forms of a new type—if indeed such forms are even conceivable).

As I have said, both of these ways of framing the problem of the autonomy of art—as the phenomenological experience of the "work" or as the socially given space of culture itself—inevitably develop consequences which seem to turn on a

third and rather different matter, which is that of aesthetic ideology or value. What is in our time the *value* of the aesthetic—of reception as well as production? Indeed, what is the point (political or otherwise) of culture itself in the first place? Putting the questions this way at once forces us to confront what older generations of aesthetes necessarily felt (or feel) as anti-intellectualism: namely, culture's radical self-doubt, the profound guilt of culture workers at their own "elitist" and (appropriately Kantian) un-practicality, the temptation to solve these anxieties by radical acts of destruction, the trashing of "respectable" forms of culture first of all, and ultimately the disavowal of all forms of cultural production.

In this critical area of aesthetic ideology—that is, of the various theories and apologia of art and culture—no work has been more radical or profound than that of Pierre Bourdieu; the "applied" sociological dimensions of his research can be seen as one long implacable assault on the very rationalizations and self-justifications of culture itself. For it is precisely as the essential *rationalization* of forms of activity determined by very different social dynamics that Bourdieu demystifies all theories of aesthetic value.

This is something most beautifully demonstrated in an early work of Bourdieu and his collaborators on amateur photography, *Un art mineur* (Paris, 1965). There the very marginality and recent emergence of amateur photography as a medium allow processes to be deciphered and demonstrated which remain deeply muffled within the long-established bad faith of the "higher" arts. What is striking about Bourdieu's analysis can best be staged in the light of a paradox (mine, not his): namely, that photography is an "art" from which some first stage of "realism" is necessarily and structurally absent, and that, on the contrary, all photography *qua* art is modernist (if not postmodernist). What is meant, no doubt, is that realistic or representational photography is not an art. But that is simply a banal and negative way of stating a rather different social fact: that "realistic" photography belongs primarily to the practices of a different space of social life—one which has little to do with the spaces of cultural production proper—namely, the family. In one way or another, "realistic" photography is part of the social reproduction of the family. Bourdieu demonstrates this by showing that the people who utilize photography for specifically "artistic" reasons are, in sociological terms, marginals: bachelors, young people, unsuccessful "family men." For them, the practice of photography is a way of escaping from the family and its ideologies and, at the same time, affirming a different kind of identity. Yet, in the area of photography, that identity is not socially given in advance as a role, since the medium is too new in its mass accessibility (at least in the 1950s, when Bourdieu and his group carried out their

field work) to have developed institutional status. The practitioners of this art—of an art which is not really a mode of cultural production, but rather a symbolic form of social praxis and of the refusal of a certain form of social life—are therefore forced (in order to give themselves conscious reasons for persisting in this particular activity) to become aestheticians and to invent, *ex nihilo* as it were, all the positions which Western aesthetics has elaborated over a long tradition to justify their practice of "photography," now considered an autonomous activity in its own right.

Lower- and lower-middle-class practitioners, for instance, rapidly and seemingly instinctively develop the two great opposing ideological positions which in other forms split modern art down the middle: there is the technological apologia, of those interested in the machinery and its possibilities, and for whom the value of photographs is determined by their technical innovations; and there is what may more narrowly be called the "aesthetic" (or perhaps we may say the "symbolist") apologia, in which various idiosyncratic experiences of beauty or strangeness are appealed to in justification of the otherwise inexplicable activity of snapping pictures at leisure times and in otherwise peculiar places. Meanwhile, as one rises in the social scale, amateur photographers with bourgeois and upper bourgeois backgrounds already begin to fall back on the established languages and rationales of the older (aristocratic) high arts. Their aesthetic theories, now contaminated with the traditions of high culture, begin systematically to make analogies between photography and painting, analogies which immediately secure the appropriate self-justifications, since the value of painting is already socially and institutionally grounded in the bourgeois social order itself.

Few analyses are more devastating for all cultural and aesthetic theory than these, for Bourdieu unmasks *all* of the theories of cultural value (autonomous or otherwise) as so much Sartrean bad faith in the service of class activities and class praxis of a nonaesthetic nature (some of Haacke's works—for example, the *Visitors' Polls* or the *Residence Profiles*—perform analogous operations, with suggestively different results: since in these installations, no preexisting aesthetic "pleasure" is present to be demystified, the focus shifts from the destruction of categories of "taste" and "art," as in Bourdieu, to the attempt to grasp and "map" the social system that subtends them). The values of high art (or modernism), then, become merely the disguises of behavior by which aesthetes of a given period seek to distinguish themselves from business and from labor. Under such analysis, even the value of political art like that of Haacke's is not exempt from the overturning of the aesthetic. Instead, Haacke's work would perhaps have to be seen as a way of

using the dead and conventionalized shells of museum-going and art appreciation for the unexpected purpose of transmitting outright political lessons.

But in my opinion it is theoretically useful to distinguish considerations such as these, which revolve around the issue of cultural autonomy (as a historical development, as well as an aesthetic ideology), from institutional analysis as such. This distinction recognizes and acknowledges a problematic gap within ideological analysis in general, which corresponds to what used to be called base and superstructure (these being the traditional Marxist terminology for the underlying "realities" of economic production and the less tangible experiences and structures of the social and the cultural, respectively). The demystification of aesthetic ideology begins in the realm of superstructures, which it positions and defamiliarizes by designating a putative functional relationship to the base. So, for example, a particular aesthetic gives itself as a philosophically coherent theory in its own right, but becomes more problematical when we interrogate that theory socially and when we become aware of the various functions (class legitimation, status, socially symbolic praxis, or whatever) which it fulfills and which then seem to have little enough to do with the overt content of the aesthetic itself. Analysis in terms of base, however, begins with institutions, such as the museum, to which superstructural or ideological effects are attributed. These two analytical movements are symmetrical, but rarely coincide; to achieve a satisfying mediation between the study of aesthetic ideologies and the analysis of the institutions that produce or reproduce them is a complicated activity whose terms are never given in advance and which always seems to involve a dialectical leap of some kind.

We must therefore begin afresh on the second great current of analysis to which Haacke's work clearly has a relationship—what I have called institutional analysis. In its distinctive contemporary form, institutional analysis is relatively recent, having been fully developed as a theoretical proposition only in the 1960s. At first this theorization may seem startling or paradoxical, since one assumes that Marxist ideological analysis has always operated in terms of ruling class institutions, at least in a general sense. But it is precisely the degree of specificity which is at issue here: for we will not be able to grasp what is distinctive about the newer approaches unless we initially pose a sharp break between a traditional global focus on such entities as "the ruling class," "the bourgeoisie," "hegemonic ideology," and the "state," and the finer differentiations of institutional analysis, which aims at delaying as long as possible the assimilation of specific institutions—the school system, the gallery network, the culture industry, Madison Avenue—into the great totalizing generality of "ruling class ideology." Indeed, the

longer one dwells on one of these specific institutions and the more intensely its mechanisms and "semi-autonomy" appear, the more difficult it becomes to take that second step and to drown its achieved detail in some global vision (which in our time has come to carry overtones of conspiracy and paranoia with it).

It is convenient to mark the moment of the maturity of institutional analysis with the publication of Louis Althusser's programmatic essay, "Ideology and Ideological State Apparatuses (Notes Towards an Investigation)," in 1970. Certainly the essay comes long after the fact, but it has offered one of the most influential codifications and theorizations of a tendency at work much earlier in any number of fields. Unfortunately, Althusser's terminology is unnecessarily confusing, especially insofar as its fundamental term—the so-called ISA—specifically designates institutions which are *not* necessarily formally related to state power at all (the family, for example), although, as with the educational system, they may be semi-autonomous components of an enlarged modern governmental system.

Approaches of this kind—practical analyses as well as self-conscious theorization and codification of method—do not arise in a void, but are themselves symptoms and indices of the emergence of new phenomena or the relative restructuration of social reality. When we remember that, alongside a leftist critical and theoretical attention to such ideological institutions, there has also emerged a whole new gamut of "micro-politics"—as opposed to an older class party politics—it seems plausible enough to assume, not that such institutions suddenly appeared for the first time, but that, in the age of multinational corporations, they have become more socially visible and have also been endowed with semi-autonomous powers rather different from those which their earlier equivalents exercised. Thus, if bourgeois civil society, emerging from an earlier feudal order, in the process opened a space for the development of the classical forms of social class, perhaps it can now be asserted that in our time that same civil society has itself undergone dialectically new changes—in particular, a prodigious social fragmentation and atomization, in which a variety of new nonclass political forces appear, but within which relatively new forms of bureaucratic reorganization of power also appear (of which the great corporations are only the most dramatic manifestations), therefore demanding that new type of investigation which we have termed "institutional."

Haacke's work seems to me to emerge at this point, as a solution to certain crucial dilemmas of a left cultural politics based on this heightened awareness of the role of institutions. For the gap mentioned earlier—between superstructure and base, or between the analysis of ideologies and the analysis of institutions—can here be reformulated as a split between specific texts or works and whole processes

of production. Thus, in the case of "Literature"—which may well be a strategic cultural and ideological institution in the middle-class period—its history can be written, its institutional subsystems (the university, the publishing house, the literary journal, etc.) can be the object of more detailed scrutiny, or its various "ideologies" (defenses and apologia, "theories" of literature as such, etc.) can be demystified; yet in all this the individual texts seem to slip through the meshes of such an approach. That Literature in general is ideological, that a specific work of literature is *also* necessarily ideological—both these propositions can be allowed without there being any necessary or coherent relationship between the two ideologies in question. For a certain radical left or anarchist tradition the solution to this dilemma—the incommensurability of what Terry Eagleton has usefully called "aesthetic ideology" versus "general ideology"—lies in a cutting of the knot and in a denunciation of Literature in general. For a bourgeois literary tradition, on the other hand, the tension is resolved the other way around, by enforcing a distinction between "extrinsic" and "intrinsic" approaches, which systematically excludes the first from literary study and thereby masks the institutional dynamics of Literature altogether. Thus posed, the issue of institutional analysis appears to have at least two important determinants. On the one hand, it is generally framed in retrospective or historical terms, as a question of what to do about already existing works or the tradition or the canon, rather than as a tension to be engaged (if not resolved) by new cultural production. On the other hand, our example—Literature and the written, published, and privately read text—is as a medium seemingly less propitious for institutional analysis than the other arts, which on the whole necessarily deploy a complex and specific infrastructure around their "texts" or "performances." The study of art patronage, for example, was a perfectly respectable, even essential, component of art history long before the study of publishing houses was thought to have any relevance to literary study.

At any rate, Haacke's "solution"—to transform the "extrinsic" determinants of art into the "intrinsic" content of a new artistic text—is best evaluated as a response to this dilemma and to the wider situation we have attempted to outline here. Now "patronage," for example (the owners of a particular painting, the trustees and donors of a particular museum), is drawn within the "work" itself (if that is still the right word to use) in such a way that its content can be excluded as "extrinsic" only at the price of repudiating the installation itself and denying it any status as a "work of art." (In Haacke's case, the institutions in question—the Guggenheim Museum, or the Cologne Museum which solicited his *Manet-PROJEKT '74*—drew the appropriate conclusions and excluded the works.)

Even the problems and limits of this strategic reversal seem to me instructive, for in the world of micro-groups and increasing social fragmentation, such intense identification of the social determinants of a specific art risks running a kind of micro-political or secessionist danger in its own right. The power of estrangement and scandal this work may have over its immediate public may be incalculable, but significantly this now takes place in a society in which the museum-going and gallery-going public (not to mention the bureaucratic structure specific to the art world) remains (or has become) something of a micro-group or ethnic group in its own right, one which coexists with or without overlaps with the specialized publics to other arts (to say nothing of the obviously crucial question of New York City itself as one enormous micro-group). The political effect on such a public is therefore of a rather different type than what was possible in, say, a nineteenth-century situation, in which the mass of visitors to the appropriate Parisian exhibition are "typical" or "representative" of a more general class-determined public at large.

Meanwhile, Haacke's procedure seems to me somewhat different even from more recent artistic gestures which would, at least initially, seem to have certain strategies and intentions in common with it. I'm thinking, for instance, of the moment at which the Rockefellers appear on the great mural Diego Rivera had been commissioned to paint for Rockefeller Center. Those "patrons," however (who immediately covered over the mural and ultimately had it destroyed), for all kinds of reasons did not particularly require any mediations: in other words, their immediate function was to designate the "ruling class," and their role as patrons of this particular mural was only a rich irony. This is to say that Diego did not, in his particular situation, confront quite the same problem of the autonomy of institutions which is a fact of life of cultural institutions today.

Haacke's way of handling this problem is exemplary (although perhaps inimitable) because of the particular mapping and totalizing representations which he dramatizes in a situation in which not only the concept of totalization but also its politics had seemed to have been rendered archaic. For Haacke's installations recreate the process of totalization by acknowledging the power and existence of the micro-public or institution (rather than by attempting, in traditional realistic or "representational" ways, to elude or short-circuit it). These proper names, these patrons, are very specifically the trustees of the particular cultural institution where the work is shown—so that to make of them the theme and subject of a particular artistic "text" is to reinvent in a new and heightened, dialectically transformed practice of "auto-referentiality." But that they should also be linked in various

systematic ways to corporations active in the perpetuation of apartheid in South Africa or to multinationals contributing to the overthrow of Allende in Chile, for example, moves us beyond "culture" and its autonomy. Rather, it poses an imperative of totalization of an equally new type, one which does not draw on a received idea or preexistent category of the "ruling class," yet which makes its reinvention—in a socially and globally far more complex situation—indispensable.

Institutions Trust Institutions

Brian Wallis

One of the most emulated and symbolically significant innovations of Thomas Hoving's ten-year reign (1966-1977) as director of the Metropolitan Museum of Art was his introduction of large banners, hanging on the facade of the museum, to advertise temporary exhibitions. Along with the retinue of other changes now associated with the temporary exhibition—popular themes, dramatic lighting, gift shops, and, of course, anything *gold*—the banners signaled the beginning of a new era for museums: the age of corporate sponsorship. They also marked a more general alliance of the museum with mass spectacle, entertainment, and consumerism. But more specifically, the banners symbolized the ascendance in the museum world of a particular brand of liberal philosophy which was, in the early 1970s, best characterized by Hoving's personal blend of elitism and populism.[1] With these banners as his standard—connoting both royal fanfare and suburban mall promotions—Hoving was able to prove to corporate sponsors and diplomats alike that temporary exhibitions could associate them with quality and, at the same time, attract a large middle-class audience. In so doing, Hoving dramatically and effectively instituted a situation that today appears as a rather devalued and tricky combination of mass culture and the aesthetic biases of Reagan-era corporatism.

Corporate sponsorship can be traced back twenty-five years or more, but it is only since the beginning of Hoving's term that it has grown so prodigiously. In 1967 American corporations spent only about $22 million on the arts; today that figure tops $600 million and by the end of 1987 the figure will be close to $1 billion annually. To the extent that this increase in corporate support has coincided with the expansion of multinational or global corporations, it should be noted that a large proportion of this sponsorship has come from just a handful of multinationals: IBM, Exxon, Philip Morris, Mobil, and a few others. Increasingly, this corporate largesse is directed toward the larger, more visible institutions—and on a scale that makes refusal difficult. At the Metropolitan Museum, for instance, the current director, Philippe de Montebello, reports that his museum is now "dependent on corporate sponsorship."[2] And, despite his belief that corporate sponsorship has become "an inherent, insidious, hidden form of censorship," the Metropolitan more actively than ever woos the corporate patron, insisting, as one museum brochure puts it, that "The Business Behind Art Knows the Art of Good Business."

1. Hoving's directorship of the Metropolitan Museum has been the subject of much discussion (including his own). Particularly useful are: Karl E. Meyer, The Art Museum: Power, Money, Ethics *(New York: William Morrow & Co., 1979); Thomas Hoving,* The Chase, The Capture: Collecting at the Metropolitan Museum *(New York: Metropolitan Museum of Art, 1975); Thomas Hoving,* King of Confessors *(New York: William Morrow & Co., 1982).*

2. Quoted in Douglas C. McGill, "Art World Subtly Shifts to Corporate Patronage," The New York Times, *February 5, 1985, p. C14.*

As this brochure makes clear, corporate funding of exhibitions is not simply a type of cultural welfare for tax deductions or (as de Montebello suggests) a necessary evil which museums endure for their public. Rather, it is a mutual pact which both parties actively court and which is based on a shared set of values: liberal humanism. This ideology, common to the museum and the corporation, provides the subtext for the sponsored exhibitions. The "official" ideology of the humanities, liberal humanism stresses the importance of the unique individual; it advocates abstract notions of freedom and democracy; and it prefers purified aesthetics divorced from politics. These positions are structured on a foundation of idealized moral values, abstracted from everyday application. As the British critic Terry Eagleton has suggested:

Liberal Humanism is a suburban moral ideology, limited in practice to largely interpersonal matters. It is stronger on adultery than on armaments, and its valuable concern with freedom, democracy and individual rights is simply not concrete enough. Its view of democracy, for example, is the abstract one of the ballot box, rather than a specific, living and practical democracy which might also concern the operations of the Foreign Office and Standard Oil.[3]

3. *Terry Eagleton,* Literary Theory *(Minneapolis: University of Minnesota Press, 1983), p. 207.*

The contradictions of this moral program are nowhere more apparent than in the conflict between its humanitarian pretenses and the neo-imperialist expansion of multinational capitalism today. In a demonstrative, public way, sponsorship of art exhibitions helps to conceal these contradictions by providing both the museum and the corporation with a tool for enriching individual lives while suppressing real cultural and political difference, for promoting art "treasures" while masking private corporate interests. Indeed, as Hal Foster as observed, it is the temporary exhibition's calculated suppression of its material bases that "allows for its pretenses of social neutrality and cultural autonomy."[4]

4. *Hal Foster,* Recodings: Art, Spectacle, Cultural Politics *(Port Townsend, Wash.: Bay Press, 1985), p. 101.*

Given this general ideological schema, the questions we might ask include: How do the museum and the corporation employ the art exhibition as a promotional vehicle for advancing their interests and, specifically, for propping up existing class, racial, and sexual hierarchies? How is it possible that the "spiritual enrichment" of art can be shared at the same time as business is being promoted? In short, in the current cultural context, how does art function—in the words of one Mobil slogan—"for the sake of business"? The groundwork for an understanding of these questions is laid by the remarkably candid text of the Metropolitan Museum's brochure: "Many public relations opportunities are available through the sponsorship of programs, special exhibitions and services. These can often provide

a creative and cost effective answer to a specific marketing objective, particularly where international, governmental or consumer relations may be a fundamental concern." The museum and the multinational corporation speak the same language; they both understand that an exchange is being offered—promotion for patronage.

As this entreaty suggests, a corporation's motives for sponsoring temporary art exhibitions are various, numerous, and, in many cases, an open secret. For instance, in its weekly *New York Times* op-ed advertisement of October 15, 1985, Mobil Corporation sought to explain (or extol) the uses of art "for the sake of business." With smug candor, Mobil listed various reasons "scores of businesses support the arts": to "spark economic development and revitalize urban areas" (e.g., Soho, the East Village); to "encourage commercial and residential real estate projects" (e.g., the Museum of Modern Art Tower, Equitable Tower); and to "be utilized in a business's advertising, marketing and public relations efforts" (e.g., Mobil's own "Masterpiece Theatre"). These reasons—various as they are—all remain components of what is cited in the editorial ad as the primary reason for sponsoring art: "Improving—and ensuring—the business climate."

But what does this mean—to improve and ensure the business climate? The French theorist Jacques Attali has observed that, as the multinational corporation moves from the status of a purely economic entity to that of a political entity, it must develop a language which is no longer that of profit only, but is instead based on a clearly defined and publicly promoted set of social, ethical, and moral values.[5] Given the condition that, to the general audience and to politicians alike, a corporation's public image is now as important as its balance sheet, the establishment of or affiliation with a respectable liberal-humanist value system is clearly essential. However, these values are often merely grafted onto the corporation's image and reinforced through advertising and public relations. Increasingly, corporate advertising, for example, has moved away from promotion of products or services and toward the encouragement of an idealized lifestyle which will harmonize with the corporation's goals and purposes. Accordingly, when IBM is associated with intelligence ("THINK") or Mobil is linked to "quality television," this intangible "do-gooder" image impresses both potential critics and future lawmakers. Wedding the strategies inherent in the construction of the corporate image to the innate prestige and upper-crust cachet of art museums, the temporary art exhibition has achieved a specialized utility as a device for promoting corporate interests.

For a corporation to structure and promote a coherent value system requires a

5. Jacques Attali, "Comment," in Multinational Corporations and European Public Opinion, *by George Peninou et al. (New York: Praeger Publishers, 1978), pp. 190-191.*

certain control of information and a deliberate constitution of representations. Thus, the selection of exhibitions, as well as the presentation of them through advertising, press releases, and even banners, is purposeful and highly calculated. The result is that this self-conscious system of representations—at least as formulated in sponsored exhibitions—tends toward cautionary exclusion, the fixing of stereotypic interpretations, and the development of abstract rather than historically specific concepts. Beyond the obvious "special interests" of corporations (such as regional themes or themes related to particular products), most corporate sponsors finance exhibitions based on centrist ideals and uncontroversial subject matter. Hence, the proliferation of tame exhibitions of impressionist painting, generic theme shows (e.g., *Man and the Horse*), and historical exhibitions with few direct ties to the social and material culture either of the art exhibited or of the present day.

6. For Haacke's own description of MetroMobiltan *and some of its factual sources, see* Hans Haacke: 4 Works, 1983-1985 *(New York: John Weber Gallery, 1985), n.p. The text on* MetroMobiltan *is also reprinted in* Impulse *12, no. 2 (1985): 41-44.*

One of Haacke's most recent works, *MetroMobiltan*,[6] takes as its subject these relationships between the museum and corporate public relations. It is therefore appropriate that he uses as his principal formal device the large banners that hang in front of the Metropolitan Museum, and that he has inscribed on the frieze of the work precisely that statement from the Metropolitan's brochure by which the museum offers itself up for "public relations opportunities." In the work, three banners like the ones at the Metropolitan hang under a fiberglas mock-up of the museum's entablature. In the center is a goldish banner for the 1980 Mobil-sponsored Metropolitan show, *Treasures of Ancient Nigeria*, which largely obscures a big black-and-white photo of a funeral for South African blacks; this is flanked on both sides by two blue banners inscribed with statements made by Mobil regarding its interests in South Africa.

As in all of Haacke's art works and writings, *MetroMobiltan* draws attention to the rhizome of largely concealed corporate relations which link art to the "real world" of economic and political interests. In order to do this, his art functions on several levels, "rewriting" the fixed images or practices of corporate semiotics, utilizing a montage of specific but loosely connected information to produce both an intensive and an extensive reading. Intensively, his work activates an involvement by the audience, provoking the viewer to become a reader of texts, and beyond this to burrow into obscured factual information which lies "behind" the work and forms the network of facts and associations connecting and supporting his images. (Haacke often provides this more detailed information in crisply stated and neatly argued expository wall labels.) Extensively, his art provokes an extrapolation from the individual work outward, establishing or suggesting macroscopic links between

the art world and other economic, social, and political power formations. Inevitably then, the picture we get of the position of the art object is not one of fixed meanings and universal attributes, but rather the art work as a matrix of conflicting and contradictory interests governed by a cabal of institutions and conjoined with the overriding profit motive of the corporate community.

In this way, *MetroMobiltan* synthesizes a vast amount of information about multinational corporations, political and economic conditions in South Africa, and the conflicted politics of corporate patronage of temporary art exhibitions. In the actual work, Haacke focuses on Mobil's logistical, financial, and psychological support for the white minority government of South Africa and its flagrantly racist policies. Mobil is inextricably linked to South Africa's economy since, despite its great natural resources, South Africa does not have its own oil reserves. It is therefore dependent on outside oil corporations, such as Mobil, to supply its civilian consumers, as well as its military and police.[7] As explained in Mobil's own fact sheet on the subject, the corporation (through a subsidiary) has more than $400 million worth of investments in South Africa; what Mobil doesn't say is that this makes it one of the principal U.S. investors in South Africa.[8] According to estimates of the Investor Responsibility Research Center, the oil supplied by Mobil constitutes about twenty percent of the oil consumed by the country and about the same percentage of the total amount of oil used by the South African military and police.[9]

The effects of Mobil's involvement in South Africa have not gone unnoticed. Many advocacy groups have stressed that the removal of oil investments in South Africa would be the quickest way to end that country's policy of apartheid; as a result, pressure has been brought to bear on Mobil and other oil companies. In 1981, in a resolution included in Mobil's proxy statement, a coalition of church groups with Mobil stock encouraged other shareholders to demand that Mobil desist from supplying oil to the South African military and police. The corporation recommended a vote against this resolution, calling it "unwise," and it was in fact refused. (Part of Mobil's circuitous response is quoted on the flanking banners of Haacke's work.) What is more, lawyers for Mobil's South African subsidiary have warned the corporation that it faces potential prosecution for divulging information on the transfer of oil, since the oil it supplies the Botha government technically qualifies as "munitions of war."[10] This legality remains unchallenged. More direct opposition has come, however, from South African activists who, recognizing the strategic importance of Mobil's operations, have twice attacked its facilities. The first attack was in November 1982 at the Mobil storage depot on the northern Natal

7. On the situation of the oil industry in South Africa, see David M. Liff, The Oil Industry in South Africa (Washington, D.C.: Investor Responsibility Research Center, 1979); African National Congress of South Africa, Fuelling Apartheid (New York: UN Centre Against Apartheid, 1980); Martin Bailey, Oil Sanctions: South Africa's Weak Link (New York: UN Centre Against Apartheid, 1980); Elizabeth Schmidt, Decoding Corporate Camouflage: U.S. Business Support for Apartheid (Washington, D.C.: Institute for Policy Studies, 1980); Ann Seidman and Neva S. Makgetla, South Africa and U.S. Multinational Corporations (Westport, Conn.: Lawrence Hill and Co., 1977); Ann Seidman and Neva S. Makgetla, Outposts of Monopoly Capitalism: Southern Africa in the Changing Global Economy (Westport, Conn.: Lawrence Hill and Co., 1980); Kevin Danaher, In Whose Interest? A Guide to U.S.-South Africa Relations (Washington, D.C.: Institute for Policy Studies, 1984).

8. Mobil Corporation, "Mobil in South Africa—A Fact Sheet for 1984," n.p.

9. These statistics are given by Haacke in Hans Haacke: 4 Works, n.p.

10. Schmidt, Decoding Corporate Camouflage, p. 71.

coast. More recently, in May 1984, guerrillas of the African National Congress fired rocket-launched grenades at Mobil's oil refinery in Durban, causing approximately $25,000 worth of damage.[11]

Obviously, sponsoring art exhibitions does not eliminate such real opposition. However, it does help to establish more favorable conditions for business in such host countries and at home. In this respect, the temporary exhibition serves as a remarkably flexible public relations tool. It stresses the corporation's interests in the life and culture of the host country; it promotes that culture in the home country, winning approval from both constituencies; and it functions as a bargaining chip—as yet another beneficial service the multinational corporation can offer. Haacke's *MetroMobiltan* highlights a specific instance of Mobil's self-conscious (and self-interested) promotion of the national art of one of its host countries. The central banner refers specifically to Mobil's 1980 sponsorship of a traveling exhibition of ancient Nigerian art as a direct inducement toward improving business relations between Nigeria—one of the richest oil nations of Africa—and the United States. This general cultural policy—set in motion by President Carter—was designed to help shift Nigeria's alliances away from Great Britain and toward the United States. As it happened, Mobil Corporation, which had extensive holdings in Nigeria, was able to improve its own standing in the eyes of the Nigerian government at the expense of British Petroleum, whose extensive holdings in Nigeria were expropriated in 1979 (by coincidence, shortly after Mobil had sealed its sponsorship of the *Treasures of Ancient Nigeria* exhibition).[12]

Haacke's parody, in *MetroMobiltan*, of corporate promotional tactics also clarifies the relation of that promotion to the establishment of a new, more conservative type of liberal humanism. In the work Haacke suggests that this value system—jointly promoted by the museum and its corporate sponsors—can be delineated in the following ways: first, in the reinforcement of class hierarchies through language and representation; secondly, in the reinstitution of primitivism as an effective form of cultural hierarchization and as a possible device for the consolidation of multinational corporate expansion; and thirdly, in the general shift from the museum as the tender of art and values to the corporation as arbiter of representations.

Immediately, we observe, for example, that the vocabulary of class division dominates the flanking banners of *MetroMobiltan*, where Haacke demonstrates how corporations structure into their language the same social dichotomy which characterized Hoving's banners: elitism and populism. In the statements reinscribed on the banners, Mobil defends its potentially illegal actions in South Africa. Yet,

11. Both events are recorded in the useful chronology provided in Danaher, In Whose Interest?, pp. 170 and 189.

12. For a useful contemporary summary of the situation in Nigeria in 1979, see "Nigeria: The Grandiose Plans of Africa's Oil Giant," Business Week, no. 2570 (January 29, 1979): 46-48. An alternate view of the situation in Nigeria and its relation to MetroMobiltan is provided in Jeremy Gilbert-Rolfe, "The Politics of Art," Arts Magazine 61, no. 1 (September 1986): 21-27 (esp. note 14, p. 27).

each employs a different language: in the banner on the right, Mobil's management assumes a firm, authoritarian tone to certify the practices of its South African subsidiary as "responsible citizenship," while in the banner on the left, Mobil humbly suggests that its South African sales are "but a small part of its total sales." To point up the simultaneous contradiction in rhetoric of both statements, they are exhibited in *MetroMobiltan* in front of the mostly hidden image of a funeral for South African blacks—those who have no voice, no access to language.

Typically, this implicit and generalized program of elitist domination underlies a corporation's cooperation with a museum, for the museum is a virtual sign for quality, discrimination, connoisseurship: while providing fine entertainment, it also institutionalizes and validates the proclivities and dominance of the upper class. (In terms of temporary exhibitions, perhaps the most blatant example of such institutionalized class supremacy was the recent National Gallery exhibition, *The Treasure Houses of Britain: Five Hundred Years of Private Patronage and Art Collecting*. This exhibition, sponsored by the Ford Motor Company of Great Britain, sought to reify and revalidate the institutionalized practices of the upper class, that is, not only a particular aristocratic "lifestyle," but also a determining economic structure.) As in advertising, this valorization of wealth and upper-class values in museum exhibitions is depicted as a normative state of affairs, one available for all to view equally, democratically, at a distance. Everyone, it is stressed repeatedly, benefits from the patronage and sponsorship of those with money. In *MetroMobiltan*, Haacke makes clear how this "trickle-down" theory of patronage[13] is applied both to arts patronage and to multinational involvement in South Africa (where—as Mobil stated in a recent advertisement—"the business community . . .—including the affiliates of American corporations—is a most effective instrument for social and economic change"). The corporation, it seems, knows what is best for the people—what "responsible citizenship" really means.

A second form this patronage has taken recently is a widespread support for temporary exhibitions whose theme is primitivism. The central banner of *MetroMobiltan* alludes not only to the specific exhibition *Treasures of Ancient Nigeria*, sponsored by Mobil, but more generally to the plethora of tribal art exhibitions (e.g., *Asante: Kingdom of Gold*, or *Te Maori: Maori Art from New Zealand Collections*) which have emerged in the last few years, many under the sponsorship of multinational corporations. Whether or not these exhibitions can be tied directly to neocolonialist expansion into the tribal homelands of these (now Third World) countries, this flurry of exhibitions has released the previously closeted skeleton of liberalism: primitivist racism. The particular iconography of

13. *This theory of patronage is best illustrated in an earlier work of Haacke's entitled* Tiffany Cares *(1977-1978). In that work, Haacke had engraved on silver plate an actual editorial advertisement placed by Tiffany & Co. on page 3 of the* New York Times *(June 6, 1977). Under the title "Are the rich a menace?" the advertisement explains how the works of the rich benefit all, how—through investments—each rich man supports approximately a hundred other people. (This advertisement was reportedly written by the chairman of the board of Tiffany, Walter Hoving, father of Thomas Hoving.) Haacke's reply is succinct: "The 9,240,000 Unemployed in The United States of America Demand the Immediate Creation of More Millionaires."* Tiffany Cares *is discussed and illustrated elsewhere in this catalogue.*

14. See, for example, Edward W. Said, Orientalism (New York: Vintage Books, 1979).

primitivism—analogous for Africa to what Edward Said has characterized as Orientalism for the Middle East[14]—demonstrates how national and colonialist discourses continue to posit black Africans and tribal cultures as a unified racial, geographical, political, and cultural zone. Mapped onto this generic otherness is the hierarchical system of linguistic and representational discrimination developed for class distinctions, but now applicable to racial difference as well. One way in which this otherness is fixed and stereotyped is through constant reference to African blacks in historical terms only (as in an exhibition of treasures of ancient Nigeria), never in terms of contemporary African art or reality.

Philip Morris' promotional advertisement for the 1984 MoMA exhibition *"Primitivism" in 20th-Century Art: Affinity of the Tribal and the Modern* provides a typical example of the contradiction faced by a corporation in representing a liberal view of primitivism. In the advertisement, three pairs of modern and tribal objects—which look vaguely alike but are culturally unrelated—are pictured under the question "Which is 'primitive'? Which is 'modern'?" Here, while Philip Morris raises (and reinforces) a semantic distinction between "primitive" and "modern," it also suggests, motivated as it is by liberal values, that there is no difference between the two. More subtly, in the context of its motto—"It takes art to make a company great"—the initial question "Which is 'primitive'? Which is 'modern'?" reverberates with new meaning, whereby these are no longer aesthetic categories only, but economic ones as well. This new meaning is elaborated in a preface to the exhibition catalogue by Hamish Maxwell, chairman and chief executive officer of Philip Morris, Inc., who speaks of his company's abiding interest in "developing countries" and of the "debt that modern culture owes these peoples." His conclusion is remarkably understated: "We understand the benefit of cultural interchange."[15] In the context of the *Primitivism* show, "cultural interchange" here can be read as a euphemism for an institutionalized positioning of other races and cultures that deliberately appropriates and Westernizes them by encouraging a view of tribal cultures as underdeveloped in relation to Western "progress," by fixing cultural achievements in terms of individual yet anonymous artisans rather than cultural contexts, by establishing a false unity among a variety of cultures, and by yoking tribal groups to Western culture in a Family-of-Man assumption of common goals and motivations.

15. In William Rubin, ed., "Primitivism" in 20th-Century Art: Affinity of the Tribal and the Modern (New York: Museum of Modern Art, 1984). For other "primitivist" art exhibitions occurring in New York at the same time, see the list provided in Art in America 73, no. 4 (April 1985): 167.

That these class and racial values have been strengthened in museum exhibitions through the linking of corporation and museum is evident in all manner of advertisements and promotional devices. Insofar as such advertisements are developed by the corporation (and not the museum), they constitute extensions and

interpretations of the temporary exhibition in light of the corporation's particular philosophical outlook. Like the banners on the museum facade, these advertisements provide an introduction to potential visitors and suggest a new role for both the museum and the corporate-sponsored temporary exhibition. Just as the department store initiated the middle-class consumer into the lifestyle of capitalism at the beginning of the modernist period, so now the temporary exhibition welcomes visitors in droves to imbibe "culture" within a particularly restricted value system, rigorously crafted through the combined efforts of the museum and the corporate sponsor. Like the department store in its heyday, perhaps the temporary exhibition is a paradigmatic institution for this era, corresponding to one phase of social and economic development—in this case, multinational capitalism.

As for the museum as an institution, Haacke's *MetroMobiltan* seems to encapsulate Hoving's prescient perception of its changing status. For in Hoving's time, the traditional concept of the museum as a scholarly accumulation of artifacts had already begun to recede before the new, corporatized notion of the museum as a thoroughfare for an endless flow of temporary exhibitions and their audiences. As if to broadcast this function symbolically, when it came to adding extensions to the museum, Hoving no longer envisioned solid facades, but sheer glass walls revealing and reflecting the constant trafficking of art objects and museum-goers. And across the monumental front of the museum—as in *MetroMobiltan*—Hoving erected the triptych of banners, now obscuring and displacing the former solidity of the museum's facade. So, as a final irony, it seems appropriate that as corporations begin to assimilate museum branches and even generate their own in-house museums, the reverse seems also to be true. It is thoroughly in keeping, then, with the confederation of institutions and the museum's own shifting function that the facade of the Metropolitan Museum no longer elicits a visual correspondence to a bank vault or a library, but rather to an image and a site more in keeping with its contemporary role—that of the commercial billboard.

This article is a revised version of an essay previously published in Art in America 74, *no. 6 (June 1986).*

Museums, Managers of Consciousness

Hans Haacke

The art world as a whole, and museums in particular, belong to what has aptly been called the "consciousness industry." More than twenty years ago, the German writer Hans Magnus Enzensberger gave us some insight into the nature of this industry in an article which used that phrase as its title. Although he did not specifically elaborate on the art world, his article did refer to it in passing. It seems worthwhile here to extrapolate from and to expand upon Enzensberger's thoughts for a discussion of the role museums and other art-exhibiting institutions play.

Like Enzensberger, I believe the use of the term "industry" for the entire range of activities of those who are employed or working on a freelance basis in the art field has a salutary effect. With one stroke that term cuts through the romantic clouds that envelop the often misleading and mythical notions widely held about the production, distribution, and consumption of art. Artists, as much as galleries, museums, and journalists (not excluding art historians), hesitate to discuss the industrial aspect of their activities. An unequivocal acknowledgment might endanger the cherished romantic ideas with which most art world participants enter the field, and which still sustain them emotionally today. Supplanting the traditional bohemian image of the art world with that of a business operation could also negatively affect the marketability of its products and interfere with fundraising efforts. Those who in fact plan and execute industrial strategies tend, whether by inclination or need, to mystify art and conceal its industrial aspects and often fall for their own propaganda. Given the prevalent marketability of myths, it may sound almost sacrilegious to insist on using the term "industry."

On the other hand, a new breed has recently appeared on the industrial landscape: the arts managers. Trained by prestigious business schools, they are convinced that art can and should be managed like the production and marketing of other goods. They make no apologies and have few romantic hang-ups. They do not blush in assessing the receptivity and potential development of an audience for their product. As a natural part of their education, they are conversant with budgeting, investment, and price-setting strategies. They have studied organizational goals, managerial structures, and the peculiar social and political environment of their organization. Even the intricacies of labor relations and the ways in which interpersonal issues might affect the organization are part of their curriculum.

Of course, all these and other skills have been employed for decades by art-world denizens of the old school. Instead of enrolling in arts administration courses taught according to the Harvard Business School's case method, they have learned their skills on the job. Following their instincts, they have often been more successful managers than the new graduates promise to be, since the latter are mainly taught by professors with little or no direct knowledge of the peculiarities of the art world. Traditionally, however, the old-timers are shy in admitting to themselves and others the industrial character of their activities and most still do not view themselves as managers. It is to be expected that the lack of delusions and aspirations among the new art administrators will have a noticeable impact on the state of the industry. Being trained primarily as technocrats, they are less likely to have an emotional attachment to the peculiar nature of the product they are promoting. And this attitude, in turn, will have an effect on the type of products we will soon begin to see.

My insistence on the term "industry" is not motivated by sympathy for the new technocrats. As a matter of fact, I have serious reservations about their training, the mentality it fosters, and the consequences it will have. What the emergence of arts administration departments in business schools demonstrates, however, is the fact that in spite of the mystique surrounding the production and distribution of art, we are now—and indeed have been all along—dealing with social organizations that follow industrial modes of operation, ranging in size from the cottage industry to national and multinational conglomerates. Supervisory boards are becoming aware of this fact. Given current financial problems, they try to streamline their operations. Consequently, the present director of the Museum of Modern Art in New York has a management background, and the boards of trustees of other U.S. museums have or are planning to split the position of director into that of a business manager and an artistic director. The Metropolitan Museum in New York is one case where this split has already occurred. The debate often centers merely on which of the two executives should and will in fact have the last word.

Traditionally, the boards of trustees of U.S. museums are dominated by members who come from the world of business and high finance. The board is legally responsible for the institution and consequently the trustees are the ultimate authority. Thus the business mentality has always been conspicuously strong at the

decision-making level of private museums in the United States. However, the state of affairs is not essentially different in public museums in other parts of the world. Whether the directors have an art-historical background or not, they perform, in fact, the tasks of the chief executive officer of a business organization. Like their peers in other industries, they prepare budgets and development plans and present them for approval to their respective public supervising bodies and funding agencies. The staging of an international exhibition such as a Biennale or a Documenta presents a major managerial challenge with repercussions not only for what is being managed, but also for the future career of the executive in charge.

Responding to a realistic appraisal of their lot, even artists are now acquiring managerial training in workshops funded by public agencies in the United States. Such sessions are usually well attended, as artists recognize that the managerial skills for running a small business could have a bearing on their own survival. Some of the more successful artists employ their own business managers. As for art dealers, it goes without saying that they are engaged in running businesses. The success of their enterprises and the future of the artists in their stables obviously depend a great deal on their managerial skills. They are assisted by paid advisors, accountants, lawyers, and public relations agents. In turn, collectors often do their collecting with the assistance of a paid staff.

At least in passing, I should mention that numerous other industries depend on the economic vitality of the art branch of the consciousness industry. Arts administrators do not exaggerate when they defend their claims for public support by pointing to the number of jobs that are affected not only in their own institutions, but also in communications and, particularly, in the hotel and restaurant industries. The Tut show at the Metropolitan Museum is estimated to have generated $111 million for the economy of New York City. In New York and possibly elsewhere, real-estate speculators follow with great interest the move of artists into low-rent commercial and residential areas. From experience they know that artists unwittingly open these areas for gentrification and lucrative development. New York's Soho district is a striking example. Mayor Koch, always a friend to the realtors who stuff his campaign chest, tried recently to plant artists into particular streets on the Lower East Side to accomplish what is euphemistically called the "rehabilitation" of a neighborhood, but what in fact means squeezing out an indigenous poor population in order to attract developers of high-rent housing. The *Terminal Show* was a brainchild of the city's Public Development Corporation; it was meant to draw attention to the industrial potential of the former Brooklyn

Army Terminal building. And the Museum of Modern Art, having erected a luxury apartment tower over its own building, is also now actively involved in real estate.

Elsewhere, city governments have recognized the importance of the art industry. The city of Hannover in West Germany, for example, sponsored several widely publicized art events in an attempt to improve its dull image. As large corporations point to the cultural life of their location in order to attract sophisticated personnel, so Hannover speculated that the outlay for art would be amortized many times by the attraction the city would gain for businesses seeking sites for relocation. It is well-documented that *Documenta* is held in an out-of-the-way place like Kassel and given economic support by the city, state, and federal government because it was assumed that Kassel would be put on the map by an international art exhibition. It was hoped that the event would revitalize the economically depressed region close to the German border and that it would prop up the local tourist industry.

Another German example of the way in which direct industrial benefits flow from investment in art may be seen in the activities of the collector Peter Ludwig. It is widely believed that the motive behind his buying a large chunk of government-sanctioned Soviet art and displaying it in "his" museums was to open the Soviet market for his chocolate company. Ludwig may have risked his reputation as a connoisseur of art, but by buying into the Soviet consciousness industry he proved his taste for sweet deals. More recently, Ludwig recapitalized his company by selling a collection of medieval manuscripts to the J. Paul Getty Museum for an estimated price of $40 to $60 million. As a shrewd businessman, Ludwig used the money to establish a foundation that owns shares in his company. Thus the income from this capital remains untaxed and, in effect, the ordinary taxpayer winds up subsidizing Ludwig's power ambitions in the art world.

Aside from the reasons already mentioned, the discomfort in applying industrial nomenclature to works of art may also have to do with the fact that these products are not entirely physical in nature. Although transmitted in one material form or another, they are developed in and by consciousness and have meaning only for another consciousness. In addition, it is possible to argue over the extent to which the physical object determines the manner in which the receiver decodes it. Such interpretive work is in turn a product of consciousness, performed gratis by each viewer but potentially salable if undertaken by curators, historians, critics, appraisers, teachers, etc. The hesitancy to use industrial concepts and language can probably also be attributed to our lingering idealist tradition, which associates

such work with the "spirit," a term with religious overtones and one that indicates the avoidance of mundane considerations.

The tax authorities, however, have no compunction in assessing the income derived from the "spiritual" activities. Conversely, the taxpayers so affected do not shy away from deducting relevant business expenses. They normally protest against tax rulings which declare their work to be nothing but a hobby, or to put it in Kantian terms, the pursuit of "disinterested pleasure." Economists consider the consciousness industry as part of the ever-growing service sector and include it as a matter of course in the computation of the gross national product.

The product of the consciousness industry, however, is not only elusive because of its seemingly nonsecular nature and its aspects of intangibility. More disconcerting, perhaps, is the fact that we do not even totally command our individual consciousness. As Karl Marx observed in *The German Ideology*, consciousness is a social product. It is, in fact, not our private property, homegrown and a home to retire to. It is the result of a collective historical endeavor, embedded in and reflecting particular value systems, aspirations, and goals. And these do not by any means represent the interests of everybody. Nor are we dealing with a universally accepted body of knowledge or beliefs. Word has gotten around that material conditions and the ideological context in which an individual grows up and lives determines to a considerable extent his or her consciousness. As has been pointed out (and not only by Marxist social scientists and psychologists), consciousness is not a pure, independent, value-free entity, evolving according to internal, self-sufficient, and universal rules. It is contingent, an open system, responsible to the crosscurrents of the environment. It is, in fact, a battleground of conflicting interests. Correspondingly, the products of consciousness represent interests and interpretations of the world that are potentially at odds with each other. The products of the means of production, like those means themselves, are not neutral. As they were shaped by their respective environments and social relations, so do they in turn influence our view of the human condition.

Currently we are witnessing a great retreat to the private cocoon. We see a lot of noncommittal, sometimes cynical playing on naively perceived social forces, along with other forms of contemporary dandyism and updated versions of art for art's sake. Some artists and promoters may reject any commitment and refuse to accept the notion that their work presents a point of view beyond itself or that it fosters certain attitudes; nevertheless, as soon as work enjoys larger exposure it inevitably

participates in public discourse, advances particular systems of belief, and has reverberations in the social arena. At that point, art works are no longer a private affair. The producer and the distributor must then weigh the impact.

But it is important to recognize that the codes employed by artists are often not as clear and unambiguous as those in other fields of communication. Controlled ambiguity may, in fact, be one of the characteristics of much Western art since the Renaissance. It is not uncommon that messages are received in a garbled, distorted form; they may even relay the opposite of what was intended (not to mention the kinds of creative confusion and muddle-headedness that can accompany the art work's production). To compound these problems, there are the historical contingencies of the codes and the unavoidable biases of those who decipher them. With so many variables, there is ample room for exegesis and a livelihood is thus guaranteed for many workers in the consciousness industry.

Although the product under discussion appears to be quite slippery, it is by no means inconsequential, as cultural functionaries from Moscow to Washington make clear every day. It is recognized in both capitals that not only the mass media deserve monitoring, but also those activities which are normally relegated to special sections at the back of newspapers. The *New York Times* calls its weekend section "Arts and Leisure" and covers under this heading theater, dance, film, art, numismatics, gardening, and other ostensibly harmless activities. Other papers carry these items under equally innocuous titles, such as "culture," "entertainment," or "lifestyle." Why should governments, and for that matter corporations which are not themselves in the communications industry, pay attention to such seeming trivia? I think they do so for good reason. They have understood, sometimes better than the people who work in the leisure suits of culture, that the term "culture" camouflages the social and political consequences resulting from the industrial distribution of consciousness.

The channeling of consciousness is pervasive not only under dictatorships, but also in liberal societies. To make such an assertion may sound outrageous because according to popular myth, liberal regimes do not behave this way. Such an assertion could also be misunderstood as an attempt to downplay the brutality with which mainstream conduct is enforced in totalitarian regimes, or as a claim that coercion of the same viciousness is practiced elsewhere as well. In nondictatorial societies, the induction into and the maintenance of a particular way of thinking and seeing must be performed with subtlety in order to succeed. Staying within the acceptable range of divergent views must be perceived as the natural thing to do.

Within the art world, museums and other institutions that stage exhibitions play an important role in the inculcation of opinions and attitudes. Indeed, they usually present themselves as educational organizations and consider education as one of their primary responsibilities. Naturally, museums work in the vineyards of consciousness. To state that obvious fact, however, is not an accusation of devious conduct. An institution's intellectual and moral position becomes tenuous only if it claims to be free of ideological bias. And such an institution should be challenged if it refuses to acknowledge that it operates under constraints deriving from its sources of funding and from the authority to which it reports.

It is perhaps not surprising that many museums indignantly reject the notion that they provide a biased view of the works in their custody. Indeed, museums usually claim to subscribe to the canons of impartial scholarship. As honorable as such an endeavor is—and it is still a valid goal to strive for—it suffers from idealist delusions about the nonpartisan character of consciousness. A theoretical prop for this worthy but untenable position is the nineteenth-century doctrine of art for art's sake. That doctrine has an avant-garde historical veneer and in its time did indeed perform a liberating role. Even today, in countries where artists are openly compelled to serve prescribed policies, it still has an emancipatory ring. The gospel of art for art's sake isolates art and postulates its self-sufficiency, as if art had or followed rules which are impervious to the social environment. Adherents of the doctrine believe that art does not and should not reflect the squabbles of the day. Obviously they are mistaken in their assumption that products of consciousness can be created in isolation. Their stance and what is crafted under its auspices have not only theoretical but also definite social implications. American formalism updated the doctrine and associated it with the political concepts of the "free world" and individualism. Under Clement Greenberg's tutelage, everything that made worldly references was simply excommunicated from art so as to shield the Grail of taste from contamination. What began as a liberating drive turned into its opposite. The doctrine now provides museums with an alibi for ignoring the ideological aspects of art works and the equally ideological implications of the way those works are presented to the public. Whether such neutralizing is performed with deliberation or merely out of habit or lack of resources is irrelevant: practiced over many years it constitutes a powerful form of indoctrination.

Every museum is perforce a political institution, no matter whether it is privately run or maintained and supervised by governmental agencies. Those who hold the

purse strings and have the authority over hiring and firing are, in effect, in charge of every element of the organization, if they choose to use their powers. While the rule of the boards of trustees of museums in the United States is generally uncontested, the supervisory bodies of public institutions elsewhere have to contend much more with public opinion and the prevailing political climate. It follows that political considerations play a role in the appointment of museum directors. Once they are in office and have civil service status with tenure, such officials often enjoy more independence than their colleagues in the United States, who can be dismissed from one day to the next, as occurred with Bates Lowry and John Hightower at the Museum of Modern Art within a few years time. But it is advisable, of course, to be a political animal in both settings. Funding, as much as one's prospect for promotion to more prestigious posts, depends on how well one can play the game.

Directors in private U.S. museums need to be attuned primarily to the frame of mind represented by the *Wall Street Journal,* the daily source of edification of the board members. They are affected less by who happens to be the occupant of the White House or the mayor's office, although this is not totally irrelevant for the success of applications for public grants. In other countries the outcome of elections can have a direct bearing on museum policies. Agility in dealing with political parties, possibly even membership in a party, can be an asset. The arrival of Margaret Thatcher in Downing Street and of François Mitterand at the Élysée noticeably affected the art institutions in their respective countries. Whether in private or in public museums, disregard of political realities, among them the political needs of the supervising bodies and the ideological complexion of their members, is a guarantee of managerial failure.

It is usually required that, at least to the public, institutions appear nonpartisan. This does not exclude the sub rosa promotion of the interests of the ultimate boss. As in other walks of life, the consciousness industry also knows the hidden agenda which is more likely to succeed if it is not perceived as such. It would be wrong, however, to assume that the objective and the mentality of every art executive are or should be at odds with those on whose support his organization depends. There are natural and honorable allegiances as much as there are forced marriages and marriages of convenience. All players, though, usually see to it that the serene facade of the art temple is preserved.

During the past twenty years, the power relations between art institutions and their sources of funding have become more complex. Museums have to be maintained

either by public agencies—the tradition in Europe—or through donations from private individuals and philanthropic organizations, as has been the pattern in the United States. When Congress established the National Endowment for the Arts in 1965, U.S. museums gained an additional source of funding. In accepting public grants, however, they became accountable—even if in practice only to a limited degree—to government agencies.

Some public museums in Europe went the road of mixed support, too, although in the opposite direction. Private donors came on board with attractive collections. As has been customary in U.S. museums, however, some of these donors demanded a part in policy making. One of the most spectacular recent examples has been the de facto takeover of museums (among others, museums in Cologne, Vienna, and Aachen) that received or believed they would receive gifts from the German collector Peter Ludwig. As is well known in the Rhineland, Count Panza di Biumo's attempt to get his way in the new museum of Mönchengladbach, down the Rhine from Ludwig's headquarters, was successfully rebuffed by the director, Johannes Cladders, who is both resolute and a good poker player in his own right.[1] How far the Saatchis in London will get in dominating the Tate Gallery's Patrons of New Art—and thereby the museum's policies for contemporary art—is currently watched with the same fascination and nervousness as developments in the Kremlin. A recent, much-noticed instance of Saatchi influence was the Tate's 1982 Schnabel show, which consisted almost entirely of works from the Saatchis' collection. In addition to his position on the steering committee of the Tate's Patrons of New Art, Charles Saatchi is also a trustee of the Whitechapel Gallery.[2] Furthermore, the Saatchis' advertising agency has just begun handling publicity for the Victoria and Albert, the Royal Academy, the National Portrait Gallery, the Serpentine Gallery, and the British Crafts Council. Certainly the election victory of Mrs. Thatcher, in which the Saatchis played a part as the advertising agency of the Conservative Party, did not weaken their position (and may in turn have provided the Conservatives with a powerful agent within the hallowed hall of the Tate).[3]

If such collectors seem to be acting primarily in their own self-interest and to be building pyramids to themselves when they attempt to impose their will on "chosen" institutions, their moves are in fact less troublesome in the long run than the disconcerting arrival on the scene of corporate funding for the arts—even though the latter at first appears to be more innocuous.[4] Starting on a large scale towards the end of the 1960s in the United States and expanding rapidly ever

1. Dr. Cladders, who for several years was also in charge of the German pavilion of the Venice Biennale, has since retired from the directorship of the museum in Mönchengladbach and Count Panza di Biumo has sold a major portion of his collection to the Museum of Contemporary Art in Los Angeles.

2. A major exhibition of the work of Julian Schnabel was held at the Whitechapel Gallery in the fall of 1986.

3. The vice-chairman of Saatchi & Saatchi, Michael Dobbs, is chief of staff of the Conservative Party chairman, Norman Tebbit. For further, updated information on the Saatchis and Ludwig, see texts on Taking Stock (unfinished), Der Pralinenmeister, and Weite und Vielfalt der Brigade Ludwig in this catalogue.

4. The influence of the Saatchis has since grown considerably, in tandem with the expansion of their advertising empire. As experienced toilers in that branch of the consciousness industry, the Saatchis now seem to have an impact on the art world that matches or even surpasses that of corporations, particularly in regard to contemporary art. However, because this influence is originating with individuals, it may not survive them and may in the end have only minor structural consequences.

since, corporate funding has spread during the last five years to Britain and the Continent. Ambitious exhibition programs that could not be financed through traditional sources led museums to turn to corporations for support. The larger, more lavishly appointed these shows and their catalogues became, however, the more glamour the audiences began to expect. In an ever-advancing spiral the public was made to believe that only Hollywood-style extravaganzas were worth seeing and that only they could give an accurate sense of the world of art. The resulting box-office pressure made the museums still more dependent on corporate funding. Then came the recessions of the 1970s and 1980s. Many individual donors could no longer contribute at the accustomed rate, and inflation eroded the purchasing power of funds. To compound the financial problems, many governments, facing huge deficits—often due to sizable expansions of military budgets—cut their support for social services as well as their arts funding. Again museums felt they had no choice but to turn to corporations for a bail-out. Following their own ideological inclinations and making them national policy, President Reagan and Mrs. Thatcher encouraged the so-called private sector to pick up the slack in financial support.

Why have business executives been receptive to the museums' pleas for money? During the restive Sixties the more astute ones began to understand that corporate involvement in the arts is too important to be left to the chairman's wife. Irrespective of their own love for or indifference towards art, they recognized that a company's association with art could yield benefits far out of proportion to a specific financial investment. Not only could such a policy attract sophisticated personnel, but it also projected an image of the company as a good corporate citizen and advertised its products—all things which impress investors. Executives with a longer vision also saw that the association of their company (and, by implication, of business in general) with the high prestige of art was a subtle but effective means for lobbying in the corridors of government. It could open doors, facilitate passage of favorable legislation, and serve as a shield against scrutiny and criticism of corporate conduct.

Museums, of course, are not blind to the attractions for business of lobbying through art. For example, in a pamphlet with the telling title "The Business Behind Art Knows the Art of Good Business," the Metropolitan Museum in New York woos prospective corporate sponsors by assuring them: "Many public relations opportunities are available through the sponsorship of programs, special exhibitions

5. *Carl Spielvogel, the head of one of the Saatchi & Saatchi subsidiaries in New York, is the chairman of the Metropolitan Museum's Business Committee. Charles Saatchi is vice-chairman of the museum's International Business Committee.*

6. *In an op-ed page advertisement in the* New York Times *on October 10, 1985, Mobil explained, under the headline "Art, for the sake of business," the rationale behind its involvement in the arts in these words: "What's in it for us—or for your company? Improving—and ensuring—the business climate." More extensive reasons are given by Mobil director and vice-president of public affairs, Herb Schmertz, in "Affinity-of-Purpose Marketing: The Case of* Masterpiece Theatre,*" from his book* Good-bye to the Low Profile: The Art of Creative Confrontation *(Boston: Little, Brown, and Co., 1986).*

7. *The headquarters of Philip Morris in New York and the headquarters of the Champion International Corporation in Stamford, Connecticut. An additional branch has since been opened at the headquarters of the Equitable Life Assurance Society in New York. Benjamin D. Holloway, chairman and chief executive officer of the Equitable Real Estate Group, a subsidiary of the insurance company, has joined the museum's board of trustees.*

and services. These can often provide a creative and cost-effective answer to a specific marketing objective, particularly where international, governmental or consumer relations may be a fundamental concern."[5]

A public relations executive of Mobil in New York aptly called the company's art support a "good will umbrella," and his colleague from Exxon referred to it as a "social lubricant."[6] It is liberals in particular who need to be greased, because they are the most likely and sophisticated critics of corporations and they are often in positions of influence. They also happen to be more interested in culture than other groups on the political spectrum. Luke Rittner, who as outgoing director of the British Association of Business Sponsorship of the Arts should know, recently explained: "A few years ago companies thought sponsoring the arts was charitable. Now they realize there is also another aspect; it is a tool they can use for corporate promotion in one form or another." Rittner, obviously in tune with his prime minister, has been appointed the new secretary general on the British Arts Council.

Corporate public relations officers know that the greatest publicity benefits can be derived from high-visibility events, shows that draw crowds and are covered extensively by the popular media; these are shows that are based on and create myths—in short, blockbusters. As long as an institution is not squeamish about company involvement in press releases, posters, advertisements, and its exhibition catalogue, its grant proposal for such an extravaganza is likely to be examined with sympathy. Some companies are happy to underwrite publicity for the event (which usually includes the company logo) at a rate almost matching the funds they make available for the exhibition itself. Generally, such companies look for events that are "exciting," a word that pops up in museum press releases and catalogue prefaces more often than any other.

Museum managers have learned, of course, what kind of shows are likely to attract corporate funding. And they also know that they have to keep their institutions in the limelight. Most shows in large New York museums are now sponsored by corporations. Institutions in London will soon be catching up with them. The Whitney Museum has even gone one step further. It has established branches—almost literally a merger—on the premises of two companies.[7] It is fair to assume that exhibition proposals that do not fulfill the necessary criteria for corporate sponsorship risk not being considered, and we never hear about them. Certainly, shows that could promote critical awareness, present products of consciousness dialectically and in relation to the social world, or question relations of power have a slim chance of being approved—not only because they are unlikely to attract corporate funding, but also because they could sour relations with

8. Philippe de Montebello, director of the Metropolitan Museum, is quoted in Newsweek (November 25, 1985): "It's an inherent, insidious, hidden form of censorship . . . But corporations aren't censoring us— we're censoring ourselves."

potential sponsors for other shows. Consequently, self-censorship is having a boom.[8] Without exerting any direct pressure, corporations have effectively gained a veto in museums, even though their financial contribution often covers only a fraction of the costs of an exhibition. Depending on circumstances, these contributions are tax-deductible as a business expense or a charitable contribution. Ordinary taxpayers are thus footing part of the bill. In effect, they are unwitting sponsors of private corporate policies, which, in many cases, are detrimental to their health and safety, the general welfare, and in conflict with their personal ethics.

Since the corporate blanket is so warm, glaring examples of direct interference rare, and the increasing dominance of the museums' development offices hard to trace, the change of climate is hardly perceived, nor is it taken as a threat. To say that this change might have consequences beyond the confines of the institution and that it affects the type of art that is and will be produced therefore can sound like over-dramatization. Through naiveté, need, or addiction to corporate financing, museums are now on the slippery road to becoming public relations agents for the interests of big business and its ideological allies. The adjustments that museums make in the selection and promotion of works for exhibition and in the way they present them create a climate that supports prevailing distributions of power and capital and persuades the populace that the status quo is the natural and best order of things. Rather than sponsoring intelligent, critical awareness, museums thus tend to foster appeasement.

Those engaged in collaboration with the public relations officers of companies rarely see themselves as promoters of acquiescence. On the contrary, they are usually convinced that their activities are in the best interests of art. Such a well-intentioned delusion can survive only as long as art is perceived as a mythical entity above mundane interests and ideological conflict. And it is, of course, this misunderstanding of the role that products of the consciousness industry play which constitutes the indispensable base for all corporate strategies of persuasion.

Whether museums contend with governments, power-trips of individuals, or the corporate steamroller, they are in the business of molding and channeling consciousness. Even though they may not agree with the system of beliefs dominant at the time, their options not to subscribe to them and instead to promote an alternative consciousness are limited. The survival of the institution and personal careers are often at stake. But in nondictatorial societies, the means for the production of consciousness are not all in one hand. The sophistication required to

This is a slightly altered version of an essay that was originally delivered as a talk at the annual meeting of the Art Museum Association of Australia in Canberra, August 30, 1983, and published in Art in America 72, no. 2 (February 1984). The photographs of volcanos erupting and surfers surfing were taken from slides bought by Haacke in Hawaii en route to his lecture in Canberra; these slides were projected during the talk.

promote a particular interpretation of the world is potentially also available to question that interpretation and to offer other versions. As the need to spend enormous sums for public relations and government propaganda indicates, things are not frozen. Political constellations shift and unincorporated zones exist in sufficient numbers to disturb the mainstream.

It was never easy for museums to preserve or regain a degree of maneuverability and intellectual integrity. It takes stealth, intelligence, determination—and some luck. But a democratic society demands nothing less than that.

Catalogue of Works: 1969-1986

Texts accompanying the works in the catalogue
were written by Hans Haacke.

Nachrichten

1969-1970

Installation: teletype machine, wire service, fifteen plastic containers with newsprint, each 9⅝ x 5½" (24.5 x 14 cm).

First exhibited in the international group exhibition *Prospect 69,* at the Kunsthalle Düsseldorf, September 18-October 12, 1969. Director Karl Ruhrberg.

Owned by Hans Haacke.

During *Prospect 69*, a teletype machine installed at the Kunsthalle printed out the messages transmitted by the dpa (Deutsche Presse Agentur) news wire service. On the day after the transmission, the paper printouts were displayed for further reading and, eventually, on the third day, these rolls were labeled, dated, and stored in transparent tubular containers. During the time of the exhibition, the West German federal elections were held. *Prospect 69* was organized with the stated goal of providing a preview of the exhibition programs for the following year of an internationally selected group of galleries. These galleries co-financed the exhibition.

Two months later, on the occasion of a one-person exhibition at the Howard Wise Gallery in New York (November 4-November 30, 1969), the UPI (United Press International) news service was printed by a teletype machine in the gallery. In this installa-

tion, as in the previous one, the printed paper rolls were displayed after the day of transmission and then stored (twenty-six plastic containers, each 3½ x 9¾" [8.9 x 24.8 cm]).

For an installation at the Jewish Museum, as part of the *Software* exhibition (September 16-November 8, 1970), five teletype machines simultaneously recorded the wire services of ANSA (Italian), dpa (German), the New York Times News Service, Reuters, and UPI. The printouts accumulated on the floor and were not posted or preserved beyond the time of the exhibition.

This was also the way *News* was presented in the exhibition *Directions 3: Eight Artists* at the Milwaukee Art Center (June 18-August 8, 1971). In Milwaukee, the wire services recorded were those of the Los Angeles Times/Washington Post, the New York Times, and UPI.

Facing page: (Left) Installation at Howard Wise Gallery, New York, November 1969. (Right) Excerpt from UPI printout, November 21, 1969.

This page: (Above) Installation, *Prospect 69*, Kunsthalle, Düsseldorf, September-October 1969. (Below) Installation, *Software*, Jewish Museum, September-November 1970.

1969

Installation for audience participation: maps of Manhattan and the five boroughs of New York City, 64 x 88" (162.5 x 226 cm); the New York metropolitan area (50 miles radius), 44 x 38" (111.7 x 96 cm); the United States, 44 x 64" (111.7 x 162.5 cm); and the world, 44 x 64" (111.7 x 162.5 cm). Red and blue pins.

Installed as part of a one-person exhibition at the Howard Wise Gallery, New York, November 1-November 30, 1969.

Photo of map excerpt: Robert Mates and Paul Katz.

Owned by Hans Haacke.

On maps in the gallery, visitors to the exhibition were requested to mark their birthplace (with red pins) and their current residence (with blue pins). At the end of the exhibition, 2,022 locations had been pinpointed as residences and 2,312 as birthplaces.

	Residence	*Birthplace*
Manhattan	732	257
Brooklyn	78	91
Queens	81	42
Bronx	43	62
Staten Island	6	5
New York City	940	457
New York State (excluding NYC)	265	184
New Jersey	164	162
Connecticut	52	66
Tri-State area	1421	860
United States (excluding NY,NJ,CT)	402	920
United States	1823	1789
Canada	43	52
South and Central America	22	50
Europe	63	213
Asia	27	105
Africa	15	22
Australia	6	9
Isolated islands, oceans, edge of map	19	72
Total	2022	2312

INDICATE YOUR BIRTHPLACE WITH RED PIN,

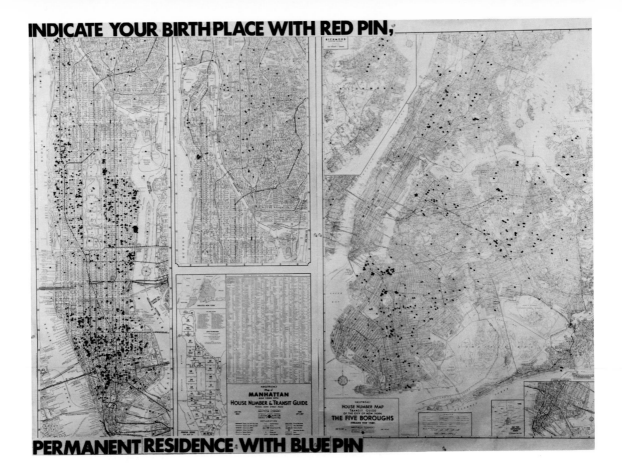

PERMANENT RESIDENCE WITH BLUE PIN

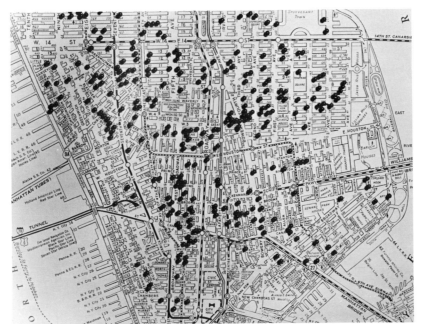

Gallery-Goers' Residence Profile, Part 2

1970

Wall installation: 732 black-and-white photographs, each 5 x 7″ (12.5 x 17.8 cm); 189 typewritten cards, each 5 x 7″ (12.5 x 17.8 cm).

First exhibited in one-person exhibition at Galerie Paul Maenz, Cologne, January 16-February 13, 1971.

Owned by Hans Haacke.

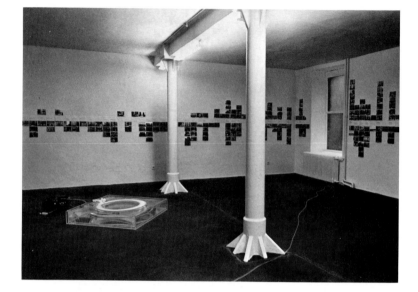

Photographs of 732 building facades in Manhattan were mounted with pins on the four walls of Galerie Paul Maenz in Cologne. These buildings had been designated as their residences by visitors to an exhibition of Hans Haacke's work at the Howard Wise Gallery, New York (November 1969). The installation followed schematically the layout of Manhattan, with Fifth Avenue serving as a horizontal axis on the wall: for addresses east of Fifth Avenue, photographs extended up toward the ceiling; for addresses west of Fifth Avenue, photographs extended down toward the floor. North was to the left, south to the right. Each vertical row of photographs represented a street. The street blocks in question were listed on typewritten cards positioned on the horizontal axis.

En vente à la Fondation Maeght

1970

Performance, at the Fondation Maeght, St.-Paul-de-Vence, France, July 26, 1970; in conjunction with performances by Bob Israel and Robert Whitman.

Presented as part of the *Nuits de la Fondation Maeght,* a series of nighttime performances held in the context of the exhibition *L'art vivant américain,* guest-curated by Dore Ashton at the Fondation Maeght, in the summer of 1970.

Over the loudspeakers of the theater, a female voice read the titles and prices of representative original prints on sale in the bookstore of the ostensibly not-for-profit Fondation Maeght. All prints were from artists of the Galerie Maeght in Paris. Their aggregate value amounted to more than $190,000. During the performance, the reading of price quotations was interrupted at regular intervals by a male voice, which transmitted over the telephone from the local *Nice-Matin* newspaper office the latest news bulletins coming off the wire service of Agence France Press. Halfway through the performance, the director of the Fondation demanded an immediate stop to it. As he was not prepared to explain his reasons to the audience, the performance was completed as planned, with the collaboration of the sound engineer.

Reportedly, the Fondation was created by the Parisian art dealer Aimé Maeght as part of a settlement of a dispute with the French tax authorities. It was to be structured as a not-for-profit institution for the public display of a collection of modern art and for changing exhibitions.

En vente à la Librairie de la Fondation Maeght:

"SPIRALE" de Jack Youngerman
Litographie originale signée et numérotée,
tiré à 30 exemplaires
1200 Frs. pièce.

"Feuilles" de Ellsworth Kelly
Litographie originale, signée et numérotée
tiré à 75 exemplaires
1200 Frs. pièce

"Le chiffre huit" de Tapiès
eau forte originale en 2 couleurs, signée et numérotée
tiré à 75 exemplaires
1300 Frs. pièce

"Lekū III" de Edouardo Chillida
eau forte originale, signée et numérotée
tiré à 50 exemplaires
1400 Frs. pièce.

"Papouse" de Alexander Calder
Litographie originale en 3 couleurs, signée et numérotée
tiré à 75 exemplaires
6000 Frs. pièce

"Le bonheur" de Marc Chagall
Litographie originale en 5 couleurs, signée et numérotée
tiré à 75 exemplaires
7500 Frs. pièce

"Objet inquiétant I" de Alberto Giacometti
Litographie originale, signée et numérotée
tiré à 75 exemplaires
10 000 Frs. pièce

"Oiseau de feu" de Joan Miró
intaglio originale en 2 couleurs, signée et numérotée
tiré à 75 exemplaires
15 000 Frs pièce

"Oiseau bleu et jaune" de Georges Braque
Litographie originale en 3 couleurs, signée et numérotée
tiré à 75 exemplaires
15 000 Frs. pièce

Aujourd'hui l'ensemble des œuvres graphiques signées présentées à la vente à la Librairie de la Fondation Maeght à des prix imposés représente la somme totale de 965.640 Frs.

FIN De l'event

En vente à la Librairie de la Fondation Maeght:

"SPIRALE" de Jack Youngerman
"Lithographie originale, signée et numérotée,
tiré à 30 exemplaires"
1200 Frs. pièce.

.

"Feuilles" de Ellsworth Kelly
"Lithographie originale, signée et numérotée
tiré à 75 exemplaires
1200 Frs. pièce

"Le chiffre huit" de Tàpiès
eau forte originale en 2 couleurs, signée et numérotée
tiré à 75 exemplaires
1300 Frs. pièce.

"Lekú III" de Edouardo Chillida
eau forte originale, signée et numérotée
tiré à 50 exemplaires
1400 Frs. pièce.

"Papouse" de Alexander Calder
Lithographie originale en 3 couleurs, signée et numérotée
tiré à 75 exemplaires
4000 Frs. pièce.

Polls

1969-1973

Between 1969 and 1973 a variety of polls were conducted among art audiences in the United States and West Germany.

1. The first poll was held as part of a one-person exhibition at the Howard Wise Gallery in New York, November 1-November 29, 1969. The visitors were requested to mark their birthplace and their current residence with pins on maps. (See *Gallery-Goers' Birthplace and Residence Profile, Part 1.*)

2. Also in 1969, a proposal was developed for the *Software* exhibition, to be held at the Jewish Museum, September 16-November 8, 1970. This proposal contained the following description:

Teletype terminals are positioned in the exhibition area at locations that will be passed by all visitors. These keyboard terminals are connected with a digital computer on a time-sharing basis and serve both as input as well as output devices.

Each visitor begins his interaction with a computer by typing in a self-chosen code identification. In order to preserve anonymity, actual names never enter the system. Using a keyboard he then proceeds to answer questions posed to him via teletype print-out. Moving on to another terminal he identifies himself again by his code. Recognizing the code of the individual, the computer presents additional questions without repeating or asking questions that do not apply, because of answers previously given. Due to branches in the polling program a number of questions are personalized and vary from visitor to visitor.

Essentially the questions are of two types. One set asks the visitor for factual *information about himself, e.g., age, sex, educational* background, income bracket, etc. *The other set of questions inquires about* opinions on a variety of subjects.

The computer compiles the answers, compares them with information received from other visitors, and correlates data relevant for a statistical breakdown.

At the exit area of the exhibition a teletype terminal prints out the processed information in the form of statistics giving the number of persons who have answered the questions, absolute figures for the answers, percentages, and finally correlations between opinions and the visitors' demographic background. The processing speed of the computer makes it possible for the statistical evaluation of all answers to be up-to-date and available at any given time. A closed circuit television set-up projects the constantly changing data from the print-out onto a large screen, so that it is accessible to a great number of people.

Based on their own information gradually a statistical profile of the exhibition's visitors emerges.

Questions were formulated, flow charts for the branches were drawn, and computer experts affiliated with the Massachusetts Institute of Technology prepared the necessary software. However, because of equipment failure, the polling project had to be abandoned at the start of the exhibition.

These questions are and your answers will be part of

Hans Haacke's VISITORS' PROFILE

a work in progress during the Haacke exhibition at the

Guggenheim Museum.

Please fill out the questionnaire and drop it into the box on

the white round table near the windows on the Museum's ground

floor. Do not sign your name.

1) Do you have a professional interest in art,
 e.g. artist, student, critic, historian, etc?
 yes ___ no ___

2) Is the use of the American flag for the expression
 of political beliefs, e.g. on hard-hats and in
 dissident art exhibitions a legitimate exercise
 of free speech?
 yes ___ no ___

3) How old are you?
 years ___

4) Should the use of marijuana be legalized,
 lightly or severely punished?
 legalized ___ lightly ___ severely
 punished

5) What is your marital status?
 married ___ single ___ divorced ___ separated
 widowed ___

6) Do you sympathize with Womens' Lib?
 yes ___ no ___

7) Are you male, female?
 male ___ female ___

8) Do you have children?
 yes ___ no ___

9) Would you mind busing your child to integrate
 schools?
 yes ___ no ___

10) What is your ethic background?

11) Assuming you were Indochinese, would you
 sympathize with the present Saigon regime?
 yes ___ no ___

12) In your opinion is the moral fabric of this
 country strengthened or weakened by the US
 involvement in Indochina?
 strengthened ___ weakened ___

13) What is your religion?

14) Do you think the interests of profit-
 oriented business usually are compatible
 with the common good of the world?
 yes ___ no ___

15) What is your annual income (before taxes)?
 $ ___

16) In your opinion are the economic difficulties
 of the US mainly attributable to the Nixon
 Administration's policies?
 yes ___ no ___

17) Where do you live?
 city ___ county ___ state ___

18) Do you think the defeat of the SST was a step
 in the right direction?
 yes ___ no ___

19) Are you enrolled in or have you graduated
 from college?
 yes ___ no ___

20) In your opinion should the general orientation
 of the country be more or less conservative?
 more ___ less ___

Your answers will be tabulated later today together with the
answers of all other visitors of the exhibition. Thank you.

3. As part of the exhibition *Information* at the Museum of Modern Art (June 20-September 20, 1970), a single either-or question of a political nature was posed to the museum's visitors. This question was prominently posted and could be answered by dropping a ballot into one of two ballot boxes. (See *MOMA-Poll*.)

4. A multiple-choice questionnaire with ten demographic questions and ten questions on topical sociopolitical issues was prepared for a one-person exhibition that was scheduled to open at the Guggenheim Museum in April 1971. The questions were almost identical to those incorporated in the program for the poll of the visitors to the *Software* exhibition. They were to be answered anonymously. Thomas Messer, director of the Guggenheim Museum, objected to the poll, as well as two other works prepared for the exhibition. As a result, the exhibition was canceled and this work was not realized. (See Rosalyn Deutsche, "Property Values: Hans Haacke, Real Estate, and the Museum," in this catalogue.)

5. During the group exhibition *Directions 3: Eight Artists*, at the Milwaukee Art Center (June 19-August 8, 1971), as well as a one-person exhibition at the Museum Haus Lange in Krefeld, Germany (May 22-July 16, 1972), visitors were invited to complete a multiple-choice questionnaire similar to the one prepared for the aborted exhibition at the Guggenheim Museum. In Milwaukee, the answers were processed by computer, whereas in Krefeld they were tabulated manually. In both institutions the results were posted and regularly updated over the time of the exhibitions. Of the 1,316 visitors to the Krefeld exhibition, a total of 717 (45.6%) participated in the poll.

6. At *Documenta 5* in Kassel, Germany (June 30-October 8, 1972), the visitors were requested in German, English, and French to complete a machine-readable multiple-choice questionnaire, again with ten demographic questions and ten questions on topical sociopolitical issues. The answers were processed by the regional computer center for Kassel. Regularly updated printouts were posted in the exhibition. A total of 41,810 (19.8%) visitors to *Documenta 5* participated in the poll.

7. In May and in September 1972, polls were conducted along similar lines at the John Weber Gallery in New York (see *John Weber Gallery Visitors' Profile 1* and *2*).

8. A similar poll was also conducted during the group show *Kunst im politischen Kampf*, at the Kunstverein Hannover (March 31-May 13, 1973).

Subsequently, the answers to overlapping questions in the three German polls (Museum Haus Lange, Krefeld; Documenta 5, Kassel; and Kunstverein Hannover) were tabulated and compared with each other in bar graphs, similar to those of the *John Weber Gallery Visitors' Profiles*. These graphs were exhibited in one-person exhibitions at the Frankfurter Kunstverein (September 10-October 24, 1976) and the Badischer Kunstverein in Karlsruhe (March 8-April 17, 1977).

(Above) Poll taking at *Documenta 5*, Kassel, June-October 1972. (Below) Excerpts from tabulated results of poll taken at *Directions 3: Eight Artists*, Milwaukee Art Center, June-August 1971.

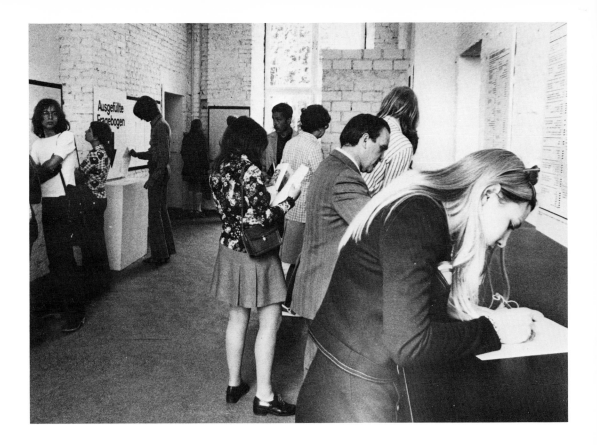

11

Assuming you were Indochinese, would you sympathize with the Saigon regime?

	yes	no	other or no answer
WITH PROFESSIONAL INTEREST IN ART	9%	21%	7%
WITH NO PROFESSIONAL INTEREST IN ART	15%	34%	11%
OTHER ANSWER OR NO RESPONSE	0%	0%	0%
UNDER 18 YEARS OF AGE	6%	12%	4%
18 TO 30 YEAR OF AGE	10%	29%	9%
31 TO 45 YEARS OF AGE	3%	7%	3%
46 TO 65 YEARS OF AGE	2%	5%	2%
OVER 65 YEARS OF AGE	0%	0%	0%
OTHER ANSWER OR NO RESPONSE	0%	0%	0%
MARRIED	8%	19%	7%
SINGLE	14%	33%	11%
DIVORCED	0%	1%	0%
SEPARATED	0%	0%	0%
WIDOWED	0%	0%	0%
OTHER ANSWER OR NO RESPONSE	0%	0%	0%
MALE	11%	28%	6%
FEMALE	12%	26%	13%
NO RESPONSE	7%	15%	6%
HAVE CHILDREN	16%	19%	13%
HAVE NO CHILDREN	0%	0%	0%
OTHER ANSWER OR NO RESPONSE	0%	0%	0%
AFRICAN (BLACK)	0%	0%	0%
ANGLO – SAXON	5%	12%	3%
EAST EUROPEAN	1%	3%	1%
GERMAN	8%	19%	6%
ITALIAN	0%	3%	0%
ORIENTAL	0%	0%	0%
POLISH	2%	4%	1%
SCANDINAVIAN	1%	3%	0%
SPANISH – AMERICAN	0%	0%	0%
OTHER	3%	9%	4%
ANNUAL INCOME UNDER $2000	8%	15%	5%
(BEFORE TAXES) $2000 – 4999	7%	15%	6%
$5000 – 9999	0%	3%	0%
$10000 –25000	2%	6%	2%
OVER $25000	3%	9%	2%
OTHER ANSWER OR NO RESPONSE	1%	4%	2%
CATHOLIC	7%	16%	5%
PROTESTANT	1%	6%	1%
JEWISH	3%	10%	2%
OTHER	4%	10%	3%
NO RELIGION	1%	2%	0%
NO RESPONSE	5%	9%	5%
LIVING IN CITY OF MILWAUKEE	9%	23%	7%
WITHIN MILWAUKEE COUNTY, OUTSIDE OF CITY	8%	17%	6%
WITHIN 50 MILE RADIUS OF MILWAUKEE	1%	1%	0%
ELSEWHERE IN WISCONSIN	1%	3%	1%
ELSEWHERE IN MIDWEST	1%	4%	1%
ELSEWHERE IN U. S. A.	1%	3%	0%
ABROAD	0%	0%	0%
OTHER ANSWER OR NO RESPONSE	0%	0%	0%
WITH COLLEGE EDUCATION	13%	34%	10%
WITHOUT COLLEGE EDUCATION	10%	20%	8%
OTHER ANSWER OR NO RESPONSE	0%	0%	0%

20

In your opinion, should the general orientation of the country be more conservative or less conservative?

	more	less	other or no answer
WITH PROFESSIONAL INTEREST IN ART	10%	25%	2%
WITH NO PROFESSIONAL INTEREST IN ART	18%	37%	5%
OTHER ANSWER OR NO RESPONSE	0%	0%	0%
UNDER 18 YEARS OF AGE	8%	12%	2%
18 TO 30 YEAR OF AGE	10%	36%	3%
31 TO 45 YEARS OF AGE	4%	8%	0%
46 TO 65 YEARS OF AGE	4%	5%	0%
OVER 65 YEARS OF AGE	0%	0%	0%
OTHER ANSWER OR NO RESPONSE	0%	0%	0%
MARRIED	12%	20%	2%
SINGLE	14%	39%	4%
DIVORCED	0%	1%	0%
SEPARATED	0%	0%	0%
WIDOWED	0%	0%	0%
OTHER ANSWER OR NO RESPONSE	0%	0%	0%
MALE	13%	29%	3%
FEMALE	15%	32%	4%
NO RESPONSE	0%	0%	0%
HAVE CHILDREN	11%	16%	1%
HAVE NO CHILDREN	17%	46%	5%
OTHER ANSWER OR NO RESPONSE	0%	0%	0%
AFRICAN (BLACK)	0%	0%	0%
ANGLO – SAXON	5%	13%	1%
EAST EUROPEAN	1%	4%	0%
GERMAN	11%	21%	2%
ITALIAN	1%	4%	0%
ORIENTAL	0%	0%	0%
POLISH	2%	4%	0%
SCANDINAVIAN	1%	4%	0%
SPANISH – AMERICAN	0%	0%	0%
OTHER	4%	10%	2%
ANNUAL INCOME UNDER $2000	10%	17%	2%
(BEFORE TAXES) $2000 – 4999	10%	16%	2%
$5000 – 9999	0%	4%	0%
$10000 –25000	2%	8%	0%
OVER $25000	2%	11%	0%
OTHER ANSWER OR NO RESPONSE	1%	5%	1%
CATHOLIC	7%	19%	2%
PROTESTANT	2%	7%	0%
JEWISH	4%	11%	1%
OTHER	5%	11%	1%
NO RELIGION	1%	2%	0%
NO RESPONSE	6%	10%	0%
LIVING IN CITY OF MILWAUKEE	11%	26%	2%
WITHIN MILWAUKEE COUNTY, OUTSIDE OF CITY	9%	20%	2%
WITHIN 50 MILE RADIUS OF MILWAUKEE	1%	2%	0%
ELSEWHERE IN WISCONSIN	1%	4%	0%
ELSEWHERE IN MIDWEST	2%	4%	0%
ELSEWHERE IN U. S. A.	1%	3%	0%
ABROAD	0%	0%	0%
OTHER ANSWER OR NO RESPONSE	0%	0%	0%
WITH COLLEGE EDUCATION	13%	41%	3%
WITHOUT COLLEGE EDUCATION	15%	20%	1%
OTHER ANSWER OR NO RESPONSE	0%	0%	1%

MOMA-Poll

1970

Installation for audience participation: two transparent acrylic ballot boxes, each 40 x 20 x 10" (101.6 x 50.8 x 25.4 cm), equipped with a photoelectrically triggered counting device able to record any piece of paper dropped through a slot in the top of the box. One box marked "yes," the other "no." Ballots. Text posted above the boxes:

Question:
Would the fact that Governor Rockefeller has not denounced President Nixon's Indochina policy be a reason for you not to vote for him in November?

Answer:
If 'yes' please cast your ballot into the left box, if 'no' into the right box.

Installed as part of the international group exhibition, *Information,* at the Museum of Modern Art, New York, June 20-September 20, 1970. Curator Kynaston McShine, director John Hightower.

Each visitor was given a ballot at the museum entrance. The color of the ballots differed according to his/her status as a full-paying visitor, a member of the museum, a holder of a courtesy pass, or a visitor who came on Monday, the one day of the week when admission to the museum was free (a concession to the demand for free admission by the Art Workers' Coalition). Every evening the tally of the various categories of visitors and the number of boxes was to be entered on a chart next to them. As it happened, ballots were not handed out regularly by the museum, and not always according to the color code. Consequently, some visitors cast improvised ballots of torn paper.

At the close of the twelve-week exhibition, the automatic counting devices of the ballot boxes had registered the following results:

Yes:	25,566 (68.7%)
No:	11,563 (31.3%)

Total participation in the work was 37,129, or 12.4% of the 299,057 visitors to the museum during the exhibition. More than 153,433 visitors (figures for five days are missing) paid the full admission fee of $1.50 or $1.75 (admission was raised August 7), totaling more than $136,995.25. Admission by courtesy passes or membership cards accounted for 67,312 visitors and another 67,057 museum-goers entered free on Mondays and certain evenings.

The question refers to Nelson Rockefeller, a four-term Republican governor of the state of New York, who was running for reelection in 1970. The Rockefeller family was instrumental in the founding of the Museum of Modern Art in 1929. Nelson Rockefeller was a member of the museum's board of trustees from 1932 until his death in 1979; he had been president, 1939-41, and chairman of the board, 1957-58. Nelson's brother, David Rockefeller, served as chairman of the board (1986, vice-chairman) and their sister-in-law, Mrs. John D. Rockefeller III, was also a member of the board (1986, chairman). At the time, and until his retirement in 1981, David Rockefeller held the position of chairman of the Chase Manhattan Bank. He was succeeded at the bank by Willard C. Butcher, who had been the executive vice-president and had also served as treasurer of the museum.

Two months before the opening of the exhibition, U.S. military forces bombed and invaded Cambodia, although that country had declared itself neutral in the Indochina conflict. In protest against the bombings, large demonstrations were held throughout the United States. During one of these demonstrations, on the campus of Kent State University in Ohio, four students were shot dead by members of the Ohio National Guard. Many artists in New York, under the banner of the Art Strike, called for the temporary closing of museums as a gesture of protest and as a sign that "business should not go on as usual."

Question:

Would the fact that Governor Rockefeller
has not denounced President Nixon's
Indochina policy be a reason for you not
to vote for him in November ?

Answer:

If 'yes'
please cast your ballot into the left box
if 'no'
into the right box.

Sol Goldman and Alex DiLorenzo Manhattan Real Estate Holdings, a Real-Time Social System, as of May 1, 1971

1971

Map of Manhattan in six sections (photo-enlargements), each section 20 x 24″ (50.8 x 61 cm); twenty-four typewritten sheets with collaged photographic contact prints, each 23 x 9″ (58.4 x 22.9 cm), one 17 x 9″ (43.2 x 22.9 cm), and one 21¼ x 9″ (54 x 22.9 cm); one typewritten sheet (photo-enlargement), 24 x 20″ (61 x 50.8 cm).

First exhibited in the international group exhibition, *Prospect 71*, at the Städtische Kunsthalle, Düsseldorf, September 1971. Organized by Konrad Fischer, Jürgen Harten, and Hans Strelow. Director of the Kunsthalle: Karl Ruhrberg.

First U.S. exhibition in the group exhibition, *Making Megalopolis Matter*, at the New York Cultural Center, October 12-November 9, 1972. Director Mario Amaya.

Edition of 2. One in the Sol LeWitt Collection at the Wadsworth Atheneum, Hartford, Connecticut; the other owned by Hans Haacke.

The work comprises the following: a map of Manhattan marking the locations of the properties owned by the real estate partnership Sol Goldman & Alex DiLorenzo, photographs of the facades of these properties, documentation of the buildings, and a list of the nineteen corporations operating them.

In 1971, the partnership of Sol Goldman & Alex DiLorenzo represented the largest noninstitutional real estate holdings in Manhattan, with a market value estimated at $666.7 million (*Forbes*, June 1, 1971). In addition, the two partners were reported to own 300 real estate parcels in other boroughs of New York and 400 more nationwide. At various times their holdings included the St. Moritz Hotel, the Plaza Hotel, the St. Regis Hotel, and the Stanhope Hotel. They ranged from choice buildings, such as the Chrysler Building and properties in the Wall Street area, to high-rise residential properties. But they also included many run-down tenements, warehouses, and garages, as well as properties in the Times Square area housing topless bars, porno shops, peep shows, and massage parlors.

The partners have been accused of planting pimps and prostitutes in their residential buildings and of having tenants physically attacked by hired goons. During a strike by building employees at the Chrysler Building, they hired a firm related to the Carlo Gambino crime family for assistance. They have been charged with large-scale tax delinquencies, nonpayment of electric bills, and serious building violations which, in one case, led to the deaths of three pedestrians.

Alex DiLorenzo died in 1975. His share of the partnership was inherited by his son, Alex DiLorenzo III, who severed ties with Sol Goldman in 1979.

In 1984, in an article about a new joint real estate venture with William Zeckendorf, the *New York Times* stated that Sol Goldman "probably holds more power to reshape the city's skyline than any other single individual." Goldman claims to own more than 600 properties, seventy-five percent of them in the New York metropolitan area. He claims that the Chase Manhattan Bank was and remains his principal lender. In recent years, he has bought large blocks of stock in Mays Department Store, American Maize-Products, American Hoist & Derrick, and Katy Industries. In 1985, *Forbes* listed Goldman among the four hundred wealthiest people in the U.S. His estate has been valued at about $1 billion. In the same year, the *Village Voice* cited him as one of the twelve worst landlords in New York City.

Thomas Messer, director of the Guggenheim Museum, rejected this and two other works which were all made for a scheduled one-person exhibition at the Guggenheim Museum. Messer canceled the exhibition six weeks before the opening, when the artist refused to withdraw the disputed works.

Alerted by reports in the press, law enforcement agencies in New York requested access to the data in the work in the hope that it could assist them in an investigation of suspected ties between Sol Goldman & Alex DiLorenzo and the underworld.

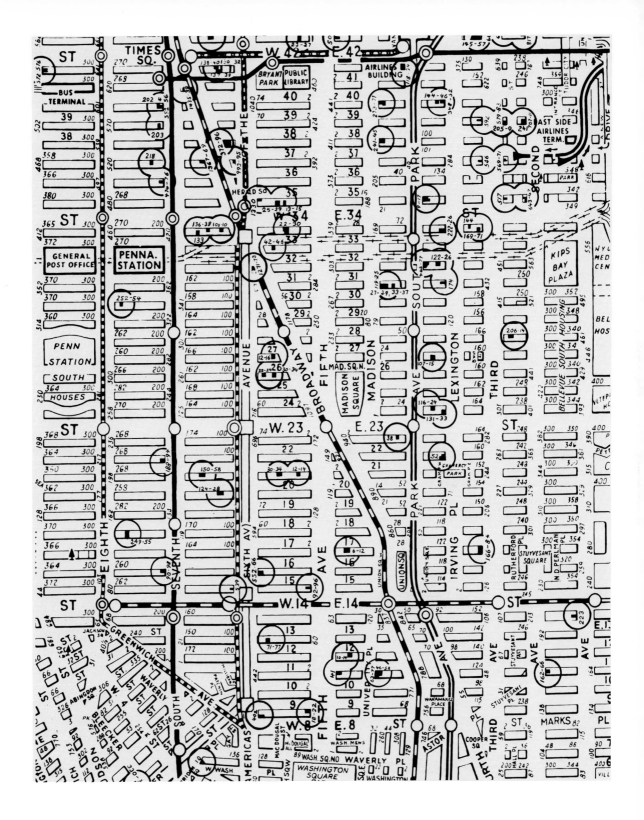

590 Fifth Ave.

Block 1263, Lot 39 , 27 x 100'
6 story office bldg.
Owner Avon Associates, Inc.
Transfer from Chatham Associates, Inc. 12-15-1971, rec. 5-23-1972
Land value $480 000 , total $675 000 (1971)

572 Fifth Ave.

Block 1262, Lot 38 , 25 x 100'
6 story office bldg.
Owner Sutton Associates, Inc.
Transfer recorded 9-16-1968
Land value $450 000 , total $725 000 (1971)

550-54 Fifth Ave.

Block 1261, Lot 36, 75 x 100'
8 story loft bldg. with retail stores
Owner Sol Goldman & Alex DiLorenzo
Transfer rec. 8-15-1969 from Wellington Associates, Inc.
Land value $1 510 000 , total $2 300 000 (1971)

539-45 Fifth Ave.

Block 1279, Lot 69, 75 x 150'
13 story office bldg. (Lorraine Bldg.)
Owner Chatham Associates, Inc.
Transfer rec. 11-21-1969
Land value $2 650 000 , total $4 500 000 (1971)

531-37 Fifth Ave.

Block 1279, Lot 1, 125 x 140'
33 story office bldg. (Ruppert Building)
Owner Avon Associates, Inc.
Transfer from Chatham Associates, Inc. 12-17-1971
Land value $3 700 000 , total $7 000 000 (1971)

509 Fifth Ave.

Block 1277, Lot 72, 7 x 123'
12 story office bldg.
Owner Avon Associates, Inc.
Transfer from Chatham Associates, Inc. 12-15-1971, rec. 5-25-1972
Land value $850 000 , total $1 700 000 (1971)

92-96 Fifth Ave.

Block 816, Lot 42, 103 x 150'
18 story fireproof elevator apt. bldg.
West Haven Associates, Inc.
Transfer rec. 11-11-1970
Land value $545 000 , total $3 000 000 (1971)

41 Fifth Ave.

Block 568, Lot 6, 54 x 141'
15 story fireproof elevator apt. bldg.
Owner Newport Associates, Inc.
Transfer rec. 10-22-1964
Land value $10-22-1964 , total $1 205 000 (1971)

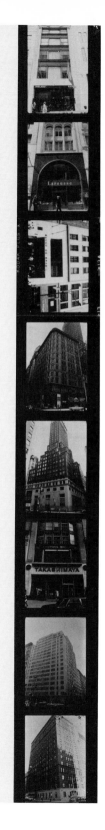

Sol Goldman and Alex DiLorenzo

18-22 Fifth Ave.

Block 572, Lot 38, 80 x 124'
17 story fireproof elevator apt. bldg.
Owner Newport Associates, Inc.
Transfer rec. 7-20-1964
Land value $420 000, total $1 560 000 (1971)

2321-27 Eighth Ave.

Block 1951, Lot 33, 107 x 150'
1 story store bldg.
Owner Newport Associates, Inc.
Transfer rec. 1-9-1970
Land value $315 000, total $550 000 (1971)

987-89 Eighth Ave.

Block 36, Lot 36, 50 x 100'
8 story hotel (Alpine), 4 story office bldg.
Owner Avon Associates, Inc.
Transfer from Chatham Associates, Inc. 12-15-1971, rec. 5-25-1972
Land value $395 000, total $500 000 (1971)

760-66 Eighth Ave.

Block 1018, Lot 61, 80 x 100'
3 story store bldg.
Owner Greenpoint Terminal Warehouse, Inc.
Transfer rec. 12-11-1963
Land value $470 000, total $670 000 (1971)

728 Eighth Ave.

Block 1017, Lot 2, 18 x 66'
4 story walk-up old law tenement
Owner Southern Associates, Inc.
Land value $75 000, total $110 000 (1971)

727-31 Eighth Ave.

Block 1036, Lot 36, 75 x 108'
4 story walk-up old law tenement
Owner Newport Associates, Inc.
Transfer rec. 8-1-1968
Land value $465 000, total $490 000 (1971)

184-86 Dyckman St.

Block 2175, Lot 61, 42 x 100'
1 story store bldg.
Owner Chatham Associates, Inc.
Transfer rec. 4-1-66
Land value $99 000, total $150 000 (1971)

160-66 Dyckman St.

Block 2175, Lot 74, 100 x 200'
2 story store bldg.
Owner Newport Associates, Inc.
Transfer 2-24-1971
Land value $295 000, total $365 000 (1971)

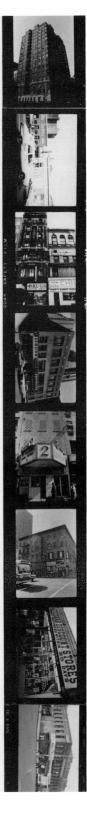

Shapolsky et al. Manhattan Real Estate Holdings, a Real-Time Social System, as of May 1, 1971

1971

Two maps (photo-enlargements), one of the Lower East Side and one of Harlem, each 24 x 20″ (61 x 50.8 cm); 142 photos of building facades and empty lots, each 10 x 8″ (25.4 x 20.3 cm); 142 typewritten data sheets, attached to the photos and giving the property's address, block and lot number, lot size, building code, the corporation or individual holding title, the corporation's address and its officers, the date of acquisition, prior owner, mortgage, and assessed tax value, each 10 x 8″ (25.4 x 20.3 cm); six charts on business transactions (sales, mortgages, etc.) of the real estate group, each 24 x 20″ (61 x 50.8 cm); one explanatory panel, 24 x 20″ (61 x 50.8 cm).

First exhibited in one-person exhibition at Galleria Françoise Lambert, Milan, January 1972.

In the U.S., first exhibited in the group exhibition *Art Without Limit,* Memorial Art Gallery, University of Rochester, Rochester, N.Y., April 7-May 7, 1972; guest curator, Ira Licht.

Edition of 2. One in the collection of Françoise Lambert, Milan; the other owned by Hans Haacke.

Corporations are mentioned in the work if their officers included a member of the Shapolsky family and if they bought or sold, or held mortgages from or mortgaged properties to the Shapolsky clan. In turn, Shapolsky family members and persons who had real estate dealings with these corporations are named. Approximately twenty years prior to 1971 are covered. The information was culled from public records at the New York County Clerk's Office. Because of the volume and the complexity of the data, absolute accuracy and completeness cannot be guaranteed, even though every effort was made in that direction. The properties of Shapolsky et al. are mostly located on the Lower East Side and in Harlem, where, in 1971, they represented the largest concentration of real estate under the control of a single group. They were owned by about seventy corporations and were frequently sold and mortgaged among them.

Harry Shapolsky appears to be the key figure of the group. He has been described by the New York District Attorney's Office as a "front for high officials of the Department of Buildings," and has been indicted for bribing building inspectors. In 1959, he was convicted of rent gouging; he had taken under-the-table payments from Puerto Rican tenants in exchange for allowing them to rent apartments in his buildings on the Lower East Side. He received a $4,000 fine and a suspended jail sentence of four years. The district attorney severely criticized the suspension of the jail sentence, saying: "There have been a number of rent gougers in the past who have gone to jail, and none has been as notorious as Shapolsky." The district attorney's assistant further accused Harry Shapolsky of having "ruthlessly exploited the shortage of housing space." The sentencing judge stated that he

(continued, page 96)

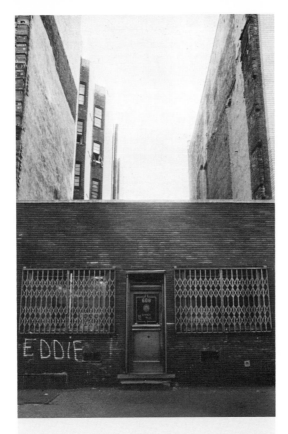

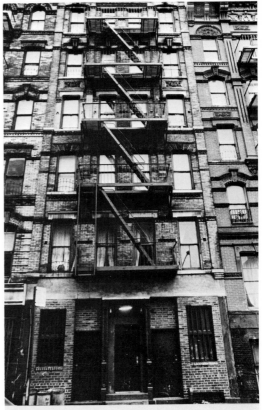

608 E 11 St.
Block 393 Lot 11
25 x 94' 1 story store bldg.

Business office of Shapolsky related corporations
Owned by 194 Ave. A Realty Corp., 608 E 11 St., NYC
Contracts signed by Sam Shapolsky, President('58)
 Harry J. Shapolsky, Pres.('60)
 Alfred Fayer, Vicepres. ('58)
Principal Harry J. Shapolsky(according to Real
Estate Directory of Manhattan)

Acquired 3-27-1963 from Surenko Realties Inc,
608 E 11 St., NYC, Harry J. Shapolsky, President(63)

No mortgage(1971)

Assessed land value $8 500.- , total $24 000.- (1971)

264 E 4 St.
Block 386 Lot 18
24 x 96' 6 story walk-up old law tenement

Owned by 507 E 11 St. Corp., 608 E 11 St., NYC
Contracts signed by Anthony Schimizzi, President('68)
Principal Harry J. Shapolsky(according to Real Estate
Directory of Manhattan)

Acquired 1-8-1965 through foreclosure from
Chivalle Realty Corp. et al defendants

No mortgage(1971)

Assessed land value $8000.- total $27 000.- (1971)

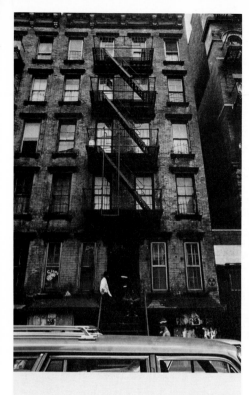 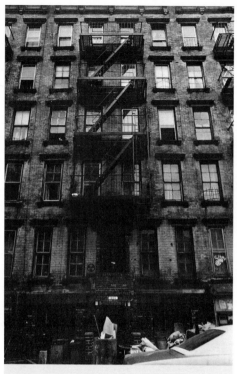 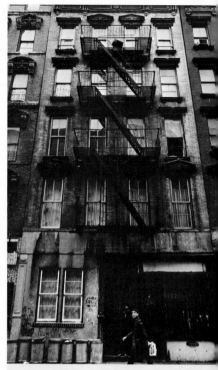

212 E 3 St.
Block 385 Lot 11
5 story walk-up old law tenement

Owned by Harpmel Realty Inc., 608 E 11 St., NYC
Contracts signed by Harry J. Shapolsky, President('63)
 Martin Shapolsky, President('64)
Principal Harry J. Shapolsky(according to Real Estate
Directory of Manhattan)

Acquired 8-21-1963 from John the Baptist Foundation,
c/o The Bank of New York, 48 Wall St., NYC,
for $237 600.- (also 7 other bldgs.)

$150 000.- mortgage at 6% interest, 8-19-1963, due
8-19-1968, held by The Ministers and Missionaries
Benefit Board of the American Baptist Convention,
475 Riverside Drive, NYC(also on 7 other bldgs.)

Assessed land value $25 000.-, total $75 000.- (includ-
ing 214-16 E 3 St.)(1971)

214 E 3 St.
Block 385 Lot 11
5 story walk-up old law tenement

Owned by Harpmel Realty Inc., 608 E 11 St., NYC
Contracts signed by Harry J. Shapolsky, President('63)
 Martin Shapolsky, President('64)
Principal Harry J. Shapolsky(according to Real Estate
Directory of Manhattan)

Acquired 8-21-1963 from John the Baptist Foundation,
c/o The Bank of New York, 48 Wall St., NYC,
for $237 600.- (also 7 other bldgs.)

$150 000.- mortgage at 6% interest, 8-19-1963, due
8-19-1968, held by The Ministers and Missionaries
Benefit Board of the American Baptist Convention,
475 Riverside Drive, NYC (also on 7 other bldgs.)

Assessed land value $25 000.-, total $75 000.- (includ-
ing 212 and 216 E 3 St.) (1971)

228 E 3 St.
Block 385 Lot 19
24 x 105' 5 story walk-up old law tenement

Owned by Harpmel Realty Inc. 608 E 11 St. NYC
Contracts signed by Harry J. Shapolsky, President('63)
 Martin Shapolsky, President('64)

Acquired from John The Baptist Foundation
c/o The Bank of New York, 48 Wall St. NYC
for $237 000.- (also 5 other properties) , 8-21-1963

$150 000.- mortgage (also on 5 other properties) at 6%
interest as of 8-19-1963 due 8-19-1968
held by The Ministers and Missionaries Benefit Board of
The American Baptist Convention, 475 Riverside Dr. NY

Assessed land value $8 000.- total $28 000.-(1971)

Shapolsky et al.

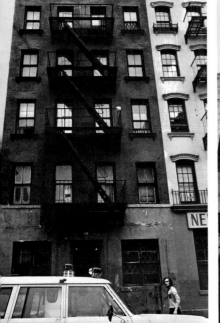

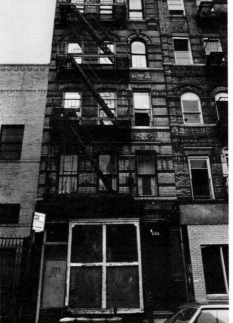

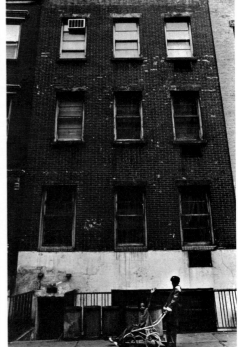

E 3 St.
ck 372 Lot 19
x 105' 5 story walk-up semi-fireproof apt. bldg.

ed by Broweir Realty Corp., 608 E 11 St., NYC
tracts signed by Seymour Weinfeld, President
 Alfred Fayer, Vicepresident
ncipal Harry J. Shapolsky(according to Real Estate
ectory of Manhattan)

uired 10-22-1965 from Apponaug Properties Inc.
Riverside Drive, NYC, Frank L.Taylor, President

000.- mortgage at 6% interest, 10-22-1965, held by
Ministers and Missionaries Benefit Board of The
rican Baptist Convention, 475 Riverside Drive, NYC
so on 312 E 3 St.)

ssed land value $6 500.- , total $55 000.- (1971)

299 E 3 St.
Block 373 Lot 56
18 x 96' 5 story walk-up old law tenement

Owned by West No. 10 Realty Corp., 608 E 11 St., NYC
Contracts signed by Martin Shapolsky, Pres.('65)
 Donald Sherman, Pres. ('68)

Principal Harry J. Shapolsky(according to Real Estate
Directory of Manhattan)

Acquired 3-11-1965 from 300 Realty Corp.,
608 E 11 St., NYC,
contracts signed by Harry J. Shapolsky, Pres.('66/67)
 Pearl Shapolsky, Pres.('64/65/67)
 Donald Sherman, Vicepres.('71)
Principal Harry J. Shapolsky(according to Real Estate
Directory of Manhattan)

Due $8 875.27 of mortgage at 6% interest, held through
assignment, 8-30-1967, by 428 Realty Corp., 608 E 11 St.,
NYC, Harry J. Shapolsky, Pres.('61/3/5/6), due 12-1-1967,

Due $8000.- of mortgage held through assignment, 7-30-1965,
by 428 Realty Corp.

Assessed land value $5 200.- , total $18 000.- (1971)

512 E 3 St.
Block 372 Lot 29
22 x 105' 3 story walk-up old law tenement

Owned by Broweir Realty Corp., 608 E 11 St., NYC
Contracts signed by Seymour Weinfeld, President
 Alfred Fayer, Vice president
Principal Harry J. Shapolsky(according to Real Estate
Directory of Manhattan)

Acquired 10-22-1965 from Apponaug Properties Inc.
475 Riverside Drive, NYC, Frank L. Taylor, President

$55 000.- mortgage at 6% interest, 10-22-1965, held by
The Ministers and Missionaries Benefit Board of The
American Baptist Convention, 475 Riverside Drive, NYC
(also on 292 E 3 St.)

Assessed land value $6 500.- , total $28 000.- (1971)

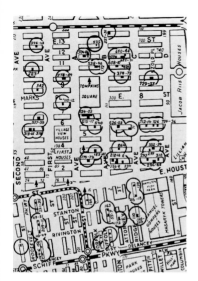

Detail of map of Lower East Side showing Shapolsky properties.

had received many letters attesting to the defendant's good character, including letters from the East Side Chamber of Commerce, the American Baptist Convention (which, along with another Baptist agency, held more than two dozen mortgages on Shapolsky-owned properties), and the New York Board of Rabbis.

In 1965, the radio station WMCA listed Shapolsky among about a dozen slumlords who were "hiding behind the obscurity of corporate names." It also reported that he owned or controlled some 200 old-law tenements, many of which he had been buying and selling or foreclosing in inside deals, thereby increasing his profits. Moreover, it was revealed that the IRS was disputing in Tax Court Shapolsky's declaration of $29,000 adjusted taxable income for 1955; according to IRS computations, his income amounted to $417,697.

In 1971, Thomas Messer, director of the Solomon R. Guggenheim Museum, rejected this and two other works which were all made for a scheduled one-person exhibition at the

Guggenheim Museum. Messer canceled the exhibition six weeks before the opening, when the artist refused to withdraw the disputed works. Messer called them "inappropriate" for exhibition at the museum and stated that he had to fend off "an alien substance that had entered the art museum organism." Edward F. Fry, the curator of the exhibition, was fired when he defended the works. Artists held a protest demonstration inside the museum and over one hundred pledged not to exhibit at the Guggenheim "until the policy of art censorship and its advocates are changed."

Many commentators of the controversy assumed that the trustees of the Guggenheim were linked to the Shapolsky real estate group. There is no evidence to support such suspicions. (The background information on Harry Shapolsky's brushes with the law is not part of the work and never surfaced during the arguments that led to the cancellation of the exhibition and the ensuing controversy.)

The Shapolsky group is still active in real estate in 1986.

Detail of maps and charts, as installed at Stedelijk Van Abbemuseum, Eindhoven, January 1979.

Shapolsky et al.

Apache Realty Corp.	1	
Aram Estates, Inc.	2	
Ave. B & East 14th St. Corp.	3	
Broweir Realty Corp.	4	
Anna Callipari	5	
Callipari Construction Corp.	6	
Ernest Callipari	7	
Ernest Callipari Estate	8	
Clarmar Realty Corp.	9	
Eastboard Realty Corp.	10	
East 47 Realty Corp.	11	
East No. 8 Realty Corp.	12	
East No. 1 Realty Corp.	13	
East 115 St. Realty Corp.	14	
Efsher Realty Corp.	15	
Eighth Realty Estate, Inc.	16	
88 Hopkins St. Corp.	17	
Espearl Realty Corp.	18	
Alfred Fayer	19	
57 Columbia Inc.	20	
507 E 11 St. Corp.	21	
419 Tenth Realty Corp.	22	
428 Realty Corp.	23	
Edwin Frederick	24	
Catherine Greco	25	
George Greenberger	26	
Anna Gruber	27	
Harry Gruber	28	
Grushap Realty Corp.	29	
Abraham Haftel	30	
Fannie Haftel	31	
Hapea Realty Estates, Inc.	32	
Harpeel Realty, Inc.	33	
Ian Adam Realty Corp.	34	
Incfran Realty, Inc.	35	
Jath Realty Corp.	36	
Daniel Kirschenbaum	37	
Sam Kirschenbaum	38	
Kirshop Realty Corp.	39	
Pearl Kleinberg(Shapolsky)	40	
Kupehap Realty Corp.	41	
Lijuto Realty Corp.	42	
John Loiaconon Jr.	43	
Lopahs Realty Corp.	44	
Marol Realty, Inc.	45	
Maryn Realty Corp.	46	
Clara Moskowits	47	
No. 3 Madison Corp.	48	
One Fifty Four Realty Corp.	49	
189 St. Nicholas Realty Corp.	50	
183 Realty Corp.	51	
156 Forsyth, Inc.	52	
142 Ninth Ave. Corp.	53	
194 Ave. A Realty Corp.	54	
117 Realty Corp.	55	
174 E 3 St. Corp.	56	
170 Norfolk Corp.	57	
177 Mulberry Realty Corp.	58	
166 Norfolk St. Corp.	59	
131 Lexington Realty Corp.	60	
128 Realty Corp.	61	
102 W 115 St. Realty Corp.	62	
1951 Second Ave. Corp.	63	
1771 1st Ave. Realty Corp.	64	
Ray Dome Realty Corp.	65	
S & K Estates, Inc.	66	
Saral Estates, Inc.	67	
Saturn 1850 Estates, Inc.	68	
Anthony Schimizzi	69	
Scotty Lee Realty Corp.	70	
Shalane Realty Estates, Inc.	71	
Shapmar Realty Corp.	72	
Shapol Realty Corp.	73	
Anita Shapolsky	74	
Arthur Shapolsky	75	
Harry J. Shapolsky	76	
Martin Shapolsky	77	
Marylin Shapolsky	78	
Pearl Shapolsky	79	
Sam Shapolsky	80	
Donald Sherman	81	
Surenko Realties, Inc.	82	
300 Realty Corp.	83	
28 West 132 St. Corp.	84	
29 Ridge St. Corp.	85	
292 E 3 St. Corp.	86	
278 Tenth, Inc.	87	
213 Madison Jefferson Corp.	88	
232 Harper Estates Realty, Inc.	89	
227 E 127 St. Corp.	90	
2357 Realty Corp.	91	
Venus 3843, Inc.	92	
Seymour Weinfeld	93	
West No. 4 Realty Corp.	94	
West No. 1 Realty Corp.	95	
West No. 6 Realty Corp.	96	
West No. 10 Realty Corp.	97	
West No. 3 Realty Corp.	98	
West No. 2 Realty Corp.	99	
Winthrop Properties, Inc.	100	
Wonmart Realty Corp.	101	

1	Apache Realty Corp.
2	Aram Estates, Inc.
3	Ave. B & East 14th St. Corp.
4	Broweir Realty Corp.
5	Anna Callipari
6	Callipari Construction Corp.
7	Ernest Callipari
8	Ernest Callipari Estate
9	Clarmar Realty Corp.
10	Eastboard Realty Corp.
11	East 47 Realty Corp.
12	East No. 8 Realty Corp.
13	East No. 1 Realty Corp.
14	East 115 St. Realty Corp.
15	Efsher Realty Corp.
16	Eighth Realty Estate, Inc.
17	88 Hopkins St. Corp.
18	Espearl Realty Corp.
19	Alfred Fayer
20	57 Columbia Inc.
21	507 E 11 St. Corp.
22	419 Tenth Realty Corp.
23	428 Realty Corp.
24	Edwin Frederick
25	Catherine Greco
26	George Greenberger
27	Anna Gruber
28	Harry Gruber
29	Grushap Realty Corp.
30	Abraham Haftel
31	Fannie Haftel
32	Hapea Realty Estates, Inc.
33	Harpeel Realty, Inc.
34	Ian Adam Realty Corp.
35	Incfran Realty, Inc.
36	Jath Realty Corp.
37	Daniel Kirschenbaum
38	Sam Kirschenbaum
39	Kirshop Realty Corp.
40	Pearl Kleinberg(Shapolsky)
41	Kupehap Realty Corp.
42	Lijuto Realty Corp.
43	John Loiaconon Jr.
44	Lopahs Realty Corp.
45	Marol Realty, Inc.
46	Maryn Realty Corp.
47	Clara Moskowits
48	No. 3 Madison Corp.
49	One Fifty Four Realty Corp.
50	189 St. Nicholas Realty Corp.
51	183 Realty Corp.
52	156 Forsyth, Inc.
53	142 Ninth Ave. Corp.
54	194 Ave. A Realty Corp.
55	117 Realty Corp.
56	174 E 3 St. Corp.
57	170 Norfolk Corp.
58	177 Mulberry Realty Corp.
59	166 Norfolk St. Corp.
60	131 Lexington Realty Corp.
61	128 Realty Corp.
62	102 W 115 St. Realty Corp.
63	1951 Second Ave. Corp.
64	1771 1st Ave. Realty Corp.
65	Ray Dome Realty Corp.
66	S & K Estates, Inc.
67	Saral Estates, Inc.
68	Saturn 1850 Estates, Inc.
69	Anthony Schimizzi
70	Scotty Lee Realty Corp.
71	Shalane Realty Estates, Inc.
72	Shapmar Realty Corp.
73	Shapol Realty Corp.
74	Anita Shapolsky
75	Arthur Shapolsky
76	Harry J. Shapolsky
77	Martin Shapolsky
78	Marylin Shapolsky
79	Pearl Shapolsky
80	Sam Shapolsky
81	Donald Sherman
82	Surenko Realties, Inc.
83	300 Realty Corp.
84	28 West 132 St. Corp.
85	29 Ridge St. Corp.
86	292 E 3 St. Corp.
87	278 Tenth, Inc.
88	213 Madison Jefferson Corp.
89	232 Harper Estates Realty, Inc.
90	227 E 127 St. Corp.
91	2357 Realty Corp.
92	Venus 3843, Inc.
93	Seymour Weinfeld
94	West No. 4 Realty Corp.
95	West No. 1 Realty Corp.
96	West No. 6 Realty Corp.
97	West No. 10 Realty Corp.
98	West No. 3 Realty Corp.
99	West No. 2 Realty Corp.
100	Winthrop Properties, Inc.
101	Wonmart Realty Corp.

John Weber Gallery Visitors' Profile 1

1972

Installation for audience participation, John Weber Gallery, October 7-October 24, 1972.

Results: twenty-one blueprints, 24 x 30" (61 x 76 cm). Mounted on walls with masking tape.

First exhibited in one-person exhibition at the John Weber Gallery, New York, April 28-May 17, 1973.

Edition of 3. All owned by Hans Haacke.

Note: This work consists of twenty charts recording the results of the poll; four charts are shown here as a representative excerpt.

During an exhibition of works by Carl Andre, Hans Haacke, Nancy Holt, Laurie James, Brenda Miller, and Mary Obering, October 7-October 24, 1972, visitors to the John Weber Gallery were requested to complete a multiple-choice questionnaire with twenty questions. Ten of these questions inquired about their demographic background and ten questions related to the visitors' opinions on sociopolitical issues. The questionnaires were provided in two file trays on either end of a long table in the gallery, together with pencils. The completed forms were dropped into a wooden box with a slot in the top. Throughout the exhibition intermediate results of the survey were posted on the nearby wall.

During the time of the polling, the other galleries sharing the same address with the John Weber Gallery at 420 West Broadway in New York's Soho district had the following exhibitions: *New Works by Artists* (Judd, Morris, Nauman, Rauschenberg, Serra, Stella) at the Leo Castelli Gallery, *Jannis Kounellis* at the Sonnabend Gallery, and *Sylvia Stone* at the André Emmerich Gallery. The public of each of these galleries usually also visits the other exhibitions in the building.

During the thirteen days of the exhibition, 858 questionnaires were completed. Since the total number of visitors is unknown, the ratio of participation cannot be ascertained. It is open to speculation whether nonparticipating visitors differed essentially in their demographic backgrounds and opinions.

The answers to the first question ("Do you have a professional interest in art?") were tabulated in a pie chart. Seventy percent of the respondents declared that they had a professional interest in art (30% as artists, 11% as students, and 29% in another capacity).

The charts were exhibited while a second poll of the John Weber Gallery visitors was conducted in April-May 1973.

These questions and your answers are part of

420 WEST BROADWAY VISITORS' PROFILE

a work in progress by Hans Haacke at the John Weber Gallery, October 7 through 24, 1972

Please fill out this questionnaire and drop it into the box provided for this. Dont sign!

1) Do you have a professional interest in art (e.g. artist, dealer, critic, etc.)? Yes ___ No ___

2) Where do you live? City _____ County _____ State _____

3) It has been suggested that artists and museum staff members be represented on the Board of Trustees of art museums. Do you think this is a good idea? Yes ___ No ___ Dont know ___

4) How old are you? ___ years

5) If elections were held today, for which presidential candidate would you vote? Mc Govern ___ Nixon ___ None ___ Dont know ___

6) In your opinion, are the interests of profit-oriented business usually compatible with the common good? Yes ___ No ___ Dont know ___

7) What is your annual income(before taxes)? $_____

8) Do you think present US taxation favors large incomes or low incomes, or is distributing the burden correctly? Favors large incomes ___ Favors low incomes ___ correct ___

9) What is your occupation? _____

10) Would you bus your child to integrate schools? Yes ___ No ___ Dont know ___

11) Do you have children? Yes ___ No ___

12) What is the country of origin of your ancestors (e.g. Africa, England, Italy, Poland etc.)? _____

13) Esthetic questions aside, which of these New York museums would in your opinion exhibit works critical of the present US Government?

Brooklyn Museum ___ Finch College Museum ___ Guggenheim Museum ___ Jewish Museum ___ Metropolitan Museum ___ Museum of Modern Art ___ New York Cultural Center ___ Whitney Museum ___ All museums ___ None of these museums ___ Dont know ___

14) Are you enrolled in or have you graduated from college? Yes ___ No ___

15) Assuming the prescriptions of the M.I.T. (club of Rome) study for the survival of mankind are correct, do you think the capitalist system of the US is better suited for achieving the state of almost zero economic growth required than other socio-economic systems? Yes ___ No ___ Dont know ___

16) Do you think civil liberties in the US are being eroded, have been increasingly respected, or have not gained or lost during the past few years? Eroded ___ Increasingly respected ___ Not gained or lost ___

17) What is your religion? Catholic ___ Protestant ___ Jewish ___ Other ___ None ___

18) Sex? Male ___ Female ___

19) Do you think the bombing of North Vietnam favors, hurts, or has no effect on the chances for peace in Indochina? Favors ___ Hurts ___ No effect ___ Dont know ___

20) Do you consider yourself politically a conservative, liberal or radical? Conservative ___ Liberal ___ Radical ___ Dont know ___

Thank you for your cooperation. Your answers will be tabulated with the answers of all other visitors. The results will be posted during the exhibition.

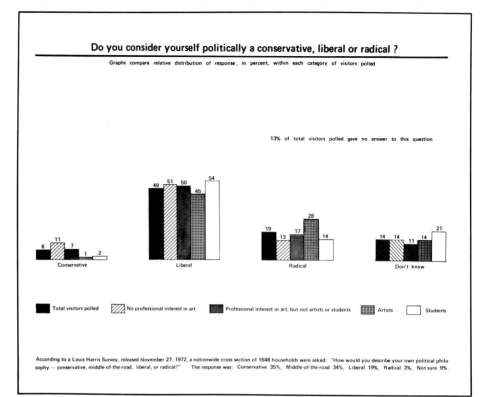

Do you consider yourself politically a conservative, liberal or radical ?

Graphs compare relative distribution of response, in percent, within each category of visitors polled

13% of total visitors polled gave no answer to this question

Conservative	Liberal	Radical	Don't know	

Conservative: 6, 11, 7, 1, 2
Liberal: 49, 51, 50, 45, 54
Radical: 19, 13, 17, 28, 14
Don't know: 14, 14, 11, 14, 21

■ Total visitors polled ▨ No professional interest in art ▦ Professional interest in art, but not artists or students ▦ Artists □ Students

According to a Louis Harris Survey, released November 27, 1972, a nationwide cross section of 1648 households were asked: "How would you describe your own political philosophy --- conservative, middle-of-the-road, liberal, or radical?" The response was: Conservative 35%, Middle-of-the-road 34%, Liberal 19%, Radical 3%, Not sure 9% .

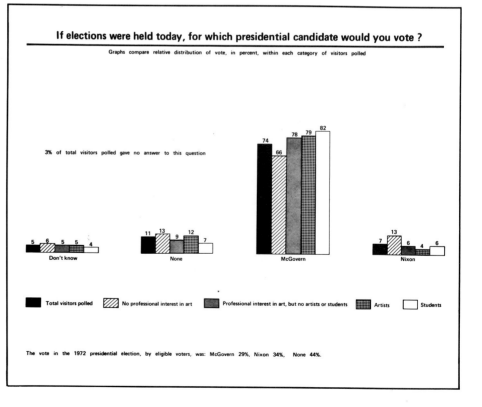

If elections were held today, for which presidential candidate would you vote ?

Graphs compare relative distribution of vote, in percent, within each category of visitors polled

3% of total visitors polled gave no answer to this question

Don't know: 5, 6, 5, 5, 4
None: 11, 13, 9, 12, 7
McGovern: 74, 66, 78, 79, 82
Nixon: 7, 13, 6, 4, 6

■ Total visitors polled ▨ No professional interest in art ▦ Professional interest in art, but no artists or students ▦ Artists □ Students

The vote in the 1972 presidential election, by eligible voters, was: McGovern 29%, Nixon 34%, None 44%.

In your opinion, are the interests of profit - oriented business usually compatible with the common good ?

Graphs compare relative distribution of opinions, in percent, within each category of visitors polled

6% of total visitors polled gave no answer to this question

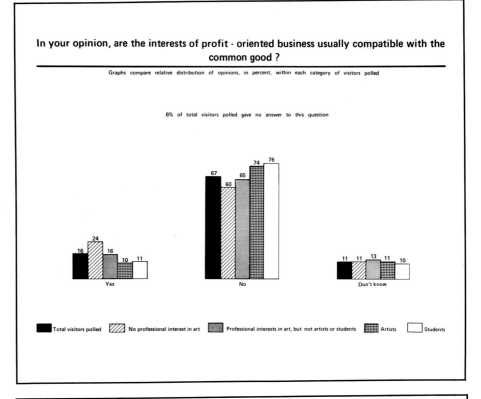

| | Total visitors polled | No professional interest in art | Professional interests in art, but not artists or students | Artists | Students |

Esthetic questions aside, which of these New York museums would in your opinion exhibit works critical of the present US Government ?

Graphs compare the relative frequency, in percent, by which any one of the museums was named by each category of visitors polled
More than one museum could be named

3% of total visitors polled gave no answer to this question

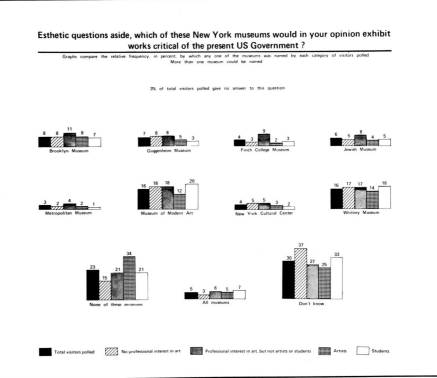

| | Total visitors polled | No professional interest in art | Professional interest in art, but not artists or students | Artists | Students |

John Weber Gallery Visitors' Profile 2

1973

Installation for audience participation, John Weber Gallery, April-May, 1973.

Results: twenty-nine sheets of drawing paper, 11 x 8½" (28 x 21.5 cm).

First exhibited in group exhibition at the John Weber Gallery, New York, September 1973.

Collection of Gilbert and Lila Silverman.

Note: This work consists of twenty-nine charts recording the results of the poll; eight charts are shown here as a representative excerpt.

During the exhibition of graphs presenting the results of a previous survey of the John Weber Gallery public (taken October 7-October 24, 1972), a second poll was conducted at the John Weber Gallery, April 28-May 17, 1973.

Visitors to the show were requested to answer twenty-one multiple-choice questions, printed on both sides of a key-sort card, by punching out the answers of their choice. The questions inquired about the visitors' demographic background and opinions on sociopolitical and art issues. The questionnaires were provided in two file trays sitting on either end of a long table in the center of the exhibition. Punchers were hanging from the ceiling above the table. The punched cards were to be dropped into a wooden box with a slot in the top. Throughout the exhibition intermediate results of the new survey were posted as part of the show.

During the time of the polling, the other galleries sharing the same address with the John Weber Gallery at 420 West Broadway in New York's Soho district had the following exhibitions: *Hanne Darboven* at the Leo Castelli Gallery, *John Baldessari* at the Sonnabend Gallery, and *Miriam Shapiro* at the André Emmerich Gallery. Simultaneous with the first part of the Haacke exhibition, a show of works by Robert Ryman was held in the front room of the John Weber Gallery. This was later replaced by Steve Reich's music scores, displayed on the occasion of several concerts in the gallery. The public of each of the galleries in the building usually also visits the exhibitions of the three other galleries.

During the fourteen days of the exhibition, 1,324 questionnaires were tabulated. Since the total number of visitors is unknown, the ratio of participation cannot be ascertained.

In answer to the first question, "Do you have a professional interest in art?" 74% of the respondents declared that they did (47% as artists, 14% as students, and 13% in another capacity).

The results of the poll were tabulated in simple graphs. The answers to the question, "Do you think the preferences of those who financially back the art world influence the kind of work artists produce?" were correlated through bars of different textures with the responses to six other questions. The uncorrelated answers to this question were: "Yes a lot," 30%; "somewhat," 37%; "slightly," 10%; "not at all," 9%.

The question, "Would your standard of living be affected, if no more art of living artists were bought?" was answered "yes" by 43%, "no" by 33%, "don't know" by 11%, and was not answered by 12% of the participants in the poll.

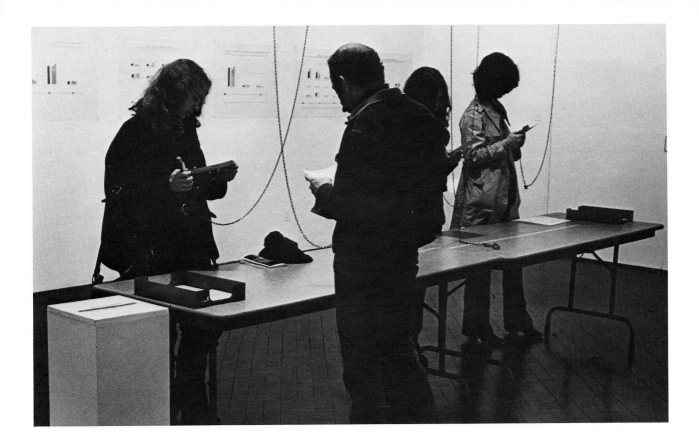

JOHN WEBER GALLERY VISITORS' PROFILE 2 by Hans Haacke

A work in progress during his exhibition at the J. Weber Galler, 420 W. Broadway, NYC, April 28 – May 17, 1973.

Please answer by punching out bridge between edge and hole next to the answer of your choice.

as artist	Do you have	What do you think is the approx-	100 %
as art/art history student	a professional	imate proportion of Nixon sympa-	75 %
other professional interest	interest in art?	thizers among art museum trustees?	50 %
no professional interest			25 %
Manhattan	Where do you live?		0 %
Brooklyn			don't know
Queens		What do you think is the approx-	100 %
Bronx		imate proportion of Nixon sympa-	75 %
Richmond		thizers among visitors to contem-	50 %
adjoining counties		porary art exhibitions?	25 %
elsewhere North/Middle Atlantic States			0 %
South Atlantic States			don't know
Central and Mountain States		What was your personal	none
Pacific States		income in 1972 (before	$1 - 1999
abroad		taxes)?	$2000 - 4999
favor	Does your notion of art favor,		$5000 - 9999
tolerate	tolerate, or reject works that		$10000 - 14999
reject	make deliberate reference to		$15000 - 19999
don't know	socio-political things?		$20000 - 24999
yes, 50 %	Do you think, as a		$25000 - 29999
yes, but no specified quota	matter of principal,		over $30000
sex should be no criterion	that all group shows	Sex?	male
don't know	should include		female
	women artists?		

Continued ▶

K15 671B

none	How much money	Do you think the preferences	yes, a lot
$1 – 1999	have you spent on	of those who financially back	somewhat
$2000 – 4999	buying art(total)?	the art world influence the	slightly
$5000 – 14999		kind of work artists produce?	not at all
$15000 – 29999			don't know
over $30000			
only to themselves	To whom should the	Have you ever lived or worked for more	yes
patrons of museum	trustees of art museums	than one half year in a poverty area?	no
museum membership	be accountable(more	It has been charged that the	always
museum staff	than one can be	present U.S. Government is	often
artists' representatives	named)?	catering to business interests.	occasionally
publicly elected officials		Do you think this is the case?	never
American Association of Museums			don't know
College Art Association		Do you think the collectors who	generally yes
National Endowment for the Arts		buy the kind of art you like, share	generally no
Associated Councils of the Arts		your political/ideological opinions?	don't know
foundation representatives		How old are you?	under 18 years
other(write in)_____			18 - 24 years
don't know			25 - 30 years
responsible	Some people say President		31 - 35 years
not responsible	Nixon is ultimately respon-		36 - 45 years
don't know	sible for the Watergate		46 - 55 years
	scheme. Do you agree?		56 - 65 years
poverty	How would you charac-		over 65 years
lower middle income	terize the socio-economic	Would your standard of living be	yes
middle income	status of your parents?	affected, if no more art of living	no
upper middle income		artists were bought?	don't know
wealthy		Do you daily read the political	yes
Catholic	What is the religious back-	section of a newspaper?	no
Protestant	ground of your family?	Do you think the visitors of	very different
Jewish		the J. Weber Gallery who	somewhat d.
other		participated in the poll dif-	essentially same
mixed		fered from those who did	don't know
none		not?	

Thank you. Drop the card into the ballot box. Your answers will be tabulated with the answers of all other visitors. Intermediate results will be posted during the exhibition.

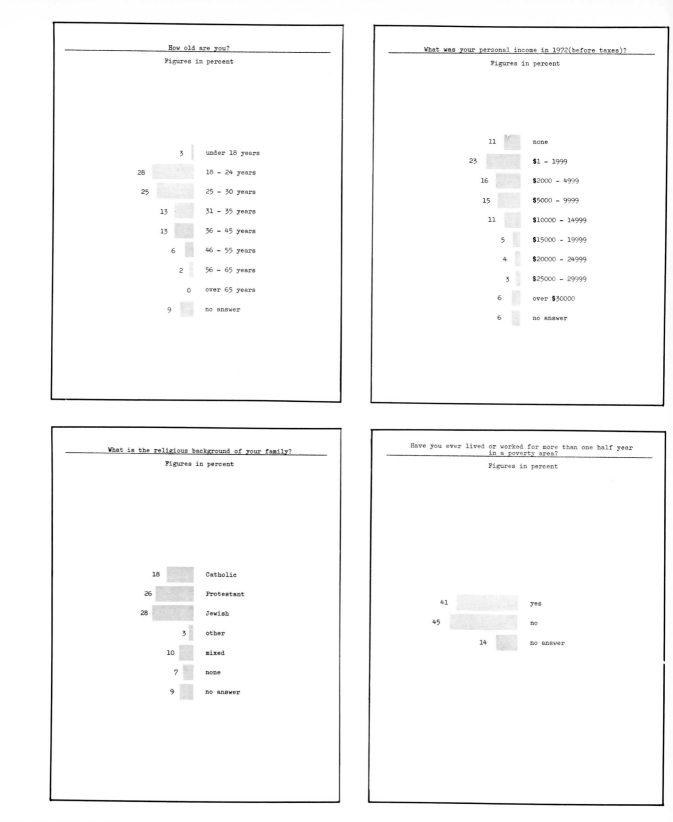

How old are you?

Figures in percent

3	under 18 years
28	18 - 24 years
25	25 - 30 years
13	31 - 35 years
13	36 - 45 years
6	46 - 55 years
2	56 - 65 years
0	over 65 years
9	no answer

What was your personal income in 1972(before taxes)?

Figures in percent

11	none
23	$1 - 1999
16	$2000 - 4999
15	$5000 - 9999
11	$10000 - 14999
5	$15000 - 19999
4	$20000 - 24999
3	$25000 - 29999
6	over $30000
6	no answer

What is the religious background of your family?

Figures in percent

18	Catholic
26	Protestant
28	Jewish
3	other
10	mixed
7	none
9	no answer

Have you ever lived or worked for more than one half year
in a poverty area?

Figures in percent

41	yes
45	no
14	no answer

Does your notion of art favor, tolerate, or reject works that make
deliberate reference to socio-political things?

Figures in percent

31 favor
48 tolerate
6 reject
8 don't know
7 no answer

Do you think, as a matter of principal, that all group shows
should include women artists?

Figures in percent

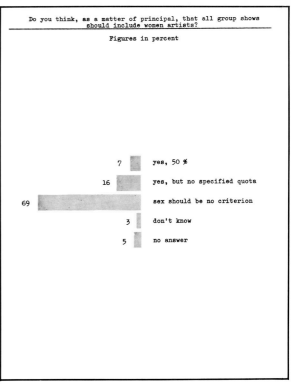

7 yes, 50 %
16 yes, but no specified quota
69 sex should be no criterion
3 don't know
5 no answer

Do you think the preferences of those who financially back the art
world influence the kind of work artists produce?

Graphs compare relative distribution of opinions to above question,
in percent, within each group of responses to bottom question.

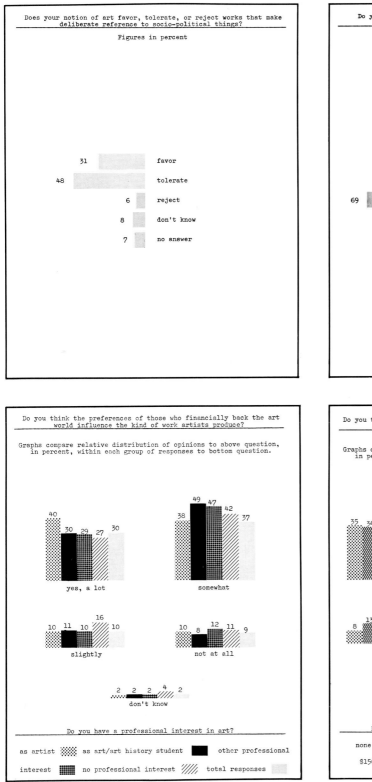

yes, a lot
40 30 29 27 30

somewhat
38 49 47 42 37

slightly
10 11 10 16 10

not at all
10 8 12 11 9

don't know
2 2 2 4 2

Do you have a professional interest in art?

as artist ▦ as art/art history student ■ other professional
interest ▦ no professional interest ⧄ total responses ▧

Do you think the preferences of those who financially back the art
world influence the kind of work artists produce?

Graphs compare relative distribution of opinions to above question,
in percent, within each group of responses to bottom question.

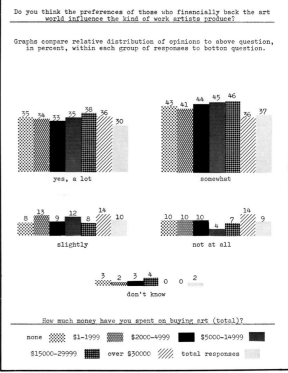

yes, a lot
35 34 33 35 38 36 30

somewhat
43 41 44 45 46 36 37

slightly
8 13 9 12 8 14 10

not at all
10 10 10 4 7 14 9

don't know
3 2 3 4 0 0 2

How much money have you spent on buying art (total)?

none ▦ $1-1999 ▦ $2000-4999 ■ $5000-14999 ▦
$15000-29999 ▦ over $30000 ⧄ total responses ▧

Rheinwasseraufbereitungsanlage

1972

Installation: glass and acrylic plastic containers, pump, polluted Rhine water, tubing, filters, chemicals, goldfish.

Assistance in design and construction by Raimund Schröder of the Kaiser Wilhelm Museum, Krefeld, and Ernst Tiessen of the Stadtwerke Krefeld.

Exhibited in one-person exhibition at the Museum Haus Lange, Krefeld, West Germany, May 22-July 16, 1972. Director Dr. Paul Wember.

From large glass bottles, extremely polluted Rhine water was pumped into an elevated acrylic basin. Injections of chemicals caused the pollutants to settle. The sedimentation process continued in a second basin. From there the partially purified water flowed through a charcoal and sand filter and eventually dropped into a large basin with goldfish. A hose carried the overflow out to the garden, where it seeped into the ground and joined the groundwater.

At the time of the exhibition, the city of Krefeld annually discharged over forty-two million cubic meters of untreated household and industrial sewage into the Rhine. In response to the exhibition, a regional newspaper reported extensively on the city's part in the pollution of the river.

The Museum Haus Lange (like its parent, the Kaiser Wilhelm Museum, in Krefeld) is a municipal institution; the director is a civil servant.

A related work, produced for the same exhibition, is *Krefeld Sewage Triptych* (1972). This documentation records the level of untreated sewage the city of Krefeld spews into the Rhine annually (42 million cubic meters). The left panel lists data on volume, rate of pollution (official code), breakdown into industrial and household sewage, and fees charged per volume. The right panel lists data on volume of deposable and dissolved matter, and breakdown by volume and name of major contributors of Krefeld sewage. The center panel is a photograph taken January 21, 1972, at Krefeld-Uerdingen (Rhine kilometer mark 765.7), where the city discharges its sewage.

Krefeld Sewage Triptych, 1972, central panel.

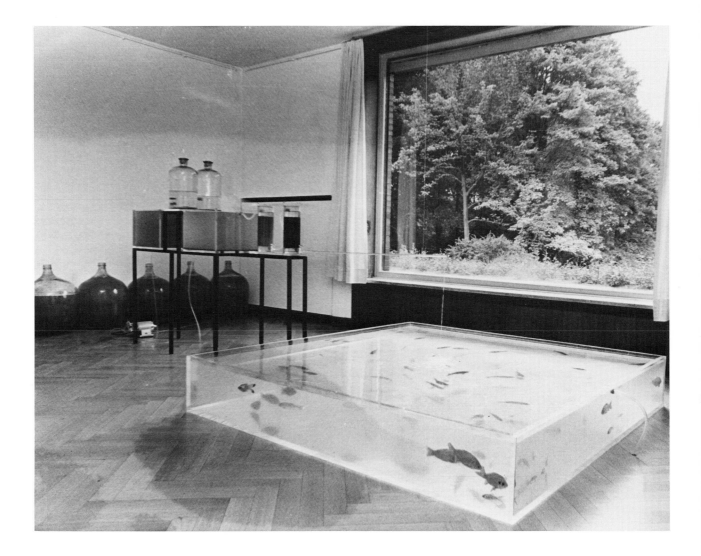

Vorschlag "Niemandsland"

1973-1974

Photographs on cardboard, 28¼ x 42″
(71.6 x 106.6 cm).

First exhibited in the group exhibition
Kunst und Architektur at Galerie
Magers, Bonn, December 9, 1977-
January 31, 1978.

Collection of the Städtisches
Kunstmuseum, Bonn.

In the latter part of the 1970s and into the
1980s, the entire complex of the completed
buildings of the Bonn Ministries of Science,
Education, and Justice was surrounded by
barbed wire and heavily patrolled by guards.

Prior works, conceptually related to
Vorschlag "Niemandsland":

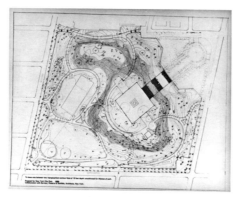

Proposal for Fort Greene Park, Brooklyn
(collaboration with Berman, Roberts & Scofi-
dio, Architects, New York), 1968: "To leave
area between two topographical contour lines
of 10 feet depth uncultivated for lifetime of
park."

Monument to Beach Pollution, 1970.
Carboneras, Spain. Garbage from two hundred
yards of beach collected and piled up.

Bowery Seeds, 1970. A patch of soil on
the roof of 95 East Houston Street at the cor-
ner of the Bowery, New York.

Translation:

Federal Construction Agency
II B 1-B 1100/2-116/74-

Bonn-Beuel,
February 19, 1974
Bonner Str. 86
Telephone 4011
Direct dial 401/266

Mr. Hans Haake
415 Krefeld
Kaiser-W-Karlsplatz

Re: New construction of federal office
buildings in the Bonn-Bad Godesberg/
North region.
Artistic design for construction area A.
First meeting of art jury on January 1,
1974.

Dear Mr. Haake:

In its first meeting the art jury pro-
posed to invite you to participate in an
art contest for the new buildings of the
Federal Ministries.

I would therefore like to ask you to
attend a meeting on Friday, March 15,
at 2 p.m., to introduce you to the pro-
position.

The meeting will take place in the con-
struction supervisory office of the
Federal Construction Agency in Bonn-
Bad Godesberg, Langer Grabenweg.

Travel expenses will be reimbursed
according to the schedule of the Feder-
al Travel Expense Act.

Signed for

(Winde)
Ltd. Regierungsbaudirektor

No-Man's Land

The square or the long rectangular sunken court of the building complex of the Ministry of Education and Science and the Ministry of Justice of the Federal Republic of Germany is to be completely paved with concrete. On it a circular area of approximately 25 meters in diameter is to be marked.

Soil is to be deposited into the center of the circular area with a conveyor belt, until, while naturally slipping off to the perimeter, it covers the entire area. The height of the hill is determined by the amount of soil necessary to fill the designated zone in the manner described.

After completion, the hill of soil is to be left untouched. It is to be expected that erosion will change it, that airborne seeds and seeds which were imbedded in the soil will sprout, and eventually wild vegetation will cover the hill. The designated area must not be cultivated or cleaned in any way by those in charge of the adjoining area. The natural processes should take their course.

When the deposition of soil is completed, the marked territory is given the status of an independent enclave in terms of international law. No state has any sovereign rights and the laws of no state are valid there.

The Federal Republic signs an internationally binding treaty of unlimited duration with me, by which it relinquishes all rights in and to this territory, and in which it pledges to grant access to the enclave to everybody, and that it will neither directly nor indirectly influence events and developments inside this no-man's land. I also pledge in this treaty to refrain

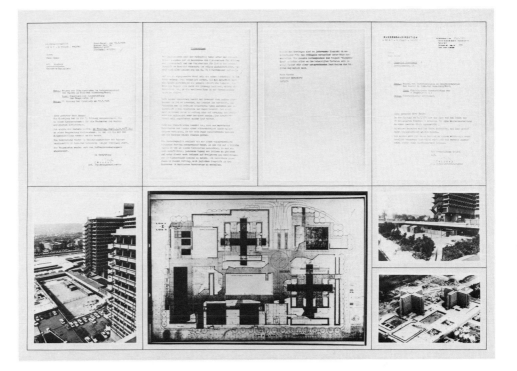

from any interference in what happens in the marked territory.

A copy of this treaty is to be exhibited near the hill of soil, protected from the weather under glass, so that anyone can study it. The complete correspondence relating to the project "no-man's land" should be accessible to the public in a museum or an equivalent institution.

Hans Haacke
Bonn-Bad Godesberg
1973/74

Federal Construction Agency
II B i-B 1100/2-145/75-

53 Bonn-Beuel 1,
February 27, 1975
Bonner Str. 86, Block E,
P.O. Box 510 149
Telephone 4011
Direct dial 401, ext. 266
Telex: bbdbn 886 869

Mr. Hans Haake
53 Bonn-Bad Godesberg 1
Beethovenstr. 24

Re: New construction of federal office buildings in the Bonn-Bad Godesberg/ North region
Artistic design of construction area A
Art competition

Dear Mr. Haake:

In a meeting on January 9, 1975, the jury selected from the proposals of the 18 participating artists 4 projects for further exploration in a second phase.

I am sorry to have to inform you that your proposal could not be considered.

I would like to thank you very much for your participation in this competition. I am certain there will be an opportunity to work together on other construction projects.

Sincerely yours,
Signed for

(Winde)
Ltd. Regierungsbaudirektor

Solomon R. Guggenheim Museum Board of Trustees

Since 1974, the composition of the board of trustees has undergone considerable changes. Only Peter O. Lawson-Johnston, Joseph W. Donner, and Michael Wettach remain; the others have resigned or are deceased.

In 1986, the Guggenheim family is represented on the Guggenheim Museum board by Peter O. Lawson-Johnston, then and now the president of the board; Wendy L.-J. McNeil (daughter of Peter O. Lawson-Johnston), serving as vice-president; Michael F. Wettach; and also serving as vice-president, the Earl Castle Stewart.

Peter O. Lawson-Johnston continues as chairman of Anglo Energy, and has moved to the chairmanship of the Pacific Tin Consolidated Corporation, now called Zemex. He is president and director of the Elgerbar Corporation, which manages Guggenheim family investments. He is also a senior partner of Guggenheim Brothers, a director of McGraw-Hill, Inc., and chairman and director of the Harry Frank Guggenheim Foundation.

Trustees on the Guggenheim Museum board of directors in 1986, who were not members in 1974, are:

Elaine Dannheisser, art collector; also a trustee of The New Museum of Contemporary Art, New York; **Michael David-Weill,** senior partner, Lazard Frères, New York, and Lazard Frères & Cié, Paris (investment banking); vice-chairman, Metropolitan Museum of Art Business Committee; **Carlo De Benedetti,** chairman, Olivetti (business machines); **Robin Chandler Duke,** national co-chairman, Population Crisis Committee; **Robert M. Gardiner,** senior advisor, Dean Witter Reynolds (broker, investment banking); **John S. Hilson,** vice-chairman, Wertheim and Company (investment banking); **Harold W. McGraw, Jr.,** chairman, McGraw-Hill, Inc. (publishing); **Wendy L.-J. McNeil,** daughter of Peter O. Lawson-Johnston; **Thomas Messer,** dir., Solomon R. Guggenheim Museum; **Bonnie Ward Simon,** East Asian historian; **Seymour Slive,** art historian; **Stephen C. Swid,** associated with General Felt Industries and Knoll International, Inc. (carpet and furniture manufacturers); vice-chairman, Metropolitan Museum of Art Business Committee; **Rawleigh Warner, Jr.,** dir., until February 1986, chairman and CEO of Mobil Corp.; dir., American Express, American Telephone & Telegraph, Caterpillar Tractor, Chemical Bank, Allied-Signal Company, Squibb Corp.; member, board of dirs., Business Committee for the Arts; **William T. Ylvisaker,** until his resignation in September 1986, chairman and CEO of Gould, Inc. (electronics manufacturer with sizable defense contracts).

In 1973, the Kennecott Copper Corporation was called to testify before the Subcommittee on Multinational Corporations of the U.S. Senate Committee on Foreign Relations. The committee was investigating U.S.-directed efforts to destabilize Chile. The junta of General Augusto Pinochet agreed in 1975 to pay Kennecott $68 million as compensation for the properties the Chilean Parliament had nationalized in 1971.

The Kennecott Copper Corporation is now called the Kennecott Corporation. The company sold its Peabody Coal subsidiary in 1977 for $1.2 billion, following an order issued by the Federal Trade Commission in 1971. It then bought the Carborundum Corporation, an international producer of abrasives. Frank R. Milliken, the president of Kennecott in 1974, became chairman in 1978, for one year, until his retirement. After an abrasive take-over attempt by the Curtiss-Wright Corporation in 1978, he and Peter O. Lawson-Johnston continued as members of the Kennecott board of directors. The company was sold to the Standard Oil Co. (Ohio) in 1981 for $1.77 billion.

SOLOMON R. GUGGENHEIM MUSEUM

GUGGENHEIM FAMILY MEMBERS AMONG TRUSTEES

ELEANOR COUNTESS CASTLE STEWART

Born Eleanor Guggenheim. Daughter of Solomon R. and Irene (Rothschild) G.

MRS. HENRY OBRE

Born Barbara Guggenheim. Daughter of Solomon R. and Irene (Rothschild) G.

PETER O. LAWSON-JOHNSTON

Son of Barbara Guggenheim's first marriage to John R. Lawson-Johnston

MICHAEL F. WETTACH

Son of Barbara Guggenheim's second marriage to Fred Wettach Jr.

SOLOMON R. GUGGENHEIM MUSEUM

CORPORATE AFFILIATION OF TRUSTEES

Pacific Tin Consolidated Corporation

PETER O. LAWSON-JOHNSTON, Vice Chairman & Member Board of Directors

ALBERT E. THIELE, Member Board of Directors

A. CHAUNCEY NEWLIN, past Member Board of Directors

(F. Stuart Miller, Chairman & Member Board of Directors of Pacific Tin Consolidated Corp. is a partner of
P.O. Lawson-Johnston and A.E. Thiele in Guggenheim Brothers firm)

Mining and processing tin, feldspar, diamonds

Operations in the United States, Malaysia. Brazil

Investment in Companhia de Diamantes de Angola

Sales range $9-12 million. 800 employees

Office: 120 Broadway, New York, N.Y.

Feldspar Corporation
Subsidiary of Pacific Tin Consolidated Corp.

PETER O. LAWSON-JOHNSTON, Chairman & Member Board of Directors

(F. Stuart Miller, Member Board of Directors of Feldspar Corp., is a partner of P.O. Lawson-Johnston in
Guggenheim Brothers firm)

Products: Feldspar, mica, silica sand

Sales range $3-6 million. 280 employees

Office: 120 Broadway, New York, N.Y.

Companhia de Diamantes de Angola

ALBERT E. THIELE, Member Board of Directors

Diamond mining with investment of Pacific Tin Consolidated Corp.

SOLOMON R. GUGGENHEIM MUSEUM

CORPORATE AFFILIATION OF TRUSTEES

Anglo Company Ltd.
Formerly Anglo-Lautaro Nitrate Co.

PETER O. LAWSON-JOHNSTON, Chairman & Member Board of Directors

ALBERT E. THIELE, Member Board of Directors

(Albert van de Maele, President & Member Board of Directors, John A. Peeples and Oscar S. Straus II, Members Board of Directors of Anglo Co. Ltd., are partners of P.O. Lawson-Johnston and A.E. Thiele in Guggenheim Brothers firm)

Directors and related trusts, incl. Guggenheim interests held 49% of total voting power, Feb. 13, 1973

Business: General Finance

Nitrate Industry of former Anglo-Lautaro Nitrate Co. Ltd., in Chile, was nationalized 1971

24.9% interest in Robert Garrett & Sons, Inc., investment banking firm, Jan. 1973

53% interest in Nabors Drilling Ltd., Canada. Acquired 1974 for $3,100,000 cash. Oil and gas well drilling in Western Canada and the Arctic. Sales approx. $10-million

Office: 120 Broadway, New York, N.Y.

Anglo Ventures Corporation
Subsidiary of Anglo Co. Ltd.

ALBERT E. THIELE, Member Board of Directors

Office: 120 Broadway, New York, N.Y.

Minerec Corporation
Subsidiary of Anglo Co. Ltd.

ALBERT E. THIELE, Vice President & Member Board of Directors

PETER O. LAWSON-JOHNSTON, Member Board of Directors

(Albert van de Maele, Chairman & Member Board of Directors, and John A. Peeples, Member Board of Directors of Minerec Corp., are partners of A.E. Thiele and Peter O. Lawson-Johnston in Guggenheim Brothers firm)

Products: Chemical flotation reagents

Sales $1-2 million. 30 employees

Office: 120 Broadway, New York, N.Y.

Robert Garrett & Sons, Inc.

PETER O. LAWSON-JOHNSTON. Member Board of Directors

(Albert van de Maele, also Member Board of Directors of Garrett & Sons, Inc., is partner of P.O. Lawson-Johnston in Guggenheim Brothers firm)

Investment banking firm

Anglo Co. Ltd. has 24.9% interest, Jan. 1973. Merger with Anglo Co. Ltd. proposed

Office: 100 Wall St., New York, N.Y.

Manet-PROJEKT '74

1974

Ten panels, each 20½ x 31½" (52 x 80 cm); color photo reproduction of Manet's *Bunch of Asparagus,* with frame (actual size), 32¾ x 37" (83 x 94 cm); in black frames under glass. Color reproduction by Fotofachlabor Rolf Lillig, Cologne.

First exhibited in one-person exhibition at Galerie Paul Maenz, Cologne, July 4-July 31, 1974.

Collection of Dr. Roger Matthys, Deurle, Belgium.

PROJEKT '74 was an exhibition billed as representing "aspects of international art at the beginning of the seventies." It was staged in the summer of 1974 by the Wallraf-Richartz-Museum in Cologne (now Wallraf-Richartz-Museum/Museum Ludwig), on the occasion of its 150th anniversary. The exhibition reportedly cost more than $300,000. It was promoted with the slogan, "Art Remains Art." The Cologne Kunsthalle (like the museum, a city institution) and the local Kunstverein (a private institution with subsidies from the city) joined the Wallraf-Richartz-Museum in presenting this exhibition.

Invited to participate in the exhibition, Haacke submitted a general outline for a new work:

Manet's Bunch of Asparagus *of 1880, collection Wallraf-Richartz-Museum, is on a studio easel in an approx. 6 x 8 meter room of* PROJEKT '74. *Panels on the walls present the social and economic position of the persons who have owned the painting over the years and the prices paid for it.*

Dr. Evelyn Weiss, the modern art curator of the Wallraf-Richartz-Museum (1986, senior curator and deputy director of the Museum Ludwig) and one of six members of the *PROJEKT '74* organizing team, responded that this plan was "one of the best projects submitted," but that it could not be executed in the exhibition or printed in the catalogue.

This decision was reached in what was described as a "democratic vote" by the organizing team; the vote was three to three. Voting for the work's exhibition were Dr. Evelyn Weiss; Dr. Manfred Schneckenburger, then director of the Kunsthalle (organizer of *Documenta* in 1977 and 1987); and Dr. Wulf

Herzongenrath, director of the Kunstverein. The votes against the work were cast by Dr. Horst Keller, director of the Wallraf-Richartz-Museum (now retired); Dr. Albert Schug, the museum's librarian; and Dr. Dieter Ronte, the personal aide of Prof. Dr. Gert von der Osten, who was head of all Cologne municipal museums and co-director of the Wallraf-Richartz-Museum until his retirement in 1975 (Ronte is the director of the Museum of Modern Art, Vienna, since 1979). With the exception of the director of the private Kunstverein, all team members were subordinates of Prof. von der Osten.

Dr. Keller objected to listing Hermann J. Abs' nineteen positions on boards of directors. Information about his social and economic standing was provided in the work because, in his capacity as chairman, he represented the Wallraf-Richartz-Kuratorium (Association of the Friends of the Museum), when it acquired the Manet painting. In a letter to the artist, Dr. Keller elaborated on his position. After explaining that the museum, although financially carried by the city and the state, depends on private donations for major acquisitions, he continued:

It would mean giving an absolutely inadequate evaluation of the spiritual initiative of a man if one were to relate in any way the host of offices he holds in totally different walks of life with such an idealistic engagement . . . A grateful museum, however, and a grateful city, or one ready to be moved to gratefulness, must protect initiatives of such an extraordinary character from any other interpretation which might later throw even the slightest shadow on it . . .

(continued, page 130)

EDOUARD MANET (1832-1883) Spargel-Stilleben

Das Spargel-Stilleben

1880 gemalt von

Edouard Manet

Lebt von 1832 bis 1883 in Paris. – Entstammt einer katholischen Familie des franz. Großbürgertums. Vater Auguste Manet Jurist, Personalchef im Justizministerium, später Richter (magistrat) am Cour d'appel de Paris (Berufungsgericht). Republikaner. Ritter der Ehrenlegion. – Großvater Clément Manet Bürgermeister von Gennevilliers an der Seine, vor Paris. Familie besitzt dort ein 54 Hektar großes Landgut. – Mutter Eugénie Désirée Fournier, Tochter eines franz. Diplomaten, der die Wahl Marschall Bernadottes zum schwedischen König betrieb. Karl XIV. von Schweden ihr Pate. – Ihr Bruder Clément Fournier Artillerieoberst. Demissioniert während der Revolution 1848. – Zwei Brüder Manets im Staatsdienst.

Manet besucht renommiertes Collège Rollin (Mitschüler Antonin Proust, späterer Politiker und Schriftsteller). Entgegen dem väterlichen Wunsch nach einem Jurastudium fährt er für kurze Zeit zur See. Fällt bei der Aufnahmeprüfung zur Seekadettenanstalt durch.

1850–56 Kunststudium im Privatatelier von Thomas Couture, einem erfolgreichen Salonmaler. Studienreisen nach Italien, Deutschland, Österreich, der Schweiz, Belgien, Holland, Spanien.

Finanziell unabhängig. Nicht auf den Verkauf seiner Bilder angewiesen. Wohnt in großen standesgemäß eingerichteten Häusern in Paris, mit Dienerschaft.

Stellt ab 1861 mit wechselndem Erfolg im Salon und in Kunsthandlungen aus. 1863 Beteiligung am „Salon des Réfusés" (Salon der Zurückgewiesenen). Bilder werden wegen Verstössen gegen die Konvention von der offiziellen Kritik bekämpft. Kritische Unterstützung durch Zola, Mallarmé, Rimbaud.

Heiratet 1863 nach dem Tod seines Vaters Suzanne Leenhoff, seine ehemalige Klavierlehrerin, die Tochter eines holländischen Musikers. Léon Edouard Koëlla, ihr 1852 geborener Sohn, ist ein illegitimes Kind Manets; wird von ihm adoptiert.

Stellt 1867 aus Protest gegen die konservative Jury 50 Bilder in einer für 18 000 Francs selbstfinanzierten Baracke auf einem Grundstück des Marquis de Pomereu in der Nähe der Weltausstellung in Paris aus. Anhänger unter jüngeren, besonders impressionistischen Künstlern.

Als Nationalgardist 1870 bei der Verteidigung von Paris im Deutsch-Französischen Krieg, Meldegänger im Regimentsstab. Während der Pariser Kommune bei seiner Familie in Südfrankreich. – Antiroyalist. Bewunderer des Republikaners Léon Gambetta, des späteren Ministerpräsidenten.

1871 umfangreiche Bilderkäufe durch den Kunsthändler Durand-Ruel, einem Freund impressionistischer Malerei. Findet Anerkennung in den für künstlerische Neuerungen aufgeschlossenen Kreisen der Pariser Gesellschaft. Zahlreiche Porträtaufträge. 1881 Gewinn der 2. Medaille des Salons. Auf Vorschlag Antonin Prousts Ernennung zum Ritter der Ehrenlegion.

Während seiner tödlichen Krankheit Behandlung durch früheren Leibarzt Napoleon III.

1883 Gedächtnisausstellung in der Ecole des Beaux-Arts Paris. Katalogvorwort von Emile Zola. Verkaufserlös zugunsten der Erben 116 637 Francs.

Das Spargel-Stilleben

1880 für 800 Francs gekauft durch

Charles Ephrussi

Geboren 1849 in Odessa, gestorben 1905 in Paris. – Entstammt jüdischer Bankiersfamilie mit Bankunternehmen in Odessa, Wien und Paris. Familiäre Beziehungen zur franz. Hochfinanz (Baron de Reinach, Baron de Rothschild).

Studiert in Odessa und Wien. – 1871 Übersiedlung nach Paris.

Eigene Bankgeschäfte. – Kunstschriftstellerische Arbeiten u. a. über Albrecht Dürer, Jacopo de Barbarij und Paul Baudry. 1875 Mitarbeit an der „Gazette des Beaux Arts", 1885 Mitinhaber, 1894 Herausgeber.

Mitglied zahlreicher kultureller Komitees und Salons der Pariser Gesellschaft. Organisiert mit Gustave Dreyfus, der Comtesse Greffulhes und der Prinzessin Mathilde Kunstausstellungen und Konzerte, u. a. von Werken Richard Wagners. – Zweites Vorbild für Marcel Prousts Swann.

Sammelt Kunst der Renaissance, des 18. Jahrhunderts, Albrecht Dürers, Ostasiatische Kunst und Werke zeitgenössischer Maler.

Zahlt Manet statt der vereinbarten 800 Francs für das „Spargel-Stilleben" insgesamt 1000 Francs. Aus Dankbarkeit schickt im Manet das Stilleben eines einzelnen Spargels (1880, Öl auf Leinwand, 16,5 x 21,5 cm, Paris Musée de l'Impressionisme) mit der Bemerkung : „Es fehlte noch in Ihrem Bündel".

Ritter (1882) und Offizier (1903) der Ehrenlegion.

Gravure von M. Patricot „Charles Ephrussi" aus „La Gazette des Beaux Arts", Paris 1905

Das Spargel-Stilleben

zwischen 1900 und 1902 gekauft durch

Alexandre Rosenberg

Entstammt jüdischer Familie aus Ungarn. – In jungen Jahren Übersiedlung nach Paris.

1870 Gründung einer Kunst- und Antiquitätenhandlung in Paris. – Stirbt 1913 in Paris.

Fortführung der Firma durch seinen Sohn Paul Rosenberg. Spezialisierung auf die Kunst des 19. und 20. Jahrhunderts. 1940 Umzug nach New York. Gegenwärtig Paul Rosenberg & Co. in New York.

Das Spargel-Stilleben
von unbekanntem Datum an im Besitz von oder
in Kommission bei

Paul Cassirer

Geboren 1871 in Görlitz, Selbstmord 1926 in Berlin. – Entstammt wohlhabender jüdischer Familie. Vater Louis Cassirer gründet mit 2 Söhnen die Firma Dr. Cassirer & Co., Kabelwerke in Berlin. – Bruder Prof. Richard Cassirer, Berliner Neurologe. – Vetter Prof. Ernst Cassirer bekannter Philosoph.

Kunstgeschichtsstudium in München. Mitredakteur des „Simplizissimus". Eigene literarische Arbeiten.

Gründet mit Vetter Bruno Cassirer 1898 in Berlin Verlags- und Kunsthandlung. 1901 Trennung. Weiterführung als Kunstsalon Paul Cassirer, Victoriastraße 35, in vornehmer Berliner Gegend.

Mit der Künstlervereinigung „Berliner Sezession" Kampf gegen offizielle Hofkunst. Trotz Unwillen des Kaisers Handel und publizistische Förderung des franz. Impressionismus. Enge Beziehungen zum Pariser Kunsthändler Durand-Ruel. Verhilft den Deutschen Malern Trübner, Liebermann, Corinth und Slevogt zum Erfolg.

1908 Gündung des Verlags Paul Cassirer für Kunstliteratur und Belletristik. Publikationen des literarischen Expressionismus. 1910 Gründung der Halbmonatsschrift „Pan" und „Pan"-Gesellschaft zur Förderung von Bühnenwerken, u. a. Wedekind.

Aus erster Ehe eine Tochter und ein Sohn (Selbstmord im 1. Weltkrieg). Heiratet 1910 in zweiter Ehe die Schauspielerin Tilla Durieux.

1914 Kriegsfreiwilliger. Erhält Eisernes Kreuz in Ypern. Wird Kriegsgegner.

Zeitweilig in Haft (beschuldigt, unrechtmäßig franz. Bilder verkauft zu haben). Flucht in die Schweiz und Aufenthalt in Bern und Zürich bis Kriegsende. Verhilft Harry Graf Keßler zu franz. Kontakten für Verhandlungen mit Frankreich im Auftrage Ludendorffs. Verlegt mit Max Rascher pazifistische Literatur.

Nach der Revolution 1918 in Berlin Eintritt in die USPD. Verlegt sozialistische Bücher, u. a. von Kautzky und Bernstein.

Grund für Selbstmord 1926 vermutlich Konflikt mit Tilla Durieux.

Weiterführung des Kunstsalons Paul Cassirer in Amsterdam, Zürich und London durch Dr. Walter Feilchenfeldt und Dr. Grete Ring, eine Nichte Max Liebermanns.

Lithographie von Max Oppenheimer, „Bildnis Paul Cassirer", um 1925.

Das Spargel-Stilleben

für 24 300,– RM gekauft durch

Max Liebermann

Maler, lebt von 1847 bis 1935 in Berlin. – Entstammt einer jüdischen Fabrikantenfamilie. Vater Louis Liebermann Textilindustrieller in Berlin. Besitzt ebenfalls Eisengießerei Wilhelmshütte in Sprottau, Schlesien. – Mutter Philipine Haller, Tochter eines Berliner Juweliers (Gründer der Firma Haller & Rathenau). – Bruder Prof. Felix Liebermann, bekannter Historiker. – Vetter Walther Rathenau, Industrieller (AEG), Reichsaußenminister (1922 ermordet).

Liebermann besucht renommiertes Friedrich-Werdersches Gymnasium in Berlin zusammen mit Söhnen Bismarcks. – Kunststudium im Privatatelier Steffeck, Berlin, und auf der Kunstakademie Weimar. Längere Arbeitsaufenthalte in Paris, Holland, München. – Freiwilliger Krankenpfleger im Deutsch-Französischen Krieg 1870/71.

Heiratet 1884 Martha Marckwald, zieht nach Berlin zurück. 1885 Geburt der Tochter Käthe Liebermann.

Erbt 1894 väterliches Palais am Pariser Platz 7 (Brandenburger Tor). Baut 1910 Sommersitz am Wannsee, Große Seestraße 27 (seit 1971 Clubhaus des Deutschen Unterwasserclubs e.V.). Finanziell unabhängig. Lebt nicht vom Verkauf seiner Werke.

1897 Gesamtausstellung in der Berliner Akademie der Künste. Große Goldene Medaille. Seine durch Realismus und franz. Impressionismus beeinflußten Bilder werden von Wilhelm II. empört abgelehnt. – Malt Genreszenen, Stadtlandschaften, Strand- und Gartenszenen, Gesellschaftsporträts, Künstler, Wissenschaftler, Politiker. – Ausstellung und Verkauf durch Kunstsalon Paul Cassirer in Berlin. Werke in öffentlichen Sammlungen u. a. Wallraf-Richartz-Museum Köln.

Professorentitel 1897. – Präsident der „Berliner Sezession" (Künstlervereinigung gegen Hofkunst) 1898–1911, Rücktritt wegen Opposition jüngerer Künstler. – 1898 Mitglied, 1912 im Senat, 1920 Präsident der Preußischen Akademie der Künste. Rücktritt 1933. – Ehrendoktor der Universität Berlin. Ehrenbürger der Stadt Berlin. Ritter der franz. Ehrenlegion. Orden von Oranje-Nassau. Ritter des Ordens Pour le mérite und andere Auszeichnungen.

Besitzt Werke von Cézanne, Daumier, Degas, Manet, Monet, Renoir. Deponiert seine Sammlung 1933 im Kunsthaus Zürich.

1933 von Nazis aus allen Ämtern entlassen. Ausstellungsverbot. Entfernung seiner Bilder aus öffentlichen Sammlungen.

Stirbt 1935 in Berlin. Frau Martha Liebermann begeht 1943 Selbstmord, um sich drohender Verhaftung zu entziehen.

Photo um 1930

Das Spargel-Stilleben

vererbt an

Käthe Riezler

Geboren 1885 in Berlin, gestorben 1951 in New York.

Tochter des Malers Max Liebermann und seiner Frau Martha Marckwald.

Heiratet 1915 in Berlin Dr. phil. Kurt Riezler. 1917 Geburt der Tochter Maria Riezler.

Dr. Kurt Riezler, geboren 1882 in München, Sohn eines Kaufmanns. Studium der Klassischen Antike an der Universität München. 1905 Dissertation : „Das zweite Buch der pseudoaristotelischen Ökonomie".

1906 Eintritt ins Auswärtige Amt in Berlin. Legationsrat, später Gesandter. Arbeitet im Stab des Reichskanzlers von Bethmann-Hollweg. 1919/20 Leiter des Büros des Reichspräsidenten Friedrich Ebert.

1913 unter dem Decknamen J. J. Ruedorffer Veröffentlichung der „Prolegomena zu einer Theorie der Politik", 1914 „Grundzüge der Weltpolitik in der Gegenwart". – Später Publikationen zur Geschichtsphilosophie, zur politischen Theorie und Ästhetik.

1927 Honorarprofessor, stellvertretender Geschäftsführer und Vorsitzender des Kuratoriums an der Goethe Universität in Frankfurt am Main.

1933 Entlassung durch Nazis.

Umzug der Familie nach Berlin in das Haus Max Liebermanns, Pariser Platz 7. – Erben 1935 seine Kunstsammlung, die Liebermann 1933 dem Kunsthaus Zürich in Obhut gegeben hatte.

1938 Emigration der Familie nach New York. Sammlung folgt dorthin.

1939 erhält Dr. Riezler eine Professur für Philosophie an der New School for Social Research in New York, einer von Emigranten gegründeten Universität. Gastprofessuren an der University of Chicago und der Columbia University in New York.

Käthe Riezler stirbt 1951. Dr. Riezler emeritiert 1952, stirbt in München 1956.

Pastell von Max Liebermann, „Die Tochter des Künstlers" 1901

Das Spargel-Stilleben

vererbt an

Maria White

Geboren 1917 in Berlin. – Tochter von Prof. Dr. Kurt Riezler und Käthe Liebermann.

Emigriert 1938 mit ihren Eltern nach New York.

Heiratet Howard Burton White.

Howard B. White, geboren 1912 in Montclair, N. J., studiert 1934–38 an der New School for Social Research in New York, wo Dr. Kurt Riezler lehrt. 1941 Rockefeller Stipendium. Promoviert 1943 an der New School zum Doctor of Science.

Unterrichtet an der Lehigh University und am Coe College. Gegenwärtig Professor im Graduate Department of Political and Social Science der New School for Social Research. Lehrt Political Philosophy.

Veröffentlichungen u. a. „Peace Among the Willows – The Political Philosophy of Francis Bacon", den Haag 1968. „Copp'd Hills Towards Heaven – Shakespeare and the Classical Polity," den Haag 1968.

Maria und Howard B. White leben in Northport, N. Y. Sie haben zwei Kinder.

Ölbild von Max Liebermann „Tochter und Enkelin des Künstlers" (Maria Riezler im Bild rechts), um 1930

Das Spargel-Stilleben
1968 über Frau Marianne Feilchenfeldt, Zürich
für 1 360 000,- DM erworben durch das

Wallraf-Richartz-Kuratorium und die Stadt Köln

Dem Wallraf-Richartz-Museum von Hermann J. Abs, dem Vorsitzenden des Kuratoriums,
am 18. April 1968 im Andenken an Konrad Adenauer als Dauerleihgabe übergeben.

Das Wallraf-Richartz-Kuratorium und Förderer-Gesellschaft e. V.

Vorstand

Hermann J. Abs
Prof. Dr. Kurt Hansen
Dr. Dr. Günter Henle
Prof. Dr. Ernst Schneider
Prof. Dr. Otto H. Förster
Prof. Dr. Gert von der Osten (geschäftsführend)

Kuratorium

Prof. Dr. Viktor Achter
Dr. Max Adenauer
Fritz Berg
Dr. Walther Berndorff
Theo Burauen
Prof. Dr. Fritz Burgbacher
Dr. Fritz Butschkau
Dr. Felix Eckhardt
Frau Gisela Fitting
Prof. Dr. Kurt Forberg
Walter Franz
Dr. Hans Gerling
Dr. Herbert Girardet
Dr. Paul Gülker
Iwan D. Herstatt
Raymund Jörg
Eugen Gottlieb von Langen
Viktor Langen
Dr. Peter Ludwig
Prof. Dr. Heinz Mohnen
Cai Graf zu Rantzau
Karl Gustav Ratjen
Dr. Hans Reuter
Dr. Hans-Günther Sohl
Dr. Dr. Werner Schulz
Dr. Nikolaus Graf Strasoldo
Christoph Vowinckel
Otto Wolff von Amerongen

Hermann J. Abs bei der Übergabe des Bildes

Das Spargel-Stilleben
erworben durch die Initiative des
Vorsitzenden des Wallraf-Richartz-Kuratoriums

Hermann J. Abs

Geboren 1901 in Bonn. – Entstammt wohlhabender katholischer Familie. Vater Dr. Josef Abs, Rechtsanwalt und Justizrat, Mitinhaber der Hubertus Braunkohlen AG. Brüggen, Erft. Mutter Katharina Lückerath.

Abitur 1919 Realgymnasium Bonn. – Ein Sem. Jurastudium Universität Bonn. – Banklehre im Kölner Bankhaus Delbrück von der Heydt & Co. Erwirbt internationale Bankerfahrung in Amsterdam, London, Paris, USA.

Heiratet 1928 Inez Schnitzler. Ihr Vater mit Georg von Schnitzler vom Vorstand des IG. Farben-Konzerns verwandt. Tante verheiratet mit Baron Alfred Neven du Mont. Schwester verheiratet mit Georg Graf von der Goltz. – Geburt der Kinder Thomas und Marion Abs.

Mitglied der Zentrumspartei. – 1929 Prokura im Bankhaus Delbrück, Schickler & Co., Berlin. 1935-37 einer der 5 Teilhaber der Bank.

1937 im Vorstand und Aufsichtsrat der Deutschen Bank, Berlin. Leiter der Auslandsabteilung. – 1939 von Reichswirtschaftsminister Funk in den Beirat der Deutschen Reichsbank berufen. – Mitglied in Ausschüssen der Reichsbank, Reichsgruppe Industrie, Reichsgruppe Banken, Reichswirtschafts-kammer und einem Arbeitskreis im Reichswirtschaftsministerium. – 1944 in über 50 Aufsichts- und Verwaltungsräten großer Unternehmen. Mitgliedschaft in Gesellschaften zur Wahrnehmung deutscher Wirtschaftsinteressen im Ausland.

1946 für 6 Wochen in britischer Haft. – Von der Alliierten Entnazifizierungsbehörde als entlastet (5) eingestuft.

1948 bei der Gründung der Kreditanstalt für Wiederaufbau. Maßgeblich an der Wirtschafts-planung der Bundesregierung beteiligt. Wirtschaftsberater Konrad Adenauers. – Leiter der deutschen Delegation bei der Londoner Schuldenkonferenz 1951-53. Berater bei den Wiedergutmachungsver-handlungen mit Israel in Den Haag. 1954 Mitglied der CDU.

1952 im Aufsichtsrat der Süddeutschen Bank AG. – 1957-67 Vorstandssprecher der Deutschen Bank AG. Seit 1967 Vorsitzender des Aufsichtsrats.

Ehrenvorsitzender des Aufsichtsrats:
Deutsche Überseeische Bank, Hamburg – Pittler Maschinenfabrik AG, Langen (Hessen)
Vorsitzender des Aufsichtsrats:
Dahlbusch Verwaltungs-AG, Gelsenkirchen – Daimler Benz AG, Stuttgart-Untertürkheim –
Deutsche Bank AG, Frankfurt – Deutsche Lufthansa AG, Köln – Philipp Holzmann AG, Frankfurt –
Phoenix Gummiwerke AG, Hamburg-Harburg – RWE Elektrizitätswerk AG, Essen –
Vereinigte Glanzstoff AG, Wuppertal-Elberfeld – Zellstoff-Fabrik Waldhof AG, Mannheim
Ehrenvorsitzender:
Salamander AG, Kornwestheim – Gebr. Stumm GmbH, Brambauer (Westf.) –
Süddeutsche Zucker-AG, Mannheim
Stellvertr. Vors. des Aufsichtsrats:
Badische Anilin- und Sodafabrik AG, Ludwigshafen – Siemens AG, Berlin-München
Mitglied des Aufsichtsrats:
Metallgesellschaft AG, Frankfurt
Präsident des Verwaltungsrats:
Kreditanstalt für Wiederaufbau – Deutsche Bundesbahn

Großes Bundesverdienstkreuz mit Stern, Päpstl. Stern zum Komturkreuz, Großkreuz Isabella die Katholische von Spanien, Cruzeiro do Sul von Brasilien. – Ritter des Ordens vom Heiligen Grabe. – Dr. h.c. der Univ. Göttingen, Sofia, Tokio und der Wirtschaftshochschule Mannheim.

Lebt in Kronberg (Taunus) und auf dem Bentgerhof bei Remagen.

Photo aus Current Biography Yearbook 1970 New York

Das Spargel-Stilleben
erworben mit Stiftungen von

He also remarked,

A museum knows nothing about economic power; it does indeed, however, know something about spiritual power.

Dr. Keller and Prof. von der Osten never saw or showed any interest in seeing the work before they rejected it. Instead, on July 4, the day of the press opening of *PROJEKT '74*, *Manet-PROJEKT '74* went on exhibition at Galerie Paul Maenz in Cologne, with a full-size color reproduction in place of the original *Bunch of Asparagus*.

Daniel Buren incorporated in his own work in *PROJEKT '74* a scaled-down facsimile of *Manet-PROJEKT '74*, which Haacke had provided at his request. He also attached to it a poster entitled, "Art Remains Politics"—referring to the exhibition's official slogan, "Art Remains Art"—with an excerpt from "Limites Critiques," an essay Buren had written in 1970:

. . . Art, whatever else it may be, is exclusively political. What is called for is the analysis of formal and cultural limits (and not one or the other) within which art exists and struggles. These limits are many and of different intensities. Although the prevailing ideology and

the associated artists try in every way to camouflage them, and although it is too early—the conditions are not met—to blow them up, the time has come to unveil them.

On the morning after the opening, Prof. von der Osten had those parts of Buren's work which had been provided by Haacke (including a color reproduction of the Manet still life) pasted over with double layers of white paper.

Several artists, among them Antonio Diaz, Frank Gillette, and Newton and Helen Harrison, temporarily or permanently closed down their works in protest. Carl Andre, Robert Filliou, and Sol LeWitt had previously withdrawn from the exhibition, after hearing that *Manet-PROJEKT '74* would not be admitted.

In response to a question by Prof. Carl R. Baldwin, who was preparing an article on the incident for *Art in America*, Dr. Keller wrote in a letter of September 25, 1974: "In any event, it is not an uncommon practice for a museum to paste over an artist's work, when an artist has expressly disregarded an agreement previously reached with a museum . . ."

Hermann J. Abs, still an honorary president and member of the Deutsche Bank's advisory board, has lately represented German interests at international art auctions. In 1983, he successfully bid for an old German illuminated manuscript, the Gospels of Henry the Lion, at Sotheby Parke-Bernet in London. The manuscript was acquired by the German consortium for $11.7 million.

In 1982, Abs was appointed by Pope John Paul II to the advisory board of the Institute of Religious Works, the agency that manages the Vatican's finances. The appointment drew strong protests and an immediate call for Abs' resignation by the Simon Wiesenthal Center at Yeshiva University in Los Angeles.

Translation:

Bunch of Asparagus
1880 painted by
Edouard Manet

Lived from 1832 to 1883 in Paris. Descendant of a well-to-do Catholic family of the French bourgeoisie. Father, Auguste Manet, lawyer, chief of personnel at Ministry of Justice, later judge *(magistrat)* at the Cour d'appel de Paris (court of appeals). Republican. Knight of the Legion of Honor. Grandfather, Clément Manet, mayor of Gennevilliers, on the Seine, near Paris. Family owns 133-acre farm there. Mother, Eugénie-Désirée Fournier, daughter of French diplomat who managed the election of Marshall Bernadotte to the Swedish throne. Charles XIV of Sweden, her godfather. Her brother, Clément Fournier, colonel in the artillery. Resigned during revolution, 1848. Two brothers of Manet in the civil service.

Manet attends renowned Collège Rollin (with Antonin Proust, later politician and writer). Goes to sea for a short while, contrary to his father's wish for law studies. Fails entrance exam for École Navale (Naval Academy).
1850-56, studies art in private atelier of Thomas Couture, a successful salon painter. Travels to Italy, Germany, Austria, Switzerland, Belgium, Holland, Spain.
Financially independent of the sale of his paintings. Lives in richly furnished Parisian houses, with servants.
Exhibits since 1861 at the Salon and in private art galleries with uneven success. 1863, participation in the "Salon des Refusés" (Salon of the Rejected). Paintings are attacked by establishment critics for their offenses against convention. Support from Zola, Mallarmé, Rimbaud.
After the death of his father in 1863, marries Suzanne Leenhoff. She is his former piano teacher, daughter of a

Dutch musician. Her son, Léon-Edouard Köella, born 1852, is Manet's illegitimate child; adopted by Manet.
1867, in protest against conservative jury, exhibits fifty paintings in a pavilion specially constructed at his own expense for 18,000 francs on the grounds of the Marquis de Pomereu, near the Exposition Universelle in Paris. Followers among younger, especially impressionist artists.
As a national guardsman, participates in the defense of Paris during the Franco-Prussian War, 1870. Messenger for the regimental staff. During the Paris Commune with his family in southern France. Antiroyalist. Admirer of the Republican Léon Gambetta, the future prime minister.
1871, the art dealer Durand-Ruel, a friend of impressionist painting, buys a great number of his works. Meets with the approval of circles of Parisian society that are open to artistic innovation. Numerous commissions of portraits. Wins second-class medal at the Salon, 1881. At the suggestion of Antonin Proust, appointed Knight of the Legion of Honor.
During his fatal illness, treated by former physician of Napoleon III. 1883, memorial exhibition at the École des Beaux-Arts, Paris. Preface to catalogue by Émile Zola. Proceeds of sales for heirs, 116,637 francs.

Bunch of Asparagus
1880 for 800 francs acquired by
Charles Ephrussi

Born 1849 in Odessa, dies 1905 in Paris. Descendant of Jewish family of bankers with banks in Odessa, Vienna, Paris. Family relations to French high finance (Baron de Reinach, Baron de Rothschild).
Studies in Odessa and Vienna. 1871, moves to Paris.
Own banking activities. Art historical writings about Albrecht Dürer, Jacopo de Barbarij, Paul Baudry, etc. 1875, works for *Gazette des Beaux-Arts;* 1885, co-owner; 1894, publisher.

Member of numerous cultural committees and salons of Parisian society. With Gustave Dreyfus, the Comtesse Greffulhe, and Princess Mathilde, organizes art exhibitions and concerts of the works of Richard Wagner, among others. Second model for Marcel Proust's Swann.
Collector of works from the Renaissance, the eighteenth century, and contemporary painters, plus works by Albrecht Dürer and East Asian art.
Instead of paying Manet 800 francs for *Bunch of Asparagus* as agreed upon, he pays 1000 francs. To show his gratitude, Manet sends him the still life of a single asparagus (1880, oil on canvas, 6½ x 8½", Paris, Musée de l'Impressionisme) with a note: "Your bunch was one short."
Knight (1881), officer (1903) in the Legion of Honor.

———

Engraving by M. Patricot, *Charles Ephrussi,* from *Gazette des Beaux-Arts,* Paris, 1905.

Bunch of Asparagus
between 1900 and 1902 acquired by
Alexandre Rosenberg

Born about 1850 in Pressburg (Bratislava), dies 1913 in Paris. Descendant of a Jewish family from Bohemia. Emigrates to Paris at the age of nine.
1870, founds a firm dealing with antiques and fine art.
1878, marries Mathilde Jellineck of a Viennese family. They have three sons and one daughter.
After his death in 1913, continuation of the firm by his youngest son, Paul, born 1881 in Paris. Specialization in the art of the nineteenth and twentieth centuries. 1940, moves to New York. At present, Paul Rosenberg & Co. in New York, headed by Alexandre Rosenberg, a grandson.

———

Charlot, charcoal, *Portrait of Alexandre Rosenberg.*

Bunch of Asparagus
as of unknown date owned
by or on consignment with
Paul Cassirer

Born 1871 in Görlitz, commits suicide 1926 in Berlin. Descendant of well-to-do Jewish family. Father, Louis Cassirer, with two sons, founder of firm Dr. Cassirer & Co., Kabelwerke (cable factory) in Berlin. Brother, Prof. Richard Cassirer, neurologist in Berlin. Cousin, Prof. Ernst Cassirer, renowned philosopher.
Studies art history in Munich. One of the editors of *Simplizissimus.* Own writings.
1898, with his cousin, Bruno Cassirer, founder of publishing house and art gallery in Berlin. 1901, partnership dissolved. Continues Kunstsalon Paul Cassirer (gallery), Victoriastrasse 35, in wealthy section of Berlin.
Opponent, along with "Berliner Sezession" (association of artists), of official art of the court. Despite the kaiser's indignation, supports French impressionism through publications and art dealing. Close relation to Parisian art dealer Durand-Ruel. Promotes German painters Trübner, Liebermann, Corinth, and Slevogt.
1908, founds publishing house, Paul Cassirer, for art publications, fiction, and poetry. Publishes works of literary expressionism. 1910, foundation of bimonthly magazine *Pan,* and *Pan*-Society for the promotion of dramatic works, among them works by Wedekind.
From first marriage, one daughter and one son (commits suicide during World War I). Second marriage to actress Tilla Durieux.
1914, army volunteer. Awarded Iron Cross at Ypres. Becomes pacifist. Temporarily imprisoned (accused of having illegally sold French paintings). Escapes to Switzerland and stays in

Bern and Zurich until the end of the war. Assists Harry Graf Kessler with French contacts for negotiations with France on behalf of Ludendorff. Publishes pacifist writings with Max Rascher.

After revolution of 1918, in Berlin, member of USPD (leftist faction of Social Democratic Party). Publishes socialist books, by Kautzky and Bernstein, among others.

Motives for suicide, 1926, probably related to conflict with Tilla Durieux. Continuation of Kunstsalon Paul Cassirer in Amsterdam, Zurich, and London by Dr. Walter Feilchenfeldt and Dr. Grete Ring, a niece of Max Liebermann.

———

Lithograph by Max Oppenheimer, *Portrait of Paul Cassirer,* c. 1925.

Bunch of Asparagus
for Reichsmark 24,300.—acquired by Max Liebermann

Painter. Lived from 1847 to 1935 in Berlin. Descendant of a Jewish family of industrialists. Father, Louis Liebermann, textile industrialist in Berlin. Also owns Eisengiesserei Wilhelmshütte (iron foundry) in Sprottau, Silesia. Mother, Philipine Haller, daughter of Berlin jeweler (founder of firm Haller & Rathenau). Brother, Felix Liebermann, well-known historian. Cousin, Walther Rathenau, industrialist (AEG), foreign minister of German Reich (murdered 1922).

Liebermann attends renowned Friedrich-Werdersches Gymnasium in Berlin, together with sons of Bismarck. Art studies in private Atelier Steffeck, Berlin, and at the Art Academy of Weimar. Works several years in Paris, Holland, Munich. Voluntary medic during Franco-Prussian War, 1870-71. Marries Martha Marckwald, 1884. Moves back to Berlin. 1885, birth of daughter Käthe Liebermann. Inherits father's mansion at Pariser Platz 7 (Brandenburg Gate), 1894.

Builds summer residence at Wannsee, Grosse Seestrasse 27 (since 1971, clubhouse of Deutscher Unterwasserclub e.V.). Financially independent of the sale of his works.

1897, major one-man exhibition at the Berliner Akademie der Künste. Great Gold Medal. His paintings, influenced by realism and French impressionism, indignantly rejected by Kaiser Wilhelm II. Paints genre scenes, urban landscapes, beach and garden scenes, society portraits, and portraits of artists, scientists, and politicians. Exhibition and sale through Kunstsalon Paul Cassirer in Berlin. Works in public collections, e.g., Wallraf-Richartz-Museum, Cologne.

Awarded honorary title of Professor, 1897. President of the "Berliner Sezession" (association of artists against art of the kaiser's court), 1898-1911; resignation due to opposition from younger artists. Member (1898), in the senate (1912), president of the Prussian Academy of Arts, 1920. Resignation, 1933. Honorary doctorate, University of Berlin. Honorary citizen of Berlin. Knight of the French Legion of Honor. Order of Oranje-Nassau. Knight of the German Order pour le mérite and other decorations.

Owns works by Cézanne, Daumier, Degas, Manet, Monet, Renoir. Deposits his collection with Kunsthaus Zürich, 1933.

1933, dismissed from all offices by Nazis. Forbidden to exhibit. Removal of his paintings from public collections. Dies 1937 in Berlin. His wife, Martha Liebermann, commits suicide, 1943, to avoid arrest.

———

Photo around 1930.

Bunch of Asparagus
inherited by Käthe Riezler

Born 1885 in Berlin, dies 1951 in New York. Daughter of the painter Max Liebermann and his wife Martha Marckwald.

Marries Kurt Riezler (Ph.D.), 1915, in Berlin. 1917, birth of their daughter, Maria Riezler.

Dr. Kurt Riezler, born 1882 in Munich. Son of a businessman. Classical Greek studies at the University of Munich. 1905, dissertation: "The Second Book of Pseudo-Aristotelian Economics." 1906, enters Foreign Service in Berlin. Second secretary, later minister. Worked on the staff of Chancellor von Bethmann-Hollweg. 1919-20, head of the office of President Friedrich Ebert of the German Reich.

1913, under the pseudonym J. J. Ruedorffer, publication of "Prolegomena for a Theory of Politics"; 1914, "Basic Traits of World Politics of the Present." Later publications on the philosophy of history, political theory, and aesthetics.

1927, professor, vice-president, and chairman of the board of Goethe University in Frankfurt-am-Main. 1933, dismissed by Nazis. Family returns to Berlin, moves into Max Liebermann's house, Pariser Platz 7. 1935. Inherits his art collection, which Liebermann had deposited with the Kunsthaus Zürich for protection. 1938, emigration of family to New York. Collection follows.

1939, Dr. Kurt Riezler becomes professor of philosophy at the New School for Social Research in New York, a university founded by emigrants. Visiting professor at the University of Chicago and Columbia University in New York. Käthe Riezler dies in 1951. Dr. Riezler retires 1952, dies in Munich, 1956.

———

Pastel by Max Liebermann, *The Artist's Daughter,* 1901.

Bunch of Asparagus
inherited by Maria White

Born 1917 in Berlin. Daughter of Prof. Dr. Kurt Riezler and Käthe Liebermann. Emigrates with her parents to New York in 1938.

Marries Howard Burton White. Howard B. White, born 1912 in Montclair, N.J. Studies 1934-38 at the New School for Social Research in New York, where Dr. Kurt Riezler teaches. 1941, Rockefeller fellowship. Ph.D. Science, 1943, from New School. Teaches at Lehigh University and Coe College. At present, Professor for Political and Social Science on the graduate faculty of the New School for Social Research. Teaches political philosophy. Publications: *Peace Among the Willows: The Political Philosophy of Francis Bacon,* The Hague, 1968, and *Copp'd Hills Toward Heaven: Shakespeare and the Classical Polity,* The Hague, 1968, among others. Maria and Howard B. White live in Northport, N.Y. They have two children.

———

Oil on canvas by Max Liebermann, *The Artist's Daughter and Granddaughter (Maria Riezler on the right),* c. 1930.

Bunch of Asparagus
1968, by way of Mrs. Marianne Feilchenfeldt, Zurich, for 1,360,000 Deutschemarks ($260,000) acquired by the Wallraf-Richartz-Kuratorium and the City of Cologne

Handed over to the Wallraf-Richartz-Museum as a permanent loan by Hermann J. Abs, chairman of the Kuratorium (friends of the Museum), on April 18, 1968, in memory of Konrad Adenauer.

Hans Gerling, Dr. Herbert Girardet, Dr. Paul Gülker, Iwan D. Herstatt, Raymund Jörg, Eugen Gottlieb von Langen, Viktor Langen, Dr. Peter Ludwig, Prof. Dr. Heinz Mohnen, Cai Graf zu Rantzau, Karl Gustav Ratjen, Dr. Hans Reuter, Dr. Hans-Günther Sohl, Dr. Dr. Werner Schulz, Dr. Nikolaus Graf Strasoldo, Christoph Vowinckel, Otto Wolff von Amerongen.

Bunch of Asparagus
acquired through the initiative of the Chairman of the Wallraf-Richartz-Kuratorium (Friends of the Museum) Hermann J. Abs

Born Bonn 1901. Descendant of a well-to-do Catholic family. Father, Dr. Josef Abs, attorney and judge *(Justizrat),* co-owner of Hubertus Braunkohlen AG, Brüggen, Erft (brown coal mining company). Mother, Katharina Lückerath. Passes final exam, 1919, at Realgymnasium Bonn. Studies one semester law, University of Bonn. Bank training at Bankhaus Delbrück von der Heydt & Co., Cologne. Gains experience in international banking in Amsterdam, London, Paris, the United States.
Marries Inez Schnitzler, 1928. Her father related to Georg von Schnitzler of executive committee of I.G. Farben syndicate. Aunt married to Baron Alfred Neven du Mont. Sister married to Georg Graf von der Goltz. Birth of two children, Thomas and Marion Abs. Member of Zentrumspartei (Catholic Party). 1929, on the staff, with power of attorney, of Bankhaus Delbrück, Schickler & Co., Berlin. 1935-37, one of five partners of the bank.
1937, on the board of directors and member of the executive committee of the Deutsche Bank in Berlin. Chief of its foreign division. 1939, appointed member of advisory council of the Deutsche Reichsbank by Walther Funk, minister of economics of the Reich. Member of committees of the Reichsbank, Reichs-

gruppe Industrie, Reichsgruppe Banken, Reichswirtschaftskammer, and Arbeitskreis of the minister of economics. 1944, represented on over fifty boards of directors. Membership in associations for the advancement of German economic interests abroad.
1946, for six weeks in British prison. Cleared by Allied denazification board and placed in category 5 (exonerated of active support of Nazi regime). 1948, participated in foundation of Kreditanstalt für Wiederaufbau (Credit Institute for Reconstruction). Extensive involvement in economic planning of West German federal government. Economic advisor to Chancellor Konrad Adenauer. 1951-53, head of German delegation to London conference to negotiate German war debts. Advisory role during negotiations with Israel at Conference on Jewish Material Claims in The Hague. 1954, member of CDU (Christian Democratic Party).
1952, on board of directors of Süddeutsche Bank AG. 1957-67, president of Deutsche Bank AG. Since 1967, chairman of the board.
Honorary chairman of the board of directors: Deutsche Überseeische Bank, Hamburg; Pittler Maschinenfabrik AG, Langen (Hesse).
Chairman of the board of directors: Dahlbusch Verwaltungs-AG, Gelsenkirchen; Daimler Benz AG, Stuttgart-Untertürkheim; Deutsche Bank AG, Frankfurt; Deutsche Lufthansa AG, Köln; Philipp Holzmann AG, Frankfurt; Phoenix Gummiwerke AG, Hamburg-Harburg; RWE Elektrizitätswerk AG, Essen; Vereinigte Glanzstoff AG, Wuppertal-Elberfeld; Zellstoff-Fabrik Waldhof AG, Mannheim.
Honorary chairman: Salamander AG, Kornwestheim; Gebr. Stumm GmbH, Brambauer (Westf.); Süddeutsche Zucker-AG, Mannheim.
Vice-chairman of the board of directors: Badische Anilin- und Sodafabrik AG, Ludwigshafen; Siemens AG, Berlin-München.

Member of the board of directors: Metallgesellschaft AG, Frankfurt.
President of the supervisory board: Kreditanstalt für Wiederaufbau; Deutsche Bundesbahn.
Great Cross of the Order of Merit with Star of the Federal Republic of Germany, Papal Star with the Cross of the Commander, Great Cross of Isabella the Catholic of Spain, Cruzeiro do Sul of Brazil. Knight of the Order of the Holy Sepulcher. Honorary doctorates of the universities of Göttingen, Sofia, Tokyo, and the Wirtschaftshochschule Mannheim.
Lives in Kronberg (Taunus), and on Bentgerhof near Remagen.

Bunch of Asparagus
acquired with donations from

Hermann J. Abs, Frankfurt; Viktor Achter, Mönchengladbach; Agrippina Rückversicherungs AG, Köln; Allianz Versicherung AG, Köln; Heinrich Auer Mühlenwerke, Köln; Bankhaus Heinz Ansmann, Köln; Bankhaus Delbrück von der Heydt & Co., Köln; Bankhaus Sal. Oppenheim Jr. & Cie., Köln; Bankhaus C. G. Trinkaus, Düsseldorf; Dr. Walter Berndorff, Köln; Firma Felix Böttcher, Köln; Robert Bosch GmbH, Köln; Central Krankenversicherungs AG, Köln; Colonia Versicherungs-Gruppe, Köln; Commerzbank AG, Düsseldorf; Concordia Lebensversicherungs AG, Köln; Daimler Benz AG, Stuttgart-Untertürkheim; Demag AG, Duisburg; Deutsch-Atlantische Telegraphenges., Köln; Deutsche Bank AG, Frankfurt; Deutsche Centralbodenkredit AG, Köln; Deutsche Continental-Gas-Ges., Düsseldorf; Deutsche Krankenversicherungs AG, Köln; Deutsche Libby-Owens-Ges. AG, Gelsenkirchen; Deutsche Solvay-Werke GmbH, Solingen-Ohligs; Dortmunder Union-Brauerei, Dortmund; Dresdner Bank AG, Düsseldorf; Farbenfabriken Bayer AG, Leverkusen; Gisela Fitting, Köln; Autohaus

Jacob Fleischhauer KG, Köln; Glanzstoff AG, Wuppertal; Graf Rüdiger von der Goltz, Düsseldorf; Dr. Paul Gülker, Köln; Gottfried Hagen AG, Köln; Hein. Lehmann & Co. AG, Düsseldorf; Hilgers AG, Rheinbrohl; Hoesch AG, Dortmund; Helmut Horten GmbH, Düsseldorf; Hubertus Brauerei GmbH, Köln; Karstadt-Peters GmbH, Köln; Kaufhalle GmbH, Köln; Kaufhof AG, Köln; Kleinwanzlebener Saatzucht AG, Einbeck; Klöckner Werke AG, Duisburg; Kölnische Lebens- und Sachvers. AG, Köln; Viktor Langen, Düsseldorf-Meerbusch; Margarine Union AG, Hamburg; Mauser-Werke GmbH, Köln; Josef Mayr KG, Hagen; Michel Brennstoffhandel GmbH, Düsseldorf; Gert von der Osten, Köln; Kurt Pauli, Lövenich; Pfeifer & Langen, Köln; Preussag AG, Hannover; William Prym Werke AG, Stolberg; Karl-Gustav Ratjen, Königstein (Taunus); Dr. Hans Reuter, Duisburg; Rheinische-Westf. Bodenkreditbank, Köln; Rhein.-Westf. Isolatorenwerke GmbH, Siegburg; Rhein.-Westf. Kalkwerke AG, Dornap; Sachtleben AG, Köln; Servais-Werke AG, Witterschlick; Siemag Siegener Maschinenbau GmbH, Dahlbruch; Dr. F. E. Shinnar, Tel-Ganim (Israel); Sparkasse der Stadt Köln, Köln; Schlesische Feuervers.-Ges., Köln; Ewald Schneider, Köln; Schoellersche Kammgarnspinnerei AG, Eitorf; Stahlwerke Bochum AG, Bochum; Dr. Josef Steegmann, Köln-Zürich; Strabag Bau AG, Köln; Dr. Nikolaus Graf Strasoldo, Burg Gudenau; Cornelius Stüssgen AG, Köln; August Thyssen-Hütte AG, Düsseldorf; Union Rhein. Braunkohlen AG, Wesseling; Vereinigte Aluminium-Werke AG, Bonn; Vereinigte Glaswerke, Aachen; Volkshilfe Lebensversicherungs AG, Köln; Jos. Voss GmbH & Co. KG, Brühl; Walther & Cie. AG, Köln; Wessel-Werk GmbH, Bonn; Westdeutsche Bodenkreditanstalt, Köln; Westd. Landesbank Girozentrale, Düsseldorf; Westfalenbank AG, Bochum; Rud. Siedersleben'sche O. Wolff-Stiftg., Köln.

Seurat's "Les Poseuses" (small version), 1888-1975

1975

Fourteen panels, each 20 x 30" (50.8 x 76.2 cm), one color reproduction of *Les Poseuses,* size of original plus frame 23⅜ x 27¼" (59.3 x 69.2 cm); all in thin black frames, under glass.

First exhibited in one-person exhibition at the John Weber Gallery, New York, May 3-May 28, 1975.

Edition of 3. One in the collection of the Stedelijk Van Abbemuseum, Eindhoven; one in the collection of Gilbert and Lila Silverman; one owned by Hans Haacke.

Les Poseuses (small version) is no longer on loan at the Neue Pinakothek in Munich. According to one press report, it was sold in 1975 by Heinz Berggruen "at a satisfactory profit." In 1986, it was on exhibition at the Metropolitan Museum of Art in New York, on anonymous loan.

Henry P. McIlhenny who, in 1970, sold the Seurat painting, died in Philadelphia on May 11, 1986 at the age of seventy-five. At the time of his death, he was chairman of the board of trustees of the Philadelphia Museum of Art. He bequeathed his entire collection to the museum.

Several directors of the 1975 board of directors of Artemis S.A. are no longer on the board (1985). David Carritt died in 1982. Heinz Berggruen resigned in 1983. Walter Barreiss, Philippe R. Stoclet, and Count Artur Strachwitz also resigned and have become honorary directors.

Since 1983, Artemis S.A. is registered in Luxembourg as a Fixed Capital Investment Fund. Its subsidiaries are Arhold, Inc. (book value $3,799,900) and David Carritt Ltd. (book value $135,925) in London.

In 1985 the board was composed of:

Baron Léon Lambert, * chairman, Brussels (since 1970); **Timothy Bathurst,** * art dealer, London (joined 1980); **Adrian Eeles,** art dealer; formerly a director of Sotheby's and head of its print department; became director in charge of prints and drawings at London art dealers P. & D. Colnaghi in 1976; since 1981, head of newly formed print department of Artemis Fine Arts (UK) Ltd., London (joined 1984); **Dr. Jost Enseling,** banker, Frankfurt; represents investments in Artemis by Deutsche Genossenschaftsbank, Frankfurt (joined 1984); **Ludwig Poullain,** former German banker (joined 1984); represents Grundig Foundation's investments in Artemis; resigned in 1985, proposed replacement, Prof. Dr. Stephan Waetzold, director of Department of Fine Arts of Nordstern Allgemeine Versicherungs AG,

Cologne (insurance company); **Baron Alexis de Redé,** Vevey, Switzerland (since 1970); **Howard Stein,** * New York, financial advisor (joined 1982); **Eugene Victor Thaw,** * art dealer, New York (since 1974); **Lucien Vlerick,** Kortrijk, Belgium; represents investments in Artemis by Gevaert Photo-Producten (joined 1984); **Guy Wildenstein,** art dealer, Lausanne (joined 1984); **Viscount Arnold van Zeeland,** * banker, Brussels; manager of Groupe Bruxelles Lambert's North American affairs

* Members of Executive Committee

Among the directors between 1975 and 1985 was Claus von Bülow (resigned in 1982).

Serving on the Art Advisory Board of Artemis between 1975 and its dissolution in 1983 were: Mr. and Mrs. Entwistle (dealers in African, Oceanic, and Eskimo art), London; Xavier Fourcade (dealer in twentieth-century art), New York; Heinz Herzer (dealer in Greek and Roman art), Munich; Robert M. Light (dealer of prints and drawings), Boston; John Richardson (art writer), New York.

Since 1983, replacing the Art Advisory Board, Artemis has a "consultant," The Hon. Michael Tollemache, London, "specializing in tax-free sales from private to public collections." He is also a director of David Carritt Ltd. and Artemis Fine Arts (UK) Ltd., London.

Art dealers with whom Artemis has collaborated since 1975, in addition to those listed in the work are: John Berggruen, San Francisco; L. & R. Entwistle & Co., London; Greater India Co., New York; Harari and Johns Ltd., London; Newhouse Galleries, New York; N.G. Stogdon, Inc., New York.

For 1984-85, Artemis reported a consolidated net profit of $1,849,192; total consolidated net assets of $16,608,547; works of art (assets) at cost of $10,638,782. The company's capital issued and fully paid up was $4,768,110, represented by 476,811 shares of common stock of $10 nominal value per share. The proposed cash dividend per share was $2.40.

Among the spectacular items handled by Artemis is a fourth century BC Greek bronze sculpture of an athlete attributed to Lysippus; it was found by Italian fishermen in the Adriatic Sea in 1964. Artemis sold it to the J. Paul Getty Museum in Malibu in 1977 for $3.9 million. It had bought the statue in the early 1970s and was embroiled in a dispute over whether the export of the statue from Italy had been handled in compliance with Italian law. Artemis also bid on behalf of the Getty Museum for a painting by Mantegna in 1985;

it was acquired by the museum for £8.1 million, the highest price ever paid at auction for a painting.

The Belgian Groupe Bruxelles Lambert, which is headed by the Artemis chairman, Baron Léon Lambert, is the largest shareholder (26%) of the New York-based Drexel Burnham Lambert, the fastest growing investment banking firm in the U.S. Among its major clients are the corporate raiders T. Boone Pickens, Saul Steinberg, and Carl Icahn. The firm dominates the market in high-risk, high-yield "junk bonds." It is known for its unconventional, aggressive techniques and scandals over insider-trading and misappropriation of funds by employees.

<div align="center">

"Les Poseuses"
(small version)
painted 1888, Paris, by

Georges Pierre Seurat

</div>

Born 1859, in Paris, 60 rue de Boudy, near the Porte Saint Martin.

His father, Chrysotome-Antoine Seurat, son of a farmer of the Champagne region, belongs to rich Parisian middle class. Retired at age 41 as a minor court official (huissier) of the Tribunal of the Département Seine.at La Villette, then an independent commune north of Paris. Maintains house in le Raincy, near Paris. His mother, Ernestine Faivre, 13 years younger than her husband, is the daughter of a Parisian jeweller. Paul Haumonté-Faivre, his uncle, owns "Au Père de Fouille", prosperous fancy goods store at 48, avenue des Ternes. His brother Émile, a playwright of comedies, with minor success. His sister Marie-Berthe marries Léon Appert, an engineer and glass-maker.

Soon after his birth, family moves to large apartment in newly built neighborhood of 10th arrondissement at 110, boulevard Magenta. 1871, during Paris Commune, escape to Fontainebleau. Attends Lycée until 1876. At age 15, starts taking drawing classes at vocational École Municipale de Dessin with Justin Lequien, an academic sculptor.

1877 student at the École des Beaux-Arts, under Henri Lehmann, a pupil of Ingres. 1879-80 one year of military service in an infantry regiment at Brest, a port in Brittany. Shortens normal 3-5 year service by paying 1,500 francs. Family supports him financially. Does not live from sales of his work. On return to Paris, 1880, takes small studio at 19, rue de Chabrol in Montmartre; later moves to newly constructed building, 128 bis, Boulevard de Clichy.

1883 exhibition of a drawing in the official Salon. 1884 the Salon's jury refuses his first major painting, "La Baignade à Asnières." Together with other rejected artists, he exhibits in the "Salon des Artistes Indépendents," a newly founded artists' collective with exhibition space in the Pavillon de la Ville de Paris on the Champs Elysées. He is a member of its executive committee and exhibits regularly with the group until his death. His friends and followers, Signac, Dubois-Pillet, Angrand, and Luce also belong to the Société des Artistes Indépendents. Camille Pissarro successfully lobbies for his invitation to the 8th impressionist exhibition 1886, against vigorous opposition of Renoir, Monet, Cézanne, and Sisley. Same year, dealer Durand-Ruel exhibits one of his paintings in New York. 1887, 1889 and 1891 exhibitions with Brussels avant-garde group "Les XX."

Draws and paints everyday life scenes, work, leisure, and entertainment of the lower and middle class, landscapes, and seascapes. Frequent painting excursions to industrial suburban Paris and the Atlantic coast. Based on the scientific theories for the optical mixtures of colors and simultaneous contrasts by Blanc, Sutter, Chevreul, Maxwell, Rood, Helmholtz and the writings on the associative expressiveness of lines by Charles Henry, he tries to methodically construct harmony in geometricized compositions according to scientific laws.

These so-called "neo-impressionist," "pointillist," or "divisionist" paintings, composed of myriads of small dots of pure pigment, meet hostility and derision. Few are sold, at low prices. Many are given to his friends as presents. His work is defended and admired by the critic Félix Fénéon and his circle of symbolist writers and poets, including Gustave Kahn, Émile Verhaeren, Paul Adam, Jean Ajalbert, Paul Alexis, and his biographer, Jules Christophe. He shares their sympathies with anarchist communism.

1890 birth of his son, Pierre Georges, from his mistress, Madeleine Knobloch, a 20 year old model. Acknowledges his paternity. Moves with mother and child to 39, passage de l'Elysée-des-Beaux-Arts, now rue André-Antoine, in Montmartre.

Dies, at age 32, probably of meningitis, 1891. His son dies 2 weeks later.

"Les Poseuses"
(small version)
acquired, probably as a present, by

Jules F. Christophe

Born 1840 in Paris. Son of a merchant.

Writer and government official. 1889 appointed Deputy Chief of Staff in the French Ministry of War.

Author of theater plays and fiction. 1887 co-author with Anatole Cerfberr of "Repertoire de la Comédie humaine," a biographical dictionary for Balzac readers. Contributor of theater and art criticism, essays and biographical articles to numerous literary magazines associated with symbolism and anarchist communism. Publishes 1890 one of the early extensive articles on Seurat and his theories ever written, in "Les Hommes d'Aujourd'hui," a symbolist weekly. In the same magazine appear his articles on the painters Dubois-Pillet and Maximilian Luce. He himself is the subject of a biographical sketch by Félix Fénéon in "Les Hommes d'Aujourd'hui."

Closely related to circle of symbolist/anarchist writers and neo-impressionist painters, including Fénéon, Gustave Kahn, Charles Henry, Paul Adam, Jean Ajalbert, Jules Laforgue, Seurat, Signac, Pissarro.

Has strong sympathies with anarchist communism. Contributes to fund for the destitute children of imprisoned anarchists.

Author of Seurat's obituary in "La Plume," 1891.

Reportedly gives his son "Les Poseuses" during his own life time. Date of death unknown.

Detail of Drawing by Dubois-Pillet, 1888

"Les Poseuses"
(small version)
acquired after 1892 by

B.A. Edynski and Max Hochschiller

"Les Poseuses"
(small version)
purchased 1909 by

Josse and Gaston Bernheim-Jeune

Twin brothers born 1870 in Brussels. Father, Alexandre Bernheim, paint manufacturer and merchant in art supplies from Besançon. 1854 moves to Paris to continue business there at 8, rue Lafitte, near the Rothschild family mansion; expands to dealing with contemporary art, helped by the protection of Princess Mathilde and the Duc d'Aumale, son of King Louis Philippe.

Brothers attend Lycée Condorcet, Paris; join their father's business. Their cousins, Jos Hessel and Georges Bernheim, also art dealers. Their sister, Gabrielle, married to painter Félix Valloton.

Move to larger gallery quarters at 25, boulevard de la Madeleine and 15, rue Richepance. Participate in organization of Centennial Exhibition 1900 in Paris and many exhibitions abroad. Assist in building private collections, among them those of the wealthy importer Sergei I. Shchukin and of Morosoff in Moscow; form the collection of the Museum of Tananarive, Madagascar. Charged with sale of important collections. Accredited experts with Appellate Court in Paris. Officers of Legion of Honor.

Artists exhibited and represented are predominantly impressionist, neo-impressionist, and fauvist. Félix Fénéon artistic director for 25 years. Numerous publications by gallery.

1925 gala opening of large new gallery quarters by Gaston Doumergue, the President of France, on corner rue du Faubourg-Saint-Honoré and avenue Matignon, in the immediate neighborhood of the palaces of the French President and Prime Minister.

The family mansion at 107, avenue Henri Martin, has grand salon with 25 foot ceiling, decorated by 80 Renoirs; the walls of the dining room are covered by 30 Cézannes, 20 Toulouse-Lautrecs, an El Greco, and a large Corot. Family also owns a château in the provinces, and maintains several large automobiles and a dirigible balloon.

Gaston has apartment avenue du Maréchal Maunoury, decorated by Raoul Dufy. He, himself, paints landscapes, still lifes, and nudes, under the name Gaston de Villers. His paintings exhibited at the Société Nationale des Beaux-Arts, the Salon d'Automne, and Société des Artistes français. He is co-founder and treasurer and exhibits with the Société coloniale des Artistes français. 1927 retrospective exhibition at Galerie Bernheim-Jeune. Works in French provincial museums.

Brothers actively participate in defense of Alfred Dreyfus, the French officer falsely condemned for treason in an anti-semitic conspiracy. During World War I, gallery's paintings are evacuated to Bordeaux, where French Government also takes refuge. 1940 move to Lyons. Josse Bernheim dies there in 1941. Gaston Bernheim flees German invasion of Lyons. Eventually lives in Monte Carlo. Dies 1953.

Reopening of gallery in Paris 1947.

Painting by Édouard Vuillard, "Gaston and Josse Bernheim." 1912

"Les Poseuses"
(small version)
purchased 1910 for 4,000 ffrs. by

Alphonse Kann

Descendant of family of financial advisors to the courts and aristocracy of Europe. His father, Louis Kann, married to a cousin of Lord Burnham. Her family associated with the English business world. His uncles, Rudolphe and Maurice Kann, build famous art collections in Paris, on the income from gold mines in Transvaal, South Africa. (Rembrandt's "Aristotle Contemplating the Bust of Homer," in Rudolphe Kann collection, now at Metropolitan Museum, New York. Art dealers Gimpel and the brothers Duveen buy the collection 1907, for 17-million ffrs.).

Grows up in Paris. Spends time in London working in business of his mother's family there.

Becomes closely associated with literary and art circles in Paris. Frequently sees Roussel, Cocteau, Éluard, Breton, Picasso, Braque, and is part of Gertrude Stein's "salon."

Owns large eclectic collection, ranging from Egyptian sculpture through archaic, Greek, Roman, Persian, and Chinese art, Pre-Columbian, African and Pacific objects, Romanesque and Gothic sculpture, enamels, ivories, illuminated manuscripts, Coptic works, paintings by Cimabue, Pollaiolo, Tintoretto, Brueghel the Elder, Fabrizius, Rubens, Fragonard, Turner, to period furniture, impressionist works and modern art of the École de Paris.

Often buys and sells on his own, acting as amateur dealer. Recognized by many as arbiter of taste. Advises the banker David-Weill, Arturo Lopez, Charles de Noailles. Assists contemporary art dealer Paul Guillaume.

1920 major auction of part of his collection at Galerie Petit, Paris. 1927 large sale of works at American Art Association in New York, for a total of $282,222.

Inhabits 17th century mansion in St. Germain-en-Laye, near Paris. A convent he owns on Capri is sold to his friend, Princess Margherita of Savoy. Buys castle at Cintra, Portugal.

Escapes to England from German invasion of France. Dies there around 1950.

"Les Poseuses"
(small version)
purchased 1913 or after by

Marius de Zayas

Born 1880 at Vera Cruz, Mexico. Descendant of well-to-do family of Spanish nobility. Father Professor of law and history, judge, publisher of major daily newspaper in Vera Cruz, poet laureate of Mexico and painter; personal friend of Mexican President Porfirio Diaz until his articles, critical of Diaz's increasingly dictatorial regime, lead to break and force family to emigrate to the U.S.

No formal education. Contributes illustrations to *El Diario*, Mexico City newspaper. 1905 first visit to U.S. Settles in New York 1907. Caricaturist for the *New York World*, a daily newspaper.

Joins the circle of Alfred Stieglitz, photographer and promoter of new art. Exhibits 1909 caricatures of New York society figures, theatre, and art personalities, at his Photo-Secession Gallery. Contributes numerous articles on avant-garde art, photography and African art to *Camera Work*, a Stieglitz publication. Frequent visits to Paris 1910-14; meets many avant-garde figures there. With photographer Edward Steichen scouting for new art to be shown at "291" Fifth Avenue, the new Stieglitz gallery. Selects Picasso exhibition there 1911, Braque paintings for 1914 show. 1913 exhibition of his own cubist influenced "abstract" caricatures. Exhibition of African sculpture mainly from his own collection, in 1914-15.

Co-author 1913, of "A Study of the Modern Evolution of Plastic Expression," with his friend Paul B. Haviland, the American representative of Haviland & Co., china manufacturers of Limoges, France. Under Stieglitz's auspices, 1915-16, co-editor with Haviland of the proto-dadaist magazine "291," with contributions from Picabia, Man Ray, Duchamp, and others.

1915 establishment of Modern Gallery at 500 Fifth Avenue. His partners are Picabia, Haviland and Agnes Ernst Meyer, wife of Eugene Meyer, a financier and high government official. He collaborates with her on dadaist poems.

1918 establishment of his own gallery at 549 Fifth Avenue. Deals in modern European, African and Mexican art and builds sizable collection. Closes in early 1920's. Continues as private dealer, collaborates on exhibitions and serves as agent for Paris dealers Durand-Ruel, Paul Rosenberg, and Paul Guillaume.

First marriage ends in divorce, 2 daughters. Second marriage 1925 to Virginia Randolph Harrison, a woman 21 years his junior. Her father, a lawyer, ex-Congressman (D.) and U.S. Governor General of Philippine Islands (1913-21). Her mother Mary Crocker, daughter of Charles Crocker, the builder of the Central Pacific Railroad.

Move to Austrian mountain resort St. Anton. Gives up art dealing. 1928 purchase of 14th century château at Monestier de Clermont near Grenoble, France. Derives income from sales of his collection and his wife's fortune.

In the early thirties filmmaking in Spain, documentaries on flamenco music and bullfight. During war years with wife, daughter (born 1927) and son Rodrigo (born 1939) at French château pursuing studies in cryptology and musicology.

1947 move to U.S. Buys house in Greenwich, Conn. Resumes documentary filmmaking.

Dies 1961 of coronary thrombosis in Hartford, Conn.

Photo by Alfred Stieglitz

"Les Poseuses"
(small version)
purchased 1922 for $5,500 by

John Quinn

Born 1870 Tiffin, Ohio. Son of Irish immigrants. Father James William Quinn, prosperous baker in Fostoria, Ohio. Mother Mary Quinlan, orphan. Sister Julia married to William V. Anderson, successful pharmacist of Fostoria. Sister Clara nun of Ursuline Convent, Tiffin.

Graduate of Fostoria High School. 1888 at University of Michigan. 1890-93 in Washington, D.C., as private secretary of Secretary of the Treasury Charles Foster (friend of Quinn family), under President Benjamin Harrison. Graduates from Georgetown University Law School 1893, Harvard University Law School 1895.

1893 clerkship in New York law firm of General Benjamin F. Tracy. 1900 junior partner with Alexander & Colby. 1906 own law practice specializing in financial and corporate law. Offices at 31 Nassau Street in Wall Street district.

Chief Counsel to National Bank of Commerce, second largest bank in U.S. Instrumental in acquisition of Equitable Life Assurance Society by Thomas Ryan, financier with extensive interests in coal, tobacco, Congolese and Angolan diamond mining. His chief counsel as of 1906. Negotiates merger of Bowling Green Trust and Madison Trust with Equitable Trust, 1908-1909. New York Stock Exchange counsel on tax law, 1913. Special counsel to N.Y. State Comptroller in inheritance tax proceedings against estate of John Jacob Astor, 1914. Represents munitions makers in Federal Tax case, 1917. Submits brief in Congress for adoption of Alien Property Act, same year. Represents U.S. Alien Property Custodian and private American interests in suit over seizure of German properties. Wins 1920 in U.S. Supreme Court establishing the law's constitutionality (legal fee $174,000).

Tammany Hall Democrat. Delegate to National Convention 1908 and 1912. Campaigns for candicacy of Oscar W. Underwood against Woodrow Wilson. Theodore Roosevelt a personal friend.

Staunch supporter of Irish causes. Contemptuous of American cultural life, francophile, anti-semitic, anti-German; proposes to French President Poincare take-over of German Ruhr industries by Allies, 1923.

Collects 19th and 20th century French and English painting and sculpture, including Cézanne, van Gogh, Gauguin, Seurat, Derain, Matisse, Picasso, Duchamp-Villon, Brancusi, Epstein. Investment in art estimated at $500,000. Has personal contact with artists in Paris and London. Helps with organization and promotion of Armory Show, 1913. Conducts successful campaign in Congress for the exemption of modern art from customs duty. Wins in Congress tax exemption of art sales by living artists, 1918.

Sponsors U.S. tours of Irish writers and theater productions. Assists in the publication of works by W. B. Yeats, J. M. Synge, Joseph Conrad, T. S. Eliot, James Joyce. Extensive correspondence with writers. Buys literary manuscripts, including all of Joseph Conrad's. Sells most in auction 1923 (Conrad for $110,000 and Joyce's "Ulysses" for $2,000). Defends "Ulysses" against obscenity charges in New York Court.

Lives, as of 1911, in top floor apartment at 58 Central Park West. Frequent travels to Ireland, England, and France. Remains bachelor, though has several romances.

Member of numerous exclusive clubs, of Contemporary Art Society, and Société de Cent Bibliophiles. 1915 appointed Honorary Fellow of Metropolitan Museum, 1918 Chevalier of Legion of Honor.

Dies of cancer in New York, 1924.

Photo around 1921. From "The Man from New York," by B. L. Reid

"Les Poseuses"
(small version)
inherited 1924 by

Julia Quinn Anderson

Born 1880 in Fostoria, Ohio. Daughter of Irish immigrants. Her father William Quinn, prosperous baker in Fostoria. Her mother, Mary Quinlan, orphan. Her sister, Clara, nun at Ursuline Convent, Tiffin, Ohio. Her brother, John Quinn, well-known New York lawyer and collector of books and modern art.

Marries William Vincent Anderson 1903, a prosperous pharmacist of Fostoria. 1907 birth of daughter Mary, only child.

Beginning 1914 frequent and extended visits to New York, often acting as hostess for her bachelor brother, John Quinn. Daughter attends school in the city. Around 1919 permanent move of the family to New York, after sale of Fostoria business.

Major beneficiary of John Quinn's estate on his death 1924.

Dies of cancer 1934.

"Les Poseuses"
(small version)
inherited 1934 by

Mary Anderson Conroy

Born in Cleveland, Ohio, 1907. Her father, William Vincent Anderson, prosperous pharmacist in Fostoria, Ohio. Her mother, Julia Quinn, daughter of a prosperous baker in Fostoria, sister of John Quinn, a well-known New York Lawyer and collector of books and modern art.

Frequent visits to John Quinn in New York. Family eventually settles in the City, at 37 West 93 Street, after sale of business in Fostoria.

Attends school at the Convent of the Sacred Heart in New York 1914, and Maplehurst High School in Upper Manhattan.

Extensive travels abroad with her mother or friends. Engaged in volunteer charity work. Unpaid assistant of Mrs. Cornelius Sullivan, a co-founder of the Museum of Modern Art and a private art dealer.

At her mother's death, 1934, principal beneficiary of inheritance, including numerous works from the collection of the late John Quinn.

1941 marriage to Thomas F. Conroy, M.D., a urological surgeon of New York. Volunteer paramedical work. After World War II move to San Mateo, California. 1946 birth of only child, Thomas Anthony Conroy.

Dies of cancer, 1970.

Photo around 1950, courtesy Dr. Thomas F. Conroy

"Les Poseuses"
(small version)
purchased 1936 through Mrs. Cornelius Sullivan for $40,000 by

Henry P. McIlhenny

Born 1910 Philadelphia, Pennsylvania. Descendant of wealthy Irish family of Philadelphia society.

His father John D. McIlhenny, member of boards of directors of several large gas companies; partner of Helme & McIlhenny, manufacturers of gas meters in Philadelphia; member of the board of managers of Savings Fund Society of Germantown, Pa. Collector of European decorative arts, oriental rugs and paintings. President of Pennsylvania Museum and School of Industrial Art (now Philadelphia Museum of Art) and Director of Philadelphia Art Alliance.

His mother Frances Galbraith Plumer. Collector of 19th and early 20th century art. Trustee of Philadelphia Museum.

His uncle Francis S. McIlhenny, lawyer; vice president of Sun Oil Company; member of Board of Directors of numerous large corporations; member of Pennsylvania Senate (1907-15); director and officer of YMCA.

His sister Mrs. John (Bernice) Wintersteen married to lawyer. Collector of 19th and early 20th century art. Trustee and President (1964-68) of Philadelphia Museum of Art.

Studied at Episcopal Academy and Milton Academy, elite prep schools near Philadelphia and Boston. Bachelor of Arts 1933, Harvard; graduate studies in art history, 1933-34, Harvard, under Prof. Paul J. Sachs.

Curator of Decorative Arts at Philadelphia Museum of Art 1935-64. Since 1964 trustee and 1968 vice president of the Museum. Member Smithsonian Art Commission, Washington. 1949-62 director of Philadelphia Orchestra Association and Metropolitan Opera Association, New York.

Served to Lieutenant Commander in U.S. Naval Reserve. During World War II on active duty.

Major part of his collection purchased with his mother's financial backing during depression: silver, period furniture, and predominantly 19th century French painting and sculpture, including Cézanne, Chardin, Daumier, David, Degas, Delacroix, van Gogh, Ingres, Matisse, Renoir, Rouault, Toulouse-Lautrec, Vuillard.

Bachelor, frequent society host in his mansion, 2 adjoining mid-19th century town houses, with ballroom, on Rittenhouse Square in Philadelphia. Employs 8 servants there. Spends part of year at Victorian Glenveagh Castle, his property in County Donegal, Ireland; maintained by 30 servants.

Member of Philadelphia Club and Rittenhouse Club, in Philadelphia, Century Association and Grolier Club in New York.

Together with Seurat's "Les Poseuses" buys Picasso's "L'Arlequin" from Mrs. Mary Anderson Conroy, for a total of $52,500. Her friend, Mrs. Cornelius Sullivan, co-founder of the Museum of Modern Art, New York, and a private art dealer, receives a commission of 10%.

"Les Poseuses"
(small version)
$1,033,200 auction bid at Christie's, 1970, half share held by

Artemis S.A.

Incorporated April 2, 1970 in the Grand Duchy of Luxembourg; private holding company of subsidiaries incorporated in the United Kingdom (David Carritt, Ltd., London) and other countries. Invests and trades in works of the fine and decorative arts of all periods and cultures.

Inventory included old masters, impressionists, classical modern art, contemporary art; antique, African, Asian sculpture; decorative silver.

Collaborating art dealers include E.V. Thaw & Co., New York; Fourcade, Droll, Inc., New York; R.M. Light & Co., Boston; Heinz Berggruen & Cie., Paris; Heinz Herzer & Co., Munich; P. & D. Colnaghi, London; Heim, London; Lefevre, London; Fischer Fine Art, London.

Works sold among others to National Gallery, Washington; Cleveland Museum; Norton Simon Foundation; Ashmolean Museum, Oxford.

Board of Directors

Baron Léon Lambert. Chairman since 1970. Chairman of Compagnie Bruxelles Lambert.

Eugene Victor Thaw, managing director since 1974. Head of E.V. Thaw & Co. Private dealer. 1970-72 President of Art Dealers Association of America, Inc.

David Carritt, since 1970. Head of David Carritt Ltd., Artemis subsidiary in London. Old Master expert, formerly with Christie's, London.

Count Christian zu Salm-Reifferscheidt, 1970-73. Art historian, expert in antique art. Former curator of Bavarian State Museum, Munich. Deceased.

Philippe R. Stoclet, since 1970. Former representative of Loeb, Rhoades & Co., New York. Chief executive officer of Brussels financing company. Descendant of Alphonse Stoclet, international railroad builder and collector, who commissioned architect Josef Hoffmann of "Wiener Werkstätten" to build Palais Stoclet, Brussels.

Count Artur Strachwitz, since 1970. Born 1905. Brother-in-law of Prince of Liechtenstein. Former cultural attaché at Brussels Embassy of German Federal Republic.

Baron Alexis de Rédé, since 1970. Financial consultant, collector. Among major beneficiaries of inheritance of his late friend, Arturo Lopez, South American financier. Lives in 17th century Hôtel Lambert, Paris, rue St. Louis en Ile, now owned by Baron Guy de Rothschild, a friend.

Walter Bareiss, since 1973. Born Tübingen, Germany. Chairman of family business Schachenmeyr, Mann & Cie. GmbH., Salach, Germany, yarn factory. Chairman of Cobar Industries, Inc. Served in U.S. Army in World War II. Married to Molly Stimson, cousin of Henry L. Stimson, late US Secretary of War. Collector. Member collection committee 20th century art, chairman Gallery Association Bavarian State Museum, Munich. Trustee Museum of Modern Art, New York, 1964-73, acting director 1969-70, member committee on drawings and prints. Lives Munich and Greenwich, Conn.

Heinz Berggruen, since 1974. Head of Paris art gallery, Heinz Berggruen & Cie..

Art Advisory Board

Baron and Baroness Élie de Rothschild, 1970-73; Prof. Abraham Hammacher, 1970-73; Douglas Cooper, 1971-73; Roderic Thesiger, 1971-73; Heinz Herzer, since 1971; Count Cesare Cicogna Mozzoni, 1972-73; Valentine Abdy, since 1974.

Holding Company and Subsidiaries

Year	consolidated profit	total assets	assets works of art at cost
1970-71	$ 43,042	$ 5,431,299	$2,207,680
1971-72	641,992	5,703,195	3,676,507
1972-73	778,448	8,010,350	5,787,507
1973-74	733,397	10,256,991	7,864,400

Authorized capital: 1,000,000 shares of $10 nominal value per share. Issued capital: 413,025 shares of

"Les Poseuses"
(small version)
half share held by Artemis S.A. under chairmanship of

Baron Léon Lambert

Born Etterbeek—Brussels, 1928.

His grandfather, Léon Lambert, official agent of Paris Rothschild Bank in Belgium. Banker of King Léopold II, who gives him title of Baron, in recognition of his services as financier of Belgian colonization of Central Africa. Married to Lucie de Rothschild-Anspach, daughter of Baron Gustave de Rothschild. Their daughter marries Rudolf de Goldschmidt-Rothschild of Naples.

His father, Baron Henri Lambert, head of Banque Lambert, Brussels; correspondent of Rothschild banks in Paris and London, with extensive interests in the Belgian Congo, radio, and airline. His mother, Baroness Hansi von Reininghaus, of Austrian nobility. After her husband's death, 1933, titular head of bank while leaving affairs in hands of trusted bankers (bank survives German occupation of Belgium in WW II intact). Collector; sponsor of cultural events. Dies 1960.

During World War II, with his mother, brother Philippe, and sister, in England and the U.S. Studies at Yale, Oxford, Geneva. Licencié ès science politique, University of Geneva.

1949 assumes role in Banque Lambert, S.C.S., Brussels, a limited partnership. 1950 senior partner and chairman. 1953 absorption of Banque de reports et de dépôts. Rapid expansion of financial interests. 1966 vice-Chairman, 1971 chairman of holding Compagnie Lambert pour l'industrie et la finance; through merger with De Launoit family's interests 1972, holding becomes Belgium's second largest. Under the new name Compagnie Bruxelles Lambert, extensive international interests in banks, insurance companies, real estate, retailing, public utilities, oil, steel, and metallurgy. 1974 merger with Banque Bruxelles makes Banque Bruxelles Lambert Belgium's second largest commercial bank. Retains extensive business and family ties with Rothschild banking group.

Chairman of: Banque Lambert, S.C.S., Brussels; Compagnie Bruxelles Lambert pour la finance et l'industrie, Brussels; SOGES, Brussels; Compagnie de constructions civiles, Brussels; La Concorde S.A., Brussels; The Lambert Brussels Corporation, New York; Artemis S.A., Luxembourg; Manufacture Belge de Lampes et de Matériel Électronique (M.B.L.E.), Brussels.

Vice Chairman of: Select Risk Investments S.S., Luxembourg; Electrobel S.A., Brussels; Lambert Milanese S.p.A.

Member of Board of Directors of: Magnum Fund Ltd., Toronto; Petrofina S.A., Brussels; Berliner Handelsgesellschaft, Frankfurt-Main; Five Arrows Securities Co. Ltd., Toronto; Banca d'America e d'Italia, Milan; New Court Securities Corporation, New York; INNO-B.M.S.A., Brussels; ELECTROGAZ S.A., Brussels; ITALUNION, Luxembourg; General Fund International Management Co., Luxembourg; General Fund International S.A., Luxembourg; General Fund International Holding Co., Luxembourg; United Overseas Bank. Geneva; Compagnie Auxilière Internationale des Chemins de Fer.

Member Advisory Board of: Société Financière pour les Pays d'Outre-Mer (SFOM), Geneva.

1964 move into new bank building at 24, avenue Marnix, designed by Gordon Bunshaft of architecture firm Skidmore, Owings & Merrill, New York. Large Henry Moore sculpture on street level plaza.

Bachelor. Lives in penthouse apartment above bank. Apartment and banking floors house large collection of classical modern art, partially inherited from his mother, non-western and contemporary European and American art. Board member of Société Philharmonique de Bruxelles, Musée du Cinéma, Cinémathèque Royale de Belgique, Jeune Peinture Belge.

Decorations: Chevalier de l'Ordre de Léopold (Belgium), Commandeur de l'Ordre à la Valeur (Cameroon), Grande Ufficiale al Merito della Repubblica Italiana (Italy).

According to his wishes, Seurat's "Les Poseuses" exhibited at Bavarian State Museum, Munich.

Photo from "Banque Lambert," Brussels, 1964

"Les Poseuses"
(small version)
bid at Christie's auction and half share held by

Richard L. Feigen

Born 1930, Chicago, Ill. His father, Arthur P. Feigen, a lawyer. His mother Shirley Bierman.

Graduates with B.A. from Yale University 1952, M.B.A. of Harvard Business School, 1954. Begins to collect art.

1955-56 work in business of a relative. Becomes treasurer and member of Investment Committee of Beneficial Standard Life Insurance Company, Los Angeles, and Fidelity Interstate Life Insurance Company, Philadelphia. Member of Board of Directors and Finance Committee, Union Casualty and Life Insurance Company, Mount Vernon, New York.

1956 buys seat on New York Stock Exchange. Sells it 1957.

1957 opens art gallery in Chicago, Richard L. Feigen & Co., Inc., of which he is President and Director. Frequently exhibits contemporary artists. 1963 opening of New York gallery, dealing with old masters and exhibiting contemporary art. Stages "Richard J. Daley" show, 1968, at Chicago gallery, in protest against Chicago police conduct in confrontations with demonstrators during Democratic Convention. Chicago gallery closes 1972. Gives up showroom in New York, 1973; continues as private dealer of predominantly old masters and classical modern art. Since 1965 member and 1974, on Board of Directors of Art Dealers Association of America.

1966 Faculty member, University for Presidents, Young Presidents Organization, Phoenix, Arizona. Lectures on "Art for Your Business" and "Art for the Private Collector." Founder of Art for Business, Inc., now an inactive corporate shell.

1963 Member of the Advisory Board of Independent Voters of Illinois. 1964 on Honorary Steering Committee, Young Citizens for Johnson. 1972 unsuccessful bid to be elected alternate delegate to Democratic Convention supporting McGovern's Presidential candidacy. Member American Civil Liberties Union.

1966 marriage to Sandra Elizabeth Canning Walker. Has two children and three step-children.

In his auction bid for Seurat's "Les Poseuses," represents his own interests and the interests of ARTEMIS S.A., a Luxembourg-based art investment holding company. Armand Hammer, Chairman of Occidental Petroleum Corp., puts in one bid, then gives up.

Photo courtesy Richard L. Feigen

"Les Poseuses"
(small version)
purchased 1971 for unknown amount (part in art works) by

Heinz Berggruen

Born 1914 in Berlin, Germany.

Studies art history in Berlin and Toulouse, France, graduating there with equivalent of Master of Fine Art degree. In late 1930's moves to California. Postgraduate studies in art history at Berkeley. Assistant Curator of San Francisco Museum of Art. Writes art criticism for *San Francisco Chronicle*. Works at 1939 World Exposition on Treasure Island, San Francisco.

Marries Lilian Zellerbach of prominent San Francisco paper manufacturing family. Birth of son John Berggruen 1943 (now art dealer in San Francisco). Birth of daughter Helen, 1945.

After World War II, service in US Army. Stationed in England and Germany. Works for German language US Army publication in Munich.

Around 1947 move to Paris via Zurich. Employed by cultural division of UNESCO. In late 1940's, starts dealing in art books and prints. Becomes art dealer. Berggruen & Cie, now at 70, rue de l'Université, develops into one of major Parisian art dealers in modern art, particularly Ecole de Paris.

Lives Ile St. Louis, Paris, and on château near Pontoise. Owns large collection.

1974 elected member of the Board of Directors of Artemis S.A., a Luxembourg-based art investment holding company. Chevalier of Legion of Honor.

His purchase of Seurat's *Les Poseuses* at "impressive profit" to Artemis S.A. (annual report). Painting now on anonymous loan in Bavarian State Museum, Munich.

Photo from "Art in America," 1963

On Social Grease

1975

Six plaques, 30 x 30" (76.2 x 76.2 cm), photo-engraved magnesium plates mounted on aluminum.

First exhibited in one-person exhibition at the John Weber Gallery, New York, May 3-May 28, 1975.

Photographs: Walter Russell.

Collection of the Gilman Paper Co., New York.

Although not perceived at the time by the public at large, sponsorship of art exhibitions by large corporations and corporate art collecting developed in the early 1970s at a scale and with an impact hitherto unknown.

Authors of the quotes:

C. Douglas Dillon: Metropolitan Museum, president, 1970-78; chairman, 1978-83; Business Committee for the Arts, co-founder, first chairman; Rockefeller Foundation, chairman, 1972-75; U.S. & Foreign Securities Corp., chairman, 1972-84; Dillon, Read & Co., chairman of executive committee; director, 1971-82

Quoted from C. Douglas Dillon, "Cross-Cultural Communication Through the Arts," *Columbia Journal of World Business* (September-October 1971).

Nelson Rockefeller: Museum of Modern Art, trustee, 1932-79; president, 1939-41; chairman, 1957-58; governor of New York State, 1958-73; vice-president of the United States under President Gerald Ford, 1974-77; died 1979

Quoted from report by Grace Glueck, *The New York Times*, May 1, 1969, p. 50.

Frank Stanton: American Crafts Council, trustee, 1957-75; Business Committee for the Arts, director, 1967-77; chairman, 1972-74; Carnegie Institution, Washington, D.C., chairman; Lincoln Center for the Performing Arts, director emeritus; Rockefeller Foundation, trustee, 1961-73; Atlantic Richfield Co., director, 1973-81; American Electric Power Co., director, 1969-80; CBS Inc., president, CEO, 1946-71; vice-chairman, 1971-73; director, 1945-78; New Perspective Fund, director; New York State Council on the Arts, member, 1965-70; New York Life Insurance Co., director, 1956-81; Pan American World Airways, Inc., director, 1967-81; Rand Corporation, trustee, 1956-78; chairman, 1961-67; Interpublic Group of Cos., director

Quoted from Frank Stanton, "The Arts—A Challenge to Business," speech to 25th Anniversary Public Relations Conference of the American and Canadian Public Relations Society, Detroit, November 12, 1972.

David Rockefeller: Museum of Modern Art, vice-president; Business Committee for the Arts, co-founder and director; Chase Manhattan Bank Corp., chairman, 1969-81; chairman, International Advisory Committee, 1981–; director

Quoted from David Rockefeller, "Culture and the Corporation's Support of the Arts," speech to National Industrial Conference Board, September 20, 1966.

Richard M. Nixon: President of the United States, 1968-74 (resigned under pressure from Congress)

Quoted from address to Congress in support of the National Endowment for the Arts, in *The Wall Street Journal*, January 2, 1970, p. 6.

Robert Kingsley: Manager of Urban Affairs in Department of Public Affairs, Exxon Corp., New York, 1969-77; senior public affairs advisor, cultural and communications programs, Exxon, 1977-80; founder and chairman of Arts and Business Council, New York; died 1980

Quoted in Marylin Bender, "Business Aids the Arts . . . And Itself," *The New York Times*, October 20, 1974, section 3, p. 1.

Perhaps the most important single reason for the increased interest of international corporations in the arts is the almost limitless diversity of projects which are possible.

These projects can be tailored to a company's specific business goals and can return dividends far out of proportion to the actual investment required.

C. Douglas Dillon

My appreciation and enjoyment of art are esthetic rather than intellectual.

I am not really concerned with what the artist means; it is not an intellectual operation—it is what I feel.

Nelson Rockefeller

Mobilization

1975

Four-color silkscreen on acrylic plastic, 57½ x 48″ (146 x 121.9 cm).

First exhibited in one-person exhibition at the Max Protetch Gallery, Washington, D.C., May 4-May 29, 1976.

Edition of 6. All owned by Hans Haacke.

Mobil is the second largest U.S. oil company, after Esso (Exxon).

The Business Committee for the Arts (BCA), which is referred to by the Mobil officer, was established in 1967 by David Rockefeller and C. Douglas Dillon as an organization of business leaders with the declared goal of promoting corporate support for the arts. Rawleigh Warner, Jr., chairman and chief executive officer of Mobil (retired early 1986), served several years as chairman of the BCA. His company has been a frequent recipient of the BCA's "Business in the Arts Award." Warner has been appointed to the board of trustees of the Guggenheim Museum.

The U.S. Information Agency is a government agency in charge of U.S. propaganda abroad and administers the U.S. participation in the Venice Biennale.

C. Douglas Dillon is an important investment banker, now retired. He has been chairman of Dillon, Read & Co., and of the U.S. Foreign Securities Corporation. He has also served as secretary of the treasury, U.S. ambassador to France, and chairman of the Rockefeller Foundation. Dillon became president of the Metropolitan Museum of Art in 1970; from 1978 to 1983 he was the chairman of the museum.

The *Columbia Journal of World Business* is a periodical published by the Economics Department of Columbia University in New York.

Herb Schmertz, vice-president for public affairs and director of Mobil, said about the posters the company commissioned from thirteen American artists (William Bailey, James Brooks, Christo, Allan D'Archangelo, Roy Lichtenstein, Constantino Nivola, Robert Andrew Parker, Robert Rauschenberg, James Rosenquist, Ed Ruscha, Raymond Saunders, Ben Schonzeit, Velox Ward):

In 1975, a year before the nation's bicentennial, we started looking for a project that would be visible, long-lasting, and inexpensive—or even, if possible, self-liquidating. Somehow, I hit upon the idea of a series of posters. We came up with a theme—"America, the Third Century"—and asked thirteen leading American artists each to produce a poster. Then we approached the Bicentennial Commission and convinced its members to designate these works as the official Bicentennial posters. By arranging their sale through art galleries and poster shops, we were able to recover all our costs.

In 1976, Raymond d'Argenio moved from Mobil to become senior vice-president for communications of the United Technologies Corporation. Based in Hartford, Connecticut, United Technologies is the second largest U.S. defense contractor, manufacturing aircraft engines, helicopters, and electronic guidance equipment, and contracting work on the MX and Minuteman missiles. D'Argenio has been president of the Greater Hartford Arts Council. Mobil's creative director, Gordon Bowman, who was in charge of the poster series, has also switched to United Technologies and now supervises that company's arts grant program. Like Mobil, United Technologies regularly runs image and advocacy advertisements on the op-ed page of the *New York Times* and other newspapers. It also sponsors large art exhibitions in museums in the U.S. and abroad.

His Excellency the Foreign Minister of the Republic of Indonesia, Adam Malik; Mr. and Mrs. A. H. Massad and Mr. R. d'Argenio of Mobil Oil Corporation at the opening of the exhibition of Indonesian Art

Although a precise correlation between sales or concessions and the arts can never be proved, Esso seems convinced that the arts are an important means of ameliorating the conflict between political nationalism and international business.

The diplomatic benefits of sponsorship of the arts to a worldwide business concern have been demonstrated by Mobil Oil Corporation's international division, which operates in more than 100 countries representing divergent cultures, political systems, languages and religions. Mobil affiliates are encouraged to develop and support cultural projects appropriate to the countries in which they operate.

The reason is simple: their continued success in business depends on identifying themselves in a non-political way with the aspirations and sense of pride of the countries in which they operate. Mobil has found that support for cultural activities, which are often neglected or inadequately funded, helps to identify the company with the increasing national self-awareness in the less developed nations. Involvement in local arts projects also provides non-political access to the nation's political and cultural

> ". . . the arts are an important means of ameliorating the conflict between political nationalism and international business."

36

leaders.

Most of Mobil's recent activity has taken the form of art contests, special exhibitions, films and the publication of art books—all aimed at enriching the cultural pride of its host countries. Mobil discovered that this is an effective way of reaching the educated and cultural élite of a nation—a group often predisposed against foreign industry.

In 1968, Mobil held an art contest in Ghana which attracted over 500 entries. Some 30 of these were brought to the United States and shown in New York and Washington. A second Ghana contest was held last year. The best works from both were donated to the Ghana Arts Council, which is building a museum in Accra to house them—the first national art collection in that country. This project won a "Business in the Arts Award," sponsored annually by *Esquire* magazine and the Business Committee for the Arts. Another activity sponsored by Mobil is the publication of a leading Ghanian cultural magazine, *Image*.

In 1970, Mobil held special art contests and exhibitions in Indonesia, Portugal and the Philippines. The specific objective of the corporation in sponsoring the Indonesian exhibit was to strengthen ties with the country's leadership. Sixty-two of the works were selected and the initial showing of the collection—the first exhibition of Indonesia's contemporary art—was officially opened by Madame Suharto, wife of the nation's president. The foreign minister, Adam Malik, who had written a two-page foreword for the exhibit's catalog, was in attendance.

After display in Indonesia, the collection was flown to New York City for an exhibition. There followed a ten-day display of the collection in Washington, D.C. The U.S. Information Agency taped television shots of the Washington opening for use in a monthly program which it beams to Indonesia. The exhibit is now on a ten-week visit to three locations in the Netherlands (because of that country's links with Indonesia) and will go from there to the Art Museum in Beaumont, Texas, where Mobil has an important refinery.

Next September, 36 of the canvases are scheduled to embark on a two-year tour of major U.S. cities

Finally, let me give you a preview of one of the most ambitious projects we've ever undertaken -- Mobil's contribution to the American Bicentennial celebration. We are underwriting a major exhibition of post-war American posters, organized by the Smithsonian Institution in Washington, D. C. (58).

We also commissioned 13 major American artists, (59) to paint their visions of America. These 13 paintings have been reproduced in a limited, signed edition of prints that will be collectors items. (60) They will also be available to the general public as posters. After an American tour, the exhibition will travel to major museums in Europe. I urge you to see it, preferably in Paris.

LIGHTS UP

I think we've made some progress. We <u>have</u> established some credibility for ourselves in Washington; we <u>have</u> built up a constituency of people who recognize that we are <u>different</u>; we <u>have</u> established a leadership position in oil industry communications, and we <u>have</u> established a policy of speaking out on the issues.

Obviously, there is still a long way to go. Congress persists in thinking that battering the big oil companies is preferable to taking hard decisions on energy. But we're still optimists -- or else we wouldn't be in this business. We <u>do</u> think that the media understands our viewpoints better than it did. We also think that the

From Dillon, C. Douglas, "Cross-Cultural Communication Through the Arts", *Columbia Journal of World Business*, Vol. VI, No. 5, New York, Sept.-Oct. 1971

From D'Argenio, Raymond (Manager, Public Relations, Mobil Oil Corp.), "Farewell to the Low Profile", address to Eastern Annual Conference of American Association of Advertising Agencies, New York, November 18, 1975

The Good Will Umbrella

1976

Six panels, each 48 x 36″ (121.9 x 91.4 cm). Four-color silkscreen on acrylic plastic.

First exhibited in one-person exhibition at the Max Protetch Gallery, Washington, D.C., May 4-May 29, 1976.

Edition of 3. All owned by Hans Haacke.

During their Washington exhibition, *The Good Will Umbrella*, and *Mobilization* attracted the attention of lawyers working for the U.S. Senate committees dealing with energy legislation and of the Energy Action Committee, a private, Washington-based consumer advocacy group.

The late Senator Henry Jackson, Democrat from Washington who is referred to by the Mobil officer, was a contender for the U.S. presidency in 1976. He was a frequent critic of the oil industry. In 1973, the year of the first oil crisis, Mobil's profits rose by 46.8% over the previous year.

"Masterpiece Theatre" is a series of British theater productions filmed for television. Since 1971, Mobil has been sponsoring their presentation on the Public Broadcasting Service (PBS). Herb Schmertz, Mobil's vice-president for public affairs, explains the rationale for his company's sponsorship of cultural programs in his book *Good-bye to the Low Profile:*

First, cultural excellence generally suggests corporate excellence. Invariably, your support of first rate programs in the arts and culture will significantly enhance the image of the company . . . Second, these discretionary projects offer the opportunity to present your top management not as narrow-minded experts, but rather as corporate statesmen whose concerns go beyond the bottom line . . . and [who are] intellectually entitled to be listened to on vital public policy issues. Third, arts and cultural programs enhance the pride of your employees . . . whatever positive feelings they already have toward the company will be reinforced.

Fourth, your company's involvement in the arts provides an excellent opportunity for leadership in your community . . . it's no secret that those individuals and institutions who actively support civic activities usually find themselves in a position to play an influential role in the community's public affairs. Fifth, the sponsorship of cultural events allows you to entertain important customers at openings, special tours and similar events, where you have the opportunity to introduce important people to other important people. Business entertaining is a significant part of corporate life . . . Sixth, because government leaders often have specific cultural interests and favorite projects, your sponsorship of similar projects and causes provides the opportunity to form useful alliances and valuable contacts. Seventh, corporate sponsorship of the arts is good for recruiting . . . (From a chapter entitled, "Affinity-of-Purpose Marketing: The Case of Masterpiece Theatre.")

In addition, Schmertz points out: "Today, after fifteen years of artistic and cultural activity, we now find that when we give certain publics a reason to identify with the projects and causes that we have chosen to support, they will translate that identification into a preference for doing business with us . . . Affinity-of-purpose marketing is especially effective in promoting products (such as gasoline) . . . that seem, on the surface, to be identical to what the competition has to offer."

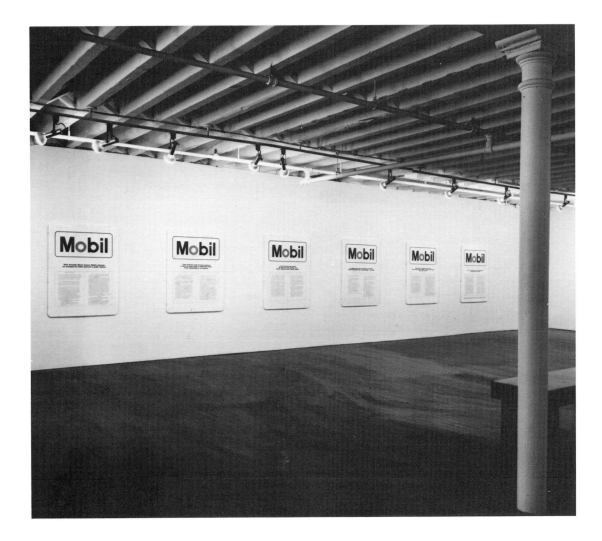

Mobil

When Rawleigh Warner became Mobil's chairman, we revamped our entire approach to public relations

FAREWELL TO THE LOW PROFILE

The American people have hated oil companies ever since the days of the Standard Oil Trust. Today, I'm pleased to report that this hate has been extended to all big business. Executives across the land are wringing their hands over the recent Harris poll reporting that trust in major U.S. companies is at an all time low.

But oil companies are certainly still tops on the publics hate list. Some of you may have read The Seven Sisters, Tony Sampson's new book which lumps us all together except for a few warts and other minor disfigurations that are distinguishing marks.

True, we are all in the same business -- oil -- but the family resemblance ends there. We think we don't look alike, or think alike, let alone act alike. We don't even like each other. But who believes this? Nobody -- except for a handful of truly enlightened individuals who, if you twist their arms in private, might admit that Mobil is a little bit different. And all of them seem to be employed by oil companies.

I say "Vive la difference" no matter how "petite" it is - because this is exactly what we set out to do six long years ago.

In 1969, when Rawleigh Warner became Mobil's chairman, we revamped our entire approach to public relations, and adopted a new program with two goals in mind:

1. to distinguish Mobil from other large corporations and from other oil companies, and

2. to build a reputation as an outspoken responsible company concerned about our energy future and major social issues.

- 2 -

Two modest but different tools were selected to implement these objectives: Masterpiece Theatre on public television, and Op-Ed ads in the New York Times.

We went sailing merrily along, when in October 1973 the Arab embargo was declared, followed by price increases, gasoline lines and big profits (which lasted for a year only). But the American consumer wrapped up the shortage and prices and profits in a neat package labeled "conspiracy," and we were in big trouble.

So we started to dig out from under, regroup, reform, and reorganize. As we saw it, we faced two related problems -- a monumental credibility gap, and a growing energy supply gap. To bridge the supply problem, we had to convince our critics that our recommendations for a national energy policy were sound.

What I want to show you now is our present program, which grew out of the "energy crisis" of 1973-74, and is still changing and developing as we try to get over the message -- that, in a real sense, the crisis is still with us and we as a nation will be in serious danger till we solve it.

I'm glad to be able to share our experience with you, although I hope you don't have to live through it yourselves.

(DIM LIGHTS)

(1) Mobil's public relations programs have bid farewell forever to the low profile. This can't be all bad, because in recent months we even received a few kudos.

(2) The Wall Street Journal seems to agree - and even Tony Sampson said Mobil is the "most extrovert," "the most aggressive" and "the most sophisticated" of the oil companies. This is probably because half of our PR executives are women!

Mobil

These programs build enough acceptance to allow us to get tough on substantive issues. Public broadcasting is the keytone

- 3 -

(3) Let me begin with our "goodwill umbrella," as I call it. These programs, we think, build enough acceptance to allow us to get tough on substantive issues.

Public broadcasting is the keystone. The best known of our PBS programs is (4) Masterpiece Theatre, with Alistair Cooke. We're proud of Masterpiece Theatre because it has helped rescue TV from the desert of mindless shows which still take up so much time on the airwaves. But it has also helped us achieve one of our major objectives -- to make Mobil stand out among oil companies as different. And, in doing this, we have created an audience of opinion leaders who may be more disposed to listen to our viewpoint on energy issues.

Some of our more popular shows have been (5) Elizabeth R, (6) Vienna 1905, and, of course, (7) Upstairs Downstairs.

This season we are offering (8) Shoulder to Shoulder, about women's battle for the right to vote in England at the turn of the century (9) The Way It Was, a nostalgic program of sports highlights soon to be in its second season, and (10) The Ascent of Man, Dr. Jacob Bronowski's personal survey of human achievement.

Also new this fall is Classic Theatre (11). PBS stations across the nation are now running a series of 13 famous plays, such as "Mrs. Warren's Profession" (12), "Candide, and Macbeth," among others, (13), all with excellent casts.

Mobil is PBS' largest single supporter. We have such high visibility -- now two evenings a week -- that we often get credit from people for programs underwritten by Exxon, Xerox and others.

- 4 -

We're also active in commercial television. By deliberate policy, we don't sponsor run-of-the-mill TV shows. Instead, we present our own high-caliber specials, and restrict our advertising to them. Spot advertising of ideas just didn't work for us, but "specials" give us the right framework for what we have to say.

You may have seen some of our programs, like (14) Ceremonies in Dark Old Men with the Negro Ensemble Company, (15) Queen of the Stardust Ballroom with Maureen Stapleton, and (16) Moon for the Misbegotten.

From the beginning, (17) we have actively promoted our television programs, especially with theatrical posters, many of which you have just seen. We also put together carefully-designed press kits (18), with photographs and releases. All shows get additional publicity through flyers (19), as well as heavy newspaper, magazine, and television advertising.

All this work was, and still is, done in-house, with great attention paid to graphics. These active campaigns not only promote the shows, but get across Mobil's concern for good programming on television.

There are dozens of other projects that help us build our "goodwill umbrella." Things like (20) "Summergarden" -- giving the New York Museum of Modern Art money to open its sculpture garden free on summer weekend evenings.

Mobil

**A city-wide jump-rope contest.
This gets even more publicity than
Senator Jackson and his "obscene profits."**

- 5 -

Another community program, (21) in New York is the Double Dutch Tournament, a city-wide jump-rope contest for girls aged 10 - 14, run by a local police precinct. This gets even more publicity than Senator Jackson and his "obscene profits".

We are sponsoring (22) "Twelve Days of Christmas" again this year, a series of free concerts at the Kennedy Center, Washington, D.C.

Mobil also underwrites National Town Meeting (23). This forum for discussion of major public issues, also at the Kennedy Center has attracted a lot of attention and several members of Congress have taken part in debates.

We have many other "goodwill" programs, but these will give you the basic idea. We think we're adding some gaiety and sparkle to American life. And we're also helping ourselves get a hearing with opinion-leaders for what we have to say.

National Town Meeting, for example,(24) not only provides a forum for debates, but dramatizes the fact that there are some ideas that can be debated but can't be discussed on TV -- which leads me to tell you something about Mobil's "access" problems.

When Mobil stopped advertising products in June 1973, we prepared a series of "idea" commercials on energy. We had these ready when the embargo hit in 1973. We wanted to get them on the air to combat the skimpy and inaccurate TV coverage that told millions of Americans what to think about the oil situation.

- 6 -

(25) Well, it didn't work. No way -- the networks turned us down cold, even when we offered to pay for equal time for rebuttal by our opponents! The TV networks told us that all editorial content must be under the control of their own news journalists.

Mobil has kept up this battle for access to the airwaves. We've even gained some converts -- government officials and even broadcasters who now believe that people with something important to say should be able to say it on TV. And we've made some strange allies -- like the Sierra Club which disagrees with us a lot but also felt that it was being denied the chance to get its message across.

(26) We also have a lot of the public with us. We ran this newspaper ad describing our problems in getting access to television for a relatively innocuous commercial on offshore drilling and asking readers what they thought about it. We got over 2,000 replies, mostly favoring our right to get our message across on the air.

Unable to broadcast idea ads, we turned to documentary commercials (27) that use real people on location talking about their jobs. We shot commercials in (28) Iran and Sumatra, and (29) Alaska and the North Sea. We also produce these in-house.

These commercials, each two or three minutes long, are (30) aired before or after network "specials" or during "intermissions."

Mobil

We aimed at the movers and shakers in many fields, including businessmen, city and state officials . . . the media

- 7 -

Obviously, since we can't put idea commercials on television, we have to rely to a great extent on newspaper and magazine ads to get our message across.

Mobil is best known for its Op-Ed ads (31), always a quarter page in The New York Times. At the height of the energy crisis, we ran these ads in as many as 100 newspapers. Right now, they are running in the six major U.S. metropolitan newspapers every week. (32)

From the outset, we have used Op-Ed space to discuss sensitive and controversial topics. The majority of the ads are on energy issues (33), such as the Alaska pipeline, the need to find more oil and gas, superports and supertankers, the risks of increased dependence on foreign sources of oil. We also use the space to discuss public issues (34), such as the need for mass transportation, or to publicize community projects and our own "goodwill" programs. We write 52 of these every year.

We know from the many letters we get that readers pay attention to what we say, even when they disagree with us. (35), And here's a booklet put out by The Wall Street Journal as an example to other companies of how they can advertise. We hope others will join us.

We think its ridiculous and dangerous that the U.S. still doesn't have a national energy policy -- two full years after the embargo began!

- 8 -

Last fall, we launched a major campaign on this subject (36) with a full page ad -- "An Energy Manifesto" -- in 50 news-papers. We followed up with two ads a week, side by side, addressed to specific topics -- natural gas regulation, offshore drilling, the outlook for alternate sources, the need for energy growth, and summarized our discussion with another full page ad in late December.

At the conclusion of the campaign, we reprinted the entire series as a oversize booklet (37), "Toward A National Energy Policy" and mailed it to everyone who had requested reprints. So far, we have over 10,000 requests for the booklets, many for large quantities, and hundreds of letters on the ads, about 80 percent favorable to our point of view.

Paralleling (38) these ads, we applied the same theme to a series of ads placed in national magazines. The copy is shorter, punchier, and accentuated with dramatic black-and-white graphics. The common angle for all of these ads is our call for action now on a National Energy Policy -- in what we hoped would be a Year of Energy Action. We then put them in booklet form (39) and we distributed 250,000 copies.

As well as popularizing the message that we need an energy policy, we have also elaborated on it in a series of booklets (41) which has just been completed. For this purpose, we aimed at the movers and shakers in many fields, including businessmen, city and state officials, environmentalists, labor leaders, professors of economics and political science, security analysts, and -- last but not least -- the media.

Mobil

We've got our top brass out on the road.
We put them through J. Walter Thompson's charm school before they went out

(41) We are now distributing copies in slip cases to members of Congress -- we're still optimistic enough to believe that we can get our message across to some people in Washington -- before the "Year of Energy Action" creaks to an unhappy close.

(42) We've also tried to alert the public and the Congress with full-page newspaper ads. (43) Here are our recommendations to Congress on the decontrol of oil prices -- another instance where Mobil does not see eye to eye with the rest of the oil industry.

While we've cut down on the number of newspapers in which we publish Op-Ed ads, we're now beginning a real push with our Observations Column (44). Observations is patterned on the signed newspaper column. It has a flexible format, basically six or seven items. It talks about energy. (45) It talks about people doing things for themselves, instead of letting big government run the show. It uses woodcuts and cartoons (46), As you can see (47), the overall look of the column is varied and interesting. We run them in 43 newspapers, usually on Sundays. The response has been encouraging.

I've now talked about our "goodwill umbrella" and our ways of getting our message across, mainly in print. Now I want to get back to television again, to show you some of the ways in which we have been able to use the medium.

Mainly, we've got our top brass out on the road, appearing on TV talk shows and debates. We put them through J. Walter Thompson's charm school before they went out, and they've learned their lessons well. Here's Rawleigh Warner (48) Mobil's chairman, in a debate on offshore drilling, and one of our vice presidents, Dayton Clewell (49), on the same topic. In all, we have half a dozen executives traveling around the country all the time.

And here's our secret weapon -- or not-so-secret any more -- Judi Hampton (50), our consumer affairs specialist. Judi tours the country several times a year, talking about energy conservation and major energy issues, including offshore drilling. Her last tour covered 20 cities: she appeared on 64 TV talk shows on news programs, and on 57 radio programs. Somewhere along the line, she also squeezed in 20 newspaper interviews!

Let me also tell you about editorial replies. (51) Sometimes, when local TV stations blasted the oil industry during the embargo period, they asked us if we wanted to reply. Now, we not only reply when asked, but we record TV editorials and send out replies when we think we can score points. They have had a high percentage of success; some have been aired as many as eight times in a day.

Speaking about radio -- which I haven't done up to now -- I should add that we have radio programs paralleling all our television work (52). Not only have we sponsored entertainment programs on radio -- including nostalgic shows -- and presented hard-hitting commercials, but we've also used it very creatively to get across our ideas on energy. We've introduced a monthly

Mobil

We also commissioned 13 major American artists to paint their visions of America

- 11 -

Consumer Radio series which mixes consumer tips with hard energy
information, and we also plan to adapt the Observations column
to radio -- complete with sound effects. Finally, we also have
a very effective method for sending out news dispatches to
radio stations across the country, thus making sure that radio
news directors have access to our side of the story.

While we've played around in the exciting world of television
and idea advertising, we haven't neglected the traditional PR
jobs -- responding to queries, putting out an Annual Report (53),
quarterly reports to shareholders, and an employee newspaper (54),
Mobil World.

We also produce more than our share of executive speeches,
position papers, and Congressional testimony. And we've added
some imaginative new publications to our regular list. I'll
just mention a few: (55), The Language of Oil, which turned out
to be a best-seller. Basically, it's just a glossary of oil
terms, simply defined. But it's proving useful to media people,
and to people in government, and we've had a lot of requests for
it. This is (56) is Mobil and Society, describing Mobil's concept
of its social responsibility, and (57), a simple, broadbrush review
of the energy supply outlook, distributed to over 100,000 people.

Finally, let me give you a preview of one of the most
ambitious projects we've ever undertaken -- Mobil's contribution
to the American bicentennial celebration. We are underwriting
a major exhibition of post-war American posters, organized by the
Smithsonian Institution in Washington, D. C. (58).

-12-

We also commissioned 13 major American artists, (59) to paint
their visions of America. These 13 paintings have been
reproduced in a limited, signed edition of prints that will
be collectors items. (60) They will also be available to the
general public as posters. After an American tour, the exhibition
will travel to major museums in Europe. I urge you to see it,
preferably in Paris.

LIGHTS UP

I think we've made some progress. We have established
some credibility for ourselves in Washington; we have built up
a constituency of people who recognize that we are different;
we have established a leadership position in oil industry
communications, and we have established a policy of speaking
out on the issues.

Obviously, there is still a long way to go. Congress persists
in thinking that battering the big oil companies is preferable to
taking hard decisions on energy. But we're still optimists --
or else we wouldn't be in this business. We do think that the media
understands our viewpoints better than it did. We also think that the
American people are ahead of their elected representatives on some
aspects of the energy situation, like the need to drill offshore to
find new oil reserves.

So we'll keep pushing ahead, trying new ways to get the
message across. We like what we do, we have fun, it's exciting,
and it's good to have a chance to tell people about it. Thanks
for having me.

###

Facsimile of *Advance Copy:* Raymond D'Argenio (Manager, Public Relations, Mobil Oil Corp.) "Farewell to The Low Profile", address to
the Eastern Annual Conference of the American Association of Advertising Agencies, Waldorf Astoria, New York, November 18, 1975

(The prognostic epistemology for ensuring security, demonstrated by the example of the interdiction of training for Christine Fischer-Defoy)

Die prognostische Erkenntnistheorie des Gewährbietens, dargestellt am Beispiel des Ausbildungsverbots der Christine Fischer-Defoy

1976

Nine panels, each 39½ x 27½". In museum mounts with sepia embossed titles, under glass in brown wooden frames.

First exhibited in one-person exhibition at the Frankfurter Kunstverein, September 10-October 24, 1976. Director Georg Bussmann.

Photographs of panels: Wera Mertens.

Owned by Hans Haacke.

Note: This work consists of nine panels; three panels, reproducing one full letter, are shown here as a representative excerpt.

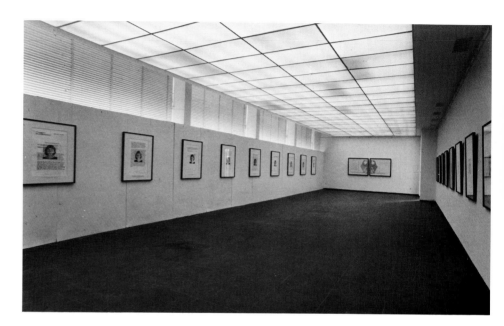

In 1972, the chancellor and the state governors of the Federal Republic of Germany issued a joint decree *(Radikalenerlass)* forbidding persons who "give room for doubt, that they would at all times stand up for the free, democratic order," to be admitted to the civil service. Since then gravediggers, locomotive engineers, postal clerks, teachers, and all other candidates for civil service are being screened by the *Verfassungsschutz*, the state and federal security services.

Politically supported by a right-wing backlash against the student rebellion of the sixties and the terrorism of the Baader/Meinhof group and their followers, this policy of the *Berufsverbot* [interdiction to practice one's profession] has been aimed in practice almost exclusively against persons of leftist persuasions.

No illegal acts on the part of the candidate need to be proven in a court of law in order to block him/her from civil service. The mere assumption by the authority, based on untested and often sketchy information from the security services, that they are *Verfassungsfeinde* (enemies of the constitution) suffices.

The degree of enforcement varies from state to state and often depends on the political climate of the day. It has generally had a chilling effect on all forms of dissent from official policy.

Der Regierungspräsident
in Kassel

11/1 b - PA Fischer-Defoy, Christine

(Im Auftrag des herr beim Geschäftszeichen angeben)

Der Regierungspräsident in Kassel | 3500 Kassel 1 | Postfach 103067

Frau
Christine Fischer-Defoy

35 **K a s s e l**
Berlepschstr. 2

Steinweg 6
Telefon: (0561) 106-1 (Vermittlung)

Durchwahl 106 _____

Mit Postzustellungsurkunde!

Betrifft: Einstellung in den _____ gsdienst des Landes Hessen

Sehr geehrte Frau F_____-Defoy!

Hiermit lehne ich ___ n Antrag vom 31. Jan___ 1975 auf Übernahme in den
Vorbereitungsdienst des Landes Hessen als _____rantsreferendarin im Be-
amtenverhältnis a__ Widerruf ab, da Sie nic__ die Voraussetzung des § 7
Abs. I Nr. 2 HBG _____en.

G r ü n d e :

Mit Schreiben vom 3___. 1975 beantr_____en Sie Ihre Einstellung als
Lehramtsreferendarin am 1. August 1975. Die Erste Staatsprüfung für das
Lehramt an Haupt- und Realschulen bestand__ Sie im Juni 1975 in den
Fächern Kunst_____g und Gesellschaft_____

Da erhebliche _____ für die freiheitlich-
demokratische Grundordnung im Sinne des Grundgesetzes und der Hessischen
Verfassung eintreten werden, ist Ihnen Gelegenheit gegeben worden, im
Rahmen eines persönlichen Gespräches mit Ihrem möglichen Dienstherrn die
Bedenken an Ihrer Verfassungstreue auszuräumen.
Bei dieser Anhörung in meinem Hause am 11. 7. 1975 haben Sie bestätigt,
daß Sie als Studentin Mitglied des MSB-Spartakus gewesen sind. Diese
Mitgliedschaft sei erloschen, als Sie Ihr Staatsexamen abgelegt haben.
Die weitere Frage, ob Sie Mitglied der DKP waren oder sind, haben Sie
nicht beantwortet. Sie hielten diese Frage für unzulässig, da Sie Ihre
Eignung für den öffentlichen Dienst durch die Ablegung eines Staats-
examens nachgewiesen hätten.

- 2 -

GLEITENDE ARBEITSZEIT ZU EMPFEHLEN SPRECHSTUNDE MO-FR VON 9.00-12.00 UND 14.00-15.30 UHR

Alle Deutschen haben das Recht, Beruf, Arbeitsplatz und Ausbildungsstätte frei zu wählen.
Die Berufsausübung kann durch Gesetz oder auf Grund eines Gesetzes geregelt werden.
Grundgesetz, Art. 12, Abs. 1

Translation:

Kassel, August 14, 1975
Steinweg 6 (Date)
Tel.: (0561)106-1 (switchboard)
Direct line: 106

Der Regierungspräsident in Kassel
(State appointed County Manager)

Il 1 b-PA Fischer-Defoy, Christine
(Please give this reference number in
your response)

Der Regierungspräsident in Kassel,
3500 Kassel 1, P.O. Box 103067
By certified mail

Miss Christine Fischer-Defoy
23 *Kassel*
Berlepschstr. 2

Re: Admission to Student Teacher
Program of the State of Hesse

Dear Miss Fischer-Defoy:

I herewith reject your application of
January 31, 1975, requesting admission
to the Student Teacher Program of the
State of Hesse with probationary civil
service status, because you do not
meet the requirements of §7, Section I,
no. 2 of the Civil Service Act of Hesse.

Reasons:

In a letter of January 1, 1975, you ap-
plied for admission to the Student
Teacher Program, starting August 1,
1975. You passed the First State Ex-
amination for teaching art and social
studies at grade and high school levels,
in June 1975.

Since there are considerable doubts as
to whether you would always stand up
for the free and democratic order
according to the Federal Constitution

and the State Constitution, you were
given the opportunity, in an interview
with your potential future employer, to
put these misgivings to rest.

At this hearing in my office, on July 11,
1975, you confirmed that during your
student years you had been a member
of the MSB-Spartakus. This member-
ship, you said, expired when you
passed your State Examination. The
next question, on whether you were or
are a member of the DKP, you did not
answer. You considered this question
inadmissible because, as you stated,
you had demonstrated your quali-
fications for the civil service by passing
the State Examination. *(cont.)*

Staggered business hours. Recommended
times for office visits: Mon-Fri from 9:00 a.m.
to 12:00 p.m. and 2:00 to 3:30 p.m.

On the mat:

All Germans have the right to freely
choose their profession, workplace,
and place of training. Professional
practice can be regulated by laws.

Federal Constitution, Paragraph 12,
Section 1.

Your statements during the hearing did not remove the existing and justified doubts about your loyalty to the Constitution. It is true, your testimony cannot be refuted that you left the MSB-Spartakus after passing your state examination and that you are consequently no longer a member of this student association, an association which, as an affiliate organization of the DKP, is pursuing aims hostile to the Constitution. However, you are mistaken in your opinion that you are not obliged to answer questions regarding party membership. According to the highest courts, recently confirmed by the *Bundesverfassungsgericht* (Federal Constitutional Court = Supreme Court), the qualification for civil service includes the obligation of the civil servant, at all times through his entire conduct, to adhere to the free and democratic order, as expressed by the Constitution. In order to ascertain this, the employment office had to ask you this question. In principal, of course, the public employer is not entitled to ask an applicant for or a member of the civil service about his membership in a certain party. However, this is only valid if the party in question is based on the Constitution. If membership in a party with totalitarian aims is suspected, the public employer is obliged to ask this question in order to protect the state. A member of the civil service must answer this question. Should the applicant refuse to answer

the question, he demonstrates, already by this refusal, even before he is employed, that he is unfit, in the sense in which employment in the civil service is viewed by the Constitution.

Aside from the factual justification for answering the questions about membership in an organization or party with totalitarian aims, the obligation to answer arises from the intention to be accepted into the ranks of the civil service. A civil servant has a mutual relationship of service and loyalty with his public employer. This requires the civil servant to cooperate with his public employer and non-compliance could, in certain cases, constitute a dereliction of his duties. It is true, this duty to cooperate is principally restricted to the position of a civil servant proper. However, just as in the preparations toward a contractual relationship, mutual duties and obligations exist already in the preparatory stage for a civil service position. *(cont.)*

On the mat:

Every German has equal access to every public position according to his fitness, qualification, and professional performance. Civil and constitutional rights, the admission to public office, as well as the rights acquired in the public service are independent of his religious denomination. It is not permitted that a disadvantage accrue to anybody on the basis of his adherence to a religious denomination or an ideology.

Federal Constitution, Paragraph 33, Sections 2 and 3.

In the case of non-compliance with such duties and obligations by the future civil servant, it is justified, in the particular case, for his future public employer to conclude that serious doubts exist about the fitness of the applicant. This is the case with you because, based on your attitude and your past activities in the MSB-Spartakus, you have not removed the existing doubts concerning your loyalty to the Constitution.

Information on legal recourse:

Within one month of delivery, you can file, in writing or in person, a protest against this decision with my agency, Kassel, Steinweg 6.

Sincerely yours,
Signed for

On the mat:

Under no circumstances is it permitted to violate a basic right in its essence.

Federal Constitution, Paragraph 19, Section 2.

Diptychon: Wer Beamter werden will, Krümmt sich beizeiten

The title of the work is derived from a well-known German proverb, "Wer ein Häkchen werden will, krümmt sich beizeiten" ("If you want to become a hook, you must bend in time"). The eagle is the official seal of the Federal Republic of Germany (FRG). The *Bundesverfassungsschutzamt* in Cologne is a federal agency under the control of the minister of the interior in Bonn (each state has its own agency as well). Its tasks include political surveillance and counterintelligence in the territory of the FRG.

In 1976, at the time of the exhibition of the work in Frankfurt, political surveillance and the *Berufsverbot* [interdiction to practice one's profession] were rampant. This coincided with the federal election campaign for the Bundestag (West German Parliament), in which the conservative CDU/CSU campaigned under the slogan "Freedom instead of socialism."

According to the press, the acquisition of the work by the Städtisches Kunstmuseum Bonn, in 1983, was controversial. The Bonn City Council held several meetings to discuss the proposed purchase.

The letters produced in the work come from the same school district in which Haacke had attended school.

496724 Bewerber für den öffentlichen Dienst sind vom Verfassungsschutz in der Zeit von August 1972 bis März 1976 überprüft worden.

Translation:

Bonn Citizens Committee against the *Berufsverbot*
c/o Heide-Rose Goergen,
Dechenstr. 10, 53 Bonn

To the Student Governments of the Bonn Schools, Bonn, March 29, 1976

Will you be that new generation which Heinrich Böll anticipates in his letter to the editor of the *Frankfurter Allgemeine* of February 16, 1976? He writes: ". . . thus one can only congratulate the FRG [Federal Republic of Germany] for a new generation of hypocrites, of fawning, intimidated individuals, opportunists, and cowards, who will no doubt be better behaved than the Hitler Youth, particularly since they can be intimidated still further through unemployment and restricted entry to higher education."

Many of you want to continue your education after high school and under certain circumstances enter the civil service. That means that you have to submit to all "screenings." The *Verfassungs-"Schutz"* [Agency for the "Protection" of the Constitution] monitors your activities (change of residence, attendance at political functions, signatures on solidarity appeals, party memberships, participation in public discussions, travel in Eastern countries, etc.) and uses the information as "evidence acceptable in court." 850,000 "screenings" have already been carried out. 2,000 of them led to proceedings for the issuance of a *Berufsverbot* [interdiction to practice one's profession] or actually resulted in the *Berufsverbot*. However, the activities mentioned are expressly protected by our constitution and the UN Charter as basic rights.

A number of Bonn teachers have been affected by the *Berufsverbot* during the past four years, a fact apparently not generally known to Bonn students (see documentation attached).

We do not want to become again a country of spineless subjects whose "civic consciousness" is just sufficient to never attract attention, serve any master, and always represent the opinions of those who just happen to be in power.

Therefore we are standing up for the defense of our basic rights and to fight the unconstitutional practice of the *Berufsverbot* which has brought the Federal Republic of Germany internationally into disrepute.

We call upon you to inform yourselves and perhaps join the Bonn Citizens Committee against the *Berufsverbot*.

We request that you post this letter and the documentation. The use of our stickers would be gratefully acknowledged as a contribution in the struggle for our basic rights. Stickers can be ordered for a small and voluntary contribution to cover our costs.

The next meeting of the Citizens Committee will take place on

Tuesday, April 15, 1976, 8 p.m. at the Protestant Student Congregation Bonn, Königstr. 88

(The Committee meets regularly every second and last Tuesday of the month in the above-mentioned place.)

Sincerely yours,
Signed Heide-Rose Goergen

Student Government of the Bonn District
General and Vocational Schools
Postal Address:
SMV-Bonn, 53 Bonn-Duisdorf,
Am Burgweiher 71

Mrs. Heide-Rose Goergen
Dechenstr. 10
5300 Bonn

Representative: Herr Trenner
Room 11
Direct dial: (02221) 62 20 11, Ext. 96

Date and your reference:
My reference: 11-11
Date April 30, 1976

March 29, 1976

Re: *Berufsverbot* [Interdiction to practice one's profession]

Dear Mrs. Goergen:

In answer to your above-mentioned letter addressed to the Student Governments, which arrived after the Easter holidays, I would like to inform you that in the interest of all Bonn students we would have preferred your having discussed the letter with us before sending it off.

Meanwhile, in a memorandum addressed to all Bonn Student Representatives we have cautioned against signing the enclosed letters to various supervisory school authorities. We note that your appeal, while serving your own interests, has jeopardized the good standing in school of those students to whom you wrote.

We certainly accept that your association concerns itself with the conditions you are referring to and makes efforts to help the students affected by the measures of the state. However, it is not the job of the Student Governments to support you. On the contrary, any Student Representative who, in his capacity as a member of an institution of public law, expresses an opinion on this problem would exceed the limits of his office, which are established through an ordinance of the Minister of Culture.

Are you aware of the fact, that any signatory would potentially endanger his professional future? Going beyond the limits of his authority could later be held against him, when he goes for a job interview with a school board. Moreover, by signing he could already be in danger of exclusion from continued enrollment in school.

I must assume that, based on your experience with this problematic area, you were aware of the risks of your undertaking. I therefore must take issue with your approach. Furthermore, I shall inform the Minister of Culture of this matter.

On behalf of the Bonn Student Governments
Sincerely yours,
Wolf-Dietrich Trenner
Treasurer

Translation:

496,724 applicants for the civil service have been screened by the *Verfassungsschutz* (Agency for the Protection of the Constitution) between August 1972 and March 1976.

Source: Ministries of the Interior of the states [of the Federal Republic of Germany]

Bonner Bürgerinitiative gegen Berufsverbote
c/o Haide-Rose Goergen, Dechenstr. 10, 53 Bonn

An die
SMVs der Bonner Schulen

Bonn, den 29. 3. 1976

Werden Sie die neue Generation sein, die Heinrich Böll in
einem Leserbrief an die "Frankfurter Allgemeine" von 16. 2.
76 erwartet? Er schreibt: "...so kann man die BRD nur be-
glückwünschen zu einer neuen Generation von Heuchlern, Krie-
chern, Eingeschüchterten, Opportunisten und Angsthasen, die
möglicherweise braver sein werden als die Hitlerjugend, zumal man
sie durch Arbeitslosigkeit, Numerus Clausus noch mehr ver-
ängstigen kann."

Viele von Ihnen wollen sich nach dem Schulbesuch weiterbil-
den und unter Umständen in den öffentlichen Dienst eintreten.
Das bedeutet, daß Sie sich alle "Überprüfungen gefallen las-
sen müssen. Der Verfassungs-"Schutz" wird Ihre Aktivitäten
(Wohnsitzwechsel, Anwesenheit bei politischen Veranstaltungen,
Unterschriften unter Solidaritätsaufrufe, Mitgliedschaft in
Parteien, Diskussionsbeiträge, Reisen in östliche Länder etc)
erfassen und als "gerichtsverwertbare Tatsachen" verwenden.
850000 "Überprüfungen" haben schon stattgefunden; 2000 von
ihnen führten dazu, daß ein Berufsverbot vorbereitet oder
ausgesprochen wurde. Die genannten Aktivitäten jedoch sind
ausdrücklich durch unsere Verfassung und die UNO-Charta als
Grundrechte geschützt.

Eine Reihe Bonner Lehrer ist in den letzten vier Jahren von
Berufsverbot betroffen worden, was den Bonner Schülern nicht
allgemein bekannt sein dürfte (s. beiliegende Dokumentation).

Wir wollen nicht, daß wir wieder ein Staat von rückgratlo-
sen Untertanen werden, deren "staatsbürgerliches Bewußtsein"
lediglich dazu ausreicht, nirgendwo aufzufallen, jedem
Herren zu dienen, jeweils die Auffassung der gerade Herr-
schenden zu vertreten.

Bitte wenden!

Deshalb treten wir für die Verteidigung der Grundrechte
einund bekämpfen aktiv die verfassungswidrige Praxis der
Berufsverbote, die die BRD international in Verruf ge-
bracht hat.

Wir fordern Sie auf, sich zu informieren und eventuell
mitzumachen bei der Bonner Bürgerinitiative gegen Berufs-
verbote.

Wir bitten Sie um Aushang dieses Briefes und der Doku-
mentation. Das Anbringen unserer Aufkleber wäre ein dan-
kenswerter Beitrag im Kampf für unsere Grundrechte.
Weitere Aufkleber können gegen einen kleinen, freiwilligen
Unkostenbeitrag angefordert werden.

Das nächste Treffen der Bürgerinitiative findet statt am
Dienstag, den 13. April 76, 20 Uhr
in der Ev. Stud.-Gemeinde, Bonn, Königstr. 88
(Die Initiative trifft sich regelmäßig jeden zweiten und
letzten Dienstag im Monat in den oben genannten Räumen)

Mit freundlichen Grüßen
gez. Haide-Rose Goergen

496 724 Bewerber für den öffentlichen Dienst sind vom Verfassungsschutz

in der Zeit von August 1972 bis März 1976 überprüft worden. Quelle: Innenminister der Bundesländer.

Aus Liebe zu Deutschland

1976

Red Curtain, emblem with heads of West German politicians, quote in white cardboard letters, tape loop with music from the *Ring der Nibelungen* by Richard Wagner, 126 x 264" (320 x 670 cm).

First exhibited in one-person exhibition at the Frankfurter Kunstverein, September 10-October 24, 1976. (The exhibition took place during the final weeks of the German federal election campaign.)

Owned by Hans Haacke.

Translation:

But all those dull questions of the internal policies of the state, i.e., planning of an infra-structure, regional planning, etc., for which one needs a lot of experience, all that is not going to decide tomorrow's election results. However, playing on people's emotions, specifically fear, anxiety, and the view of a dark future, both internally as well in foreign affairs, will do it.

Franz Josef Strauss

The slogan "Out of Love for Germany" was used by the conservative Christian Democratic Union (CDU) and her sister party, the Bavarian Christian Social Union (CSU) during the 1976 election campaign. It was complemented by their slogan "Freedom instead of socialism." The statement by Franz Josef Strauss, the CSU chairman, is quoted from his notorious *Sonthofen Address*, a speech he gave during a secret election campaign strategy meeting in Sonthofen, Bavaria.

The three profiles represent the rightwing exponents of the CDU/CSU: Franz Josef Strauss, Alfred Dregger (party chairman of Hesse), and Hans Filbinger (former party chairman and governor of Baden-Württemberg). Under intense public pressure, Filbinger resigned as governor in the summer of 1978. It became known that in his role as a Navy judge during World War II he had wholeheartedly supported the Nazi ideology. Even during the final days of the war, Filbinger sentenced several German soldiers to death for minor infractions.

ABER DIE VIELEN NÜCHTERNEN FRAGEN
DER LANDESPOLITIK, ALSO DER STRUKTURPOLITIK,
DER REGIONALPOLITIK USW.,
WO MAN VIEL SACHKUNDE BRAUCHT,
ALL DAS MACHT NICHT DIE WAHLERGEBNISSE
VON MORGEN AUS,
SONDERN DIE EMOTIONALISIERUNG DER BEVÖLKERUNG
UND ZWAR DIE FURCHT, DIE ANGST
UND DAS DÜSTERE ZUKUNFTSBILD
SOWOHL INNENPOLITISCHER WIE AUSSENPOLITISCHER ART

FRANZ JOSEF STRAUSS

The Chase Advantage

1976

Silkscreen on acrylic plastic, 48 x 48"
(121.9 x 121.9 cm).

First exhibited in one-person exhibition
at the John Weber Gallery, New York,
January 19-February 5, 1977.

Edition of 6. One in the collection of
Victor Burgin, London; others owned
by Hans Haacke.

The striped hexagonal frame is the logo of the Chase Manhattan Bank, the third largest bank of the United States, with headquarters in New York. In the late 1970s, the bank addressed the public in advertisements with the slogan "Give Yourself The Chase Advantage." At that time, David Rockefeller held 4% of the shares of the bank, and several other members of the Rockefeller family were also major individual shareholders.

In addition to the Rockefellers, Ivy L. Lee, the public relations consultant, counted among his clients Walter Chrysler, George Westinghouse, and Henry Guggenheim, and such corporations as Standard Oil, Bethlehem Steel, Pennsylvania Railroad, and I. G. Farben.

The "Ludlow Massacre" was the armed assault on the camp of striking coal miners of the Colorado Iron and Fuel Company in an attempt to break their long and bitter strike for union organization, 1913-14. More than forty died, including women and children. John D. Rockefeller was majority owner of the company.

The bank has been collecting art works for display in its offices and public areas for over twenty-five years, and has sponsored numerous museum exhibitions. Since 1985, Chase Manhattan's Soho branch, virtually next door to the New Museum of Contemporary Art, has maintained the appearance of an art gallery; this has led to a notable increase in the number of accounts it handles.

Chase is also a major financial supporter of the right-wing Manhattan Institute for Policy Research, located not far from its Soho branch in a loft building at 131 Spring Street. The Institute was founded in 1978 by William J. Casey, who in 1981 became the director of the CIA.

David Rockefeller retired from the chairmanship of the Chase Manhattan Bank in 1981. He is a vice-chairman of the Museum of Modern Art in New York.

The Chase Advantage, 1976, overall view

The Chase Advantage

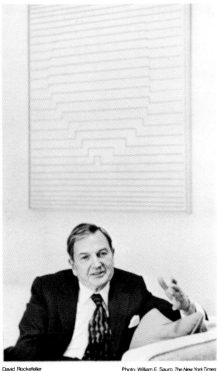

David Rockefeller

Photo: William E. Sauro, *The New York Times*

Even accountants put a money value on such intangibles as good will, and it is the conviction of Chase Manhattan's management that in terms of good will, in terms of staff morale and in terms of our corporate commitment to excellence in all fields, including the cultural, the art program has been a profitable investment.

David Rockefeller (Chairman of Chase Manhattan Bank, Vice Chairman of Museum of Modern Art) in *Art at the Chase Manhattan Bank*

The fundamental purpose, therefore, which must underlie any policy of publicity must be to induce the people to believe in the sincerity and honesty of purpose of the management of the company which is asking for their confidence.

Ivy L. Lee (public relations consultant, hired by John D. Rockefeller Jr., after «Ludlow Massacre», 1914.) in *Publicity: Some of the Things It is and is not*, New York, 1926

CHASE

The Road to Profits is Paved with Culture

1976

Three-color silkscreen on acrylic plastic, 52½ x 48" (133.3 x 121.9 cm).

First exhibited in one-person exhibition at the John Weber Gallery, New York, January 19-February 5, 1977.

Edition of 6. One in the collection of Sergio Bertola, Genoa; others owned by Hans Haacke.

In response to the Allied Chemical Corporation's establishment of an environmental foundation in Virginia, with an $8 million endowment, Judge Robert R. Murtagh, Jr. agreed in February 1977 to reduce the fine imposed on the company to $5.25 million.

Allied Chemical is estimated to have gained a tax advantage of about $4 million by giving to a foundation rather than paying the original full fine.

The company has changed its name twice since 1976. It is presently known as Allied-Signal. Ten years after the kepone dumping, the poison is still embedded in the James River and a ban exists on fishing for croaks and rockfish. Funds from the fine, used in an attempted cleanup of the river, are exhausted.

The Road to Culture Is Paved with Profits

Lincoln Center for the Performing Arts, New York

When you visit a museum or library, enjoy a touring art exhibition and public service TV program, applaud a symphony orchestra and dance group, or admire the talents of a gifted performer at a concert, chances are that contributions from business helped make it possible.

Hundreds of companies—from big ones such as IBM, Exxon, Corning Glass, Alcoa, Texaco, to many smaller ones—have made such contributions an integral part of their corporate philosophy. And each year, the business community is picking up a greater share of this aid. In fact, despite the economic downturn, business contributed $150 million in 1975, more than in any previous year. The Business Committee for the Arts estimates that companies have given over $600 million to cultural activities during the past five years.

Why do so many contribute? Because, like our corporation, they recognize the need to preserve and enhance our nation's cultural assets. Cultural endeavors provide opportunities for people to express themselves. And corporations are made up of people . . . people seeking better communities in which to live, work, raise their children. When we at Allied Chemical provide leadership for the local

arts council or help a theatrical group or contribute to libraries and museums, the life of the entire community is enriched.

But companies can spend money only in relation to their earnings. When profits are up, more funds for contributions can be set aside. When profits are down, less money is available. Yet, during a period when profits are more important than ever to our nation's future, they are far from adequate.

A recent survey showed Americans think the average manufacturing corporation makes more than 30 cents profit on every sales dollar. The truth is that in 1975 it was less than 5 cents.

The artist in America always has traveled a rocky road. It's going to take more profits, not just good intentions, to take some of the bumps out of that trip.

Allied Chemical

Where Profits Are For People

If you'd like to learn more about Allied Chemical and how we're putting profits to work, please write to P.O. Box 2245R, Morristown, New Jersey 07960.

© 1976 Allied Chemical Corporation

0.08 % of Profits for Culture

In 1975 Allied Chemical had profits of $116.2 million.

It paid dividends to its 71,208 stockholders totalling $50.2 million.

The Allied Chemical Foundation, the Company's major channel for contributions, gave to cultural activities a total of $92,750 = 0.08% of profits.

The combined contributions from the Foundation and the Allied Chemical Corporation to community and charitable organizations, hospitals, United Funds, cultural and service agencies amounted to $629,986 = 0.54% of profits.

20% of Allied Chemical's donations to its Foundation are tax deductible.

In 1976 Allied Chemical pleaded "no contest" to 940 criminal charges of having knowingly dumped Kepone laden process water and other chemical discharges into the James River at Hopewell, Virginia.

Kepone is a highly toxic insecticide used in the control of roach and banana pest infestations. It causes cancer in laboratory animals and is non-biodegradable. The poison was carried by the James River into Chesapeake Bay and the State of Virginia closed the river for fishing.

About 80 workers of the Hopewell plant suffered neurological and other disturbances. 28 of them were hospitalized for the treatment of uncontrollable trembling, loss of memory and sterility.

On October 5, 1976 Judge Robert R. Merhige Jr. of the Federal District Court in Richmond, Virginia, imposed on Allied Chemical the maximum fine of $13.3 million.

Also in 1976 Allied Chemical embarked on a $360,000 advertising campaign, designed by the New York agency Lubliner/Saltz.

9 ads with the theme "Profits Are For People" have been placed in Newsweek, The New York Times, The Wall Street Journal, The Washington Post, The Houston Post, The Houston Chronicle, and numerous business, labor and college publications. They also appeared on plant bulletin boards and in plant newspapers.

The costs of the campaign are tax deductible.

©1976 Hans Haacke

Facsimile of advertisement from Allied Chemical

Allied Chemical

Tiffany Cares

1977-1978

Brass pedestal, wood, velvet, silver-plated copper plate with etched text, satin with gold stamping, 33¾ x 22 x 22″ (83.2 x 55.9 x 55.9 cm).

First exhibited in one-person exhibition at the Baxter Art Gallery, California Institute of Technology, Pasadena, May 25-July 2, 1978. Director Michael H. Smith.

Photograph: John Ferrari.

Collection of Gilbert and Lila Silverman.

Tiffany & Co., the prominent New York purveyor of fine jewelry, silver, and other luxury items, located on the corner of Fifth Avenue and 57th Street, traditionally advertises its wares several times a week on the third page of the *New York Times*. In the 1970s, this space was also occasionally used for editorial ads, which were written by Walter Hoving, the chairman of the company, until his retirement in 1981. Titles of other such advertisements were: "Is Inflation the Real Problem?," "Full Employment," "Is Profit a Dirty Word?," "The Nitty-Gritty about Socialism," "The Truth about Capitalism," "Who Owns the Free Enterprise System?," and "Is There an American Goal?" Mr. Hoving, a born-again Christian, also promoted Tiffany silver pendants with the inscription TRY GOD. When Tiffany was sold to Avon Products for $104 million in 1979, he owned 17% of the company's shares. Avon, in turn, sold Tiffany in 1984 to a group of the store's managers and Investcorp, a consortium based in Bahrain, for $135.5 million.

ARE THE RICH A MENACE?

Some people think they are, so let's look at the record.
 Suppose you inherit, win or otherwise acquire a million dollars net after taxes. That would make you rich, wouldn't it? Now, what's the first thing you'd do? Invest it, wouldn't you?— in stocks, bonds or in a savings bank.
 So, what does that mean? It means that you have furnished the capital required to put about 30 people to work.
 How is that? National statistics show that for every person graduating from school or college, at least thirty thousand dollars of capital must be found for bricks, fixtures, machinery, inventory, etc. to put each one to work.
 Now, on your million dollar investments you will receive an income of sixty thousand, eighty thousand, or more dollars a year. This you will spend for food, clothing, shelter, taxes, education, entertainment and other expenses. And this will help support people like policemen, firemen, store clerks, factory workers, doctors, teachers, and others. Even congressmen.
 So, in other words, Mr. Rich Man, you would be supporting (wholly or partially) perhaps more than 100 people.
 Now, how about that? Are you a menace? No, you are not.

TIFFANY & CO.
FIFTH AVENUE & 57TH STREET
NEW YORK

Advertisement in The New York Times. June 6, 1977

The 9,240,000 Unemployed in The United States of America Demand The Immediate Creation of More Millionaires

Texts from this work were also used in an etching (reproduced above), also entitled *Tiffany Cares*, 1978. Black-and-white photoetching, 29 × 41″ (73.5 × 104 cm), edition of 35 (10 artists proofs), printed by Stephen Thomas at Crown Point Press, Oakland.

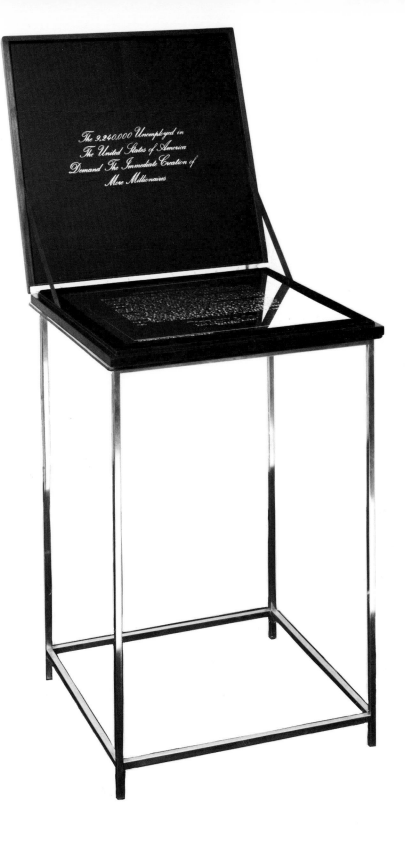

A Breed Apart

1978

Photographs on masonite (three with Jaguar images in color). Seven panels, each 36 x 36" (91 x 91 cm). Framed under glass.

First exhibited in one-person exhibition at the Museum of Modern Art, Oxford, November 18-December 24, 1978.

Owned by Hans Haacke.

British Leyland, the largest British automobile manufacturer, has changed its name twice since 1978, first to BL and then in 1986 to the Rover Group. The company continues with a major production center in Cowley, on the outskirts of Oxford. Next to the university, it is the main employer in the city. The Rover Group, like British Leyland and BL, is owned by the government of the United Kingdom. Its Jaguar division was sold in 1983.

Late in 1978, Leyland South Africa merged with the Sigma Motor Corporation, a subsidiary of Harry Oppenheim's mining and financial conglomerate, the Anglo-American Corporation of South Africa. Anglo-American is the largest South African holding company with extensive interests outside South Africa.

Sigma-Leyland, the new company, is owned 51% by Sigma and 49% by Leyland (1978). Sigma is to manufacture all passenger cars while Leyland concentrates on commercial vehicles, buses, trucks, tractors, construction, mining, earth-moving equipment, and the Land-Rover.

In July 1978, the *Economist* interpreted the deal under the heading "Political Facade," saying,

. . . if it [Leyland] wanted to appear to leave, but without risk of losing an investment worth about $50 million, and at the same time keeping South Africa as an increasingly valuable customer for its motor products, the deal could not have been better.

And the *Financial Times* of July 20, 1978, wrote:

. . . the deal's significance for BL is that it has divested itself of its loss-making car activities, while retaining a 49 per cent stake in its profitable commercial vehicle and Land-Rover manufacturing business.

The British Anti-Apartheid Movement and the Museum of Modern Art, Oxford, sponsored the production and distribution of a poster made from the first panel of *A Breed Apart*. It was printed by Nuffield Press Ltd., a Leyland subsidiary in Oxford.

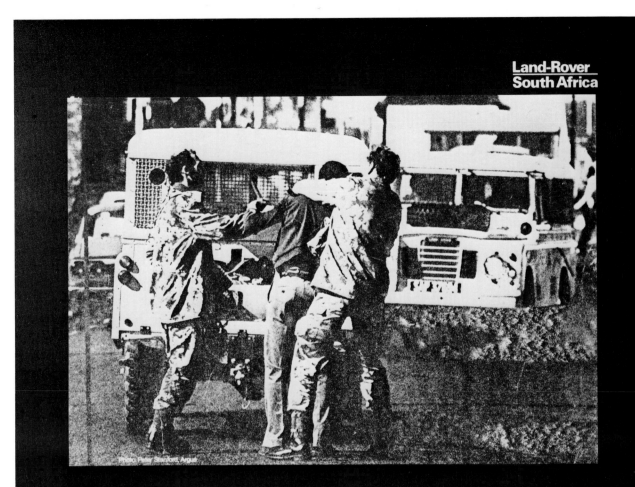

Photo: Peter Stanford, Argus

Land-Rover
South Africa

No British Leyland military display could be complete without the world-famous Land-Rover. In 28 years of production the Land-Rover has become one of the United Kingdom's greatest export winners, opening up areas of the world previously inaccessible to ordinary vehicles and playing a major role in the development of many overseas territories.

British Leyland. Press Release. Aldershot 1976

Leyland Vehicles. Nothing can stop us now.

Leyland advertising slogan

Jaguar
a breed apart

An employee may have an incentive to remain with his employer, no matter how he is treated, in order to qualify for urban residence; and it has been argued that contract workers' rights to work in urban areas are so tenuous that, regardless of how uncongenial their employment or how poor their pay, they are forced to stay in their job for fear of being endorsed out of their area and back to the homelands.

UK Parliamentary Select Committee on African Wages, 1973

Leyland Vehicles. Nothing can stop us now.

Leyland advertising slogan

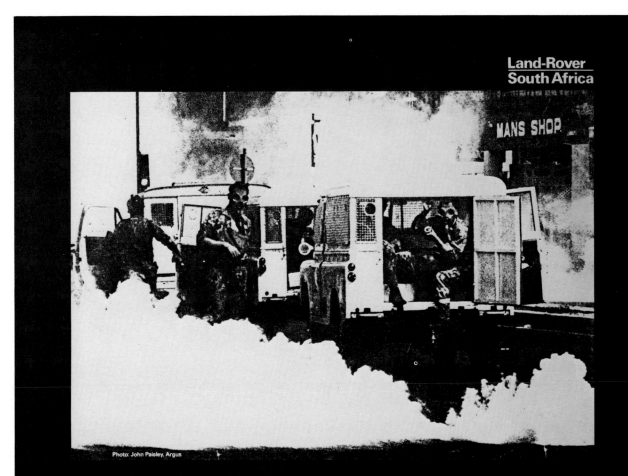

Land-Rover
South Africa

MANS SHOP

Photo: John Paisley, Argus

The Security Council decides that all States shall cease forthwith any provision to South Africa of arms and related matériel of all types, including the sale or transfer of weapons and ammunition, military vehicles and equipment, paramilitary police equipment, and spare parts of the aforementioned, and shall cease as well the provision of all types of equipment and supplies, and grants of licensing arrangements, for the manufacture or maintenance of the aforementioned.

United Nations Security Council Resolution 418, 1977

Leyland Vehicles. Nothing can stop us now.

Leyland advertising slogan

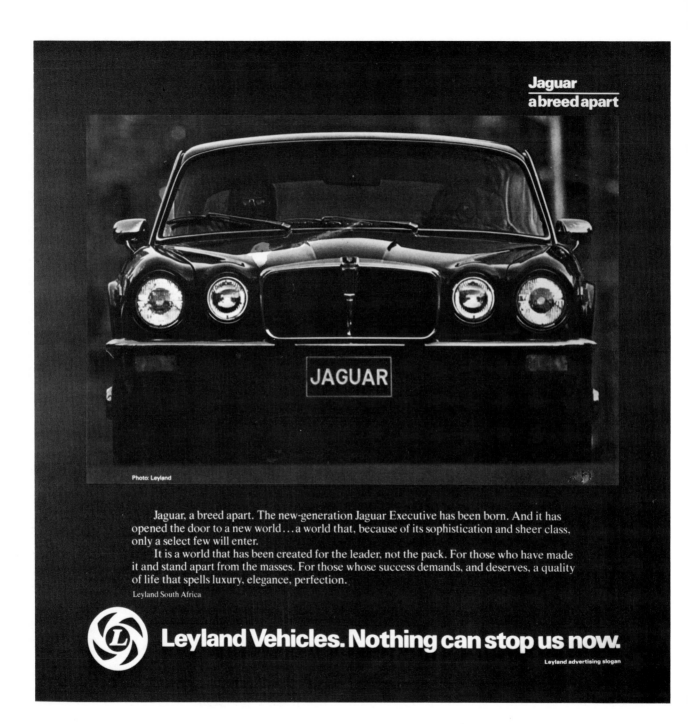

Jaguar
a breed apart

Photo: Leyland

JAGUAR

Jaguar, a breed apart. The new-generation Jaguar Executive has been born. And it has opened the door to a new world...a world that, because of its sophistication and sheer class, only a select few will enter.

It is a world that has been created for the leader, not the pack. For those who have made it and stand apart from the masses. For those whose success demands, and deserves, a quality of life that spells luxury, elegance, perfection.

Leyland South Africa

Leyland Vehicles. Nothing can stop us now.

Leyland advertising slogan

Land-Rover
South Africa

No other vehicle ever produced can claim the international admiration and fame that surround the Land-Rover; overseas military authorities, in particular, continue to rely on this famous cross-country vehicle despite ever-increasing competition from motor manufacturers worldwide.

British Leyland, Press Release, Aldershot 1976

Leyland Vehicles. Nothing can stop us now.

Leyland advertising slogan

Jaguar
a breed apart

Photo: Leyland South Africa

It is only with great reluctance that we have concluded that Leyland South Africa cannot at this point in time reasonably recognize an African trade union for bargaining purposes— outside of a more general move towards recognition by progressive South African employers— without setting our business and employment at risk.

J. P. Lowry, Director of Personnel. British Leyland. 1976

Leyland Vehicles. Nothing can stop us now.

Leyland advertising slogan

De oneindige dankbaarheid

1978

Beige wool carpet with spray paint in midnight blue and cobalt, 127 x 144" (322 x 366 cm). Translation from Persian into Dutch in black frame under glass, 15½ x 80" (39 x 203 cm).

First exhibited in one-person exhibition at the Stedelijk Van Abbemuseum, Eindhoven, January 19-February 18, 1979. Director Rudi Fuchs. (The exhibition opened one week after the Shah's forced departure from Iran.)

Photograph: Hans Biezen.

Owned by Hans Haacke.

Translation:

Philips of Iran expresses its everlasting gratitude to His Imperial Majesty, the Shah of Iran, who secured national unity by founding the Iranian Resurgence Party.

Advertisement in the Iranian newspaper *Kayhan,* March 5, 1975

With $17,834,690,000 in sales (1984), Philips ranks eleventh among non-American multinational corporations. It has approximately 337,000 employees worldwide (1985).

Philips' corporate headquarters are located in Eindhoven, The Netherlands. In spite of a decline in the number of employees from 99,000 (1971) to 68,300 (1985), the company remains the largest private employer in the Netherlands. (During the same period the number of Philips employees in low-wage countries rose significantly.)

The company is active in the fields of lighting, home electronics, domestic appliances, medical systems, telecommunications and data processing systems, the production of cable, and defense related electronics. It is known in the U.S. primarily through its Norelco and Magnavox brand name products, although the U.S. facilities of Philips are involved in the full range of its industrial activities.

In Iran, Philips maintains production facilities and a sales organization. During the Shah's regime, which was charged with gross violations of human rights, the Iranian military received, among other matériel, 210 Tiger and Phantom fighter planes, 16 Super Frélon helicopters, and 1,500 Chieftain heavy tanks, all equipped with radio-altimeters, UHF radios, and/or night vision equipment from Philips. When the Shah left the country in January 1979, twelve vessels of the *Kaman* class, with guided missile firepower, were under construction for the Iranian navy. Their missile guidance systems were produced by a Dutch subsidiary of Philips, Hollandse Signaalapparaten BV, in Hengelo.

In the second half of the 1980s, Philips began sponsoring programs of the Stedelijk Van Abbemuseum, Eindhoven.

De Iraanse vestiging van Philips getuigt van haar oneindige dankbaarheid jegens zijne Keizerlijke Majesteit, de sjah van Iran, die met de proclamatie van de Iraanse Herrijzenispartij de nationale eenheid veilig heeft gesteld.

Advertentie in het Iraanse dagblad *Keyhan*, 5 maart 1975

Toch denk ik, dat U mij niet de juiste motieven toeschrijft

1978-1979

Triptych of lightboxes in black formica. Left and right boxes, 60⅞ x 41 x 9⅞" (154.5 x 104.5 x 25 cm) with black-and-white photo transparency. Center box, 79¾ x 54 x 11¾" (202.5 x 137 x 30 cm) with color transparency. Background to images and texts, blue silkscreen printing.

First exhibited in one-person exhibition at the Stedelijk Van Abbemuseum, Eindhoven, January 19-February 18, 1979. Director Rudi Fuchs.

Owned by Hans Haacke.

Translation, first panel:

We are businessmen and we look for business opportunities. This is the only factor governing our decisions. Political considerations don't come into it. Nobody is going to help South Africa unless he is paid, and obviously, you need know-how from abroad. We are here to stay.

Jan Timmer, Managing Director of Philips in South Africa

Philips investments in South Africa amount to approximately $83 million. In a total work force of 3,321 (1982), its 1,870 non-white workers occupy predominantly jobs for untrained or low-skilled labor. At the request of the South African government, Philips established lamp manufacturing facilities in Rosslyn, at the border of a Bantustan.[1] Philips dominates the South African market for lightbulbs, radios, hi-fi equipment, tape recorders, and electrical appliances, and has a sizable share of the market for television sets and cable. Moreover, Philips is very active in telecommunications, data processing equipment, and other sophisticated electronics.

A number of government agencies are among its clients, including the Security Division, which reportedly received fingerprinting equipment from Philips.

The Mirage fighter-planes of the South African airforce as well as its Alouette, Gazelle, Puma, and Super Frélon helicopters are guided by Philips radio-altimeters and radar equipment. The company also supplies the South African police and military with mobile radio equipment, and Philips radio-altimeters guide the Exocet missiles in South Africa's arsenal.

1. Under apartheid, blacks have been forcibly resettled in these so-called homelands, areas of the country which are mostly devoid of resources and where even subsistence farming is precarious.

Installation at St. Peter's Abbey, Ghent, as part of the exhibition *Kunst in Europa na '68*, June-August 1980.

Foto: Geoff Causton, *Financial Mail*

De werknemersraden zijn adviesorganen. Zij kunnen geen onderhandelingen voeren over minimum loon of arbeidscondities; in feite wordt er zelden over lonen gesproken.

De gemiddelde zwarte arbeider verdient 229 rand (fl.618) per maand.

De zwarten zijn uitgesloten van leergangen voor radio en TV technici door de *Wet op Nywerheidsversoening.*

Financial Mail
Johannesburg, 22 juli 1977, supplement over Philips

PHILIPS

Translation, second panel:

But I think you question my motives. You see me just as a man of capital. However, above all I really would like people to have the freedom to develop themselves as much as possible, to create opportunities for themselves, to take initiatives and carry the responsibility for them.

Frits Philips, in his autobiography, *45 Years with Philips*

Translation, third panel:

The Employee Councils are advisory bodies. They are precluded from negotiating minimum wages or conditions of employment; in fact, wages are rarely discussed. The average Black worker earns 229 rand a month. Blacks are excluded from apprentice training for radio and TV technicians by the *Job Reservations Act.*

Financial Mail, Johannesburg, July 22, 1977. Supplement on Philips.

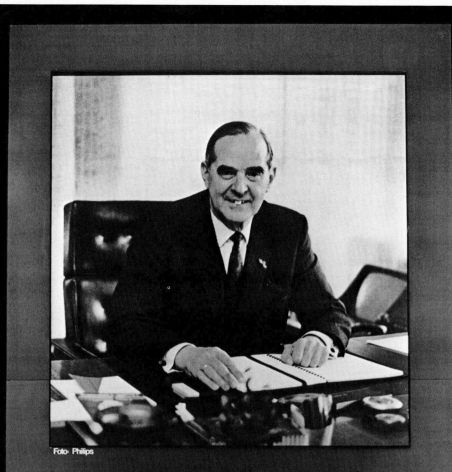

Foto: Philips

Toch denk ik, dat u mij niet de juiste motieven toeschrijft. U ziet in mij voor alles de man van het kapitaal. In werkelijkheid wil ik echter in de allereerste plaats dat de mensen de vrijheid hebben om zichzelf zoveel mogelijk te ontwikkelen, zelf kansen te scheppen, initiatieven te nemen en zelf daarvoor de verantwoordelijkheid te dragen.

Frits Philips in zijn autobiografie *"45 Jaar met Philips"*

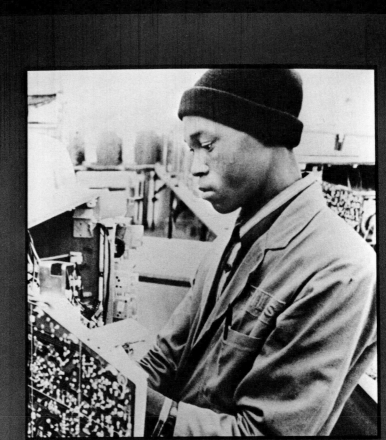

Foto: Geoff Causton, *Financial Mail*

Wij zijn zakenmensen en zoeken mogelijkheden om zaken te doen; dat is de enige factor die onze beslissing bepaalt. Politieke overwegingen spelen daarbij geen rol.

Niemand helpt Zuid-Afrika tenzij hij er voor wordt betaald, en het is duidelijk dat u de know-how uit het buitenland nodig heeft.

Wij zijn hier en wij blijven hier.

Jan Timmer
Managing Director in Zuid-Afrika van Philips

PHILIPS

Alcoa: We can't wait for tomorrow

1979

Mirror-polished aluminum letters on square aluminum tubing, 9 x 192 x 4½" (22.9 x 487.3 x 11.4 cm).

First exhibited in one-person exhibition at the John Weber Gallery, New York, May 5-May 29, 1979.

Photograph: John A. Ferrari.

Owned by Hans Haacke.

The quote is taken from the Alcoa president's address to the American Advertising Federation in Washington, June 13, 1977.

Pressed by an Internal Revenue Service investigation, the Aluminum Company of America disclosed in 1976 that it had made $166,000 in domestic political contributions. It also admitted to $348,300 in questionable payments abroad. "We can't wait for tomorrow" was a slogan used in Alcoa advertisements.

Aside from his position as president of Alcoa, William B. Renner also served as one of its directors. He left the company in 1985.

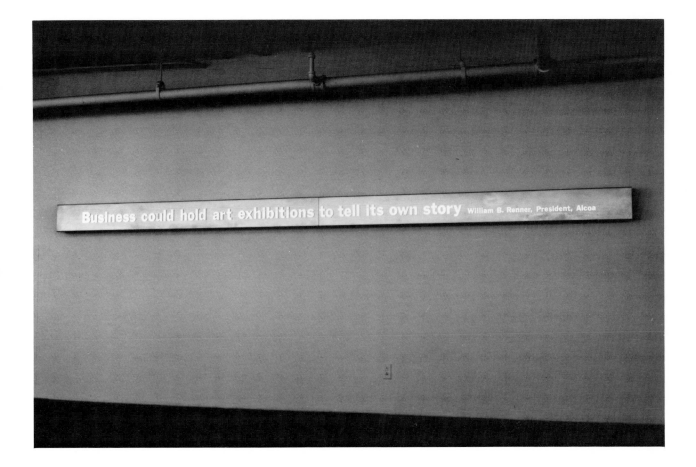

Thank you, Paine Webber

1979

Diptych: mounted color photographs in black anodized aluminum frames under glass. Left panel: facsimile reproduction of the cover of PaineWebber's annual report for 1977 with a photograph taken in Detroit during the Depression; right panel: collage combining photograph from the same annual report, with an abbreviated version of a text from a PaineWebber advertisement. Each panel, 42¼ x 40⅝" (105.5 x 103.2 cm).

First exhibited in one-person exhibition at the John Weber Gallery, New York, May 5-May 29, 1979.

Edition of 2. One in the collection of Gilbert and Lila Silverman; the other owned by Hans Haacke.

PaineWebber, one of New York's largest brokerage and investment banking firms, has used its annual reports as a vehicle to explain to stockholders and the public the workings of the economy from a conservative point of view. Titles of the voluminous and richly illustrated essays have been: "Who Needs Wall Street?—A Short Interpretative History of Investing in the United States" (1976); "Where Do Jobs Come From?—A Concise Report on Unemployment and Wall Street's Role in Preventing It" (1977); "Do You Sincerely Want to Be Poor?—PaineWebber's Centennial Essay on the Future of American Capitalism" (1978).

The slogan "Thank you, PaineWebber," which was invented by the Marschalk Company, PaineWebber's advertising agency, has been used since 1976 in television commercials, printed advertisements, on balloons, and on umbrellas.

Donald B. Marron, now the chairman and chief executive officer of the PaineWebber Group, was elected chairman of the board of trustees of the Museum of Modern Art in 1985. On that occasion, the museum's director, Richard Oldenburg, declared, "Mr. Marron represents a very important community, namely the corporate community, which has become more and more important to all cultural institutions, including museums."

PaineWebber maintains an art gallery in the lobby of its headquarters on New York's Avenue of the Americas at 51st Street.

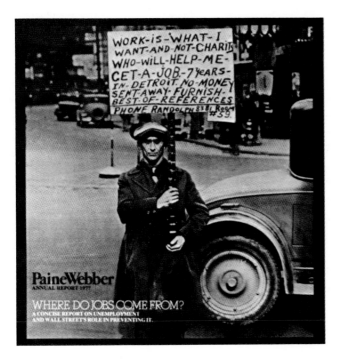

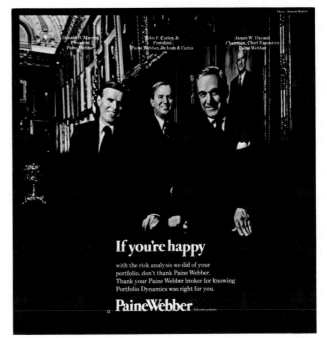

The Right to Life

1979

Color photograph on three-color silkscreen print, 50¼ x 40¼" (128.2 x 102.8 cm). In brass frame under glass.

Silkscreen printing assisted by Day Gleeson.

First exhibited in one-person exhibition at the John Weber Gallery, New York, May 5-May 29, 1979.

Edition of 2. One in the collection of the Allen Memorial Art Museum, Oberlin, Ohio; the other in the collection of Gilbert and Lila Silverman.

The Allied Chemical Corporation, like American Cyanamid, has required the sterilization of female employees of child-bearing age if they wanted to continue in certain jobs. Two women have undergone the operation.

Other large chemical companies have also practiced "protective discrimination," usually restricted to moving women of child-bearing age into lower paid jobs within the company, where they are not exposed to toxic substances. Reported among these companies are Dow Chemical, Monsanto, Du Pont, General Motors, Bunker Hill Smelting, St. Joseph Zinc, Eastman Kodak, and Firestone Tires and Rubber.

In 1980, several women affected by American Cyanamid's "fetal protection policy" sued the company. After three and a half years of pretrial proceedings the case was settled for $200,000, plus costs and attorney's fees. In another lawsuit against American Cyanamid, the U.S. Court of Appeals for the District of Columbia, in an opinion authored by Judge Robert Bork (appointed by President Reagan), upheld the company's claim that it did not violate the Occupational Safety and Health Act. This law stipulates that an employer must provide a safe workplace.

American Cyanamid is a diversified multinational corporation with headquarters in Wayne, New Jersey. Among the better known consumer products it distributes are L'Air du Temps, Niki de St. Phalle, Pierre Cardin, and Geoffrey Beene perfumes; it also makes Old Spice aftershave for men.

AMERICAN CYANAMID

AMERICAN CYANAMID is the parent of BRECK® Inc., maker of the shampoo which keeps the Breck Girl's hair clean, shining and beautiful.

AMERICAN CYANAMID does more for women. It knows: "We really don't run a health spa."

And therefore those of its female employees of child-bearing age who are exposed to toxic substances are now given a choice.

They can be reassigned to a possibly lower paying job within the company. They can leave if there is no opening. Or they can have themselves sterilized and stay in their old job.

Four West Virginia women chose sterilization.

AMERICAN CYANAMID...

Where Women have a Choice

Portrait of BRECK Girl by James Donnelly. Text · by Hans Haacke. 1979.

Wij geloven aan de macht van de creatieve verbeeldingskracht

1980

Polyptych: eleven silkscreen panels and flag. Left and right panels, each 41⅜ x 15″ (100.5 x 38.2 cm); three central panels, each 41⅜ x 32¾″ (100.5 x 83.3 cm); six upper and lower panels, each 10⅞ x 32⅜″ (27.7 x 83.3 cm); flag with flagpole, 70″ (180 cm).

Silkscreen printing assisted by Day Gleeson.

The two panels on the extreme left and right are facsimile reproductions, printed in black, of FN advertisements in military periodicals.

The three central panels, printed in red and black, incorporate black-and-white press photographs by Coetzer (SYGMA) and Al J. Venter (Gamma-Liaison).

The text below each photograph is a facsimile reproduction of part of an FN poster, publicly displayed all over Belgium in 1980.

The three upper text panels and the lower panels with mechanical drawings of the F.A.L. rifle are printed in red and black.

All panels are framed in blued brass under glass.

The black velvet flag bears the FN company logo in silver fabric on both sides and hangs above the polyptych on a blued brass pole.

First exhibited in *Kunst in Europa na '68* (Art in Europe after '68), an international exhibition organized by Jan Hoet at the Museum van Hedendaagse Kunst, Ghent, Belgium, June 21-August 31, 1980.

In the collection of the Museum van Hedendaagse Kunst, Ghent.

Fabrique Nationale Herstal S.A. (FN) is one of the major manufacturers of small arms and ammunition in the world. The company, with headquarters in Herstal, near Liège, Belgium, admits to supplying arms and ammunition to about eighty countries. It produces ten to fifteen percent of the weapons in the $80 billion arms market, and is generally ranked third or fourth in the field of small-arms sales. Numerous countries which have been singled out by Amnesty International for their violation of human rights are among the clients of FN.

During the civil war in Biafra, FN supplied both sides with weapons. FN has been questioned about arms deliveries to Uruguay, to Bolivia, and to Morocco, which is engaged in an armed conflict with the Polisario Front. According to *Armies and Weapons* (No. 5, 1974), an international military journal, the light automatic rifle F.A.L. 7.62mm of FN "has been used on a large scale in all the more recent wars and guerrilla actions (the last Arab-Israeli conflict, the Indo-Pakistan war of 1971, the Congo, Northern Ireland, South America, and so on)."

The F.A.L. rifle has been produced under license from FN in about a dozen countries, among them Argentina, Brazil, Canada, Great Britain, Israel, and South Africa. Frequently these countries have, in turn, exported the weapon. South Africa, for example, equipped the Rhodesian army under Ian Smith, while the Bolivian army has been supplied by Argentina.

FN subsidiaries produce arms in Brazil, Portugal, and the United States. Some of the foreign operations and FN's part-ownership of non-Belgian companies, e.g., Beretta of Italy, are handled by FN International SA, which is registered in Luxembourg. Participation in foreign enterprises and licensing arrangements allow FN to avoid some of the political and legal restrictions on the export of arms.

In 1977, a large number of Belgian "hunting rifles" were delivered to South Africa. The international press has since frequently reported that South African blacks were wounded or killed by shotgun blasts.

FN collaborates with Pratt & Whitney of the United States in the production of military aircraft engines.

The competition for the FN-Browning Prize for Creativity, referred to in the three central panels, was administered by the office of M. Claude Gaier. M. Gaier was also chief of the Information Service of FN, head of the company's cultural programs, and the director of the Musée des Armes in Liège.

Translation:

It goes to countries which are not in a state of war (laughs). Well, in principle ... But then it may happen that the Belgian Army takes it over and it is delivered by way of an intermediate country.

Mr. Reynvoet, representative of the Christian Labor Union at FN. (Interview on Belgian television, 1975)

In Soweto (Johannesburg) 1976
FN - Browning Prize for Creativity created on the occasion of the millenium of the Principality of Liège. *Fabrique Nationale Herstal S.A.* We believe in the power of creative imagination.

The Société Générale de Belgique owns 29.35% of FN. It is believed that the Belgian Royal Family, the Vatican, Prince Amaury de Merode, Count Lippens, and the families of Solvay, Boël, and Janssen are the controlling shareholders of the Société Générale de Belgique.

(*The Economist,* London, March 18, 1978)

In the South African Army 1977
FN - Browning Prize for Creativity created on the occasion of the millenium of the Principality of Liège. *Fabrique Nationale Herstal S.A.* We believe in the power of creative imagination.

We sell our arms to responsible governments. As soon as they have taken possession of their arms, it is they who use them. We have nothing to do with the use to which they are finally put.

Mr. Fons Ni, Director of FN. (Interview on Belgian television, 1975)

In Soweto (Johannesburg) 1976
FN - Browning Prize for Creativity created on the occasion of the millenium of the Principality of Liège *Fabrique Nationale Herstal S.A.* We believe in the power of creative imagination.

Wij geloven aan de macht

FN IS voor 29.35 procent eigendom van de Société Générale de Belgique. – Het wordt aangenomen dat het Belgisch Koninklijk Huis, het Vatikaan, Prins Amaury de Merode, Graaf Lippens en de families Solvay Boël en Janssen de grootste aandeelhouders in de Société Générale de Belgique zijn. (The Economist, Londen, 18 maart 1978)

In het Zuid-Afrikaanse leger 1977

FN-Browning Prijs van de creativiteit

gecreëerd ter gelegenheid van het Millennium van het Prinsbisdom Luik

FABRIQUE NATIONALE HERSTAL S.A.

Wij geloven aan de macht van de creatieve verbeeldingskracht

FN F.A.L. 7.62 mm

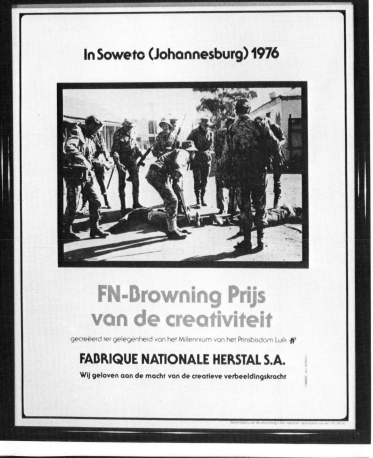

In Soweto (Johannesburg) 1976

**FN-Browning Prijs
van de creativiteit**

gecreëerd ter gelegenheid van het Millennium van het Prinsbisdom Luik

FABRIQUE NATIONALE HERSTAL S.A.

Wij geloven aan de macht van de creatieve verbeeldingskracht

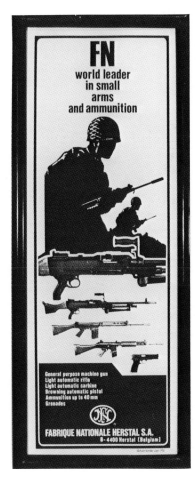

FN
world leader
in small
arms
and ammunition

General purpose machine gun
Light automatic rifle
Light automatic carbine
Browning automatic pistol
Ammunition up to 40 mm
Grenades

FABRIQUE NATIONALE HERSTAL S.A.
B-4400 Herstal (Belgium)

FN F.A.L. 7,62 mm

Mobil: On the Right Track

1980

Three-color silkscreen print and collage of photographs, 60 x 43" (152.5 x 109.2 cm). Photo of Senator Birch Bayh: UPI. Photos of Senators Church, Culver, McGovern: courtesy of the senators.

Printed by John Campione and Rick Mills, New York.

First exhibited in one-person exhibition at the John Weber Gallery, New York, February 7-March 4, 1981.

Edition of 3. One in the collection of Ohio State University, Columbus, Ohio; one in the collection of Joseph Berland; one owned by Hans Haacke.

The four senators referred to in this work were the most visible and forceful representatives of liberal politics in the United States in the late 1970s. They were all defeated in the election of 1980 which brought Ronald Reagan to the White House and were replaced by conservative politicians.

The Moral Majority is a political organization supported by fundamentalist religious groups. It is headed by the Reverend Jerry Falwell.

The National Conservative Action Committee is an arch-conservative organization which has targeted liberal politicians for defeat and has mounted well-funded campaigns to achieve this end.

The Life Amendment Political Action Committee promotes anti-abortion legislation.

Mobil continues supporting the election of political candidates. Barney Skladany, the oil company's lobbyist, was a major contributor at a fundraising event for Republican Congressman Jack Kemp, who aspires to the U.S. presidency. Among the other contributors were major defense contractors and the National Rifle Association.

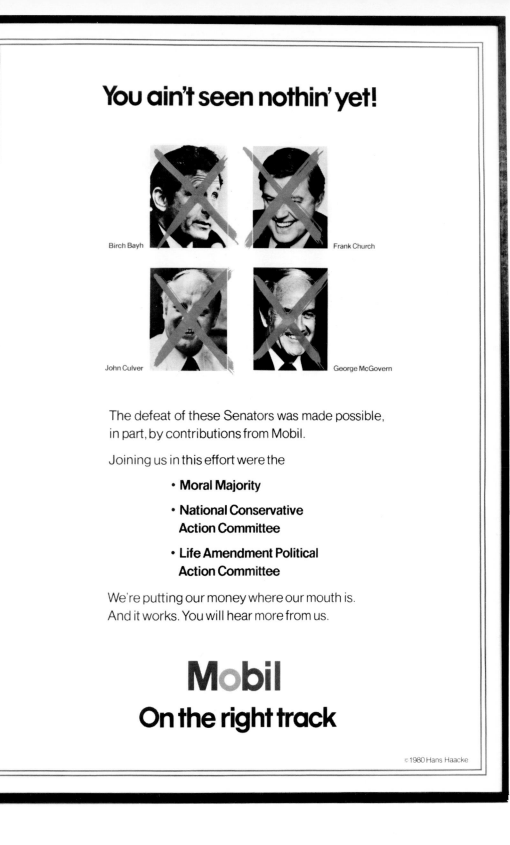

Creating Consent

1981

Oil drum, television antenna, 73 x 23 x 23″ (85.4 x 58.4 x 58.4 cm).

First exhibited in one-person exhibition at the John Weber Gallery, New York, February 7-March 4, 1981.

Owned by Hans Haacke.

The Public Broadcasting Service (PBS) was set up by Congress as a television network for public interest, education, and cultural programs. Because it is inadequately funded, PBS has had to rely heavily on donations and has increasingly turned to large corporations for financial support. The station features no commercials, but sponsored programs are introduced and ended by a prominent mention of the sponsor's name. Critics have noted that programs investigating business practices have largely disappeared and, as oil companies now provide the bulk of the station's financial support, it is sometimes referred to as the "Petroleum Broadcasting Service."

In 1986, Mobil announced it would continue spending about $4 million on the "Mystery!" and "Masterpiece Theatre" series it sponsors on PBS. The funds it allocates for the promotion of these programs, over the Mobil logo, are sizable; they occasionally come close to matching the money spent on the programs themselves.

Herb Schmertz, a director of Mobil and, as vice-president for public affairs, in charge of all public relations ventures of the company, says: "I am, in effect, the manager of an ongoing political campaign . . . We're constantly out there trying to win more votes for our positions . . . We require a visible and articulate presence, not only in the economic marketplace, but also in the marketplace of politics and ideas."

Rawleigh Warner, Jr. retired from the chairmanship of Mobil early in 1986.

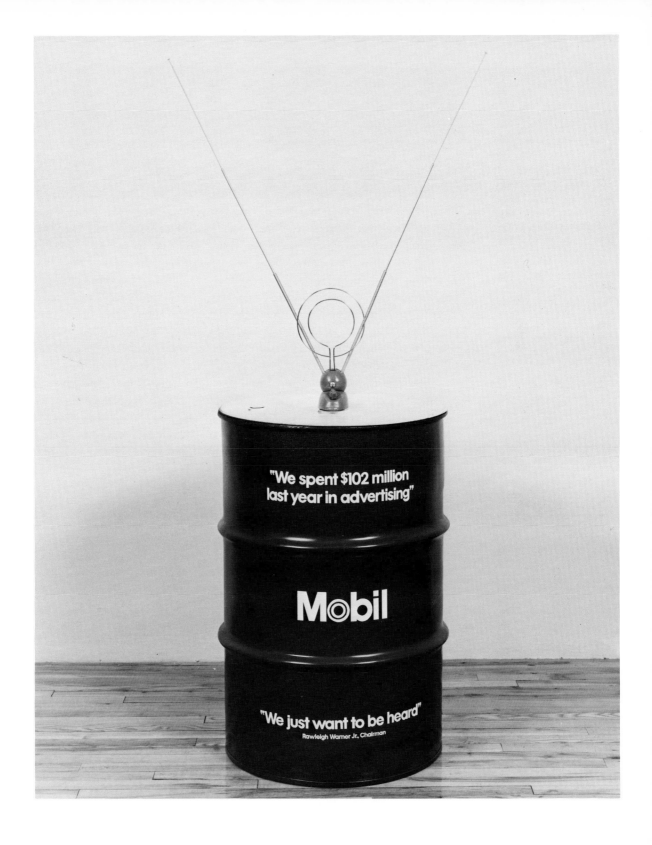

Der Pralinenmeister

1981

Seven diptychs: fourteen panels, each 39½ x 27½″ (100 x 70 cm). Multi-color silkscreens with photographs and packaging of assorted chocolates and chocolate bars attached; in brown wood frames under glass. Photograph of Peter Ludwig: Wolf P. Prange. Photographs of workers: Anonymous.

First exhibited in one-person exhibition at Galerie Paul Maenz, Cologne, May 29-June 27, 1981, at the time of *Westkunst,* a major survey of art since 1939.

Photographs of work: Lothar Schnepf.

Collection of Gilbert and Lila Silverman.

Before the exhibition of the work opened at Galerie Paul Maenz in Cologne, Peter Ludwig requested a preview of it. This privilege was not granted. Through an intermediary, he also inquired whether the work referred to tax matters. This curiosity may be explained by information received after the completion of the work. A well-known New York artist then related that Ludwig had bought a painting from him during a studio visit and had asked the painter to write an invoice for a chocolate package design. When Ludwig expressed an interest in buying *Der Pralinenmeister*, he was turned down by the artist.

In the summer of 1981, the Deutscher Museumsbund (German Museum Association) expressed "severe reservations" about the projected Ludwig Foundation. Nevertheless, a year later, in July of 1982, the city of Cologne, the state of North Rhine-Westphalia, and the federal government pledged to join the Foundation and to contribute annually DM 5.25 million, even though a recession was severely straining public budgets, and particularly the budgets of art institutions. Ludwig, however, informed Chancellor Schmidt that he was withdrawing his offer for the Foundation.

In 1982, Ludwig bought some eighty works by contemporary Soviet artists in Moscow. He was assisted in assembling this collection by the Soviet authorities. When the works went on exhibition at the Neue Galerie-Sammlung Ludwig in Aachen and at the Ludwig Museum in Cologne the critical reaction was overwhelmingly negative. One year later Ludwig proposed to the state of North Rhine-Westphalia to jointly establish an institute for the research and exhibition of Russian art in his collection. Constructivist works and contemporary Soviet art were to be administered under the same umbrella, possibly as an appendix to the new Ludwig Museum in Cologne.

On March 10, 1983, a few days after Mr. and Mrs. Ludwig had received the Federal Republic's highest decoration, Ludwig announced that he had sold his collection of 144 illuminated manuscripts to the J. Paul Getty Museum in Malibu, California. The news was greeted with widespread indignation. Ludwig had led the city of Cologne to believe that these manuscripts would eventually be donated to Cologne's Schnütgen Museum. From 1977, the city had therefore generously financed two curators of the Schnütgen Museum to work on a scholarly catalogue of the collection. Four lavishly illustrated volumes have been published. It is assumed that the art-historical work performed by the two experts considerably raised the value of the material, which was sold for an estimated price of $40 to $60 million. Questions were raised as to whether the sale conflicted with laws preventing the export of national treasures. However, it appears that the collection had been kept in a vault in Zurich, and therefore at least the letter of the law was not violated. Shortly after the sale to the Getty Museum, perhaps to assuage the furor in Cologne, Ludwig donated his Pre-Columbian collection to the municipal Rautenstrauch-Joest Museum, where it had been cared for and researched over many years.

With the proceeds of the sale, Ludwig established the Ludwig Foundation for Art and International Understanding in Aachen. It is to acquire art works, make loans, organize exhibitions, give grants, and produce publications. Its capital was invested in the Leonard

(continued, page 226)

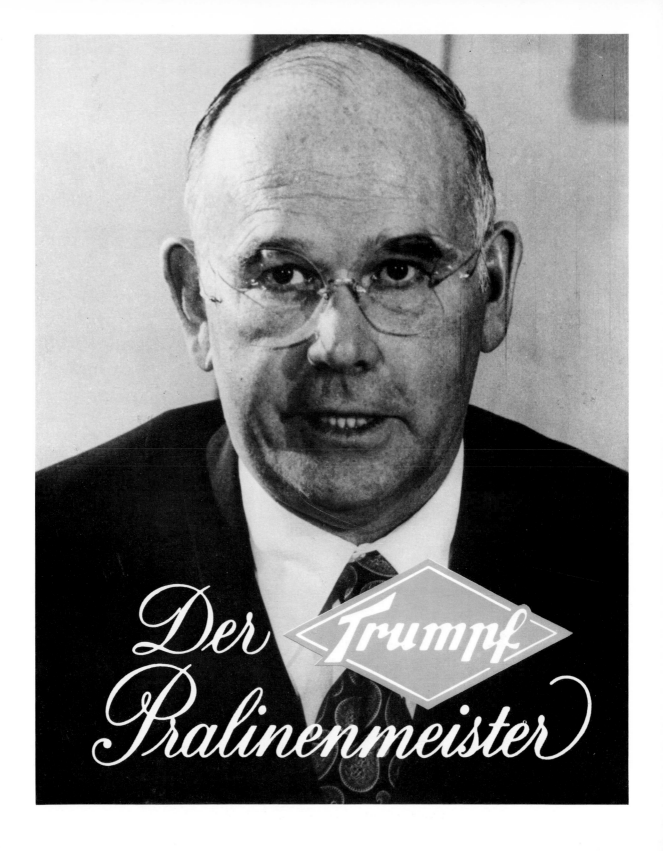

Prof. Dr. Dr. h. c. Peter Ludwig
Aufsichtsratsvorsitzender der
Leonard Monheim AG.

Kunstbesitz in Dauerleihgaben
ist vermögensteuerfrei

Peter Ludwig wurde 1925 in Koblenz als Sohn des Industriellen Fritz Ludwig (Kalkwerke Ludwig) und Frau Helene Ludwig, geb. Klöckner, geboren.

Nach dem Wehrdienst (1943–45) studierte er Jura und Kunstgeschichte; Promotion 1950 über »Das Menschenbild Picassos als Ausdruck eines generationsmäßig bedingten Lebensgefühls«. Die Dissertation stützt sich auf Bezüge zwischen zeitgenössischer Literatur und dem Werk Picassos. Historische Ereignisse werden kaum berücksichtigt.

1951 heiratete Peter Ludwig Irene Monheim, eine Mitstudentin, und trat in die *Leonard Monheim KG*, Aachen, seines Schwiegervaters ein. 1952 wurde er geschäftsführender Gesellschafter, 1969 Vorsitzender der Geschäftsleitung und 1978 Vorsitzender des Aufsichtsrats der *Leonard Monheim AG*, Aachen.

Peter Ludwig ist Aufsichtsratsmitglied der *Agrippina Versicherungs-Gesellschaft* und der *Waggonfabrik Uerdingen*; er ist Vorsitzender des Bezirksbeirates der *Deutschen Bank AG*, Köln-Aachen-Siegen.

Seit Anfang der 50er Jahre sammeln Peter und Irene Ludwig Kunst, zunächst alte Kunst. Seit 1966 konzentrieren sie sich auf moderne Kunst: Pop Art, Photorealismus, Pattern Painting, Kunst aus der DDR und die »neuen Wilden«. Seit 1972 hält Peter Ludwig als Honorarprofessor der Kölner Universität kunsthistorische Seminare im *Museum Ludwig* ab.

Dauerleihgaben moderner Kunst befinden sich im *Museum Ludwig*, Köln, der *Neuen Galerie-Sammlung Ludwig* und dem *Suermondt-Ludwig-Museum* in Aachen, den *Nationalgalerien* in West- und Ostberlin, dem *Kunstmuseum Basel*, dem *Centre Pompidou* Paris, und den Landesmuseen in Saarbrücken und Mainz. Im Kölner *Schnütgen-Museum*, im Aachener *Couven-Museum* und im bayrischen *Nationalmuseum* befinden sich mittelalterliche Werke. Das Kölner *Rautenstrauch-Joest-Museum* beherbergt Objekte aus dem präkolumbianischen Amerika, aus Afrika und Ozeanien.

Das Kölner *Wallraf-Richartz-Museum* erhielt 1976 als Schenkung eine Pop Art-Sammlung (jetzt *Museum Ludwig*), das *Suermondt-Museum* in Aachen 1977 mittelalterliche Kunst (jetzt *Suermondt-Ludwig-Museum*). Dem *Antikenmuseum Basel* (jetzt *Antikenmuseum Basel und Museum Ludwig*) wurde 1981 eine Kollektion griechisch-römischer Kunst geschenkt, die Dauerleihgaben aus Kassel, Aachen und Würzburg einschließt. In eine *Österreichische Stiftung Ludwig für Kunst und Wissenschaft* wurde 1981 eine Sammlung moderner Kunst eingebracht.

Peter Ludwig sitzt in der Ankaufskommission der *Landesgalerie Düsseldorf*, im International Council des *Museum of Modern Art*, New York, und im Advisory Council des *Museum of Contemporary Art*, Los Angeles.

Arbeiterinnen in einem Werk
der Leonard Monheim AG.

Die Monheim-Gruppe vertreibt Tafelschokolade und Pralinen der Marke Regent zu Niedrigpreisen vor allem über Aldi und Automaten.

Die Fertigung erfolgt in Aachen, wo das Unternehmen mit rund 2500 Arbeitern und Angestellten in 2 Werken die größten Produktionsstätten und seine Hauptverwaltung betreibt. Die Zahl der Arbeiter im Werk Saarlouis beträgt ca. 1300, in Quickborn ca. 400 und in West-Berlin ca. 800.

Insgesamt hat Monheim in Deutschland 1981 wie vor 10 Jahren rund 7000 Beschäftigte — bei verdreifachtem Umsatz. Davon sind 5000 Frauen. Die Zahl der gewerblich Beschäftigten beträgt 5400. Darunter sind zwei Drittel ungelernte Arbeitskräfte. Zusätzlich werden ca. 900 meist ungelernte Saisonarbeiter eingestellt.

Der von der Gewerkschaft Nahrung-Genuß-Gaststätten ausgehandelte Tariflohn bewegt sich zwischen DM 6,02 (Tarifgruppe E — Fließbandarbeit unter 18 Jahre) und DM 12,30 (Tarifgruppe S — qualifizierte Facharbeiter). Das niedrigste Gehalt, gemäß Tarifvertrag, beträgt DM 1097,—, das der höchsten Gehaltsstufe mindestens DM 3214,—.

Die überwiegende Mehrzahl der 2500 ausländischen Arbeitskräfte sind Frauen. Sie stammen vornehmlich aus der Türkei und Jugoslawien. Aber auch Gastarbeiterinnen aus Marokko, Tunesien, Spanien und Griechenland sind angeworben worden («Kopfpreis» 1973: DM 1000,—). Ausländische Arbeiterinnen kommen auch täglich aus dem belgischen und holländischen Grenzgebiet.

Das Unternehmen unterhält in Aachen auf seinem umzäunten Betriebsgelände und an anderen Orten Wohnheime, in denen Gastarbeiterinnen zu dritt oder viert in einem Zimmer untergebracht sind (der Bau von Unterkünften für ausländische Arbeitskräfte wird von der Bundesanstalt für Arbeit subventioniert). Die Monatsmiete wird vom Lohn einbehalten.

Besuche werden von der Betriebsleitung kontrolliert und zum Teil abgewiesen. Das bischöfliche Presseamt und der Caritasverband in Aachen beurteilten die Wohnverhältnisse folgendermaßen: *«Da die meisten dieser Frauen und Mädchen lediglich am Arbeitsplatz und innerhalb der Wohnheime menschliche Kontakte knüpfen können, leben sie praktisch in einem Getto.»*

Da Monheim keine Kindertagesstätte habe, müßten Gastarbeiterinnen, die ein Kind bekommen, das Heim verlassen oder für ihr Kind eine für sie kaum erschwingliche Familienpflegestelle suchen, oder aber sie müßten das Kind zur Adoption anbieten.

«Es dürfte für eine große Firma, bei der so viele Mädchen und Frauen beschäftigt sind, ohne weiteres möglich sein, eine Kindertagesstätte zu errichten.»

Die Personalabteilung antwortete darauf, Monheim sei «eine Schokoladenfabrik und kein Kindergarten». Für eine Kindertagesstätte könne kein Personal beschafft werden. Die Firma sei kein Sozialamt.

© 1981 Hans Haacke

Prof. Dr. Dr. h. c. Peter Ludwig
Aufsichtsratsvorsitzender der
Leonard Monheim AG.

Wir arbeiten nicht mit Drohungen Peter Ludwig

Peter und Irene Ludwig übergaben dem Kölner Wallraf-Richartz-Museum 1968 als Dauerleihgabe eine Sammlung moderner Kunst, in der vornehmlich Werke der Pop Art vertreten waren.

1976 ist diese Sammlung der Stadt Köln mit der Auflage geschenkt worden, daß die Stadt Köln ein Museum für die Kunst des 20. Jahrhunderts errichtet, das den Namen *Museum Ludwig* erhält:

»Die Eheleute Ludwig bzw. der Überlebende von ihnen sind berechtigt, von diesem Vertrag zurückzutreten und die Herausgabe aller laut Vertrag geschenkten Kunstgegenstände zu verlangen, wenn der Gesamtfertigstellung und Eröffnung des Museums Ludwig nicht bis zum 9. Juli 1985 gewährleistet ist.« Der 9. Juli 1985 ist der 60. Geburtstag von Peter Ludwig.

Mit dem Museumsbau ist zwischen Dom und Rhein begonnen worden. Die Bauleitung veranschlagte die Kosten 1980 auf DM 219 Millionen. Die mit dem Bau notwendige Neugestaltung der Umgebung erhöht die Kosten insgesamt voraussichtlich auf weit über DM 300 Millionen. Die Unterhalts- und Personalkosten des Museums werden auf rund DM 10 Millionen geschätzt.

Unabhängig vom Bauvorhaben waren unverzüglich alle Werke ab 1900 — einschließlich sämtlicher Schenkungen Kölner Sammler — aus dem Wallraf-Richartz-Museum auszugliedern und organisatorisch

in das neugegründete *Museum Ludwig* aufzunehmen, das vorläufig in den Räumen des Wallraf-Richartz-Museums untergebracht ist. Ebenfalls sollen die Neuerwerbungen zeitgenössischer Kunst dem *Museum Ludwig* zugefügt werden.

Im Schenkungsvertrag wurde ferner vereinbart: *»Die Berufung dieses Direktors (des Museums Ludwig) sowie der wissenschaftlichen Mitarbeiter des Museums Ludwig erfolgt nach Anhörung der Eheleute Ludwig bzw. des überlebenden Ehegatten. Herr Professor Dr. Ludwig und seine Ehefrau werden über die laufende Arbeit dieses Museums (z. B. Ausstellungswesen, Ankäufe, Publikationen) voll informiert.«*

Mit den Eheleuten Ludwig ist zweimal jährlich eine *»Grundsatzbesprechung«* zu führen, in der *»über die Arbeit des Museums Ludwig umfassend und detailliert gesprochen wird«*.

Zum Wert der Schenkung erklärte Peter Ludwig: *»Daß die Sammlung heute 45 Millionen wert ist, ist vor allem dem Umstand zu danken, daß sie jahrelang in einem so prominenten Haus wie dem Wallraf-Richartz-Museum gezeigt wurde. Ich habe für die Bilder und Objekte zusammen nicht mehr als 5 Millionen ausgegeben.«*

Die Stadt Köln machte Peter Ludwig zum Ehrenbürger.

© 1981 Hans Haacke

Arbeiterin in einem Werk
der Leonard Monheim AG.

COMET CONFECTIONARY LTD COMET COMÈTE LA CONFISERIE COMÈTE LTÉE

Die Monheim-Gruppe erwarb 1959 in St. Hyacinthe bei Montreal die Schokoladefabrik der *Kambly Company*. Zunächst unter dem Namen *Regent Chocolate Ltd.* produzierte die kanadische Tochtergesellschaft Tafelschokolade und Saisonartikel. Nach Erweiterungen in den Jahren 1968 und 1970 nahm das Werk ein Gelände von 9000 qm ein.

1974 traten nach dem Verzehr von *Regent*-Schokoladenhasen, Christbaumkugeln und den für *Woolworth* in Toronto hergestellten Milchschokolade *Crunch Break-ups* Salmonellenvergiftungen auf. Die Gesundheitsbehörden Kanadas und der Vereinigten Staaten untersagten darauf den weiteren Verkauf von *Regent*-Erzeugnissen. Die bereits ausgelieferte Ware mußte zurückgerufen werden. Das Werk wurde zur Entseuchung geschlossen.

Unter einem neuen Namen, *Comet Confectionary Ltd./Confiserie Comète Ltée*, wurde der Betrieb nach einem halben Jahr mit einer Kapitaleinlage von DM 5,3 Millionen wieder aufgenommen. Günstige Darlehen der Quebec Industrial Development Corp. und des Department of Regional Economic Expansion — zum Teil zinslos — in Höhe von can. $ 4,25 Millionen sowie stille Reserven der Tochtergesellschaft förderten die Wiedereröffnung.

Die Arbeitnehmer, in der Mehrzahl Frauen und ungelernt, deren Stundenlohn 1973 nur wenig über dem gesetzlich vorgeschriebenen Mindestlohn von can. $ 1,85 lag, gründeten 1974 während der Stille-gung des Betriebes eine Gewerkschaft, den *Syndicat des Salariés de la Confiserie Comète St-Hyacinthe (C.S.N.)*.

Vor dem Abschluß des 3. Tarifvertrages von 1979 wurde *Comet* bestreikt. Gemäß diesem auf zwei Jahre befristeten Vertrag betrugen der Mindestlohn can. $ 5,16 und der Höchstlohn $ 7,15. Saisonbedingt schwankt die Zahl der Arbeiter und Angestellten zwischen 200 und 500.

Comet vertreibt ihre Erzeugnisse unter den Marken *Comet, van Houten* und den Hausnamen zahlreicher Firmen in Kanada und den Vereinigten Staaten für die sie anonym produziert (u. a. *Dalt, Orion, Sarah Lee*). Über die Hälfte der Fertigung, vor allem Saisonartikel, wird seit Jahren in die Vereinigten Staaten exportiert.

Comet besorgt auch den Vertrieb von Erzeugnissen der Marke *van Houten*, die in Europa hergestellt worden sind, für den kanadischen Markt.

Die Monheim-Geschäftsführung beurteilt das Ergebnis von *Comet* anhaltend positiv. Im Geschäftsjahr 1979/80 steigerte sich der Umsatz um 31,7 % auf can. $ 35 Millionen. Der Gewinn stieg um 40,9 % auf $ 0,8 Millionen. Er wurde nicht ausgeschüttet, sondern in den Betrieb investiert.

Prof. Dr. Dr. h. c. Peter Ludwig
Aufsichtsratsvorsitzender der
Leonard Monheim AG.

Bei Stiftungen entfallen für Ehegatten bis zu 35 Prozent Erbschaftsteuer

Die *New Galerie-Sammlung Ludwig* der Stadt Aachen präsentiert gewöhnlich – oft in programmatischen Ausstellungen – die Neuerwerbungen von Peter Ludwig. Sie ist auch der Ausgangspunkt für Wanderausstellungen und Dauerleihgaben an andere Museen. Ihr Direktor arbeitet eng mit dem Sammler zusammen.

1977 gingen 22 Werke von Aachen als Dauerleihgabe in die *Nationalgalerie* in Ostberlin. Neuerworbene Malerei aus der DDR wurde daraufhin in Aachen gezeigt.

In Aachen wurde 1978 auch eine Ausstellung für das *Museum für moderne Kunst* in Teheran zusammengestellt (bis zum Sturz des Schahs leitete das Museum ein Stiefbruder der Kaiserin). Das *Centre Pompidou* in Paris und andere europäische Institute erhielten ebenfalls namhafte Dauerleihgaben aus Aachen.

Seit 1976 plant die Stadt Aachen deshalb, durch einen Museumsneubau Peter Ludwig dazu zu bewegen, seine Sammlung in Aachen zu belassen. An der Monheim-Allee soll ab 1982 für DM 40 Millionen ein Neubau entstehen. Die Vollendung ist für 1985 zum 60. Geburtstag des Sammlers vorgesehen. Eine Zusage, seine Sammlung in Aachen zu lassen, hat er nicht gegeben.

Als die Stadt 1976 ihre niedrige Gewerbesteuer anhob, drohte Peter Ludwig (CDU): *«Mit der Verdummbeutelung muß ein Ende sein . . . Mit Steuererhöhungen will ich aber kein Museum!»*

1979 vergab er den bedeutendsten Teil der Aachener Sammlung als Dauerleihgabe an das neugegründete *Museum moderner Kunst* in Wien. Dr. Dieter Ronte, der in Köln den Bau des *Museums Ludwig* überwachte, wurde zum Direktor des Wiener Museums ernannt.

1981 wurde eine Auswahl von 161 Werken im Nennwert von öS 150 Millionen (ca. DM 10 Mio.) in eine neugegründete *Österreichische Stiftung Ludwig für Kunst und Wissenschaft* eingebracht. Die Republik Österreich verpflichtete sich, öS 150 Millionen für Ankäufe, Ausstellungen und andere Stiftungszwecke beizusteuern.

Im Stiftungsrat sitzen Peter und Irene Ludwig mit 2 von ihnen benannten Personen. Österreich stellt seinerseits 4 Mitglieder. Der Vorsitz wechselt in jährlichem Turnus zwischen Peter Ludwig und einem Vertreter Österreichs. Den Eheleuten Ludwig steht für 10 Jahre ein Vetorecht über die Disposition (Ausstellung, Leihgaben etc.) der von ihnen gestifteten Werke zu.

Frau Irene Ludwig wurde in Wien zum Professor ernannt. Peter Ludwig erhielt die Ehrenbürgerschaft.

Foto: W. u. P. Fiangs © 1981 Hans Haacke

Arbeiterinnen in einem Werk
der Leonard Monheim AG.

VAN HOUTEN

Die Monheim-Gruppe erwarb 1971 von der amerikanischen Peter & Paul, Inc. weltweit die Produktions-, Marken- und Vertriebsrechte für *van Houten*-Erzeugnisse.

Seither betreuen die *van Houten*-Tochtergesellschaften der Monheim-Gruppe ihr gesamtes Gruppenexportgeschäft über eigene Vertriebsorganisationen in Deutschland, Frankreich (1979/80 Umsatz FF 122,7 Millionen), Großbritannien, Kanada, den Niederlanden und den Vereinigten Staaten.

Darüber hinaus sind Ostasien und die DDR bedeutende Handelspartner. Eine Expansion des Marktes in die Sowjetunion und andere Ostblockländer ist geplant. Kooperationsverhandlungen sind 1980 auch mit österreichischen Unternehmen aufgenommen worden, die den Markt des Alpenlandes für Monheim-Erzeugnisse erschließen sollen.

Rund 34 % (DM 403 Millionen) des Konzernumsatzes wurden im Geschäftsjahr 1979/80 außerhalb der Bundesrepublik erzielt.

Neben dem Markenartikelgeschäft betreibt *van Houten* auch die Herstellung von Industrieprodukten wie Kakaobutter, Kakaopulver, Kuverture, Kakaomassen und Rohkakao.

Insgesamt investierte Monheim von 1971 bis 1975 allein in West-Berlin für die *van Houten*-Produktion von Kakaopulver und Kakaobutter DM 60 Millionen. Diese Sachanlagen wurden wesentlich durch die Vergünstigungen des Berlinförderungsgesetzes getragen (Sonderabschreibungen, Investitionszuschüsse und andere Steuererleichterungen).

Die Monheim-Gruppe schloß 1973 mit *AGROS*, dem staatlichen Außenhandelsunternehmen von Polen, einen Kooperationsvertrag. Daraufhin wurde 1975 in der *Schokoladenfabrik Wawel* in Krakau mit der Lizenzproduktion von *van Houten* Tafelschokolade begonnen. Ein Teil der Erzeugnisse ist für den Export bestimmt.

Mit den staatlichen Außenhandelsfirmen der DDR wurden 1974 ebenfalls Gestattungsverträge zur Herstellung instantisierter Kakaogetränke der Marke *van Houten* unterzeichnet.

Die Schulen der DDR werden seither mit dem Kakaotrunk *Trinkfix* beliefert. Monheim-Produkte sind sonst nur in Intershops und Delikatläden erhältlich. Ein Teil der Produktion wird exportiert, auch in die Bundesrepublik. Für die Fertigung in Polen und der DDR stellt die Monheim-Gruppe nicht nur technisches Wissen bereit, sondern liefert auch hochspezialisierte Anlagen.

An Orten, in denen Erzeugnisse der Monheim-Gruppe gefertigt, vertrieben oder Geschäftsbeziehungen angeknüpft werden sollen, sind häufig Leihgaben aus dem Kunstbesitz des Aufsichtsratsvorsitzenden Peter Ludwig anzutreffen (*Nationalgalerie* in Ost-Berlin, Polen, Schweiz, Frankreich, Österreich, Saarbrücken, Aachen, geplant in der UdSSR).

Prof. Dr. Dr. h. c. Peter Ludwig
Aufsichtsratsvorsitzender der
Leonard Monheim AG.

Stiftungen sind jährlich zu 10 Prozent des Einkommens steuerabzugsfähig

Peter Ludwig unterbreitete dem Bund, dem Land Nordrhein-Westfalen und der Stadt Köln im Sommer 1980 einen gemeinsam erarbeiteten Entwurf einer *Urkunde über die Errichtung der Stiftung Ludwig zur Förderung der bildenden Kunst und verwandter Gebiete* mit dem Sitz in Köln nebst einer Satzung. Das Dokument ist das Ergebnis fast einjähriger Gespräche zwischen den drei öffentlichen Partnern der projektierten Stiftung und Peter Ludwig.

Die Stiftungspläne blieben der Öffentlichkeit verborgen, bis der *Kölner Stadt-Anzeiger* sie dank einer Indiskretion am 6. September publizierte.

Dem Stiftungsentwurf zufolge beabsichtigen die Eheleute Irene und Peter Ludwig, Kunstwerke in die Stiftung einzubringen, die in einer Anlage aufgeführt sein sollen. Über den Inhalt der Anlage ist öffentlich nichts bekannt.

Soweit das Stiftungsgut ausgeliehen ist, würde die Stiftung in die Rechte und Pflichten der Stifter als Verleiher eintreten. Irene und Peter Ludwig beabsichtigen, auch ihren künftigen Kunsterwerb der Stiftung zuzuwenden.

Der Umfang und der Wert des Stiftungsgutes ist bis zur Offenlegung einer Liste nicht einzuschätzen. Es wird spekuliert, es handele sich um die mittelalterlichen Werke, die sich als Dauerleihgabe im Kölner *Schnütgen-Museum* befinden (Schätzwert DM 100 Mio), um präkolum-

bianische, afrikanische und ozeanische Kunst, die im *Rautenstrauch-Joest-Museum* in Köln aufbewahrt werden, und um Werke moderner Kunst, die an zahlreiche europäische Museen ausgeliehen sind.

Für 10 Jahre wird den Eheleuten Ludwig ein Einspruchsrecht zugebilligt *»in Fragen der Disposition über den vom Ehepaar Ludwig eingebrachten Kunstbesitz«*.

Dauerleihgaben in Museen ersparen dem Leihgeber die Kosten der sachgerechten Lagerung, Pflege, konservatorischen Betreuung und Sicherung seines Kunstbesitzes. Die wissenschaftliche Erschließung der Werke sowie ihre Ausstellung und Publikation in Katalogen und Besprechungen erhöhen ihren Wert.

Solange Kunstbesitz öffentlich zugänglich gemacht wird, ist er von der Vermögensteuer (jährlich 0,5 % ihres Wertes) befreit.

Eine Stiftung kann jährlich zu 10 % des insgesamt zu versteuernden Jahreseinkommens abzugsfähig sein. Es ist manchmal möglich, diese Vergünstigungen auf mehrere Jahre zu verteilen.

Kunstbesitz ist erbschaftsteuerpflichtig. Für den überlebenden Ehegatten entfällt bei einer Stiftung von über DM 100 Millionen eine Steuerschuld von 35 % des Wertes: DM 35 Millionen.

Arbeiterinnen in einem Werk
der Leonard Monheim AG.

NOVESIA
De Beukelaer

Die Monheim-Gruppe übernahm 1978 von der *General Buiscuit Co.* 75 % der Anteile der belgischen *General Chocolate N.V./S.A.* für einen Gesamtpreis von bfrs. 350 Millionen. Die restlichen Anteile verblieben im Besitz der deutschen *P. F. Feldhaus-Novesia* in Neuß.

General Chocolate stellt in Herentals (Belgien) und in Neuß Schokoladenerzeugnisse her, die unter der Marke *Novesia/De Beukelaer* vornehmlich in den Benelux-Ländern, der Bundesrepublik und Frankreich vertrieben werden. Zur Zeit der Übernahme beschäftigten die beiden Produktionsstätten jeweils 500 Arbeiter und Angestellte. Das Umsatzvolumen betrug rund DM 200 Millionen.

Im Anschluß an den Erwerb der Aktienmehrheit durch die Monheim-Gruppe beschloß das Ministerium für flämische Regionalwirtschaft bei einer Darlehensaufnahme von bfrs. 478 Millionen (knapp DM 32 Millionen) eine direkte Unterstützung in Form von Zinszuschüssen und Kapitalprämien von bfrs. 68 Millionen für die Modernisierung und Rationalisierung der Betriebsanlagen in Herentals zu gewähren.

Außerdem stellte die halbstaatliche Gesellschaft für Kreditgewährung an die Industrie ein vom Staat garantiertes Darlehen von bfrs. 288 Millionen bereit. Das belgische Tochterunternehmen sollte auch für drei Jahre in den Genuß gewisser Steuererleichterungen kommen.

Die Monheim-Gruppe beabsichtigte, aus eigenen Mittel bfrs. 310

Millionen zu investieren.

1979 wurde die Beteiligung der Monheim-Gruppe an *General Chocolate* auf 100 % aufgestockt. Damit gelangten auch die deutschen Beteiligungsgesellschaften *Novesia-Schokolade GmbH* und *Meurisse Schokolade GmbH* in Neuß völlig in den Monheim-Einflußbereich.

Die Konzernleitung beschloß 1980, die *Novesia*-Betriebsstätten in Neuß (Umsatz im Geschäftsjahr 1979/80 rund DM 80 Millionen) stillzulegen und ihre Produktion der *Goldnußtafeln* und *Goldnuß Pärchen* in anderen Monheim-Werken rationeller fortzusetzen. 350 Arbeitnehmer sind davon betroffen.

Im belgischen Herentals werden unter anderem die *Melo Cakes, Leo, Ascot, Big Nuts, BiBiP* und *Alu*, vornehmlich gefüllte Schokolade oder mit Schokolade überzogene Waffeln, hergestellt. Der Vertrieb von *Alu* und *Leo* geschieht vor allem durch Automaten.

Prof. Dr. Dr. h. c. Peter Ludwig
Aufsichtsratsvorsitzender der
Leonard Monheim AG.

Wehe der (Kunstmarkt-) Koje, an
der er vorbeigegangen ist

Peter Ludwig
über sich selber

In der Satzung der von Peter und Irene Ludwig vorgeschlagenen und zusammen mit dem Bund, dem Land Nordrhein-Westfalen und der Stadt Köln geplanten *Stiftung Ludwig* heißt es:

»Für Stiftungszwecke betreibt die Stiftung das Museum Ludwig in Köln, das sie verwaltet und erhält.«

»Der Stiftungsrat entscheidet besonders über die Berufung und Abberufung des ... Direktors des Museums Ludwig.«

Im Falle der Stiftungsauflösung *»fallen das Grundstück des Stiftungsmuseums und die Gegenstände, die ihren gewöhnlichen Standpunkt in Köln haben, der Stadt Köln ohne Gegenleistung zu«*.

Daraus folgt, daß die Stadt Köln sich – für die Dauer der Stiftung – ihrer Verfügungsgewalt über ihre Sammlung der Kunst des 20. Jahrhunderts entledigt. Betroffen wären nicht nur die Pop Art Sammlung, welche die Eheleute Ludwig 1976 geschenkt hatten, sondern auch die dem *Wallraf-Richartz-Museum* von Kölner Sammlern geschenkten Werke, die in das *Museum Ludwig* integriert worden sind, sowie die Eigenerwerbungen des Museums.

Der Neubau des *Museums Ludwig* (Baukosten DM 219 Millionen) soll anscheinend ebenfalls der *Stiftung Ludwig* übereignet und möglicherweise seine Unterhalts- und Personalkosten von ihr übernommen werden.

In der Satzung ist ferner für die Stiftung *»von der Stadt Köln zur Verfügung gestellten Beamtenplanstellen der Stadt«* die Rede.

Die öffentlichen Stiftungspartner sprechen von jährlichen Beitragszahlungen – auch der Stadt Köln –, die zumindest am Anfang mehrere Millionen DM betragen sollen (der Ankaufsetat der 8 Kölner Museen beläuft sich auf DM 1,1 Mio.).

Die Vertreter der Stadt Köln gehören zu den entschiedensten öffentlichen Verfechtern der *Stiftung Ludwig*. Pressekommentaren zufolge befürchten sie, die Eheleute Ludwig zögen ihre umfangreichen Leihgaben – entgegen einem ausdrücklichen früheren Versprechen – ab, wenn die von ihnen projektierte *Stiftung Ludwig* nicht zustande kommt. Peter Ludwig hatte einmal angedeutet: *»Es gibt vielleicht noch andere Regierungen, mit denen man auch sprechen kann und auch spricht.«*

Köln erhofft sich aber auch, daß durch ihre Beteiligung in der Stiftung ein Teil der erheblichen Bau- und Folgekosten des neuen *Museums Ludwig* von Bund und Land mitgetragen werden.

Der Generaldirektor der Kölner Museen, Hugo Borger, spricht auch von einer wünschenswerten künstlerischen *»Oberzentrumsfunktion«* der Stadt. Einhellig sagen die städtischen Vertreter: *»Ohne Ludwig geht hier nichts mehr.«*

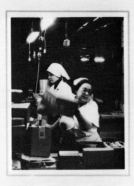

Arbeiterin in einem Werk
der Leonard Monheim AG.

Die Zusammenarbeit der Monheim-Gruppe mit der schweizerischen *Lindt & Sprüngli* geht in die Zeit vor dem 2. Weltkrieg zurück. Monheim hält gegenwärtig jeweils 80 % der Anteile von *Lindt & Sprüngli GmbH, Aachen,* und *Lindt & Sprüngli BV. Niederlande.* Die Restanteile verbleiben beim Stammhaus, der *Lindt & Sprüngli AG, Kilchberg/Schweiz.*

In Lizenz werden von Monheim *Lindt*-Erzeugnisse, Pralinen, Tafelschokolade und Saisonartikel, für den deutschen und niederländischen Markt produziert (geschätzter Umsatz 1979/80 sfrs. 195 Millionen = ein Drittel des *Lindt*-Weltumsatzes).

Die Monheim-Gruppe hatte auch mit der englischen *John Mackintosh and Sons Ltd.* und der amerikanischen *Peter & Paul, Inc.* Lizenzproduktions- und Vertriebsabkommen.

Erzeugnisse der Marke *Lindt* werden vornehmlich in einem Werk in der Aachener Innenstadt hergestellt, wo sich auch die Monheim-Verwaltungszentrale befindet.

Einem Aachener Gerücht zufolge beabsichtigte Monheim 1977 die Verlagerung eines Teiles seiner Produktion in ein Zweigwerk bei Saarlouis. Damit wären 1000—1800 Arbeitsplätze in Aachen verlorengegangen.

Die Konzernleitung erklärte dagegen zur gleichen Zeit, sie bemühe sich vielmehr darum, die Fertigung nach Aachen-Süsterfeld zu verlegen und die dort existierende Betriebsstätte zu erweitern:

«Dazu bedarf es beträchtlicher Mittel. Eine Konzentration der Aachener Betriebsstätten in Süsterfeld müßten vom Land und von der Stadt bezuschußt werden.»

Die Stadt Aachen entschloß sich im selben Jahr, das 20 000 qm große Areal in der Innenstadt zum Sanierungsgebiet zu erklären und für den Bau von Einfamilienhäusern mit Gärten zu erwerben.

Für die Aufgabe des Werkes im Stadtzentrum und als Erstattung der mit der Verlagerung anfallenden Kosten wird Monheim aus öffentlichen Mitteln eine Entschädigung von DM 45,7 Millionen gezahlt. 75 % der Summe werden vom Land Nordrhein-Westfalen getragen.

Monheim beabsichtigte, einen Teil seines für 1980 vorgesehenen Investitionsvolumens von DM 60 Millionen für den Bau des neuen Werkes und eines Verwaltungsgebäudes zu verwenden. Durch höhere Automatisation soll die Fertigung kostensparend rationalisiert werden. Der Bau in Aachen-Süsterfeld wird voraussichtlich bis Ende 1982 vollendet sein.

Prof. Dr. Dr. h. c. Peter Ludwig
Aufsichtsratsvorsitzender der
Leonard Monheim AG.

Auch Mäzene haben ihren Preis Peter Ludwig

Die Satzung der von Peter und Irene Ludwig vorgeschlagenen und zusammen mit dem Bund, dem Land Nordrhein-Westfalen und der Stadt Köln geplanten *Stiftung Ludwig* nennt als Aufgaben der Stiftung:
1. *Pflege, Betreuung und Verwaltung des Kunstbesitzes der Stiftung.*
2. *Erweiterung des Kunstbesitzes und Sicherung wertvollen deutschen Kunstgutes im Sinne von Absatz 1 gegen Abwanderung ins Ausland.*
3. *Wissenschaftliche Erschließung des Kunstbesitzes der Stiftung.*
4. *Konzeption und Durchführung von Kunstausstellungen.*
5. *Förderung von regionalen, überregionalen und internationalen Maßnahmen im Bereich der bildenden Kunst einschließlich verwandter Gebiete.*

Im Stiftungsrat sitzen Peter und Irene Ludwig, zwei von ihnen benannte Personen sowie jeweils vier vom Bund, vom Land und von der Stadt Köln benannte Mitglieder. *Der Vorsitzende ist Peter Ludwig.* Der Stiftungsrat faßt seine Beschlüsse mit einfacher Mehrheit, bei Stimmengleichheit entscheidet der Vorsitzende.

Für 10 Jahre steht Peter und Irene Ludwig »ein Einspruchsrecht gegen Beschlüsse des Stiftungsrates zu, soweit diese Fragen der Dispositionen über den vom Ehepaar Ludwig eingebrachten Kunstbesitz betreffen«.

Kritiker der *Stiftung Ludwig* weisen auf die kunstpolitische Macht hin, die dem Privatmann Peter Ludwig durch die tonangebende Position in einer öffentlich finanzierten Stiftung zufallen würde. Der

Sammler sagt selber: »*In solchen Gremien muß ja ein Konsensus herbeigeführt werden. Da traue ich mir allerdings zu, daß mein Fach- und Sachverstand ein Gewicht haben.*«

Man befürchtet, daß die numerische Überlegenheit der öffentlichen Vertreter im Stiftungsrat wegen ihrer widersprüchlichen Interessen und der großen Abhängigkeit der Stadt Köln von Peter Ludwig wenig Gewicht habe. Das Vetorecht des Sammlerehepaars und die doppelte Stimme des Vorsitzenden bei Stimmengleichheit bekräftige seine dominierende Stellung.

Seinen Einfluß auf den Kunstmarkt beurteilt der Sammler so: »*Der Markt für Pop Art ist entscheidend durch die Aktivitäten des Ehepaars Ludwig geprägt worden.*«

Die Kombination der Finanzkraft der Stiftung mit seiner eigenen gäbe Peter Ludwig im Ausstellungswesen, bei kunstpolitischen Entscheidungen und auf dem Kunstmarkt eine Machtfülle, mit der er das Kunstgeschehen international noch mehr als bisher entscheidend in seinem Sinne steuern könnte.

Arbeiterinnen in einem Werk
der Leonard Monheim AG.

Der *Trumpf*
Pralinenmeister

Die Monheim-Gruppe vertreibt unter ihrer Hausmarke *Trumpf* Tafel-schokolade, *Schogetten*, Pralinen, Kakao, Saisonartikel und Kaubon-bons. Die Fertigung erfolgt durch Tochtergesellschaften in Aachen, Quickborn bei Hamburg, Saarlouis und der seit 1979 unter neuem Namen selbständig operierenden *Trumpf-Schokolade- und Kakaofabrik Berlin GmbH.*

Die in der Vergangenheit völlig zu Monheim gehörende Berliner Gesellschaft ist 1979 zu 51 % an die neugegründete selbständige *Trumpf Berlin GmbH* veräußert worden, die ihrerseits den Kauf durch Ausgabe atypischer stiller Beteiligungen an Private finanzierte. Auf diese Weise sind Monheim 1979 rund DM 100 Millionen zugeflossen, die das Unternehmen »steuerneutral« (Ludwig) verwandte.

Dazu boten sich Investitionen an (in Berlin für 1980 DM 25 Millionen geplant) sowie die Anlage in steuerbegünstigten Berlindarle-hen (12 % des Darlehens bis zu 50 % der Jahressteuerschuld abzugsfä-hig). Außerdem wurden Rücklagen gebildet und Abschreibungen auf Rohkakaobestände und -Kontrakte getätigt.

Das Werk in Berlin-Neukölln ist 1953 gegründet und Anfang der 70er Jahre erheblich vergrößert und modernisiert worden. Dabei ka-men Monheim die Vergünstigungen der Berlinförderung zugute: die 75%ige Sonderabschreibung von Sachanlagen im 1. Jahr (in der BRD 2−3 %), öffentliche Investitionszuschüsse von 10 % oder mehr der Anlagekosten, beim Warenverkauf in die Bundesrepublik eine Um-satzsteuerpräferenz von 4,5−6,2 % und andere Steuererleichterungen.

In der DDR werden *Trumpf*-Markenartikel aufgrund von Gestat-tungsverträgen aus dem Jahre 1974 hergestellt. Die Erzeugnisse sind fast ausschließlich in Intershops und Delikatläden erhältlich und wer-den zum Teil auch exportiert.

Monheim übernimmt und vertreibt die Erzeugnisse der *Trumpf Berlin GmbH* (u. a. *Schogetten*). Außer von Kaufhäusern werden *Trumpf*-Waren in sehr großen Posten von Aldi abgenommen.

Bekannte Namen auf dem Markt sind außer den 1966 eingeführ-ten *Schogetten* unter Pralinen *Edle Tropfen in Nuß, Gute Geister in Nuß, Frische Fruchtschlückchen, Marzipanstars, Wappenklasse, Tradition* und *Klassik.*

Auf dem deutschen Markt hat Monheim mit allen Marken insge-samt bei Tafelschokolade einen Anteil von 18 %, bei Pralinen von 25 % und bei Saisonartikeln ebenfalls 25 %. Der ausgewiesene Kakaogehalt der Produkte bewegt sich zwischen 25 % und 54 %.

Von der Welternte an Kakaobohnen verarbeitet Monheim 5 % (70 000 Tonnen) bei einer Jahresproduktion von 100 000 Tonnen (1980). Im Geschäftsjahr 1978/79 lagerte das Unternehmen Rohstoffe im Werte von DM 246,6 Millionen.

Prof. Dr. Dr. h. c. Peter Ludwig
Aufsichtsratsvorsitzender der
Leonard Monheim AG.

Nichts liegt uns ferner als kulturpolitische Macht Peter Ludwig

Die Satzung der von Peter und Irene Ludwig vorgeschlagenen und zusammen mit dem Bund, dem Land Nordrhein-Westfalen und der Stadt Köln geplanten *Stiftung Ludwig* sieht eine finanzielle Beteiligung der drei öffentlichen Partner am Stiftungsvermögen vor. Über ihre Höhe gibt sie keine Auskunft.

Der Kölner Kulturdezernent Peter Nestler sagte dazu im März 1981: *»Nach dem augenblicklichen Stand wird die Stiftung jährlich ein Finanzvolumen von 14 Millionen haben.«* Dagegen nannte ein Vertreter der Landesregierung als *»Denkzahl«* einen Betrag von 2,7 Millionen, der von jedem der öffentlichen Stiftungspartner im ersten Jahr entrichtet werden solle.

Das Land Nordrhein-Westfalen hat 1981 seine traditionellen Zuschüsse von DM 3 Millionen an die kommunalen Ausstellungsinstitute um ein Drittel gekürzt. Infolgedessen können Ausstellungen nicht mehr wie geplant durchgeführt werden, und Kataloge können nicht erscheinen. Auch der Ankaufsetat der Landesgalerie Düsseldorf von DM 3 Millionen wurde trotz steigender Kunstpreise um eine Million beschnitten.

Die Leiter der betroffenen Institute hegen den Verdacht, die einschneidenden Kürzungen seien auf die 1982 zu erwartenden Zahlungen an die *Stiftung Ludwig* zurückzuführen. 15 kommunale Museumsdirektoren (Köln und Aachen ausgenommen) wandten sich deshalb in einem Protestschreiben *»mit großer Entschiedenheit . . . gegen eine von Bund und Land subventionierte Macht- und Finanzkonzentration«* in Köln. Sie fürchten, *»die auf lokalen Initiatoren gründende Vielgestaltigkeit der Museumslandschaft«* würde *»durch die Stiftung Ludwig schwerstens bedroht«.*

Die Beteiligung des Bundes erregt verfassungsmäßige Bedenken. Demnach beeinträchtige sie die Kulturhoheit der Länder und gäbe dem Bund ein kulturpolitisches Instrument, das ihm die Verfassung nicht zubilligt. Bayern denkt an eine Verfassungsklage.

Dagegen schlug Baden-Württemberg die Gründung einer verfassungsmäßig unbedenklichen *»Kulturstiftung der deutschen Bundesländer«* vor. Diese *»Einkaufsgenossenschaft der Bundesländer«* solle die Abwanderung wertvoller Werke der deutschen Kunst- und Kulturgeschichte in Fällen verhindern, in denen der Ankauf die finanziellen Kräfte eines einzelnen Museums übersteigt.

Die Abwanderung von Werken ins Ausland zu verhüten, ist aber auch eine der wesentlichen Aufgaben, denen die *Stiftung Ludwig* dienen soll. Es ist ebenfalls eines der Ziele der bisher nicht funktionsfähigen Nationalstiftung.

© 1981 Hans Haacke

Arbeiterin in einem Werk
der Leonard Monheim AG.

⊞ MAUXION

Die Monheim-Gruppe übernahm 1959 die *Schokoladenfabrik Mauxion KG* und stellt seither unter der Marke *Mauxion* Pralinen und Saisonartikel her. Nach dem 2. Weltkrieg entwickelte sich das Unternehmen folgendermaßen:

1951 Einrichtung eines Zweigwerkes in Quickborn bei Hamburg.

1952 Peter Ludwig geschäftsführender Gesellschafter. Eröffnung eines Werkes in Berlin-Neukölln (1979 Umwandlung in selbständige *Trumpf Berlin GmbH* mit 49 % Monheim Anteil).

1959 Erwerb einer Schokoladenfabrik in St. Hyacinthe bei Montreal (operiert seit 1974 unter dem Namen *Comet Confectionary Ltd.*).

1960 Angliederung der *A. Poser Schokoladenfabrik GmbH* in Saarlouis.

1969 Peter Ludwig Vorsitzender der Geschäftsleitung.

1971 Alleinproduktions- und Markenrechte für *van Houten*-Produkte. Übernahme der weltweiten *van Houten*-Vertriebsorganisation.

1974 Lizenzproduktion in der DDR und Polen.

1979 Übernahme aller Anteile der belgischen *General Chocolate NV/SA* mit Werken in Herentals (Belgien) und Neuß.

1980 Beteiligung an der neuerrichteten Kakao-Handelsgesellschaft *Eurobras BV*, Amsterdam. Kooperationsverhandlungen mit dem österreichischen *Konsum* und dem Lebensmittelkonzern *Julius Meindl AG*, Wien. Erschließung des österreichischen Marktes geplant, möglicherweise gemeinsamer Export in Ostblockländer.

Die Obergesellschaft *Leonard Monheim KG*, Aachen, wurde 1978 in eine Aktiengesellschaft umgewandelt.

Die ehemaligen Komplementäre Prof. Peter Ludwig, Dieter Monheim und Dr. Bernd Monheim aus der 3. Monheim–Generation halten «deutlich mehr als 50 %» des Grundkapitals von DM 41,5 Millionen. Die Aktien lauten auf den Namen und können nur mit Zustimmung der Gesellschaft übertragen werden. Sie verbleiben völlig in Familienbesitz.

Aufsichtsratsvorsitzender der *Leonard Monheim AG* ist Prof. Peter Ludwig.

Die Monheim-Gruppe umfaßt 24 inländische und 16 ausländische Beteiligungsgesellschaften. Im Geschäftsjahr 1979/80 betrug der Umsatz weltweit DM 1,358 Milliarden (rund 34 % außerhalb der Bundesrepublik).

Die inländischen Gewinne wurden mit insgesamt DM 19,4 Millionen besteuert. Wenn keine Nachzahlungen zu leisten waren, kann die Gewinnhöhe auf rund DM 34 Millionen geschätzt werden.

© 1981 Hans Haacke

Monheim AG, in which Ludwig and his wife held 53% of the shares and in which he served as chairman until the company was sold in 1986. The income from the Foundation's investment in the chocolate business is tax-exempt. The Foundation appears to have concentrated its activities on the promotion of art from East Germany, the Soviet Union, and Bulgaria, countries where Ludwig has or is suspected of pursuing business interests (for more on relations to Eastern Bloc countries, see background information accompanying *Broadness and Diversity of the Ludwig Brigade*). In 1983, Ludwig received an honorary doctorate from the Karl-Marx-University in Leipzig. In the following year he and his wife were given high Bulgarian decorations, and in 1985 they were both awarded doctorate degrees by the Art Academy in Sofia.

According to one press report, the capital raised through the sale of the illuminated manuscripts to the J. Paul Getty Museum was invested in a new chocolate factory in St. Albans, Vermont (a short drive from the Canadian Monheim subsidiary in St. Hyacinthe, Quebec), which started production in 1983.

The move of the company's headquarters and production facilities from the center of Aachen to a new plant on the city's outskirts (assisted by grants totaling more than DM 40 million from city and state), was also completed in 1983. Shortly after the relocation, 400 jobs were eliminated. During the same period, jobs were cut in the Berlin Trumpf factory, which had also been modernized with the infusion of public funds. Earlier, in 1981, the company had eliminated one-fourth of the jobs at its Quickborn (near Hamburg) plant and had made new investment there conditional on public grants.

In June 1986, the Leonard Monheim AG sold its license to produce and distribute Lindt chocolate products in Germany and the

Netherlands (sales, approximately DM 235 million) back to the Swiss chocolate concern for a reported DM 100 million. Ludwig's recently completed Lindt production facilities in Aachen were included in the sale to the newly formed Swiss Chokoladefabriken Lindt & Sprüngli GmbH, Aachen, in which Ludwig retains a 20% stake. The Trumpf label will no longer be made in Aachen. It is expected that 300 to 400 jobs will be lost.

Hardly a month later, Ludwig and the minority shareholders of the Leonard Monheim AG sold the entire company to the Swiss Jacob Suchard AG of Zurich. Ludwig retains his interests in the German labels Trumpf, Novesia, Regent, Mauxion, and, under license, van Houten. These brands are to be produced and distributed by the newly formed Ludwig Schokolade GmbH, Aachen, in plants it operates in Saarlouis and Quickborn, of which Ludwig is the sole owner. The factories in the U.S., Canada, Belgium, and West Berlin, as well as the international market of the van Houten label (sales, over DM 750 million), became the property of Suchard. The new owner has been said to cooperate with Ludwig and make Trumpf chocolates for him in Berlin. Other cooperative ventures are envisioned. This arrangement suggests that Ludwig's business with Eastern Bloc countries would continue. The Jacob Suchard group is now the largest chocolate maker in Germany. It replaces Ludwig in this position, who now ranks fourth, with estimated sales of DM 500 million and less than 2,000 employees (before: DM 1.9 billion; 5,500 employees). It is anticipated in Aachen that these changes will soon result in the additional loss of about 300 jobs. Experts of the industry say that Ludwig suffered from overcapacity, created through rapid expansion

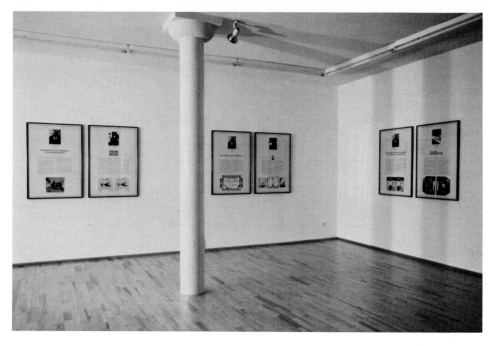

and modernization of equipment, and that long-term commitments to his major customer, the Aldi discount supermarket chain, did not permit him to raise prices to an adequate level.

Only a few weeks before the sale of his entire chocolate manufacturing facility in Aachen was announced, the city had agreed to accept a Ludwig proposal to establish a "world art center" in Aachen. It was assumed that this would require more than DM 40 million in public funds for the purchase of an old factory and its transformation into a museum. Leading members of the Aachen City Council have since expressed outrage and their feelings that they were hoodwinked. The question was raised whether under the new circumstances, the decision on building the museum should not be reversed.

The new Museum Ludwig was inaugurated in September 1986. It is housed together with the new quarters of the Wallraf-Richartz-Museum and a concert hall under the same roof. The complex took ten years to build and cost the city of Cologne about DM 273 million.

Maintenance costs are estimated to be DM 40 million a year. Two of the three exhibition floors of the museum complex are reserved for twentieth-century art (works from the Ludwig collection as well as works the city received from other donors or which it acquired out of its own resources). One floor houses the collection of the Wallraf-Richartz-Museum, covering 700 years. As stipulated in the contract that accompanied the Ludwig donation in 1976, a private studio, with shower, has been built into the museum for the donor. Also in accordance with this agreement, the new director of the Ludwig Museum, Siegfried Gohr, was chosen in consultation with Peter Ludwig (he was given a contract limited to six years, unique in West Germany). His predecessor, Karl Ruhrberg, had resigned in 1984. Ruhrberg has been quoted saying that he "was often close to tears" when he thought about the "high quality works one could have acquired" with the money Ludwig spent on massive art purchases around the world.

Postcard, *Grüsse aus Aachen* [Greetings from Aachen] 1981/1982, 4 × 6″ (10.1 × 15.3 cm). Printed by Edition Staeck, Heidelberg. Text in lower left corner reads: "Change of Shift at Trumpf Chocolate Factory."

On the occasion of the new Ludwig Museum's opening, the collector presented to the world busts he had commissioned of himself and his wife from the sculptor Arno Breker. Breker was the most celebrated sculptor of the Nazi period. His musclemen, *The Party* and *The Armed Forces*, guarded the entrance to Hitler's chancellery in Berlin. Breker was also commissioned to create mammoth reliefs that were designed to be installed along the new north/south axis in Berlin, a parade route planned by Albert Speer as the commercial and ideological center of the "victorious" German Reich, but never realized. In 1939, the year Hitler began the war, Breker unveiled a statue of a naked Nordic youth drawing his sword—a Germanic version of Rambo—entitled *Readiness*. Throughout the war, the regime spared no resources in assisting Breker's service at the ideological home front.

In an interview on his portrait commission, Ludwig declared: "I think Breker is an interesting artist, a great portraitist." He went on to criticize German museums for not exhibiting art of the Nazi period and accused them of a "lack of liberality." Pointedly he said: "It is absurd to think that the visual arts stopped on January 30, 1933. But this is how our museums act today." A protest letter, signed by prominent German artists and heads of art institutions, reminded Ludwig and the public that artists who did not subscribe to the precepts of the Nazi ideology were not allowed to work in Hitler's Germany, that their works were destroyed and the artists driven into exile or murdered.

Peter Ludwig is a member of the International Council of the Museum of Modern Art and a major client of many well-known New York art galleries.

Translation:

1. Art Objects On Permanent Loan Are Exempt From Property Taxes

Peter Ludwig was born in 1925 in Koblenz, the son of the industrialist Fritz Ludwig (Ludwig Cement Factory) and Mrs. Helene Ludwig (née Klöckner).

After his military service (1943-45), he studied law and art history. In 1950, he received a doctorate with a dissertation on "Picasso's Image of Man as an Expression of his Generation's Outlook on Life." The dissertation focuses on relations between contemporary literature and the work of Picasso. Historical events get little attention.

In 1951, Peter Ludwig married a fellow student, Irene Monheim, and joined Leonard Monheim KG, Aachen, the business of his father-in-law. In 1952, he became managing partner; in 1969, president; and in 1978, chairman of the Leonard Monheim AG, Aachen. Peter Ludwig is represented on the boards of directors of Agrippina Versicherungs-Gesellschaft and Waggonfabrik Uerdingen. He is the chairman of the regional council of the Deutsche Bank AG for the district Cologne-Aachen-Siegen.

Peter and Irene Ludwig have been collecting art since the beginning of the 1950s. At first they collected primarily ancient, medieval, and Pre-Columbian art. Since 1966, they have been concentrating on modern art: Pop Art, Photorealism, Pattern Painting, art from East Germany, and the "New Expressionists." Since 1972 Peter Ludwig has been an adjunct professor at the University of Cologne and holds seminars in art history at the Museum Ludwig.

Permanent loans of modern art are located at the Museum Ludwig, Cologne, the Neue Galerie-Sammlung Ludwig and the Suermondt-Ludwig-Museum in Aachen, the national galleries in West and East Berlin, the Kunstmuseum Basel, the Centre Georges Pompidou in Paris, and the state museums in Saarbrücken and Mainz. Medieval works are housed at the Schnütgen Museum in Cologne, the Couven Museum in Aachen, and the Bavarian state gallery. The Rautenstrauch-Joest Museum in Cologne has Pre-Columbian and African objects, as well as works from Oceania.

In 1976, the Wallraf-Richartz-Museum of Cologne (now Museum Ludwig) received a donation of Pop Art. The Suermondt-Museum of Aachen (now Suermondt-Ludwig-Museum) was given a collection of medieval art in 1977. A collection of Greek and Roman art which includes permanent loans located in Kassel, Aachen, and Würzburg, was donated to the Antikenmuseum Basel (now Antikenmuseum Basel and Museum Ludwig). In 1981, a collection of modern art was brought into the Austrian Ludwig Foundation for Art and Science.

Peter Ludwig is a member of the Acquisitions Committee of the state gallery of Düsseldorf, the International Council of the Museum of Modern Art, New York, and the Advisory Council of the Museum of Contemporary Art, Los Angeles.

2. Regent

Under the "Regent" label, the Monheim Group distributes milk chocolate and assorted chocolates, mainly through the low-priced "Aldi" chain store and vending machines.

The production takes place in Aachen, where the company employs 2,500 people in two factories. It also has its administrative headquarters there. About 1,300 employees work in the Saarlouis plant, some 400 in Quickborn, and approximately 800 in West Berlin.

As it did ten years earlier, Monheim had in 1981 a total of some 7,000 employees (sales tripled over the same period); 5,000 of these are women. The blue collar work force numbers 5,400, of which two-thirds are unskilled. In addition, the company employs approximately 900 unskilled seasonal workers.

The labor union Nahrung-Genuss-Gaststätten negotiated wages ranging from DM 6.02 (scale E = assembly line work, under eighteen years) per hour to DM 12.30 (scale S = highly skilled work). According to the union contract, the lowest salary amounts to DM 1,097.- per month, and the highest salary scale stipulates a minimum of DM 3,214.-.

The overwhelming majority of the 2,500 foreign workers are women. They come predominantly from Turkey and Yugoslavia. However, foreign workers are also hired by agents in Morocco, Tunisia, Spain, and Greece (price "per head": DM 1,000.- in 1973). Another contingent of foreign workers crosses the border daily from nearby Belgium and Holland.

The company maintains hostels for its female foreign workers on its fenced-in factory compound in Aachen, as well as at other locations. Three or four women share a room (the building of hostels for foreign workers is subsidized by the Federal Labor Agency). The rent is automatically withheld from the worker's wage. The company keeps a check on visitors to these hostels and, in fact, turns some away. The press office of the Aachen Diocese and the Caritas Association judged the living conditions as follows: "Since most of the women and girls can have social contacts only at the workplace and in the hostels, they are practically living in a ghetto."

Female foreign workers who give birth reportedly have to leave the hostel because Monheim does not have a day care center, or they must find a foster home for the child at a price they can hardly afford. Another option would be to offer their child for adoption. "It should be no problem for a big company which employs so many girls and women to set up a day care center." The personnel department retorted that Monheim is "a chocolate factory and not a kindergarten." They added that it would be impossible to hire kindergarten teachers; the company is not a welfare agency.

3. We Do Not Work With Threats (Peter Ludwig)

In 1968, Peter and Irene Ludwig gave the Wallraf-Richartz-Museum in Cologne a collection of modern art (which consisted mainly of Pop Art) on permanent loan. In 1976, this collection was donated to the city of Cologne on the condition that the city build a museum for the art of the twentieth century. The museum was to be called Museum Ludwig.

"In the event that the completion and opening of the Museum Ludwig by July 9, 1985 cannot be assured, Mr. and Mrs. Ludwig, or their survivors, are entitled to withdraw from this agreement and to demand the return of all art works donated under this agreement." July 9, 1985, is Peter Ludwig's sixtieth birthday.

The construction of the museum has begun on a site between the cathedral and the Rhine. In 1980, the building costs were officially given as DM 219 million. The reshaping of the area around the museum, made necessary by the construction, is likely to drive up the costs to well over DM 300 million. The yearly expenses for maintenance and personnel are estimated at approximately DM 10 million.

Independent from the building plans, all works of art from 1900 to the present, including all donations from Cologne collectors, were immediately to be removed from the administration of the Wallraf-Richartz-Museum and incorporated into the newly founded Museum Ludwig. For the time being, the new museum is housed in the

building of the Wallraf-Richartz-Museum. New acquisitions of modern art are also to become part of the Museum Ludwig.

Moreover, in the contract covering the donation, the following was agreed upon: "Appointments for the position of director [of the Museum Ludwig], as well as the professional staff of the Museum Ludwig, are made after consultation with Mr. and Mrs. Ludwig or the surviving spouse. Prof. Dr. Ludwig and his wife are being fully apprised of the museum's ongoing work (e.g., exhibitions, acquisitions, publications)."

Twice yearly a meeting is to be held with Mr. and Mrs. Ludwig in which "the entire work of the Museum Ludwig is discussed in detail."

Regarding the value of the donation, Peter Ludwig declared: "That the collection is now worth 45 million is to be attributed mainly to its long-term exhibition in such a prominent institution as is the Wallraf-Richartz-Museum. I did not pay more than 5 million for the paintings and objects."

Peter Ludwig was made an honorary citizen of the city of Cologne.

4. Comet Confectionary Ltd./ La Confiserie Comète Ltée.

In 1959, the Monheim Group acquired a chocolate factory from the Kambly Company in Ste. Hyacinthe, near Montreal. In the beginning, the Canadian subsidiary produced chocolate bars and seasonal articles under the name Regent Chocolate Ltd. After expansions in 1968 and 1970, the plant covered an area of 9,000 square meters.

In 1974, salmonella poisonings occurred after the consumption of Regent chocolate bunnies, Christmas balls, and "Crunch Breakups" (milk chocolate especially made for Woolworth in Toronto). The health authorities of Canada and the U.S. stopped the sale of Regent products. A recall was ordered on all items which had already been distributed to retailers. The plant was

closed for detoxification. Production was resumed after half a year under the new name of Comet Confectionary Ltd./Confiserie Comète Ltée. The new company was capitalized with DM 5.3 million. Favorable terms on loans totaling Can$ 4.25 million from the Quebec Industrial Development Corp. and the Department of Regional Economic Expansion— in part interest-free—as well as reserves of the subsidiary facilitated its reopening.

In 1973, the employees (mostly women and unskilled) were paid an hourly wage which hardly exceeded the legally established minimum wage of Can$ 1.85. In 1974, while the plant was closed, they organized themselves into a union, the Syndicat des Salariés de la Confiserie Comète Ste. Hyacinthe (CSN).

There was a strike at Comet before the conclusion of the third union contract in 1979. This two-year contract established a minimum wage of Can$ 5.00. The highest wage amounted to $7.51 per hour. Depending on the season, the number of employees fluctuates between 200 and 500.

Comet distributes its products under the names "Comet," "van Houten," and the house labels of numerous companies in Canada and the United States, for which it produces anonymously (e.g., Dalt, Orion, Sara Lee). For years, more than half of the production, particularly seasonal articles, has been exported to the United States. Comet also handles the distribution of van Houten products from Europe on the Canadian market.

The Monheim management has been consistently pleased with the results of Comet. In 1979-80 sales rose by 31.7% to Can$ 35 million. Net income increased by 40.9% to $0.8 million. It was not paid out, but, rather, reinvested in the company.

5. Through Donations A Spouse's Payment Of 35% Inheritance Tax Is Avoided

The Neue Galerie-Sammlung Ludwig of the city of Aachen usually shows Peter Ludwig's new acquisitions and often does so in programmatic exhibitions. It is also the starting point for traveling exhibitions and permanent loans to other museums. The museum's director works closely with the collector.

In 1977, twenty-two works from Aachen went on permanent loan to the Nationalgalerie in East Berlin. In return, newly acquired paintings from East Germany were exhibited in Aachen.

In 1978, Aachen also organized an exhibition for the Museum of Modern Art in Teheran (until the Shah's ouster, a cousin* of the empress was the director). The Centre Georges Pompidou and other European museums also received important loans from Aachen.

Since 1976, the city of Aachen has been planning to induce Peter Ludwig, through the building of a new museum, to leave his collection permanently in Aachen. As of 1982, a new building is to be erected on Monheim Allee, at a cost of DM 40 million. The estimated date of completion is 1985, when the collector celebrates his sixtieth birthday. He has not committed himself to leaving his collection in Aachen.

When, in 1976, the city raised its relatively low business tax, Peter Ludwig (a Christian Democrat) threatened: "There has to be an end to treating us like idiots . . . With increases in taxes I certainly do not want a museum!"

In 1979, he gave an important part of the Aachen collection on permanent loan to the newly founded Museum of Modern Art in Vienna. Dr. Dieter Ronte, who had been supervising the con-

struction of the Museum Ludwig in Cologne, was appointed director of the museum in Vienna.

In 1981, a selection of 161 works, at a stated value of s.150 million (approximately $5 million), was entered into a newly founded Austrian Ludwig Foundation for Arts and Sciences. The Republic of Austria pledged to contribute s.150 million for acquisitions, exhibitions, and other purposes of the Foundation.

On the board of the Foundation are Peter and Irene Ludwig, together with two members of their choice. Austria is also represented by four members. The chairmanship alternates yearly between Peter Ludwig and a representative of Austria. For ten years Mr. and Mrs. Ludwig retain a veto over the disposition of the works they donated (exhibitions, loans, etc.).

Mrs. Irene Ludwig was appointed professor in Vienna. Peter Ludwig became an honorary citizen of the city.

*(corrected from German text, which reads "stepbrother")

6. Van Houten

In 1971 the Monheim Group acquired the rights for the production, trademark, and distribution of van Houten products worldwide, from the American Peter & Paul Inc.

Since then, the van Houten subsidiaries have handled the Monheim Group's entire export through totally owned marketing organizations in Germany, France (sales in 1979-80, Fr. 122.7 million), the United Kingdom, Canada, and the United States.

East Asia and East Germany are also important trading partners. The market is to be expanded into the Soviet Union and other Eastern Bloc countries. Moreover, negotiations for cooperative ventures have been started to open up the Austrian market for Monheim products. Approximately 34%

(DM 403 million) of the company's sales for 1979-80 were achieved outside West Germany.

Aside from its business with brand-name products, van Houten also makes cocoa butter, cocoa powder, and other semifinished products for the chocolate industry. The Monheim Group's total investment for the production of cocoa powder and cocoa butter between 1971 and 1974 in West Berlin alone amounted to DM 60 million. This investment in plant and equipment was essentially financed through the advantageous provisions of the Berlin Aid Act (special depreciation allowances, outright grants, and other tax advantages).

In 1973, the Monheim Group signed a contract for cooperative ventures with AGROS, the state import/export agency of Poland. As a consequence of this agreement, the Cracow chocolate factory, Wawel, began production of van Houten chocolate bars under license in 1975. Part of the output is being exported.

In 1974, licensing agreements for the production of van Houten instant chocolate milk were also entered into with the East German trading organization. Since then, East German schools receive the chocolate drink "Trinkfix." Otherwise, Monheim products can be found only in "Intershops" (foreign currency stores) and "Delikatläden" (high price stores for luxury items). Part of the production is exported to West Germany and other destinations. For the production in Poland and East Germany, the Monheim Group not only makes available its technical know-how, but also provides highly specialized equipment.

Loans of art works from Peter Ludwig, the group's chairman, are frequently to be found in places where Monheim products are made or distributed, or where business relations are to be established (e.g., Nationalgalerie in East Berlin, Poland, Switzerland, France, Austria, Saarbrücken, Aachen, and, in the planning stage, the Soviet Union).

7. Donations Are Tax-Deductible Up To 10% Of The Yearly Income

In 1980, Peter Ludwig submitted to the federal government, the state of North Rhine-Westphalia, and the city of Cologne, a draft "Document on the Establishment of the Ludwig Foundation for the Promotion of the Visual Arts and Related Fields." Bylaws were attached. The document was the result of year-long discussions between Peter Ludwig and the three public partners of the proposed Foundation. The public was kept in the dark about the plans for this Foundation until, on September 6, 1980, they were disclosed in the *Kölner Stadt-Anzeiger* (local newspaper), due to a leak.

According to the draft document, Mr. and Mrs. Ludwig intend to donate art works to the Foundation; these are to be listed in an appendix. The contents of this appendix are not known.

As for art works on permanent loan, the Foundation would assume the rights and duties of the donor in his capacity as lender. Peter and Irene Ludwig intend to donate to the Foundation all their future art acquisitions.

Until the publication of the contents of the donation, its size and value cannot be judged. It is being speculated that it would include the medieval works which are now on permanent loan to the Schnütgen Museum of Cologne (estimated value DM 100 million). Also Pre-Columbian, African, and Oceanic art, which is housed in the Rautenstrauch-Joest Museum of Cologne, is supposedly being considered, as well as a collection of modern works which are on loan to numerous museums in Europe.

For ten years Mr. and Mrs. Ludwig are granted veto power "in questions relating to the disposition of art works brought in by Mr. and Mrs. Ludwig."

The permanent loan of his art work saves the lender the necessary expenses for the proper storage, care, protection, and curatorial services for his property. Scientific research on the works, as well as their exhibition and publication in catalogues and articles, increases their value.

As long as art works are accessible to the public, they are exempt from property tax (0.5% of their value every year). A donation is deductible up to 10% of the yearly taxable income. In the case of large donations, these deductions can be distributed over several years. Art works are affected by inheritance taxes. In the case of a donation of more than DM 100 million, the surviving spouse does not have to pay inheritance tax on 35% of the value, i.e., DM 35 million.

8. Novesia De Beukelaer

In 1978, the Monheim Group acquired, for a total of Bfrs. 350 million, 75% of the shares of the Belgian General Chocolate NV/SA from General Biscuit. The remaining shares stayed with P.F. Feldhaus-Novesia of Neuss (West Germany).

In Herentals (Belgium) and in Neuss, General Chocolate makes a variety of chocolate products which are mainly distributed in the Benelux countries, in Germany, and in France. At the time of the takeover, the two plants had 500 employees each. Total sales amounted to approximately DM 200 million.

Following the Monheim Group's acquisition of the majority of the shares, the ministry for the Flemish economy decided to provide grants totaling Bfrs. 68 million to support payment of interest and capital on loans of Bfrs. 478 million. These loans were earmarked for the modernization of the plant in Herentals. In addition, the semi-government Industrial Credit Corporation gave government-backed loans of Bfrs. 288 million. For three years the Belgian subsidiary was also

granted certain tax exemptions. The Monheim Group planned to invest Bfrs. 310 million of its own.

In 1979, the Monheim Group acquired the rest of the shares which were still outstanding. Thus, the German subsidiaries Novesia Schokolade GmbH and Meurisse Schokolade GmbH of Neuss came totally under Monheim control.

In 1980, management decided to close down the Novesia facilities in Neuss (sales in 1979-80 approximately DM 80 million) and to continue production of the "Goldnusstafeln" and "Goldnuss Pärchen" more efficiently in other Monheim plants. Three hundred and fifty employees are affected.

Among the products coming out of Herentals (Belgium) are "Melo Cakes," "Leo," "Ascot," "Big Nuts," "BibiP," and "Alu," mostly filled milk chocolate wafers. "Alu" and "Leo" are widely distributed through vending machines.

9. Woe The (Art Fair) Stand That He Passed By (Peter Ludwig About Himself)

In the bylaws of the Ludwig Foundation, which was proposed by Peter and Irene Ludwig and jointly planned by the federal government, the state of North Rhine-Westphalia, and the city of Cologne, it states: "For purposes of the Foundation, the Foundation administers and supports the Museum Ludwig in Cologne."

"The board of the Foundation, in particular, decides the hiring and firing of . . . the directors of the Museum Ludwig."

If the Foundation is dissolved, "the site of the Foundation-Museum and the objects which are normally located in Cologne will become the property of the city of Cologne without compensation." From this it would follow that— for the duration of the Foundation—the city of Cologne would give up the

rights over its collection of twentieth-century art. Not only the Pop Art collection which was donated by Mr. and Mrs. Ludwig in 1976 would be affected by this. It would extend to all works that had been donated to the Wallraf-Richartz-Museum by collectors from Cologne and that are now part of the Museum Ludwig, as well as the museum's new acquisitions.

Apparently the new building of the Museum Ludwig is also to be handed over to the Ludwig Foundation and possibly the cost of its maintenance and personnel are to be covered by the Foundation.

Furthermore, the bylaws speak of "civil service positions made available by the city of Cologne." The public partners of the Foundation are talking about yearly contributions which, at least in the beginning, are to amount to several million Deutschemarks, also from the city of Cologne (the acquisitions budget of the eight Cologne museums is DM 1.1 million).

The representatives of the city of Cologne are among the most ardent proponents of the Foundation. According to comments in the press, they fear that Mr. and Mrs. Ludwig might withdraw their loans, in spite of an express promise, if the projected Ludwig Foundation does not come to pass. Peter Ludwig once indicated: "Perhaps there are other governments with which one could speak and with which one does speak."

Cologne also hopes that, through the participation of the federal government and the state in the Foundation, part of the sizable cost of the construction and maintenance of the new Museum Ludwig would be carried by them.

The general director of all Cologne museums, Hugo Borger, also refers to the desirability of an art "supercenter" in Cologne. The representatives of the city agree: "Without Ludwig nothing works anymore."

10. Lindt

The collaboration between the Monheim Group and the Swiss Lindt & Sprüngli goes back to the time before World War II. At present, Monheim holds 80% of the shares of both Lindt and Sprüngli GmbH, Aachen, and Lindt & Sprüngli BV, Netherlands. The rest of the shares remain with the Lindt & Sprüngli AG, Kilchberg/Switzerland.

Under license, Monheim makes Lindt products such as assorted chocolates, milk chocolate, and seasonal articles for the German and Dutch markets (estimated sales in 1979-80, sfrs 195 million = approximately one-third of Lindt sales worldwide).

The Monheim Group also had licensing and distribution agreements with the British John Mackintosh and Sons Ltd. and Peter & Paul Inc. of the United States.

Lindt products are mostly made in a factory in the center of Aachen, where the company's headquarters are also located.

In 1977, according to a rumor circulating in Aachen, Monheim planned to move part of this production to another facility in Saarlouis. In Aachen, 1,000 to 1,800 jobs would have been lost. However, at the same time, a company spokesman declared that the company was, instead, trying to move production to Aachen-Süsterfeld, on the outskirts of the city, and to expand a plant there that was already in operation: "This requires a considerable amount of money. Concentration of the Aachen facilities in Süsterfeld would have to be subsidized by the city and the state."

In the same year, the city of Aachen decided to make the 20,000 square meters of the plant in the city center an area for rehabilitation and to buy it for the construction of one-family houses with gardens in its place.

As compensation for giving up the plant and its relocation, Monheim is being paid out of public funds a total of DM 45.7 million. Seventy-five percent of this amount is carried by the state of North Rhine-Westphalia.

Monheim intends to use part of its DM 60 million investments earmarked for 1980 for the construction of the new plant and administrative headquarters. New, automated facilities are to bring about a more efficient and profitable operation. The construction in Aachen-Süsterfeld is expected to be completed by the end of 1982.

11. Patrons Have A Price, Too (Peter Ludwig)

The bylaws of the Ludwig Foundation, which were proposed by Peter Ludwig and Irene Ludwig and which were planned together with the federal government, the state of North Rhine-Westphalia, and the city of Cologne, set forth as the purposes of the Foundation:

1. Curatorial care and administration of the art works of the Foundation.
2. Expansion of the collection and, in the spirit of paragraph 1, prevention of the sale of valuable works of the German art heritage to foreign buyers.
3. Scholarly research on the Foundation's collection.
4. Conception and organization of art exhibitions.
5. Promotion of regional, national, and international activities in the visual arts and related fields.

Represented on the board of the Foundation are Peter and Irene Ludwig, two persons of their choice, as well as four representatives each from the federal government, the state, and the city of Cologne. Peter Ludwig is the chairman. Decisions of the board of the Foundation are made by majority vote. In the event of a tie, the chairman casts the deciding vote. For ten years, Peter and Irene Ludwig are granted "a veto against decisions of the Foundation's board whenever questions relating to

the disposition of art works which were brought in by Mr. and Mrs. Ludwig are concerned."

Critics of the Ludwig Foundation point to the art-political power which would be handed to Peter Ludwig, a private individual, due to his dominant position in a publicly financed Foundation. The collector explains: "It is clear that on such boards a consensus must be achieved. However, I am certain that my expertise will have some weight." It is feared that the numerical majority of the public representatives on the board of the Foundation will not count much because they have contradictory interests, and because the city of Cologne is highly dependent on Peter Ludwig. The veto power of Mr. and Mrs. Ludwig and the deciding vote of the chairman in a tie underscore his dominant position.

The collector judges his influence on the art market as follows: "The market for Pop Art has been determined decisively by the activities of Mr. and Mrs. Ludwig." The combination of the financial resources of the Foundation with his own would give Peter Ludwig immense power in the world of exhibitions, in art-political decision making, and in the art market. It would give him the means to exert even more control over the international art world than he does already.

12. Trumpf/The Chocolate Master

The Monheim Group distributes, under its house label "Trumpf," chocolate bars, "Schogetten," assorted chocolates, hot chocolate powder, seasonal articles, and chewing candy. Production is done by subsidiaries in Aachen, Quickborn near Hamburg, Saarlouis, and the Trumpf Schokolade- und Kakaofabrik Berlin GmbH which has been operating independently since 1979 under this new name.

In 1979, 51% of the shares of the Berlin company, which was totally owned by Monheim, were sold to the newly founded Trumpf Berlin GmbH. The new

company financed this acquisition by issuing atypical nonvoting stocks to private investors. Monheim thus received, in 1979, an infusion of approximately DM 100 million, which was used by the company in a "tax-neutral" way (Ludwig).

Such opportunities are, for example, investments in the plant (in 1980 earmarked for Berlin: DM 25 million) and in special tax-favored loans to the Berlin Development Bank (12% of the loan tax-deductible). Moreover, money was set aside for future investment in the plant, and Monheim claimed depreciation on supplies (cocoa and contracts on cocoa).

The plant in Berlin was established in 1953. At the beginning of the seventies it was expanded considerably and manufacturing methods were brought up to the latest standards. Monheim benefited from the special advantages of the aid for Berlin: 75% depreciation in the first year for investment in plant and equipment (in West Germany 3%), outright public grants of 10% or more for investment in plant and equipment, the deduction of 4.5% of the sales tax for sales to West Germany, and other tax advantages.

In East Germany, "Trumpf" products are made under licensing agreements dating from 1974. They are available almost exclusively in "Intershops" (foreign currency outlets) and "Delikatläden" (special stores for high-priced luxury items). Some are also exported. Monheim handles the distribution for all products of Trumpf Berlin GmbH (a.o. Schogetten). Aside from department stores, "Trumpf" items are sold in large quantities through "Aldi" (low-priced chain stores). Well-known brand names besides the "Schogetten," which were introduced in 1966, are assorted chocolates with labels such as "Noble Drops in Nuts," "Good Spirits in Nuts," "Fresh Fruit Drinks," "Marzipan Stars," "Armorial Class," "Tradition," and "Classic."

In Germany, Monheim has a market share for chocolate bars of 18%, for assorted chocolates of 25%, as well as for seasonal items of 25%. The stated cocoa contents of the products range from 25% to 54%.

Monheim uses 5% of the world harvest in cocoa beans (70,000 metric tons) for a yearly output of 100,000 metric tons (1980). In 1979-80 the company stored raw materials valued at DM 172 million.

13. Nothing Is Of Less Interest To Us Than Cultural-Political Power (Ludwig)

The statutes of the Ludwig Foundation, which were proposed by Peter and Irene Ludwig and which were planned together with the federal government, the state of North Rhine-Westphalia, and the city of Cologne, provide for financial contributions to the Foundation's endowment from the three public partners. No mention of any amounts is made.

The commissioner of culture for the city of Cologne declared in March 1981: "At the current state, the Foundation will have a budget of 14 million." However, a representative of the state government mentioned as a "reference figure" an amount of DM 2.7 million, which is to be paid in the first year by each of the public partners of the Foundation.

In 1981, the state of North Rhine-Westphalia cut its traditional grants of DM 3 million to municipal art institutions by one-third. As a consequence, a number of exhibitions cannot be put on as planned, and catalogues cannot be published. The DM 3 million acquisitions budget of the state gallery of Düsseldorf was equally cut by one million, in spite of rising prices on the art market.

The directors of the affected institutions suspect that these cuts were motivated by the payments to the Ludwig Foundation, which are to start as of 1982. Fifteen directors of municipal museums (except those of Cologne and Aachen) therefore spoke out in a protest letter "with great determination

... against the federal government's and the state's subsidizing a concentration of money and power in Cologne." They fear that "the variety of the museum landscape which is based on local initiatives would be severely threatened by the Ludwig Foundation."

The participation of the federal government raises constitutional questions. According to these, the cultural autonomy of the states would be interfered with, and the federal government would gain an instrument with which to make cultural policy which the constitution does not allow. Bavaria has considered bringing the issue before the Supreme Court.

The state of Baden-Württemberg countered with a proposal to establish a "Cultural Foundation of the States," which would not give reason to raise constitutional objections. This "acquisition syndicate of the states" is to prevent the loss of valuable works of German art and cultural history through their sale to foreign buyers, in cases where the financial resources of a single museum would be insufficient to cover the purchases.

To prevent such losses for the nation, however, is also one of the main purposes of the Ludwig Foundation. It is also among the goals of the National Foundation, which is still not operating as designed.

14. Mauxion

In 1959 the Monheim Group took over Schokoladenfabrik Mauxion KG. Since then it has been producing assorted chocolates and seasonal items under the "Mauxion" label. Following is the development of the company since World War II:

1951 Establishment of a new plant in Quickborn near Hamburg
1952 Peter Ludwig becomes managing partner. A new plant opened in Berlin-Neukölln (since 1979 independent company Trumpf Berlin GmbH; 49% of the shares held by Monheim)

1959 Acquisition of a chocolate factory in Ste. Hyacinthe near Montreal (operating since 1974 under the name Comet Confectionary Ltd.)
1960 Addition of the A. Poser Schokoladenfabrik GmbH of Saarlouis
1969 Peter Ludwig becomes president of the company
1971 Exclusive production and marketing rights for van Houten products. Takeover of the van Houten world distribution network
1974 Licensing agreements for production in East Germany and Poland
1979 Acquisition of all shares of the Belgian General Chocolate NV/SA with plants in Herentals (Belgium) and Neuss (Germany)
1980 Participation in the newly founded cocoa trading company Eurobras BV, Amsterdam. Negotiations for cooperative ventures with the Austrian Konsum and the Julius Meinl AG food business in Vienna. Plans are made for the expansion into the Austrian market and possibly joint export to COMECON countries.

In 1978, the parent organization Leonard Monheim KG was transformed into a public company. The former partners Prof. Peter Ludwig, Dieter Monheim, and Dr. Bernd Monheim, of the third Monheim generation, are now holding "clearly more than 50%" of the capital of DM 41.5 million. The shares are issued in the name of the owner and can be transferred only with the company's approval. The shares are kept totally within the family.

The chairman of the supervisory board of the Leonard Monheim AG is Prof. Peter Ludwig.

The Monheim Group comprises twenty-four domestic and sixteen foreign subsidiaries. In 1979-80, worldwide sales amounted to DM 1.358 billion (approximately 34% outside West Germany).

The domestic income was taxed at the rate of DM 19.4 million. If no back payments in taxes had to be made, net income can be estimated at DM 34 million.

The Key to an Integrated Lifestyle at the Top

1981

Slide and sound installation.

First exhibited as part of a series of one-person exhibitions under the title *Vocation/Vacation* at the Walter Phillips Gallery, The Banff Centre—School of Fine Arts, Banff, Alberta, Canada, November 19-November 29, 1981.

For this exhibition the Walter Phillips Gallery was stripped of its burlap-covered wall panels, so that the bare black walls of the gallery were exposed and, as a consequence, the reflection of light reduced to a minimum. To prevent light from entering the gallery space through the open door towards the hallway, a baffle was erected. All gallery lights were turned off.

Voices: Steve Gauley, Karen Skidmore

Sound: Jim Cormack, Eric Richer, Ralph Temple, Ben West

Installation: Roger Steele, Keith Groat, Irene Krievins, Johanne Daoust, Iain Burnside, Ralph Temple, Helen Fields

Curator: Brian L. MacNevin

Owned by Hans Haacke.

The history of The Banff Centre, located in a ski resort in the Canadian Rocky Mountains, goes back to the nineteenth century, when the Canadian Pacific Railroad invited artists to Banff with the idea that this might help attract international tourism to the palatial hotel it had built there. Since then, the Centre has grown to comprise a small art school, facilities for professional music and theater productions, and a teaching program in the performing arts, as well as a business school. Students live in dormitories on campus. Many are supported by generous grants. The Centre is financed by the Canadian government, the Province of Alberta, and self-generated income. The program of the Business School consists primarily of short-term refresher courses in advanced management techniques, designed for students who are already employed by corporations or government bodies, including courses in arts management. The facilities of the Centre are also rented out for the holding of conferences.

It is directed by graduates of the Harvard Business School who seem to have been given the mandate and funds to make a fount of culture on an international scale in this oil-rich Canadian province. Skeptics wonder whether the business mentality governing the Centre's entire operation is not perhaps a major obstacle to reaching this goal. They also question whether the need to import students and professionals and to lure them with generous financial conditions does not perpetuate the artificiality of the institution. The suspicion is widespread that the primary attraction will remain the spectacular surroundings of the Rocky Mountains.

THE BANFF CENTRE announces

The Key to an Integrated Lifestyle at the Top

Your employees look to you not merely for a source of income, but also as an example for successful living.

About two-thirds of the way into the gallery, a twelve-foot-high projection screen faced the entrance. A single 35mm color slide was projected onto the screen continuously. Projected into the black frame around the color image of the slide and underneath the heading "The Banff Centre announces" were three continuously alternating titles:

"Executive Health Seminar"
"A Wilderness Experience"
"The Key to an Integrated Lifestyle at the Top"

A male and a female voice, on a two-track sound tape loop, were heard alternately from loudspeakers, positioned respectively on the left and right of the screen. Music of the type that is used for the presentation of a company's annual report provided a sound background for the two voices. From a separate loudspeaker at the far end of the gallery, in the dark, one could hear the sound of heavy industrial noise.

The image and texts were adapted from three promotional publications of The Banff Centre:

"The Management of Stress/A Banff Wilderness Seminar," March 6-16, 1981
"Executive Health Seminar/A Banff Wilderness Experience," June 7-13, 1981
"The Management of Stress/A Banff Wilderness Seminar," August 6-16, 1981

Male voice

The management of stress . . . A Banff wilderness experience.
The executive office is traditionally the symbol of accomplishment and success, fame and fortune, and with that image come the responsibilities of leadership. Your employees look to you not merely for a source of income, but also as an example for successful living. The behavioral norms of your company are set at the top.

Female voice

This seminar is an experience which totally removes you from everyday life—both physically and mentally—providing a fresh perspective on the stress you deal with constantly. During the seminar, you will face experiences that you have never before met: skiing through a mountain pass, awakening to the crystal-clear dawn, and watching the golden sun set on nearby peaks.

Male voice

In daily seminar sessions, your attitudes towards health and your own health practices will be examined. The seminar resource staff will assist you to integrate your physical, psychological, and philosophical experiences into a newly developed awareness of wellness lifestyles and your means of achieving them.

Female voice

This is a wilderness experience in its purest form—fifteen executives and professionals, together with five resource staff, secluded in the magnificent setting of the Skoki Lodge site—dependent on each other for support and cooperation for the entire week. Daily ski tours in the surrounding area will be climaxed with a ski ascent of the Merlin Ridge, with its unbelievable views of the Continental Divide to the west.

Male voice

The Banff Centre offers its Wilderness Seminars to assist you in seeing the adventure of your own lives as an integral part of the larger whole—your relationship to society and to the environment. The seminar is an experience in what has been called "Wholistic Education"—the intersection of mind, body, spirit, environment, and nature. It is an experience in the identification of values, the uncovering of those principles by which you presently live and those by which you might choose to live in the future.

Female voice

The Banff Wilderness Seminars are designed for senior executives in both the public and private sectors, and for top level professionals. Most participants are presidents and vice-presidents of major corporations, senior officials in federal, provincial, and state governments, and senior partners of professional firms, including doctors, lawyers, architects, and engineers.

Male voice

Take one week from your busy life to attend this seminar. Every minute will be worth it. You will enjoy the beauty of the location, the challenge of the physical activities, and the stimulating exchange. But, much more than this, you will become more conscious of yourself and others. You will re-examine the issues or priorities in your life and attempt to better order them. You will put your own health and your responsibility as a leader into perspective. Finally, your removal from your daily environment will help you better appreciate your position in it, influence your relation to others and your achievements.

Female voice

More and more, top level executives and managers are finding the benefits of the healthy lifestyle . . . Here are some comments from previous participants:

Male voice

"Absolutely the finest experience in my adult education."

Female voice

"I have never done a single thing that has had such a significant effect on my life."

Male voice

"The best ten damn days I've spent, ever!"

Female voice

The complete seminar fee, for one week, is $2,200, which includes all accommodations and meals in Lake Louise and Skoki Lodge, transportation, full tuition, instruction, and use of specialized equipment, and a non-refundable $200 registration fee.

Male voice

The Banff Wilderness Seminar is the key to an integrated lifestyle at the top.

Source material: One of three brochures used as basis for sound-track. Pamphlet, "The Management of Stress," from The Banff Centre School of Management program, 1981.

THE MANAGEMENT OF STRESS
A Banff Wilderness Seminar

The Key to an Integrated Lifestyle at the Top

March 7-14, 1981

**Ski Touring
at
Skoki Lodge in The Canadian Rockies**

WHY A WILDERNESS SEMINAR FOR EXECUTIVES AND PROFESSIONAL PEOPLE?

The executive office is traditionally the symbol of accomplishment, success, fame and fortune; but with that image comes much more, not all of it positive. Responsibility, excessive work, time pressure — built-in components of this success — are also the causes of stress, which is always present in the executive suite.

How do you deal with stress in your professional life? Does it carry over into your personal life? Are you content with your position? Secure in your lifestyle?

This seminar is an experience which totally removes you from everyday life — both physically and mentally — providing a fresh perspective on the stress you deal with constantly. During the seminar, you will face experiences that you have never before met: skiing through a mountain pass, awakening to the crystal-clear dawn, and watching the golden sun set on nearby peaks. During the seminar sessions each day, your physical achievements (or difficulties) will be compared and contrasted with stress situations faced in your everyday life. Through the integration of your physical, psychological and philosophic experiences, the seminar resource staff will assist you in developing your awareness of stress and your means of dealing with it.

This is a wilderness experience in its purest form — 15 executives and professionals, together with 6 resource staff, secluded in the magnificent setting of the Skoki Lodge site — dependent on each other for support and cooperation for the entire week. Daily ski tours in the surrounding area will be climaxed with a ski ascent of Merlin Ridge, with its unbelievable views of the Continental Divide to the west.

The Banff Centre offers its Wilderness Seminars to assist you in seeing the adventure of your own lives as an integral part of the larger whole — your relationship to society and to the environment. This seminar is an experience in what has been called "wholistic education" — the intersection of mind, body, spirit, environment and nature. It is an experience in the identification of values, the uncovering of those principles by which you presently live and those by which you might choose to live in the future. It is an experience in stress reduction, which not only creates techniques to reduce symptomatic stress, but attacks the psychological and environmental sources of stress as well.

Take one week from your busy life to attend this seminar. Every minute will be worth it. You will enjoy the beauty of your location, the challenge of the physical activities and the stimulating educational interchange. But, much more than this, you will become more conscious of yourself and of others. You will put the stress in your life into perspective — decide how much stress and what sort you need and how best to cope with it. You will re-examine the issue of priorities in your life and attempt to better order them. Finally, your removal from your daily environment will help you better appreciate your position in it, your relations to others, and your achievements.

How the Experience Will Unfold...

Saturday, March 7

Meet for lunch at **The Kings Domain Hotel** in Lake Louise, Alberta. Afternoon equipment check and review of basic cross-country skiing technique. Evening orientation to seminar agenda, and discussion of course expectations.

Sunday, March 8

Ride to Temple Chalet in the Lake Louise Ski Area, and begin 8-mile ski tour to Skoki Lodge, via Deception Pass. Instruction in flat track technique, ski waxing, and preventative care in the winter environment. Skoki Lodge lies at 7,200 feet, is primitive (no electricity, plumbing, telephone or TV) but comfortable; a rustic lodge built 50 years ago.

Monday, March 9 thru Wednesday, March 11

The routine for the next three days will follow this schedule, weather permitting:

6:00 a.m. Rise at first light.
7:00 a.m. Body stretching and relaxation exercises.
8:00 a.m. Breakfast — a low sugar and salt diet.
9:00 a.m. Daily seminars on the following topics:
 – The Stress Response
 – Social and Psychological Change and Stress
 – Type A Behaviour
 – Adult Life Transition
 – Life Inventory and Personal Values
 – Human Lifestyling
 – Social Responsibility and Meaning
11:00 a.m. Daily ski tour to Pipestone Creek, Red Deer Lakes and around Skoki Mountain. Groups will be divided according to interest, fitness and skiing ability. Instruction in touring and downhill techniques, and winter survival. Trail lunch.
4:00 p.m. Return to lodge.
6:00 p.m. Dinner — a diet low on red meat and fat.
7:00 p.m. Evening discussion, integrating the topics of the daily seminars with the day's experiences, and one's life experience.
10:00 p.m. Lanterns out!

Thursday, March 12

All-day ski tour to Merlin Ridge (8,300 feet). Spectacular valley and view across to the mountain ranges to the west.

Friday, March 13

Ski tour out. Final dinner at 7 p.m. at **The Kings Domain Hotel** in Lake Louise, followed by course evaluation and written comment. Important final seminar on Closure and the Stress of Re-entry.

Saturday, March 14

Early morning departure and flights home.

THE RESOURCE STAFF WHO WILL GUIDE YOU THROUGH THE SEMINAR:

Joe Neild (Course Director)

Currently, the Executive Director of The Ptarmigan Club, formed to develop the concept of educational wilderness seminars, Joe has directed executive adventure programs for the Young Presidents' Organization (YPO) and Outward Bound Executive Expeditions to Mt. Kilimanjaro in Africa and Escalante Canyon in Utah. Born in Saskatchewan, he was for many years the President and Director of the Colorado Outward Bound School. He holds law degrees from the University of British Columbia and Columbia University, and his principal interest addresses the role of myth and values in the life-defining processes of the mature adult.

Layne Longfellow, Ph.D.

Active nationally as a lecturer and consultant, Layne was formerly Director of Executive Seminars at the Center for Applied Behavioral Sciences of The Menninger Foundation in Topeka, Kansas. Previously, Dr. Longfellow was Academic Vice-President of Prescott College in Arizona. After completing his doctorate in physiological and experimental psychology at the University of Michigan, Dr. Longfellow was an N.I.M.H. Post-Doctoral Fellow in humanistic psychology with Dr. Carl Rogers.

George McLeod

A professional explorer, ski instructor and mountain guide, George spent 6 years in Antarctica with such distinction that he was awarded the Polar Medal by H.R.H. Queen Elizabeth II. Born in Aberdeen, Scotland, he has a Bachelor of Arts degree and is a Course Director for the Colorado Outward Bound School. He has led expeditions and directed courses in Colorado, Utah, Mexico and Bolivia.

WHO SHOULD APPLY...

The Banff Wilderness Seminars are designed for senior executives in both the public and private sectors, and for top-level professionals. Most participants are presidents and vice-presidents of major corporations, senior officials with federal, provincial and state governments, and senior partners of professional firms, including doctors, lawyers, architects and engineers.

All participants must be in good physical condition and must be willing to undertake a pre-course conditioning program. In addition, they must be willing to accept personal responsibility for potential risks inherent in undertaking adventurous activities in the mountains in winter, including avalanches. While it is not necessary to be an expert skier to take part in this seminar, all applicants should have at least one year of previous cross-country skiing experience, or be an intermediate downhill skier. Beginning skiers will not be accepted.

The complete seminar fee is $1,800, which includes all accommodation and meals in Lake Louise and at Skoki Lodge, transportation, full tuition, instruction and use of specialized equipment, and a non-refundable $200 registration fee.

To register, or for further information, contact:

John R. Amatt, Manager
Wilderness Seminars
The Banff Centre
Box 1020
Banff, Alberta T0L 0C0
Phone: (403) 762-3391, ext. 314

OTHER BANFF WILDERNESS SEMINARS PLANNED IN 1981...

Executive Health Seminar

Taking place during a six-day float trip down the Green and Yampa Rivers in Colorado and Utah, this seminar will investigate the concepts of diet, fitness and health, and their importance to the effective performance of the senior executive.

Dates: June 8-14, 1981

The Management of Stress

The original wilderness agenda, the seminar on stress management will feature a mountain climbing experience at Skoki Lodge, and will address the topics of the stress response, social and psychological change and stress, the adult life transition, life inventory and human life-styling.

Dates: July 9 - 15, 1981

Family Life for Couples

Designed exclusively for couples, and addressing a series of topics involving family life, communication and the changing roles of men and women, this seminar will take place at Skoki Lodge, amongst the beautiful fall colours of the Canadian Rockies, and will feature a series of day hikes in the area.

Dates: September 13 - 19, 1981

Upstairs at Mobil: Musings of a Shareholder

1981

Ten panels, each 35½ x 21½" (90.2 x 57.1 cm). Five-color photoetching with collage of original Mobil stock certificate for ten shares of Mobil stock owned by Hans Haacke, and handwritten text. Printed by Hidekatsu Takada and Nancy Anello at Crown Point Press, Oakland, California.

First exhibited in one-person exhibition at the John Weber Gallery, New York, February 7-March 4, 1981.

Photograph: John Abbott.

Collection of Camille and Paul Hofmann, Chicago.

The title, *Upstairs at Mobil: Musings of a Shareholder,* is derived from two Mobil public relations ventures. For a number of years, Mobil sponsored a popular television series on PBS, a British Edwardian soap opera called "Upstairs, Downstairs." And, over several years, Mobil has published advocacy advertisements on the op-ed page of the *New York Times* and other newspapers with titles that represented permutations on "Musings of an oil person (of a confused oil person, a proud oil person, etc.)."

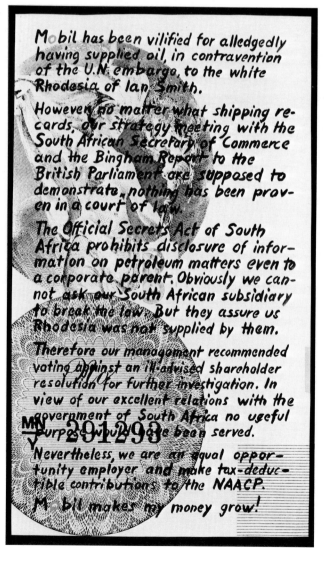

Mobil has been vilified for alledgedly having supplied oil, in contravention of the U.N. embargo, to the white Rhodesia of Ian Smith.

However no matter what shipping records, our strategy meeting with the South African Secretary of Commerce and the Bingham Report to the British Parliament are supposed to demonstrate, nothing has been proven in a court of law.

The Official Secrets Act of South Africa prohibits disclosure of information on petroleum matters even to a corporate parent. Obviously we cannot ask our South African subsidiary to break the law. But they assure us Rhodesia was not supplied by them.

Therefore our management recommended voting against an ill-advised shareholder resolution for further investigation. In view of our excellent relations with the government of South Africa no useful purpose would have been served.

Nevertheless, we are an equal opportunity employer and make tax-deductible contributions to the NAACP.

Mobil makes my money grow!

Detail, second panel, top row.

Transcriptions:

Mobil's problems with the oil glut, prior to 1973, were happily solved by the Arab oil embargo. As in every supply crisis, our inventory multiplied in value. Naturally we then also raised the price of crude from wells outside of OPEC.

While domestic oil prices are finally decontrolled, the distortion of the free-market system continues with the "windfall" profits tax.

Not surprisingly, in 1974, Mobil found itself with a lot of extra cash. We sent out Larry Woods, our planning wizard, to scout for profitable energy investments. He reported back: "I wish to hell we had enough good projects to put our money in."

So we moved into non-energy ventures. For $1.8 billion we bought Montgomery Ward and the Container Corporation of America, with unregulated profits.

In appreciation of the help from our Arab friends, Mobil produced a book entitled "The Genius of Arab Civilization: Source of Renaissance."

Mobil makes my money grow!

OPEC: Organization of Petroleum Exporting Countries.

Montgomery Ward & Co. is a nationwide chain of department stores in the United States. The Container Corporation of America produces paperboard packaging.

Mobil gets more than half of its oil from Saudi Arabia.

Mobil's increasing profits pose a public relations problem. In 1980 they rose from $2 billion to over $3 billion. Naturally, we shareholders welcome such good news. But there is a hostile public out there, accusing us of rigging gas and heating oil prices, of polluting, and generally suspecting us of every crime in the book.

This is when our public relations people have to work overtime. In full-page ads Mobil shows how little of each sales dollar is retained as profit, and we worry aloud about spending more than we earn.

But of course, a good part of such expenses is already deducted when we report our profits. In fact, we usually have enough cash left to buy other companies.

People should learn that the business of business is profits. As Herb Schmertz, our house philosopher says: "I've never seen an excessive profit. I don't think I'd recognize one if I saw it."

Mobil makes my money grow!

To counteract a critical assessment of Mobil's 1979 profits on the CBS Television Evening News, Mobil spent about $310,000 on double spread advertisements.

Mobil has been vilified for allegedly having supplied oil, in contravention of the U.N. embargo, to the white Rhodesia of Ian Smith.

However, no matter what shipping records, our strategy meeting with the South African Secretary of Commerce and the Bingham Report to the British Parliament are supposed to demonstrate, nothing has been proven in a court of law.

The Official Secrets Act of South Africa prohibits disclosure of information on petroleum matters even to a corporate parent. Obviously we cannot ask our South African subsidiary to break the law. But they assure us Rhodesia was not supplied by them.

Therefore our management recommended voting against an ill-advised shareholder resolution for further investigation. In view of our excellent relations with the government of South Africa no useful purpose would have been served.

Nevertheless, we are an equal opportunity employer and make tax-deductible contributions to the NAACP.

Mobil makes my money grow!

NAACP: National Association for the Advancement of Colored People, largest black civil rights organization in the U.S.

Mobil is committed to making real estate a major part of our business. As long as regulatory agencies, "windfall" profits taxes, and selfappointed public interest groups interfere with our petroleum operations, we see our future only in diversification.

Since 1979 we spent more than $100 million on real estate. A condominium in Hong Kong housing 70,000 people led the way.

Mobil is confident that the 3,500 acres we bought in Reston, Va., outside of Washington, will prove to be as good an investment. And so will our projects in San Francisco, Dallas and Georgia.

We promote Sailfish Point, our new golf and yachting development in Florida as "destined to be one of the world's most fashionable playgrounds for the wealthy."

We are as proud of Sailfish Point as we are of our tax-deductible contributions to the Boy Scouts.

Mobil makes my money grow!

In 1985, two Mobil directors bought lots at Sailfish Point from the company.

One of Mobil's major assets is Herb Schmertz, our public relations genius and house philosopher.

It was Herb who made Mobil a columnist of The New York Times. It was Herb who turned PBS into what our enemies call the Petroleum Broadcasting Service. And it was Herb who master-minded our entry into the art world. All this and more for little over $21 million annually.

Herb's Democratic Party background and his connection to the Kennedys, liberals we never saw before, have been invaluable. He speaks their language and knows how to keep them off balance, or even get their support. This will be easier under the Reagan administration.

Herb and our Larry Woods just bought the _Croton-Cortland News,_ as another outlet for the Mobil word. The two also tried themselves as novelists.

Takeover is a racy book about big business, corruption and sex. They dedicated it "to an endangered species, the free-market system."

Mobil makes my money grow!

Every Thursday, since 1972, Mobil has placed a quarter-page advocacy advertisement on the prestigious op-ed page of the _New York Times._ The advertisement is also carried by other large newspapers. In 1986, a new book by Herb Schmertz, _Good-bye to the Low Profile: The Art of Creative Confrontation,_ was published.

Mobil's South African subsidiary ran this ad in a leading Johannesburg business journal: "Everyone is conscious of South Africa's need for its own supply of crude oil—and Mobil is doing something about it."

Our refinery at Durban has a capacity of 100,000 barrels a day. We market 18% of all the oil in the country. With assets of $426 million, we are indeed the largest U.S. investor in South Africa. A proud record.

To protect such a major investment, Mobil does everything to insure the stability of South Africa. Our Board argues: "The denial of supplies to the police and military forces of a host country is hardly consistent with an image of good citizenship in that country."

We are not deterred in this by objections from misguided church group shareholders. However, to blunt attacks from Black Americans and to preserve our interests in Nigeria we sponsored a show of Nigerian Art at the Metropolitan Museum.
Mobil makes my money grow!

———————

In 1986, Mobil recommended to vote *against* a shareholder resolution by the New York City Employees Retirement System to terminate petroleum sales to the South African police and military.

Mobil's Italian subsidiary gave $2.1 million to parties of the Italian coalition government.
We recorded these contributions as advertising and research expenses because our Italian friends thought that this would aid our common objective. That goal was, as stated before a U.S. Senate Subcommittee "to support the democratic process." Happily Senator Frank Church is no longer Chairman of that Committee. We helped to unseat him in 1980.
In other instances, Mobil could act publicly. When their Majesties the Shah and the Empress of Iran visited the United States in 1977, we and other major corporations celebrated His Majesty's historic achievement in a full-page ad in the NY Times.
A year later, our Chairman, Rawleigh Warner greeted Her Majesty, Empress Farah, as Chairman of a gala dinner given in her honor.
Appropriately he also chairs the Business Committee for the Arts. We have learned patronage pays.
Mobil makes my money grow!

———————

Frank Church, a liberal senator, lost his position in the U.S. Senate in 1980. Mobil contributed funds to the election campaign of his opponent.

Mobil's public relations people make a killing through the support of the arts. Although our tax-deductible contributions are hardly equal to 0.1 percent of our profits, they have brought us extensive good will in the world of culture.
More important, however, opinion leaders and politicians now listen to us when we speak out on taxes, government regulations, and crippling environmentalism.
The secret for getting so much mileage out of a minimal investment is twofold: a developed sense for high visibility projects at low cost and well-funded campaigns to promote them.
Mobil, in fact, ranks lowest among the 50 companies which give most in proportion to their pretax profits.
Museums now hesitate to exhibit works which conflict with our views, and we need not cancel grants as we did at Columbia's Journalism School. The art world has earned our support: "Art is energy in its most beautiful form!"
Mobil makes my money grow!

———————

Mobil has sponsored art exhibitions in many other countries, notably Australia, Austria, the United Kingdom, and West Germany.

Mobil has developed a sophisticated media strategy.
We gain the attention of the movers and shakers through our sponsorship of PBS programs. This good will umbrella allows us to get tough on substantive issues in the printed press, with a budget of some $6 million.
There is more to it. PBS now broadcasts fewer programs critical of business. And it almost cancelled "Death of a Princess," a docu-drama we found demeaning to our Arab friends.
The networks, however, habitually present a distorted image of our in-

dustry. Hiding behind the fairness doctrine, they don't even let us air issue-oriented commercials. We call this censorship.
So Mobil occasionally forms its own ad-hoc network, with no restrictions on educational commercials. About 80% of the stations that carried our new Edwardian series were network affiliates who defected. No wonder the networks are scared. We buy our way into the marketplace of ideas.
Mobil makes my money grow!

———————

"Our good will umbrella" was how Raymond d'Argenio, one of the architects of Mobil's public relations strategy, described his company's support of cultural programs. He has since moved on to work in the same capacity for the United Technologies Corporation, a major defense contractor.

On and off Mobil has had disagreements with Government agencies.
In 1979 we agreed to pay a total of $32.3 million in refunds and $550,000 in penalties to settle alleged overcharges for crude oil and natural gas. And, in 1980, we settled our differences with the Council on Wage and Price Stability by foregoing $30 million in price increases.
In the 1980 election, Mobil helped defeat our enemies in Congress. Under the Reagan Administration, free-market forces will play their natural role. We will finally have a chance to get a fair shake.
Less credence will be given to the Ralph Naders who have been accusing us of not investing our handsome profits in energy exploration. And nobody wants to listen any longer to warmed up charges that we had an effective tax rate of less than 15 per cent.
The moral majority is in ascendance. And we are with it.
Mobil makes my money grow!

———————

Ralph Nader is a well-known public interest advocate in Washington. He is the founder of Public Citizen, a research and lobbying organization.

Announcement for one-person exhibition at John Weber Gallery, New York, February-March 1981.

Oelgemaelde, Hommage à Marcel Broodthaers

(Oil Painting, Homage to Marcel Broodthaers)

1982

Installation; overall dimensions determined by exhibition space. Oil painting in gold frame, picture lamp, brass plaque, brass stanchions with red velvet rope, red carpet, and photo mural. Painting, 35½ x 29″ (90 x 73.5 cm), including frame; carpet, 35″ (89 cm) wide, length variable; brass plaque, 4½ x 12″ (11.4 x 30.4 cm); photo mural, dimensions variable.

First exhibited at *Documenta 7,* Kassel, June 19-September 28, 1982 (photograph 118 x 161″ [300 x 400 cm]). Photograph of installation in Kassel by Udo Reuschling.

Owned by Hans Haacke.

One week before the opening of *Documenta 7,* an international art exhibition held in Kassel, President Reagan visited Bonn and delivered a speech to the Bundestag (Parliament of the Federal Republic of Germany) in an attempt to rally support for the stationing of Cruise and Pershing II missiles in Germany. His visit to Bonn was accompanied by the largest demonstration held in Germany since World War II. It was called to protest nuclear arms. The photograph for the *Documenta* installation was taken at this rally. The banner in the background reads: "Reagan Get Lost—Neither NATO nor Warsaw." *Documenta 7* was generally understood as a celebration of painting.

In subsequent exhibitions of this work, the photo mural of the original *Documenta* installation was replaced by a photo mural representing local anti-nuclear demonstrations and taken by other photographers.

On June 12, 1982, two days after the demonstration in Bonn, a record-breaking anti-nuclear march, attended by more than 500,000 people, wound through the streets of New York to Central Park. A photograph of this rally taken by Eva Cockroft from the Park Avenue overpass, facing east on 42nd Street, was used for the installation at the John Weber Gallery, New York, May 1983.

Ed Barber supplied a photograph of an anti-nuclear rally in Hyde Park for the installation at the Tate Gallery, London, January 1984.

A photograph taken by Michael v. Graffenried of an anti-nuclear demonstration on the Bundesplatz, in front of the Swiss Parliament Building in Bern, was used for the installation at the Kunsthalle Bern, March 1985.

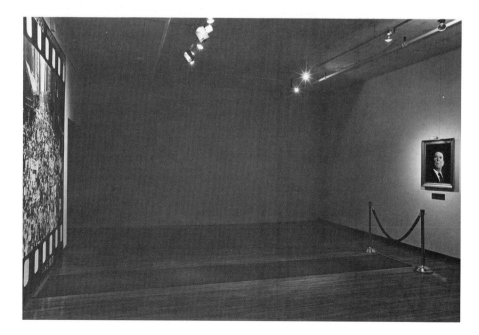

Installation at John Weber Gallery, New York, April-May 1983.

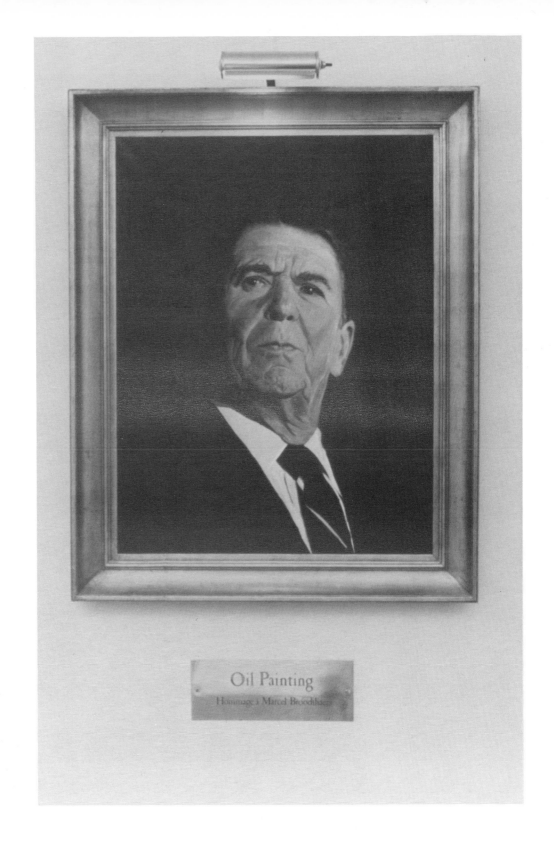

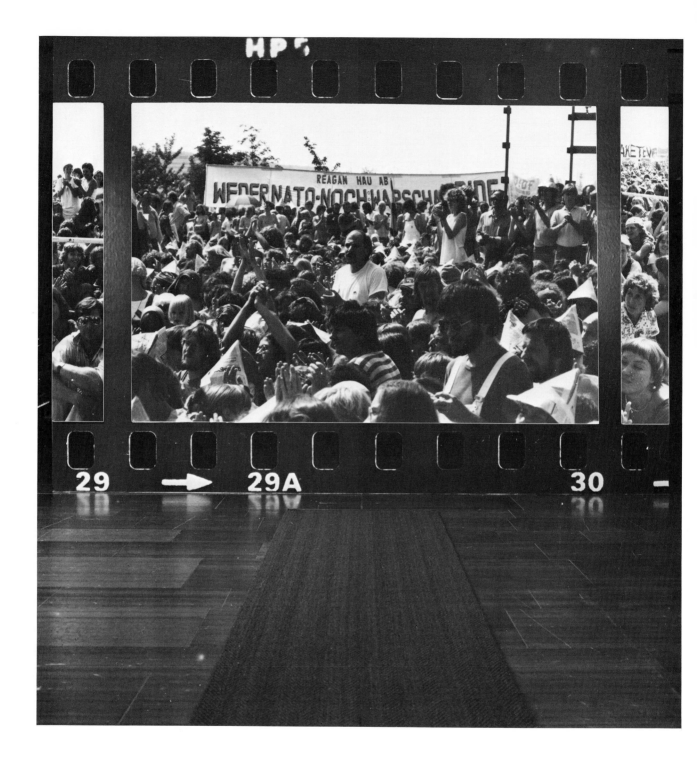

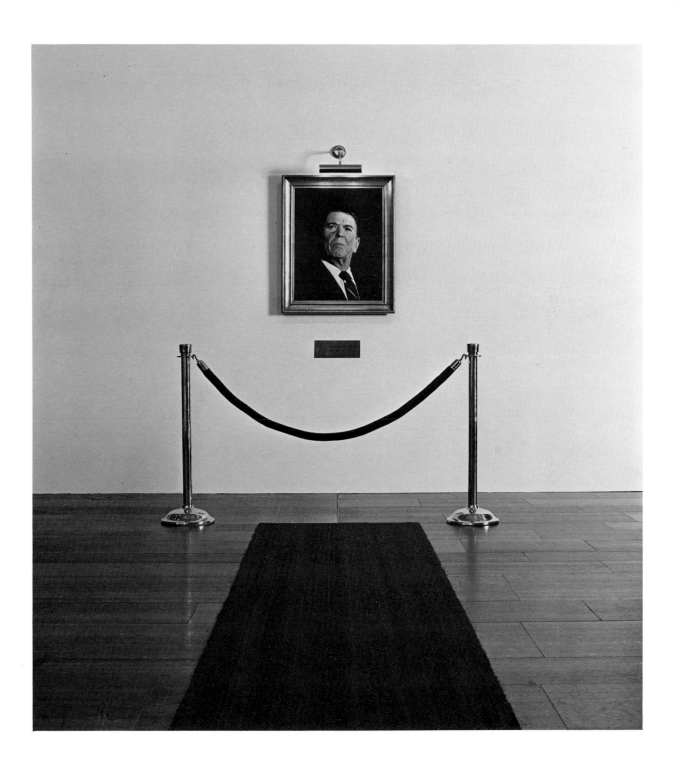

The Safety Net

(Proposal for Grand Central Station, New York)

1982

Light box and color transparency, 42 x 74 x 6½" (106.7 x 188 x 16.5 cm). Photograph of President Reagan: Michael Evans, SYGMA.

First exhibited in one-person exhibition at the Bread and Roses Gallery, District 1199, New York, March 11-April 23, 1982. (The gallery is operated by the Union of Hospital and Health Care Employees.)

Owned by Hans Haacke.

According to the White House Historical Association, Nancy Reagan sought donations to refurbish the White House. She received $822,640 in tax-exempt contributions. Most of the money was spent on the Reagans' living quarters. Well-known American dress designers such as Galanos, Adolfo, Bill Blass, and David Hayes have given the First Lady evening gowns, dresses, and sports outfits worth many thousands of dollars.

Out of a total income of $741,253 in 1982, President Reagan gave $15,563 in charitable donations (2.1%). His salary was $200,000.

Announcement for one-person exhibition at Bread and Roses Gallery, District 1199 Building, New York, March-April 1982.

You want some advice? We got $800,000 to fix up our place, all tax-exempt. And many of Nancy's designer clothes are donated.

Try charity!

Photo Michael Evans/SYGMA, Design : Hans Haacke, 1982

Reaganomics

1982-1983

Color transparency in black frame. Four fixtures with white fluorescent tubes: 72 x 49″ (183 x 124.5 cm). Photograph of President Reagan: Michael Evans/ The White House.

First exhibited in one-person exhibition at the John Weber Gallery, New York, April 30-May 21, 1983.

Owned by Hans Haacke.

The *New York Post* of October 14, 1982, carried a front-page photograph of Ron Reagan, showing the 23-year-old son of the president on an unemployment line in Manhattan. Returning to his West 10th Street home in Greenwich Village, he was reported to have said: "I talked to my mother before I signed up and she said it was fine." He had been laid off from the Joffrey Ballet troupe, where he had worked as a dancer.

Ron Reagan has since had several employments, in which he has used his celebrity status as son of the president. Among these are an appearance in a commercial for American Express and writing for *Playboy* magazine, for which he is a contributing editor.

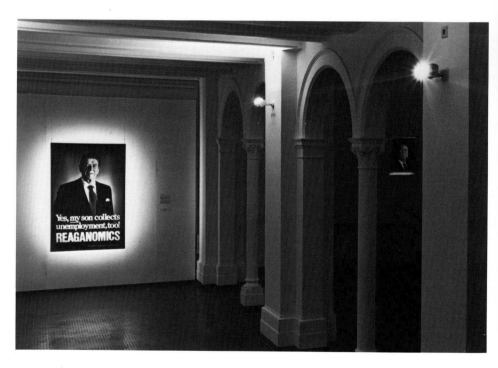

Installation of one-person exhibition at Künstlerhaus Bethanien, Berlin, September-October 1984.

Yes, my son collects
unemployment, too!
REAGANOMICS

Photo: Michael Evans / The White House Design: © 1982 Hans Haacke

Alcan: Tableau pour la salle du conseil d'administration

1983

Oil painting in aluminum frame, 55 x 60" (139 x 152 cm).

First exhibited in one-person exhibition at Galerie France Morin, Montreal, Canada, February 5-February 26, 1983.

Photograph of painting and installation: Brian Merritt.

Collection of the National Gallery of Canada, Ottawa.

Translation:

ARVIDA

The Alcan Factory at Jonquière on the [river] Saguenay.

Work in the smelters allows workers to contract various respiratory diseases as well as bone fibrosis.

They have an increased chance to develop cancer and there is a possibility that they will get *plaque de pot* ("smelter's blotches"), red patches that cover the entire body.

Alcan Aluminum Ltd., through its subsidiaries and affiliates, is one of the largest producers of aluminum ingot in the world. It operates large aluminum fabrication facilities in some thirty-five countries. Throughout the world it has approximately 66,000 employees. It is the largest manufacturing employer in Quebec. The head office of the totally integrated multinational company is in Montreal. On December 31, 1981, 48% of the common shares were held by residents of Canada, 45% by residents of the U.S. The chairman of the board, Nathaniel V. Davis, a U.S. citizen, is reputed to control a considerable block of shares.

A color photograph of Alcan's smelter in Arvida (Ar.thur Vi.ning Da.vis—first chairman of Alcan), which appeared in the company's promotional brochure *Voici Alcan* of 1979, served as a model for the painting.

Installation of one-person exhibition at Galerie France Morin, Montreal, February 1983. This view also shows the installation of *Voici Alcan.*

ARVIDA

Usine ALCAN à Jonquière au Saguenay

Le travail dans les salles de cuves permet aux ouvriers de contracter certaines maladies respiratoires ainsi que la fibrose osseuse.

Leur chance de cancer augmente et ils ont la possibilité de souffrir de «plaques de pot», des taches rouges couvrant le corps.

Voici Alcan

1983

Three panels, each 86½ x 41″. Two sepia photographs (left and right), one color photograph (center), white lettering, aluminum windows, acrylic plastic with silver foil.

First shown in one-person exhibition at Galerie France Morin, Montreal, Canada, February 5–February 26, 1983.

Photographs of panels: Brian Merritt.

Collection of the National Gallery of Canada, Ottawa.

"Voici Alcan" is the title of a glossy brochure which was published by Alcan in 1979.

Translation, first panel:

Lucia di Lammermoor, produced by the Montreal Opera Company with funding from Alcan.

Alcan's South African affiliate is the most important producer of aluminum and the only fabricator of aluminum sheet in South Africa. From a nonwhite work force of 2,300, the company has trained eight skilled workers.

Alcan has marketed aluminum in South Africa since 1930. In 1949, it started production at a new plant in Pietermaritzburg near Durban. Major new investments occurred between 1969 and 1972. When Alcan sold a block of its shares in 1973 to the South African Huletts Corporation, it stressed that this was not a political move. Duncan Campbell, a vice-president of Alcan, explained, "The decision was made purely for commercial and financial reasons. It doesn't mean we're pulling out of South Africa." The increase in South African ownership in Alcan's South African affiliate allowed the company to borrow locally and thereby to circumvent restrictions imposed by the South African government.

In the early 1970s, Alcan was accused by church groups of having paid its black workers wages below the "poverty datum line" (South African measure for poverty). In 1982, representatives of the United Church of Canada, the Canadian Conference of Catholic Bishops, the Redemptorist Fathers, and the Anglican Church of Canada filed a proxy resolution at Alcan's annual meeting, requesting the board of directors to establish a South African review committee to "examine the company's activities in South Africa, including the sale of its products to the South African military, the status of Huletts' chairman on the Defense Advisory Board, and the storage of weapons on company premises, as well as the training of militia units of Huletts employees." Speaking for the board, Nathaniel Davis, Alcan's chairman, opposed the resolution. He explained that all security regulations of South Africa are binding on Alcan's affiliate. "While it is entirely normal and indeed inevitable," he said, that Alcan products are used by the South African military, Alcan was not permitted, under South African law, to disclose the nature of sales for military use.

Stephen Biko was the co-founder and central figure in the Black People's Convention, the South African black consciousness movement. He was arrested without charges by the Special Branch of the South African Police on August 8, 1977, and detained in Port Elizabeth. The police admitted having forced Biko to spend nineteen days naked in a cell before he was interrogated around the clock for fifty hours while shackled in handcuffs and leg irons. During his detention he suffered severe head injuries. In a semiconscious state he was taken naked in a Land Rover to a hospital in Pretoria, about fourteen hours away from Port Elizabeth. He died from his injuries on September 12.

Alcan has been sponsoring cultural programs, ranging from the Théâtre Alcan and the production of the popular television series "Les Ploufs" (a series on a fictional Quebec family) to architectural conferences and an art collection in the company's Montreal headquarters.

Co-sponsorship of two productions of the Opéra de Montreal with Hydro-Quebec linked Alcan in a highly visible way with the provincially owned utility company. Cheap hydroelectric power is the main asset of Alcan's aluminum production in Quebec. In the recent past Alcan has been threatened by the nationalization of the electric power generating plants it owns in the province.

In 1986, shortly before its annual shareholder meeting, at which a church-sponsored proxy resolution for withdrawal from South Africa was to be voted on, Alcan announced that it had sold its share in the South African Huletts Corporation.

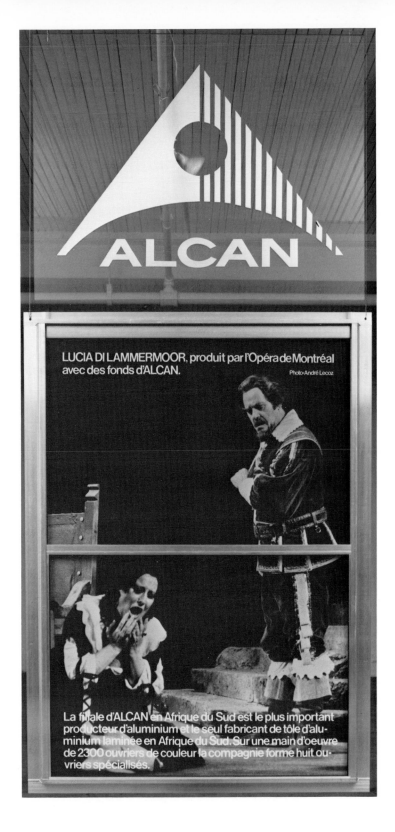

Translation, second panel:

Stephen Biko, black leader. Died from head wounds received during his detention by the South African police.

Alcan's South African affiliate sells to the South African government semifinished products which can be used in police and military equipment. The company does not recognize the trade union of its black workers.

Translation, third panel:

Norma, produced by the Montreal Opera Company.

Alcan's South African affiliate has been designated a "key point industry" by the South African government. The company's black workers went on strike in 1981.

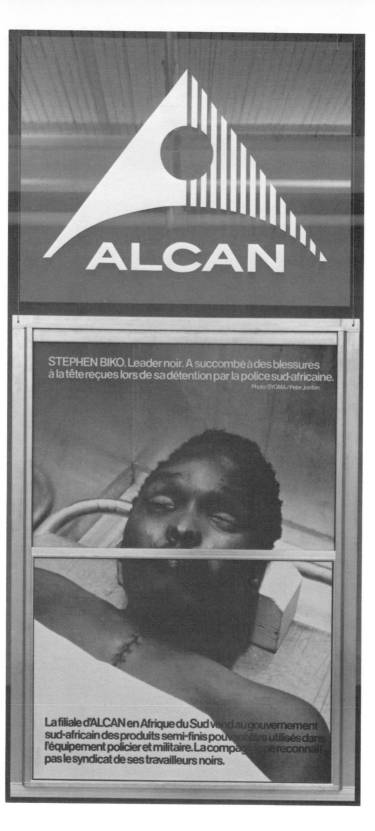

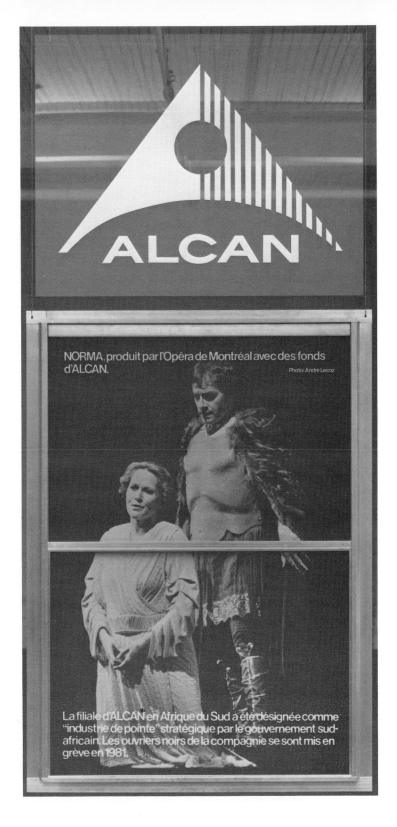

NORMA, produit par l'Opéra de Montréal avec des fonds d'ALCAN.

Photo: André Lecoz

La filiale d'ALCAN en Afrique du Sud a été désignée comme "industrie de pointe" stratégique par le gouvernement sud-africain. Les ouvriers noirs de la compagnie se sont mis en grève en 1981.

We Bring Good Things to Life

1983

Marbled wood pillar with fins, lettering, etched copper plate, gilt plaster bust, and circular fluorescent tube. Overall height 110 x 35½" (279 x 90 cm), height of bust 27" (68.5 cm).

Production assistance from Max Hyder.

First exhibited in one-person exhibition at the John Weber Gallery, New York, April 30-May 21, 1983.

Photographs: Fred Scruton.

Owned by Hans Haacke.

In the 1950s, Ronald Reagan appeared regularly in television commercials as a spokesman for the products and political views of General Electric. The company is widely known for its consumer goods, including light bulbs and fluorescent tubes, but it is also the fourth largest military contractor in the U.S. Among the company's most important nuclear weapons contracts was the production of 300 nuclear warheads of the Mark 12A type.

General Electric has built nuclear power plants with containment buildings which, according to experts, may rupture under the stress of a major accident like that at Chernobyl. This problem was raised in a confidential memo written in 1971 by Dr. Stephen Hanauer, then a top federal nuclear safety advisor and later chairman of the Nuclear Regulatory Commission. As quoted by *Private Citizen*, Dr. Hanauer stated, "G.E. wants us . . . not to mention the problem publicly."

"We bring good things to life" is the slogan with which General Electric promotes its electric appliances.

President Reagan's plan for a space-based defense system—popularly known as "star wars"—has been evaluated by many experts as being extremely costly, dangerous, and ultimately impossible. "Star wars" has become a major stumbling block in disarmament negotiations with the Soviet Union.

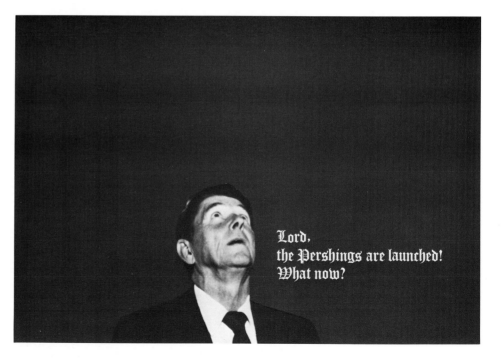

Postcard, *The Lord's Prayer*, 1984,
4 × 6" (10.1 × 15.3 cm).

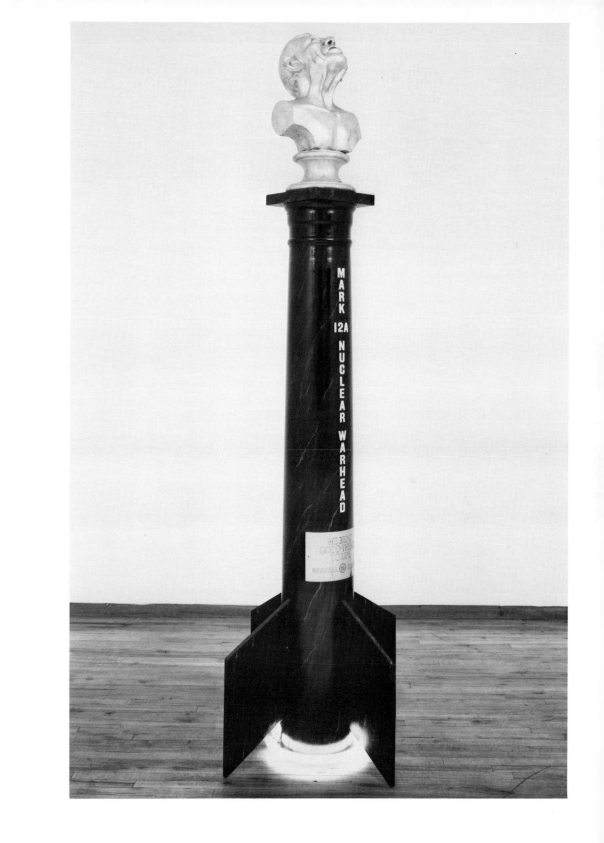

U.S. Isolation Box, Grenada, 1983

1984

Wood planks, hinges, padlock, spray painted stencil lettering, 96 x 96 x 96" (244 x 244 x 244 cm).

First exhibited in a group exhibition organized by Artists' Call Against U.S. Intervention in Central America, January 22-March 6, 1984, in the public mall of the Graduate Center of the City University of New York, between 42nd and 43rd Streets in Manhattan.

Built by Jeff Plate.

David Shribman reported in the *New York Times*, November 17, 1983, that the U.S. troops that had invaded Grenada detained prisoners in boxlike isolation chambers at the Point Salines airport. The wood boxes measured approximately eight by eight feet, had four small windows so high that one could see neither in nor out, and had a number of ventilation holes with a radius of half an inch. Inside one box a prisoner had written, "It's hot in here." The prisoners were forced to enter these boxes by crawling through a hatch that extended from the floor to about knee level.

Shortly after the exhibition opened, the administration of the Graduate Center moved the sculpture into a dark corner of the mall and turned it in such a way that the inscription was hardly visible. Only after protests was the work restored to its original position.

An editorial in the *Wall Street Journal*, February 21, 1984, attacked this work and a gravelike mound of earth in memory of Maurice Bishop, the slain prime minister of Grenada, by the New York artist Thomas Woodruff. The *Journal* found these two works to be "in proper company" with "America's greatest collection of obscenity and pornography" a few blocks down 42nd Street. The writer of the editorial also called the Isolation Box "the most remarkable work of imagination in the show."

In an article published in *The New Criterion* (April 1984), the editor, Hilton Kramer, called the *U.S. Isolation Box* "devoid of any discernable artistic quality." In the same article, he sought to discredit Artists' Call Against U.S. Intervention in Central America as well as a number of individuals and institutions, including the critic Donald B.

Kuspit and the New Museum of Contemporary Art. He broadly associated them with what he characterized as "the Stalinist ethos" and, quoting Lionel Trilling, he warned his readers not to be duped by "Stalinist-colored liberal ideas" which would lead to "an eventual acquiescence to tyranny."

Hilton Kramer's *The New Criterion* was launched in 1982 with financial support from three well-known right-wing organizations: the Smith Richardson Foundation of North Carolina, which gave $375,000; Richard Mellon Scaife's Carthage Foundation, which gave $200,000; and the John M. Olin Foundation of New York, which has made annual contributions of $100,000. With additional grants from the Florence and John Schuman Foundation of New Jersey (whose president is a former vice-president of the Sarah Scaife Foundation, another supporter of right-wing causes), *The New Criterion* received more than $1 million between 1982 and 1986.

Initially, the neoconservative journal had its offices in the headquarters of the Olin Corporation on Park Avenue in New York. The Olin Corporation has been convicted of illegally supplying arms and ammunition to South Africa. It has also been in the news for dumping mercury, price fixing, questionable payments to foreign officials, and strike breaking. Among the *Fortune 500* chemical companies, Olin is the only one bidding for a U.S. government contract for the production of poison for gas warfare. William E. Simon, the president of the John M. Olin Foundation, is a well-known fundraiser for the contras in Nicaragua.

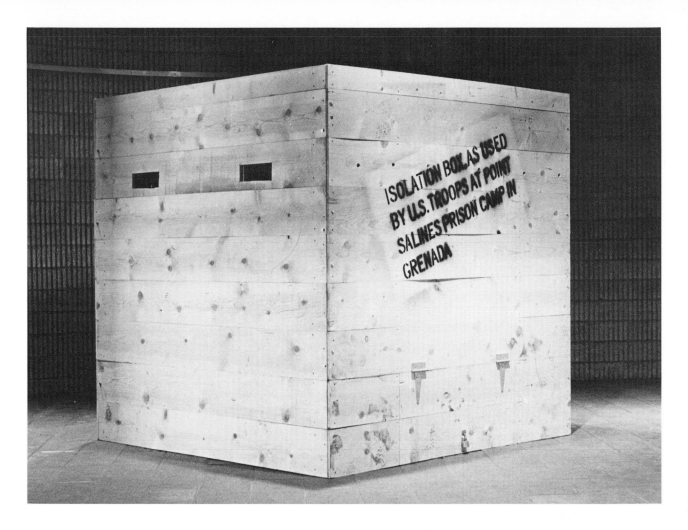

As a panelist for the National Endowment for the Arts, Hilton Kramer, together with his publisher, Samuel Lipman, a Reagan-appointed member of the National Arts Council of the NEA, spearheaded a successful campaign to eliminate NEA grants to art critics. One of Kramer's arguments for the discontinuation of this program was that, in his opinion, the grants had gone to critics who were "opposed to just about every policy of the United States government."

Artists' Call Against U.S. Intervention in Central America, an ad hoc coalition of artists in the U.S. and Canada, staged numerous exhibitions, performances, and other events in over twenty cities from January to March 1984. They were organized in protest against U.S. policy in Central America and in solidarity with the victims of that policy. Claes Oldenburg designed the poster. In New York, more than seven hundred artists of all ages and styles participated, among them both internationally renowned and totally unknown artists. Established commercial galleries such as Leo Castelli, Paula Cooper, and Barbara Gladstone, as well as alternative galleries, made their spaces available. Artists' Call took out a three-quarter-page advertisement in the Sunday edition of the *New York Times*. Most art journals reported the events extensively. *Arts Magazine* carried the Oldenburg poster on its cover.

Taking Stock (unfinished)

1983-1984

Oil on canvas, gold frame, 95 x 81 x 7"
(241 x 206 x 18 cm). Frame built by
Max Hyder and Richard Knox.

First exhibited in one-person exhibition
at the Tate Gallery, January 25-March 4,
1984. Director Alan Bowness, curator
Catherine Lacey.

Photographs: Zindman/Fremont.

Collection of Gilbert and Lila
Silverman.

Inscriptions on the painting:

On the foot of the column, left:

ES SAATCHI TRUS
ITECHAPEL GAL
TRONS OF NEW
ART COMMITTEE
HE TATE GALLER

*On the plates on the top shelf of the
bookcase:*

MS
CS

*On the spines of the books in the
bookcase:*

Allied Lyons, Avis, BL, Black & Decker,
Blue Nun, British Airways, British Arts
Council, British Crafts Council, British
Museum, British Rail, Campbell Soup,
Central Office of Information,
Conservatives-British Elections,
Conservatives-European Elections,
Cunard, Daily Mail, Dunlop (acc. lost),
Dupont, Gillette, Great Universal
Stores, Johnson & Johnson, IBM,
Massey-Ferguson, Max Factor, National
Gallery, Nestlé, Playtex, Procter &
Gamble, Rank Organisation, Rowntree
Mackintosh, Royal Academy, South
Africa-Nationalist Party, Serpentine
Gallery, Tottenham Hotspurs, TV-am,

The marble sculpture of Pandora, represented on the little Victorian table in the painting, is by the British sculptor Harry Bates, who carved it in 1890. It belongs to the collection of the Tate Gallery. Margaret Thatcher is depicted sitting on a chair with an image of the young Queen Victoria on its back. The chair is in the collection of the Victoria & Albert Museum.

The initials MS and CS on the rims of the broken plates on the top shelf of the bookcase refer to the brothers Maurice and Charles Saatchi, whose portraits appear in the center of the plates. In 1982, Julian Schnabel, who is known for his paintings incorporating broken plates, had an exhibition at the Tate Gallery. Nine of the eleven paintings in the show were owned by Doris and Charles Saatchi. It was the first exhibition the museum organized in collaboration with the Patrons of New Art of the Tate Gallery, a group which had been established the same year. Charles Saatchi was a driving force behind its establishment and an influential member of its steering committee. The Schnabel show was followed by an exhibition of Jennifer Bartlett, who had just been commissioned to make murals for the Saatchis' dining room.

The Patrons are a private association with the stated goal of acquiring and donating contemporary art works to the Tate Gallery (the museum is operated by the British government). Its membership includes many collectors and nearly all London art dealers; the New York dealer Leo Castelli is an associate member. There have been complaints that the Saatchis have never donated a work to the Tate Gallery. A disillusioned Friend of the Tate is quoted in *Harper & Queen*, saying: "The group is a vehicle for power, prestige and social climbing."

At the time, Charles Saatchi was also a member of the board of trustees of the Whitechapel Gallery, another public institution in London, predominantly exhibiting contemporary art. It is suspected that he profited from insider information about the gallery's exhibition plans, which allowed him to buy works, notably by Francesco Clemente and Malcolm Morley, at a favorable moment. In February 1984, after the opening of the Haacke exhibition at the Tate Gallery, Charles Saatchi gave up his position on the Patrons of New Art Committee of the Tate. He also resigned his trusteeship at the Whitechapel Gallery.

Doris Saatchi, the former Doris Lockhart, is a graduate of Smith College and ex-copywriter for the New York advertising agency Ogilvy & Mather. She now writes art criticism for *The World of Interiors*, *Artscribe*, and *Architectural Review*, and is the London editor of the American *House and Garden*. She and her husband, Charles, began collecting art in the early 1970s. Initially interested in photorealism and pattern painting, they shifted their attention to minimalism and neoexpressionism. When the Museum of Contemporary Art in Los Angeles opened in 1983, it invited eight collectors to present selections from their holdings. The Saatchis chose works by Baselitz, Chia, Clemente, Guston, Kiefer, Morley, Schnabel, and Stella.

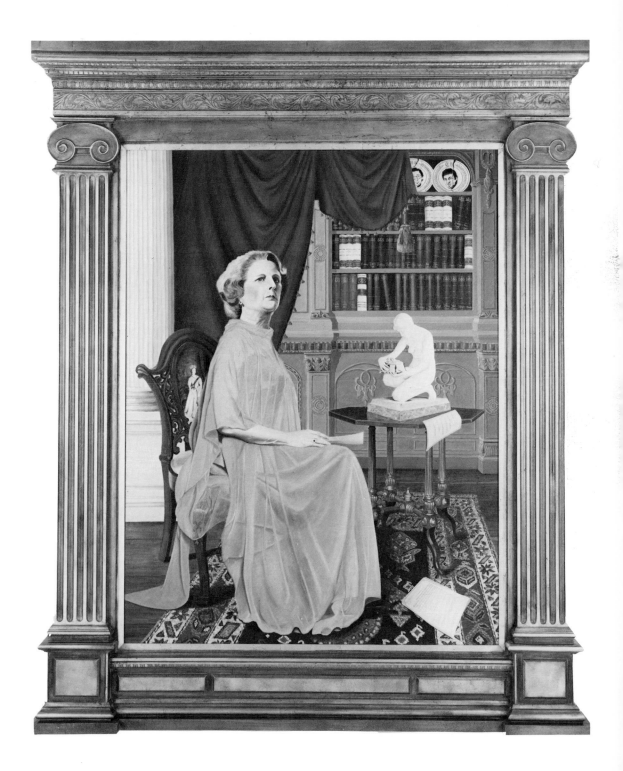

United Biscuits, Victoria & Albert Museum, Wales Gas, Walt Disney, Wimpey, Wrangler

On the paper hanging over the edge of the table:

In the year ended March 31st 1978, Brogan Developers Ltd. (Saatchi Investment Ltd.) sold art works valued at £380,319.

On the paper lying at Mrs. Thatcher's foot:

Saatchi & Saatchi Company PLC
The year ended September 1982

Furniture, equipment, works of art and motor vehicles
Gross current replacement cost:
£15,095,000
Depreciation:
£7,036,000
Net current replacement cost:
£8,095,000

Tangible net assets are stated at historical cost or valuation less accumulated depreciation. The cost and valuation of tangible fixed assets is written off by equal annual installments over the expected useful lives of the assets: for furniture and equipment between 6 and 10 years. No depreciation provided for works of art.

The financial base for their massive acquisitions on the art market is the income from Saatchi & Saatchi Company PLC, which has been built by the Saatchi brothers, through a string of spectacular mergers, into the largest advertising agency in the world. The necessary capital was raised on the London Stock Exchange, where the company has been listed since 1975, as well as through the issuance of American depository shares. It is assumed that, in order to build confidence among investors, it was valuable for the brothers to have received solid support from *Campaign*, the British advertising trade journal. Maurice Saatchi had once been promotion manager for the publisher of *Campaign*, Haymarket Publishing, which is said to be controlled by the family trusts of the former Tory minister, Michael Heseltine.

In 1982, the Saatchis acquired Compton Communications, an important New York agency. It provided them with a worldwide network and, as a client, Procter & Gamble, the world's largest advertiser. In rapid succession other U.S. agencies were bought up: in 1983, McCaffrey and McCall of New York; the following year, Yankelowitch, Skelly & White, a New York-based market research firm, and the Hay Group of Philadelphia, a management consulting firm with an international network of offices. Added in 1985 were Roland Co., the fifth largest public relations concern of the U.S.; Siegel & Gale of New York, specializing in corporate identification work; the Marlboro Group (sales promotion); and the Kleid Co., which concerns itself with direct marketing. By 1985, business in the U.S. generated 62% of the revenue of the holding company, Saatchi & Saatchi Company PLC. The pace and volume of takeovers quickened in 1986 with the acquisition of Backer & Spielvogel in New York and the addition of two international networks, through the acquisition of Dancer,

Fitzgerald, Sample (now DFS-Dorland Worldwide) and Ted Bates Worldwide. The buy-out of Ted Bates for $450 million topped the "big bang merger" of three giant U.S. agencies within weeks and made Saatchi & Saatchi the world's largest advertising agency. Saatchi & Saatchi is now estimated to have $7 billion in billings (normally 15% of billings are income for an agency) and at least 150 wholly owned offices in some fifty countries. Fearing that the newly merged agencies could not properly service competing clients under the same roof has led to defections with the loss of at least $350 million in billings. The New York headquarters will soon be relocated from Madison Avenue to a new building on the corner of Hudson and West Houston Streets, in easy walking distance from the galleries, boutiques, and restaurants of Soho.

The Saatchis are promoting the idea of "global marketing," i.e., the use of a single strategy, brand name, and advertising campaign throughout the world. They have expanded into areas beyond advertising, such as public relations, market research, and management consulting. A plan to buy Michael Deaver & Associates, the lobbying firm of President Reagan's close friend and former White House deputy chief of staff, for $18 million soured when questions were raised in Congress about whether Deaver had violated lobbying rules concerning conflicts of interest. According to an unnamed advertising associate, quoted in *Fortune*, Charles Saatchi is a man with "an insatiable desire to own everything and dominate everything all the time." In London, the brothers are referred to as "Snatchit & Snatchit." They are said to own personally 10% of the company, a stake valued in 1985 at upwards of $55 million.

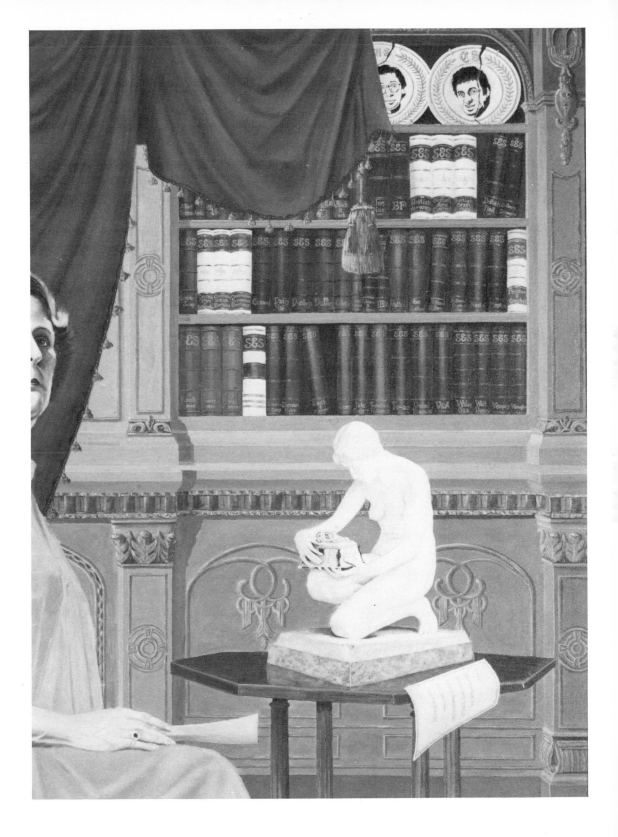

'Ruthless' Maggie!

A NEW portrait of Mrs. Thatcher, left, in the Tate Gallery in London shows the "ruthless" side of the Iron Lady.

German artist Hans Haacke painted her from Press photographs seated in one of her favourite sky-blue gowns with a strikingly haughty and arrogant expression.

Source photograph, "The Margaret Thatcher Look" (Photo: Terry O'Neill, Camera Press, London) News clipping, "'Ruthless' Maggie!" *The Star* (Sheffield), January 25, 1984.

Saatchi & Saatchi ran Margaret Thatcher's election campaigns in 1979 and 1983. The *New York Times* commented that the themes of its political advertisements "tend to be simple to the point of brutality." One of the ads suggested that the Labour Party platform was identical with that of the British Communist Party. Another ad, directed to the Asian and West Indian population of London, showed a black man with the caption "Labour Say He's Black; Tories Say He's British." Because of the Conservative Party's poor record in race relations, several West Indian publications rejected the ad as insulting. Saatchi & Saatchi was also in charge of the Tory election campaign for the European Parliament. After the Conservative victory of 1979, Thatcher handed the British Airways account, worth $25 million in billings, over to the Saatchis, thereby breaking a thirty-six-year relationship with the U.S. agency Foote, Cone & Belding.

Michael Dobbs, a deputy chairman of Saatchi & Saatchi, serves as chief of staff of Norman Tebbit, the Conservative Party chairman.

In 1983, the South African office of Saatchi & Saatchi Compton Worldwide was hired by the governing Nationalist Party of Pieter W. Botha to promote the adoption of a proposed change of the South African constitution in a national referendum. This change established a tri-camera system, which gives the 3.4 million "colored" and Asian inhabitants a nominal representation, while, in effect, it reserves power to the white minority (16% of the population). As in the past, South Africa's 21 million blacks (72% of the population) remain totally disenfranchised. The new constitution was designed as a political smokescreen. It gave the appearance of reform, while it actually cemented the apartheid system.

KMP-Compton, the South African outpost of Saatchi & Saatchi Compton Worldwide, serves government agencies, such as the Department of Trade & Industry and ISCOR,

the government controlled steel corporation. Among its clients are also Senbank, "South Africa's leading merchant bank," and the Free Enterprise Bank, a subsidiary of the Ciskei Peoples Development Bank. Ciskei is a recent creation of the South African government, which considers it an independent nation and whose inhabitants it does not recognize as South African citizens. This makes the indigenous population foreigners in their native land. Ciskei is not accepted as a nation by other countries.

In 1985, KMP-Compton ran the following full-page advertisement in the *Financial Mail*, the leading South African business weekly:

How Maurice and Charles found gold at the end of Jorissen Street. - If there's one thing that Charles and Maurice Saatchi have proved in their spectacular surge to the heights of the advertising business, it's that they know how to pick winners. So when it was announced that, by mutual agreement, the Saatchi connection in South Africa was to be KMP-Compton, it caused quite a stir. Had the Saatchis seen something happening in Bramfontein that local agency watchers had missed? Not really. What London had noted was KMP's professionalism, its solid client base, financial stability, disciplined creativity, efficient management—and its unmistakable South Africanism. For London, oddly enough, South Africanism is valued as a highly important attribute for an agency operating in this country, since it leads to more effective communication through a fuller understanding of the market. Now there's an interesting thought for an industry that's always been obsessed with how they look at things overseas. KMP-COMPTON, A SAATCHI & SAATCHI COMPTON WORLDWIDE AGENCY.

The 1985 annual report for the first time lists Barker McCormac, which handles the

Barclays Bank's (British bank) account in South Africa, as a second South African agency of the Saatchi network. Also the newly acquired Hay Group maintains a management consulting office in Johannesburg. It counts among its clients the Standard Bank of South Africa. After the merger with Ted Bates, Saatchi & Saatchi appears now to be the largest agency in the country. It is expanding in other ways in South Africa. In 1986, it acquired the majority of the shares of the National Mining Corporation, which it reportedly intends to use as a diversified, non-media-related service agency.

In 1985, Doris and Charles Saatchi opened a private museum in the north of London, designed by Max Gordon, a friend and former colleague both at the Tate Gallery and on the board of the Whitechapel Gallery. (The Whitechapel held a Schnabel show in 1986.) A lavishly illustrated four-volume catalogue of the collection has been published, with the title *Art in Our Time: The Saatchi Collection.* The catalogue does not shed light on the question of ownership of the works. When they are on loan, they are usually attributed to Doris and Charles Saatchi, yet art works of considerable value are also listed in the company's annual report under the rubric "fixed tangible assets," for which no depreciation is claimed.

The Saatchis continue to buy contemporary art, usually a large number of works by the artists of their choice, e.g., they have nineteen large paintings by Baselitz, twenty-seven by Schnabel, twenty-four by Clemente. According to Leo Castelli, "what collectors like the Saatchis do has a tremendous influence on what other people do and also on the market." Norman Rosenthal of the Royal Academy in London agrees: "If he sold . . . the whole market for that kind of art would crash." Sandro Chia, so far, has been the most well-known victim of this mechanism.

Weite und Vielfalt der Brigade Ludwig

1984

Installation: oil painting on canvas, 88⅝ x 67" (225 x 170 cm); billboard with Trumpf advertising poster, 105⅛ x 146⅛" (267 x 371 cm); masonite wall with wood beams, 145½ x 374 x 35½" (370 x 950 x 90 cm), dimensions variable according to the exhibition space, which it divides into two equal halves.

First exhibited in one-person exhibition organized by the Realismusstudio of the Neue Gesellschaft für Bildende Kunst, Berlin, and held at the Künstlerhaus Bethanien, Berlin-Kreuzberg, September 2-October 24, 1984, under the title *Nach allen Regeln der Kunst* (According to/after the Rules of the Game/Art, a pun on a German proverb).

Assistance with the installation from Udo Ropohl.

Owned by Hans Haacke.

The portrait of Peter Ludwig was painted after a photograph taken by Ulrich von Born at the opening of the exhibition *Durchblick* (Seeing Through), in June 1985. This was the first exhibition of Ludwig's collection of East German art, organized by the Ludwig-Institut für Kunst der DDR at the Städtische Galerie Schloß Oberhausen. Ludwig's posture is modeled after August Sander's 1928 photograph, *The Confectioner*. The image of Mrs. Irene Ludwig (to the left in the painting) is derived from the double portrait of the Ludwigs, which they commissioned in 1976 from the French photo-realist painter Jean-Olivier Hucleux. On the right is Erika Steinführer, a celebrated East German worker, as she appears in a painting by the East German Walter Womacka (now in the Ludwig collection). Trumpf is the leading brand name of Ludwig chocolate products. One of the products of the VEB Dresdner Süsswarenfabrik Elbflorenz in East Germany is a type of chocolate candy called Schocarrés, sold in flat rectangular packages, similar to Hershey bars. Inside the stiffened wrapper are individual bite-sized chocolate squares. This very distinctive form of packaging is virtually identical to that of Schogetten, a well-known product of the Trumpf Company of West Berlin. The billboard poster is an original Trumpf advertisement.

Broadness and Diversity of the Ludwig Brigade was produced for a specific historical, political, and art-world context in Germany. It was first exhibited at the Künstlerhaus Bethanien, an arts center located in the Kreuzberg section of West Berlin, about a hundred yards from the Wall. From the third floor of the building one has a good view over the meandering fortifications, erected in 1961 by the German Democratic Republic (GDR = East Germany), which physically divide the city and encircle West Berlin with two unscalable concrete walls. In between is a "deathstrip," complete with watchtowers, tank barriers, and all-night illumination. The GDR does not permit its citizens to leave its territory to go to West Berlin or countries outside the Eastern Bloc. Exceptions are made for old people who want to visit relatives in the West and for a small number of politically trustworthy individuals. Those who try to leave without authorization risk their lives in mine fields and under the guns of border guards. West German citizens are admitted to East Berlin, the capital of the GDR, on one-day visas issued at the border checkpoints to anyone who does not appear on a political blacklist. Entry into the territory of the GDR beyond Berlin is possible only after a lengthy visa application and on invitation from agencies or individuals that are recognized by the East German authorities as sponsors. Political considerations play a role. Border guards thoroughly scrutinize visitors from the West and often intercept newspapers, periodicals, and books, unless they have the imprimatur of the state. The GDR calls its Western border "the border of peace" and has proclaimed that "actually existing socialism" has been established on its territory.

After World War II, the tenets of socialist realist art, as they were practiced in the Soviet Union, were imposed on the Germans under its rule. Since the early 1970s, these prescriptions are interpreted more liberally and are enforced with greater latitude. Officially, an era of "broadness and diversity" was proclaimed. This relative opening coincided with

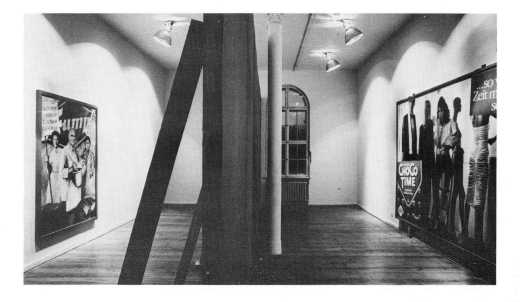

the political ascendance of Erich Honecker and the chairmanship of the painter Willi Sitte of the Verband bildender Künstler der DDR (Artists Association of the GDR). Willi Sitte is a member of the Volkskammer (East German Parliament). Membership in the Artists Association is strictly controlled. It is virtually a precondition for public exhibitions. All art institutions are state-owned. Sales of art works must be handled by the Staatlicher Kunsthandel der DDR (State Art Trading Agency of the GDR). Several East German artists who have gained a reputation in the West are not members and cannot exhibit in the GDR. The best known of these is A. R. Penck, who now lives in the West. Many East German artists are surprisingly well-informed about the Western art scene through West German television and publications they receive through underground channels.

It is only since the mid-1970s that the West German public has had an opportunity to see works by officially sanctioned artists of the GDR. This is in part due to the lack of interest in what was viewed as old-fashioned and

alien to the concerns of Western art. It was also fueled by the contempt for the political control of this art by a state from which many West German residents had fled. A further stumbling block was the condition that exhibitions of the works of East German artists could be organized only in collaboration with and under de facto control of the authorities of the GDR and its political ally in West Germany, the German Communist Party. The selection of East German art at *Documenta* in 1977, for example, was totally in the hands of the East German government. Willi Sitte and the painter Bernhard Heisig, his deputy in the Artists Association, have been represented in all of these exhibitions. While they are being credited with a relative liberalization, they also perform the role of watchdogs. When the East German singer Wolf Biermann was expatriated during a concert tour in West Germany in 1976 and a storm of public indignation broke out among East German writers and intellectuals, it was at the insistence of Willi Sitte that no visual artist signed any of the

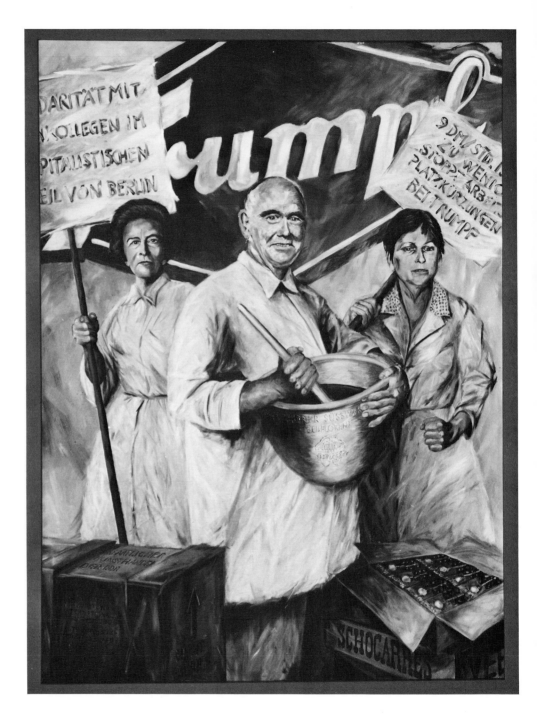

Inscriptions on oil painting:

Background:

Trumpf (logo of Trumpf chocolate and chocolate candy; Trumpf = trump).

Left placard:

DARITÄT MIT/N KOLLEGEN IM/
PITALISTISCHEN/EIL VON BERLIN
(Solidarity with our fellow workers in the capitalist part of Berlin).

Right placard:

9 DM/STD. IS/ZU WENIG/STOPPT
ARBEITS/PLATZKÜRZUNGEN/BEI
TRUMPF (9 DM/hour is not enough.
Stop the job cuts at Trumpf).

On the bowl:

VEB Dresdner Süsswarenfabriken Elbflorenz (Candy Factory of Dresden, Florence on the Elbe, People's Owned Enterprise).

On the crate, left:

STAATLICHER KUNSTHANDEL DER DDR (State Art Trading Agency of the GDR).

LUDWIG STIFTUNG FÜR KUNST UND INTERNATIONALE VERSTÄNDIGUNG (Ludwig Foundation for Art and International Understanding). c/o TRUMPF-SCHOKOLADE-U. KAKAOFAB-RIK GMBH/1 BERLIN 44/GRENZALLEE 4 (c/o Trumpf Chocolate and Cocoa Factory, Inc., 1 Berlin 44, Grenzallee 4).

On the cartons, right:

SCHOCARRÉS/VEB (VEB [Volkseigener Beitreib] = People's Owned Enterprise).

protest letters. Willi Sitte has declared that the tasks and functions of art can be reduced to basically two: "They have to foster harmony of men with themselves, their country, and their history, and they must give them strength, courage, and hope. And, where it is necessary, they have to disturb, to caution, and to admonish."

Currently, Amnesty International is working for the release of dozens of East German prisoners of conscience jailed for pressing their right of free expression. Many of them are members of church-affiliated peace groups. Neither in Willi Sitte's nor in Bernhard Heisig's work, nor in the work of other members of the Artists Association has there ever been any open criticism of the policies of the government of the GDR or its allies, whereas attacks on the "class enemy" in the West are a standard part of the repertory of subjects. For an outsider, it is difficult to discern whether or not implicit criticism occurs through allusion and metaphor. In his report as chairman of the jury for the ninth national art exhibition of Dresden in 1983, Bernhard Heisig deplored the retreat to the "noncommittal and politically imprecise" and a "turn to intellectually over-emphasized subject matter."

The art collector and chocolate manufacturer Peter Ludwig, like other West German businessmen, has had profitable contacts with the GDR for many years.

By way of licensing and other agreements with the East German authorities, Ludwig's products are also made in the GDR. He provides know-how, modern production facilities, and semifinished products to East Germany. Finished products from this low-wage country are assumed to be imported to West Germany. A key role in these transactions is played by the Trumpf-Schokolade- und Kakaofabrik Berlin GmbH in West Berlin. The plant has been established with the generous infusion of public money and, like other companies in West Berlin, enjoys preferential taxes as compared to those levied on enterprises elsewhere in West Germany. Legally, the Berlin plant is independent, though in fact controlled by Ludwig from West Germany. It can therefore take advantage of the lower taxation even in its dealings with the parent company. It will continue its collaboration with a newly created Ludwig Schokolade GmbH.

The majority of the Trumpf employees in Berlin are unskilled or semiskilled, low-wage workers. Over 60% are foreigners, mostly Turks, and a large proportion are women. Many of Ludwig's production centers have received public subsidies for the modernization of their plants, often out of fear of or in response to an implied threat that the company would otherwise move to a region with a better business climate. After the introduction of new machinery the work force was reduced in several instances. A streamlining program at the Trumpf plant in Berlin recently led to the reduction of the number of employees from 1,000 to 920. (For more on Ludwig's industrial empire, see *Der Pralinenmeister*.)

Wolfgang Schreiner, the managing director of the Berlin Trumpf company, is in charge of contacts with East Germany and other countries in the Eastern Bloc. He also serves as managing director of the Ludwig Foundation for Art and International Understanding, which was established by Peter Ludwig in 1983 with the income from the sale of 144 illuminated manuscripts from his collection to the J. Paul Getty Museum in California. One of the major activities of the Foundation has been the promotion of art from the GDR, the Soviet Union,

and Bulgaria, all countries where Peter Ludwig has or is suspected of trying to establish a favorable climate for his chocolate business.

In 1983 the city of Oberhausen, in the Ruhr district, agreed to set up a Ludwig Institute for Art of the GDR to house, administer, and promote the Ludwig collection of East German art that had been assembled since the latter part of the 1970s. As the catalogue of the collection in Oberhausen demonstrates, the institute does not fulfill the promise of scholarship that its name might imply. It is widely assumed that the institute is obliged to present the collection in accordance with official East German views, so as not to impair the business interests of Peter Ludwig in the GDR. While the collector/industrialist demands decision-making powers in museums of the West that have received loans or donations from him, he is attentive to the interests of his partners in the East and makes no such demands upon them. The selection of a loan to the Nationalgalerie in East Berlin, touted as representative of Western art, was left to the discretion of the director of the museum. He chose examples of Antes, Baily, Canogar, Colville, Erni, Estes, Genovés, Guttuso, Hausner, Johns, Klapheck, Lichtenstein, Picasso, Rauschenberg, and Tinguely. Peter Ludwig negotiates his acquisitions of Eastern art with the state art trading agencies. Prices are not fixed by the artists. By contrast, the municipal Ludwig Museum in Cologne, for example, is contractually obliged to consult with Peter Ludwig whenever the position of director or curator is to be filled. It also has to give him a full accounting of its activities twice a year.

Two days before the presentation of *Broadness and Diversity of the Ludwig Brigade* on September 2, 1984, in Berlin, the Kunsthalle Berlin opened an exhibition of the Ludwig collection of art from the GDR that was organized in Oberhausen. Willi Sitte gave an opening speech praising Ludwig and questioning the integrity and artistic achievement of artists who had left East Germany. Wolfgang Schreiner was in attendance. The exhibition included several flattering portraits of Peter Ludwig by Bernhard Heisig.

An article by Walter Grasskamp on the *Broadness and Diversity of the Ludwig Brigade*, which was commissioned for the catalogue of the *von hier aus* exhibition in Düsseldorf in 1984, was rejected by the catalogue's publisher, the Cologne DuMont Buchverlag, over the objection of the organizer of the exhibition (Kasper König). The publisher stated that he had to preclude the possibility of Peter Ludwig gaining a temporary court injunction against the distribution of the catalogue. When several legal experts disputed that there was probable cause for such fears and the issue of preventive censorship was aired in the press, the article appeared in the second edition of the catalogue, two months after the opening of the exhibition.

Mobil's Mixtures of Interest, Amusement, Raised Eyebrows, and Concern

1985

Collage, 47¼ x 72½" (120 x 184 cm).
Original letter from Mobil Oil
Corporation, Mobil dividend checks
made out to Hans Haacke, Tate Gallery
catalogue pages.

First exhibited in one-person exhibition
at the John Weber Gallery, New York,
May 4-May 25, 1985.

Photograph: Fred Scruton.

Collection of Gilbert and Lila
Silverman.

In September 1984, the Mobil Oil Corporation sent a letter to the Tate Gallery in London and to the Stedelijk Van Abbemuseum in Eindhoven, The Netherlands. In the letter, Mobil took issue with the reproduction of three works by Hans Haacke as well as an interview with him in a catalogue that accompanied his one-person exhibition in 1984 at the Tate Gallery. The catalogue was co-published by the two museums. The activities of Mobil are the subject of the three incriminated works (*Mobil: On the Right Track*, 1980; *Creating Consent*, 1981; *Upstairs at Mobil: Musings of a Shareholder*, 1981).

The oil company charged that its property rights had been violated by the use of their logo in the art works, and that the privacy rights of its officers had not been respected. In a follow-up letter, Mobil's lawyer threatened that the Tate Gallery "will make further distribution of the offending material at their risk and peril. My principals [Mobil] will have to consider what further legal steps may then be desirable." Both museums, unfamiliar with U.S. law, on which Mobil based its claims, provisionally suspended distribution of the catalogue. After almost an entire year, however, they released the publication.

Mobil is known to move against recipients of its grants who violate the company's rules of conduct (the Tate Gallery had received a grant from Mobil for an exhibition which closed the day before the Haacke exhibition opened). Mobil terminated its regular contributions to the Columbia School of Journalism when that institution filled an important position with someone who had written a book critical of the oil industry. Mobil also demanded its money back from the American Writers Congress when it felt that speakers at a conference organized by the Congress did not meet the company's political standards.

Mobil and its officers have taken more aggressive action when the corporation was exposed to direct criticism in the news media. When the *Washington Post* published an article in late 1979 suggesting nepotism in the extensive business dealings between Mobil and a company controlled by the son of Mobil president William P. Tavoulereas (retired in 1984), the newspaper was sued for libel. The case is still in the courts. In November 1985, the *Wall Street Journal* published an article indicating that the son-in-law of Mobil's chairman, Rawleigh Warner, Jr. (retired early 1986), would benefit financially from a $300 million office tower that the oil company was building in Chicago. It also referred to the information that led to the libel suit against the *Washington Post*. Mobil responded by withdrawing its advertising from the *Wall Street Journal* (worth about $500,000 annually) and declaring a total information embargo against the newspaper.

Mobil Oil Corporation

150 EAST 42ND STREET
NEW YORK, NEW YORK 10017

F. W. DIETMAR SCHAEFER
COUNSEL

September 7, 1984

The Tate Gallery
c/o The Tate Gallery Publications Department
Millbank, London SWIP4RG
ENGLAND

Stedelijk Van Abbemuseum
Bilderdijkalaan 10
Eindhoven, The Netherlands

cc: Professor Hans Haacke
 Cooper Union for the
 Advancement of Science & Art
 41 Cooper Square
 New York, New York

Re: Hans Haacke
 Volume II/Works-1978-1983, published by
 the Stedelijk Van Abbemuseum, Eindhoven, in
 association with The Tate Gallery Publications
 Department, London, for the exhibition at The
 Tate Gallery, 1/25/84 - 3/4/84
 pages 34-41 and interview by Tony Brown
 ("Artist as Corporate Critic") at Section II.3
 © 1984 by the Stedelijk Van Abbemuseum,
 Eindhoven, The Tate Gallery, London, and
 Hans Haacke, New York
 Edition of 2000 copies
 ISBN 90-701149-08-7

Dear Sirs:

 The advocacy art of Mr. Hans Haacke, as featured in
your above-identified catalogue and explained by him in
the interview with Tony Brown ("Artist as Corporate
Critic") has been viewed here with varying mixtures of
interest, amusement, raised eyebrows and concern. This

 It seems to us that certain basic issues need to be
resolved in this connection, particularly since we as-
sume it to be your unshakable intent to continue with
the exhibition of Mr. Haacke's works, their sale and
your catalogue's publicity aimed at furthering both of
these objectives.

 Your catalogue and the exhibition of art it publi-
cizes make rather free, by us unauthorized and certainly

Mobil Corporation

DIVIDEND CHECK

20·00

34034922 40 60705910 12/12/83 *********20·00 PAY

CENTS PER SHARE DIVIDEND RATE - 50 CENTS PER SHARE
UST 8, 1983 RECORD DATE - NOVEMBER 7, 1983

HANS C HAACKE
463 WEST ST
NEW YORK NY 10014

PAYABLE AT PAYABLE AT
THE CHASE MANHATTAN BANK, N.A. THE CHASE MANHAT
DIVIDEND DISBURSING AGENT DIVIDEND DISBUR

HAACKE---HANSC0000 170-36-5249 001-210

ACCOUNT KEY TAX I.D. BANK CODE

⑈34034922⑈ ⑆0210000214⑆ 901⑈7⑉0000⑈⑈

MetroMobiltan

1985

Fiberglass construction, three banners, photomural, 140 x 240 x 60″ (355.6 x 609.6 x 152.4 cm). Photo: Alan Tannenbaum, SYGMA.

Fabrication assisted by Max Hyder, Richard Knox, and Paula Payne.

First exhibited in one-person exhibition at the John Weber Gallery, New York, May 4-May 25, 1985.

Photo of installation: Fred Scruton.

Owned by Hans Haacke.

The black-and-white photomural behind the banners is based on a color slide taken by the SYGMA photographer Alan Tannenbaum. It shows the funeral procession for black victims shot by the South African police at Crossroads, near Cape Town, on March 16, 1985.

Text on plaque above the banners:

Many public relations opportunities are available through the sponsorship of programs, special exhibitions and services. These can often provide a creative and cost effective answer to a specific marketing objective, particularly where international, governmental or consumer relations may be a fundamental concern.

The Metropolitan Museum of Art

[Excerpted from a leaflet published by the Metropolitan Museum under the title "The Business Behind Art Knows the Art of Good Business—Your Company and the Metropolitan Museum of Art."]

Image on central banner:

Seated figure from Tanda, Africa, c. 1400 AD, National Museum, Lagos, Nigeria.

The texts on the left and right banners are excerpted from the Mobil Corporation's response to a 1981 shareholder resolution presented by a coalition of church groups. The resolution proposed the prohibition of sales to the South African police and military. Mobil management recommended a vote against adopting such a policy, calling it "unwise."

With more than $400 million worth of assets in South Africa, Mobil is one of the largest U.S. investors in that country. It is estimated that the company holds 20% of the petroleum market in South Africa. It maintains a refinery and an extensive network of 120 supply depots, and more than 1,200 service stations. The government of South Africa considers the oil industry as playing a vital strategic role. Oil is deemed a "munition of war." According to a 1984 estimate by the Washington-based Investors Responsibility Research Center, Mobil supplies the South African police and military with about 20% of their fuel needs. In 1984, Mobil's oil refinery in Durban was the target of a rocket-propelled grenade attack by the African National Congress, the major black liberation movement in South Africa.

In 1986, the Mobil management again recommended to vote against a shareholder resolution which demanded the termination of petroleum supplies to the South African police and military. The resolution was presented by Harrison J. Goldin, Comptroller of the City of New York, on behalf of the New York City Employees Retirement System. The Interfaith Center on Corporate Responsibility in New York has targeted Mobil for divestment. The oil company has been campaigning vigorously against divestment proposals at all levels. In an op-ed page advertisement of October 17, 1985, Mobil used many of the same arguments President Reagan later offered in an unsuccessful attempt to sustain his veto of a sanctions bill passed by the U.S. Congress.

Just one week earlier, on October 10, 1985, Mobil ran an advertisement in the same space, entitled "Art, for the sake of business." In answer to its own question "What's in it for us?" Mobil proudly declared the reasons for its involvement in cultural activities: "Improving —and ensuring—the business climate."

Mobil has provided grants for numerous exhibitions at the Metropolitan Museum of Art in New York, among them a show of ancient Nigerian art in 1980 and *Te Maori*, an exhibition of works by New Zealand tribal artists in 1984. These exhibitions are usually accompanied by an extensive publicity campaign underwritten by Mobil, including posters in New York bus shelters and advertisements with the Mobil logo. The company holds major assets in Nigeria and New Zealand, where it is planning to expand its facilities. It also gave $500,000 to keep the Metropolitan's Islamic galleries open, where it then entertained the Saudi Arabian Prince Sultan Ben Abdul Aziz (Mobil gets more than half of its oil from Saudi Arabia).

Herb Schmertz, a Mobil director and vice-president for public affairs, is vice-chairman of the museum's Business Committee. The committee is chaired by Carl Spielvogel, the head of a New York subsidiary of Saatchi & Saatchi, the world's largest advertising enterprise (Charles Saatchi is a vice-chairman of the museum's International Business Committee).

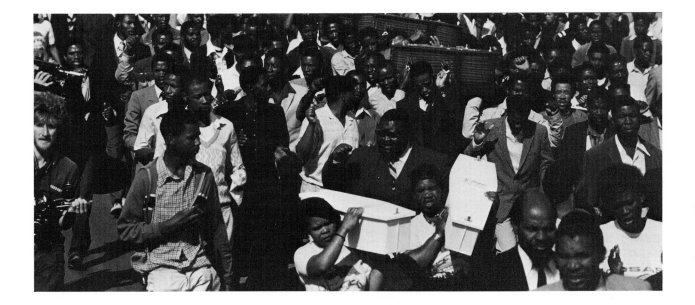

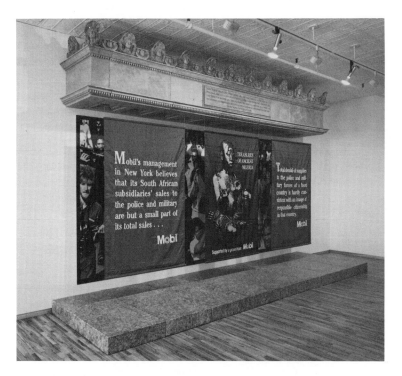

(Above) Photomural behind banners (Photo: Alan Tannenbaum, SYGMA) (Right) Installation view.

MANY PUBLIC RELATIONS OPPORTU[...]
PROGRAMS, SPECIAL EXHIBITIONS A[...]
COST EFFECTIVE ANSWER TO A SPE[...]
TERNATIONAL, GOVERNMENTAL OR C[...]
THE MET[...]

Mobil's management
in New York believes
that its South African
subsidiaries' sales to
the police and military
are but a small part of
its total sales . . .

Mobil

Supported b[...]

Buhrlesque

1985

Embroidered black tablecloth with appliqués, 95 x 56″ (243 x 143 cm). Marble table with relief of the head of Janus, 37 x 76½ x 37″ (94 x 194 x 94 cm). Bally men's and ladies' shoes, shoeboxes. Red and white candles. Color photo of magazine cover under glass in black frame with gold rim.

Execution of embroidery by Steve Diamond, Hugo Herrera, Boleslaw Hevallo, Mike Otero, Joe Pinero, Krystyna Pochadaj, Sanford Sigall.

First exhibited in one-person exhibition at the Kunsthalle Bern, March 1–March 31, 1985.

Photo of installation: Roland Aellig.

Collection of the Fond Régional d'Art Contemporain (FRAC) de Bourgogne, France.

Text on framed magazine cover, with translations:

Amptelijke Tydskrif Van Die SA Wermag (Official periodical of the SA Defense Force)

PARATUS

Registered at the GPO as a newspaper

Vol 35 No 7 July 1984 R01,00 (inclusive) ISSN 0031-1839

Ons-soldate mars vir vrede in Switserland (Our soldiers march for peace in Switzerland)

Gen Magnus Malan on the Price of Peace

Krygkor se dedelike Gogga (Armscor's deadly bug)

Oerlikon-Bührle, with headquarters in Zurich, is one of the largest diversified industrial enterprises in Switzerland. Its activities include the production of machine tools, arms and ammunition, training aircraft, automotive parts, welding equipment, textiles, and shoes, as well as real estate and hotel operations. The majority of the shares are held by the Bührle family. Dr. Dietrich Bührle, the chairman and chief executive officer, is considered to be one of the wealthiest citizens of Switzerland. Like his German father, the founder of the Oerlikon arms manufacturing empire in Zurich, he is an art collector and supporter of the Kunsthaus Zürich.

According to Oerlikon-Bührle's 1983 annual report, the company's income from the production of arms and related products

amounted to sfr. 1146 million, which represents 28.6% of the group's sales for the year. Aside from the Machine Tool Works Oerlikon-Bührle AG in Zurich, the corporation's Military Products Division comprises the British Manufacture and Research Co. Ltd. in Grantham (UK) and the Oerlikon Italiana S.I.p.A. in Milan. Their products include antiaircraft guns, vehicle armaments, tanks, and naval cannons, as well as ammunition in the 20-35mm caliber range. Oerlikon's Contraves Division, with plants in Zurich, Rome, Munich, Pittsburgh, and Regensdorf (Switzerland), produces fire-control and missile guidance systems.

The best-known civilian products of the Oerlikon-Bührle Holding AG are the shoes and leather goods of its Bally Division. They are marketed worldwide with an image of solid Swiss quality and elegance. The South African market is supplied through the M. & S. Spitz Footware Holding Ltd. in Johannesburg, in which Bally holds a minority interest. Also, Oerlikon's Welding Division is represented in South Africa: by way of its Holding Intercito SA of Panama, the Swiss conglomerate controls the South African Oerlikon Electrodes (Pty.) Ltd. in Kempten Park.

The most important South African client, however, appears to be the South African Defense Force/Suid-Afrikaans Weermag. For many years, it has been equipped with Oerlikon antiaircraft guns and 20mm Oerlikon vehicle armaments. These guns are designed for use in ground combat as well as against flying targets (Source: *Jane's Armour and Artillery*, 1983-1984, and *Small Arms Today*, 1984). The South African navy is reportedly also equipped with Oerlikon cannons.

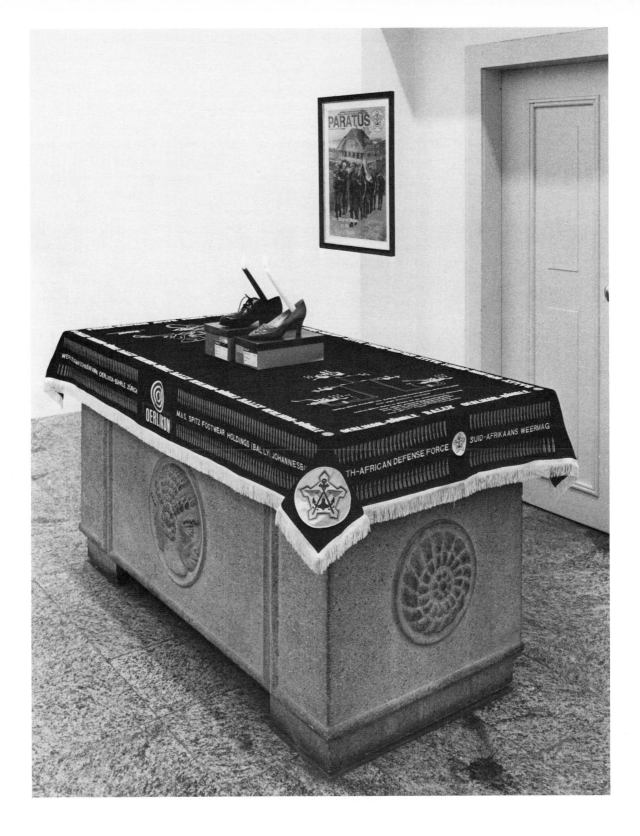

Texts on the tablecloth, with translations:

Along the edge:

Bally Oerlikon-Bührle Bally...

Werkzeugmaschinenfabrik (Machine Tool Works) Oerlikon-Bührle, Zürich Oerlikon

M. & S. Spitz Footware Holdings (Bally), Johannesburg South-African Defense Force/Suid-Afrikaans Weermag

Under the schematic drawing of an antiaircraft gun battery:

Oerlikon-Bührle 35mm GDF-002 Zwillingsabwehrgeschütz mit Feuerleitsystem (twin antiaircraft gun with fire-control system)

Auch gegen Bodenziele verwendbar (Also to be used against ground targets)

Oerlikon-Bührle Waffen im Einsatz bei der südafrikanischen Wehrmacht (Oerlikon-Bührle weapons used by the South African Defense Force):

20mm GAI-C01 leichtes Fliegerabwehrgeschütz (light automatic antiaircraft gun)

20mm KAD Fahrzeugmaschinenkanone (vehicle cannon)

35mm GDF-002 Zwillings-Fliegerabwehrgeschütz (twin automatic antiaircraft gun)

Under the drawing of ladies' shoes and handbags:

Bally aus dem Oerlikon-Bührle Konzern (From Oerlikon-Bührle)

In response to its increasing international isolation, South Africa has tried to make itself militarily independent through its own production of war matériel. For example, ARMSCOR (Arms Corporation), the large government-run enterprise which was established for this purpose, manufactures among other items 35mm Oerlikon ammunition, probably through a licensing agreement with the Swiss company. In March 1986, it unveiled a helicopter, designed primarily for a ground attack role. The helicopter is armed with a 20mm, 600-round-per-minute Oerlikon cannon. In this context, it is noteworthy that in 1983, Oerlikon registered nine patents for fuses, propellants, and projectiles with the South African patent office.

Switzerland followed the 1963 UN Security Council's call for an arms embargo against the Republic of South Africa. Moreover, a Swiss law of 1972 prohibits exports of arms to areas of tension and areas which are in a state of war. In 1977, the UN Security Council passed a resolution declaring a mandatory arms embargo against South Africa, which covers everything that could be used for military, paramilitary, or police purposes, including the granting of licenses and the supply of spare parts for such products.

Nevertheless, toward the end of the 1960s, it was discovered that Oerlikon-Bührle had illegally exported thirty-six twin antiaircraft guns, valued at sfr. 54 million, to South Africa. Four company officials, among them Dr. Dietrich Bührle, were convicted and received prison sentences (Dr. Bührle's sentence was suspended). The court noted that Dr. Bührle "had not voiced a word of regret over the illegal supplies. On the contrary, he made no secret, in court, that he had experienced a certain satisfaction over the continued supply of South Africa . . ." Dr. Bührle also stated in court that South Africa "would

no longer be supplied from Switzerland, but from another country." (The company had been involved in controversial transactions before: during the Second World War, it supplied Hitler's Germany with antiaircraft guns, and in the 1960s it shipped guns to Nigeria during that country's civil war.)

As Dr. Bührle intimated in court, the South African Defense Force, indeed, continues to be supplied by his company—not from Switzerland, but via its Italian subsidiary. There have also been reports in the Swiss press that Oerlikon may be collaborating with the CIA in providing training planes to the contras in Nicaragua. Swiss law does not regulate the export of arms manufactured by Swiss companies abroad. It does not prohibit the negotiation of agreements and the financing of such arms deliveries on Swiss territory. Nor does it forbid the granting of licenses. A move by Jean Ziegler, a socialist member of the Swiss Parliament, to close these loopholes in the law was rejected in 1978.

The authorities also permit other contacts with the South African armed forces on Swiss territory. In 1984, a delegation of the South African army, in full battle gear, marched in the popular two-day march which is organized annually by the Swiss Non-Commissioned Officers Association in Bern and its environs. *PARATUS*, the periodical of the South African Defense Force, celebrated this event as a successful goodwill operation for South Africa and its armed forces.

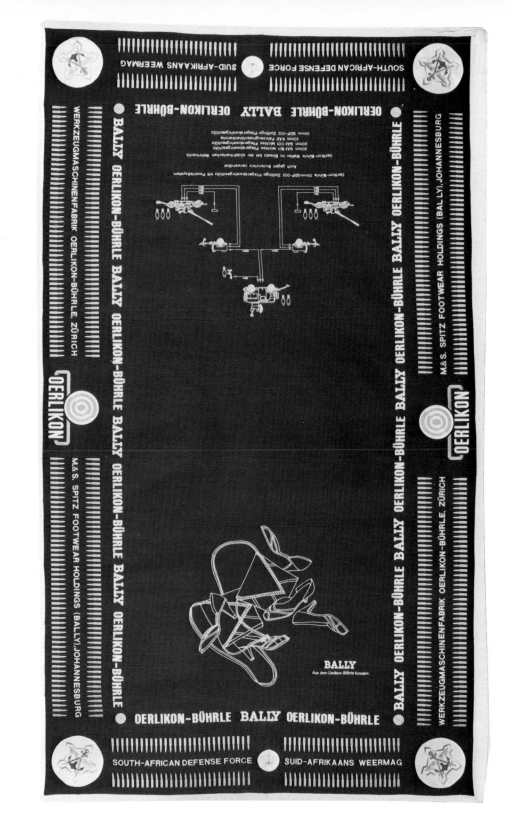

Les must de Rembrandt

1986

Installation in the two large exhibition rooms of Le Consortium, a not-for-profit art gallery in Dijon, France, June 12-August 1986.

Facade of boutique: black lacquered wood, 118 x 118 x 13" (300 x 300 x 33 cm), with black-and-white photo by W. Campbell/SYGMA in the show window. Facade of bunker: concrete, 146 x 146 x 71" (370 x 370 x 180 cm). Two concrete walls, 118 x 315" (300 x 800 cm). Awning in the South African colors: blue, white, and orange. Etched and gilded metal plaques.

Execution assisted by Catherine Bonnotte, Sylvia Bossu, Fabrice Bureau, Jules Chapit, Gérard Chevallier, Robert Chevallier, Éric Colliard, Xavier Douroux, Franck Gautherot, Mary Holder, Pierre Mathey, Marie-Ange Orivel, Jean-Marc Roblot, Yvon Roblot, Dennis Znenek.

Owned by Hans Haacke.

Translation of text on plaque underneath photo:

In September 1985, the black workers in GENCOR's gold and coal mines go on strike. The company breaks the strike with tear gas, guns, and dogs. It fires a large number of strikers and expels them from its hostels.

In January 1986, the black workers in GENCOR's platinum mine go on strike. 23,000 strikers are fired. Johan Fritz, the company director, states: "We have a shield against their irresponsible actions—a large army of unemployed."

The Rembrandt Group, an intricate network of companies with headquarters in Stellenbosch, South Africa, is headed by Anton Rupert. He is the leading figure of the Afrikaner business establishment. The Rembrandt Group derives its income from the tobacco and liquor industry on a worldwide basis as well as from interests in mining, engineering, banking and insurance, portfolio and cash investments, printing, packaging, adhesives, detergents, and petrochemical products.

The Rembrandt Group has a direct interest of 20% in Total South Africa, a subsidiary of the Compagnie Française des Pétroles. Through its sizable holdings in the South African Volkskas banking empire and other companies, Rembrandt interests in Total South Africa may well exceed half of all the South African shares in the French state-controlled oil company, which itself controls 57.6% of Total South Africa. Aside from Total's mining of coal and uranium in South Africa, the company satisfies a significant part of South Africa's petroleum needs. It operates 700 service stations and is a major source of fuel for the South African military and police.

One of Total's coal mines is managed by GENCOR, the second largest mining concern of South Africa, in which Rembrandt has a 30% stake. Aside from its coal mining operations, GENCOR is also a major producer of gold, uranium, platinum, and other precious metals and is involved in a variety of other industries, including the manufacture of armored vehicles and naval vessels.

Because of the brutal treatment of its black mining workforce, GENCOR has been declared an "enemy company" by NUM (National Union of Mine Workers), the trade union of black miners in South Africa. In September 1985, GENCOR crushed a legal strike in its gold mines with guns, tear gas, and dogs. The company publicly acknowledged that thirty-four people were injured and that it had dismissed 1,100 strikers. As a consequence of such dismissals, workers not only lose their jobs but also their right to stay outside of the so-called tribal homelands. The black population is obliged to live in these arid stretches of land unless they have certified employment in the developed regions of the country reserved for whites. The law also stipulates that not more than 3% of a mine's black workers may live with their family close to their job. Consequently migrant workers, housed in all-male company hostels, comprise 97% of the mining workforce.

During a strike over wages and working conditions in January 1986, GENCOR fired 23,000 strikers at its Impala platinum mine, two-thirds of its labor force. More than 400,000 blacks in southern Africa are said to be looking for mining jobs. Impala produces 40% of South Africa's platinum output. This

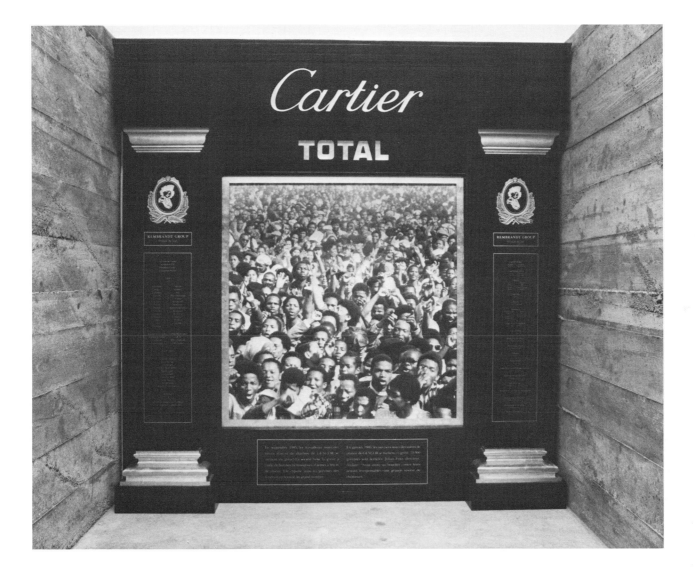

represents one-fifth of the entire world production outside the Soviet Union. Prices for platinum, a major South African export item, rose significantly during the strike, as they did again half a year later, when the government declared a state of emergency to suppress anti-apartheid protests. According to the trade union representing the Impala miners (which is not recognized by GENCOR as a bargaining agent), maximum monthly wages amount to $120 plus food and housing in the company hostels.

In September 1986, 172 black miners died at GENCOR's Kinross gold mine. Cyril Ramaphosa, the president of the National Union of Mine Workers, charged that negligence on the part of the company was to be blamed for the disaster (the mine's safety rating had already been lowered in the previous year), an assessment shared by outside observers.

The Rembrandt Group has significant interests outside of South Africa as well. Through a complex network of interlocking corporations, steered by holding companies in Luxembourg and Switzerland, Anton Rupert controls a major portion of the international cigarette market. Until 1981, Rembrandt had a 44% stake in Rothmans International, the third largest non-American cigarette company in the world. It then sold half of its share in Rothmans to Philip Morris, which ranks second among the world's cigarette manufacturers. It is generally assumed that in spite of his sale to the U.S.-based Philip Morris, Rupert, in effect, retains control over Rothmans. The two corporations have joined forces in the marketing of each other's products.

Aside from Rothmans' involvement in the tobacco industry, it has worldwide interests in breweries, wine, and liquor. Subsidiaries are engaged in the production and marketing of luxury goods and electrical household appliances. In Canada, Rothmans is also active in the gas and petroleum exploration field and owns two well-known sports clubs.

In 1983, Rothmans acquired a 21% stake in Cartier Monde, the French jeweler. This has since been raised to 47%. Even before 1983 Rembrandt appears to have been involved in the affairs of Cartier, together with Paribas, the French investment bank, Rothschild interests, and the Hocq family. Headed by Joseph Kanoui, a Geneva financier, Cartier operates flagship stores in Paris, London, and New York. The name Cartier has a reputation in the world of jewelry that goes back to 1847. Viewed as a French national institution, it caters to royalty and the rich and famous around the world. Banking on its reputation of exclusivity, Cartier launched a new line of luxury items in 1972: "les must de Cartier." Ten years later it also took over the marketing of accessories by Yves Saint-Laurent and, more recently, accessories of the Ferrari Formula 1 label. They are sold through boutiques in ninety countries.

The New York branch of Cartier was convicted in 1986 of having colluded with its customers in a scheme to avoid payment of New York state and city sales taxes. The company was fined $2.2 million. Worldwide sales of Cartier in 1985 amounted to $400 million.

Alain Perrin, the president of Cartier in Paris, announced in 1984 the establishment of the Fondation Cartier pour l'Art Contemporain, situated on the old Oberkampf estate in Jouy-en-Josas, a quiet little town on the outskirts of Paris. The foundation's declared mission is to buy contemporary art and organize exhibitions. These shows are held in a bunker which was

(Facing page) Details of text which appears on pilasters flanking photograph on boutique facade.

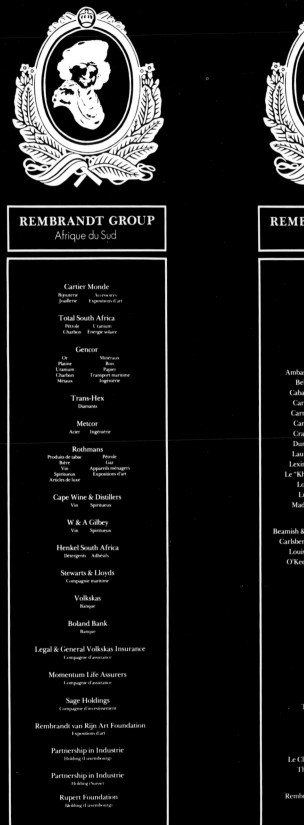

REMBRANDT GROUP
Afrique du Sud

Cartier Monde
Bijouterie / Accessoires
Joaillerie / Expositions d'art

Total South Africa
Pétrole / Uranium
Charbon / Énergie solaire

Gencor
Or / Minéraux
Platine / Bois
Uranium / Papier
Charbon / Transport maritime
Métaux / Ingéniérie

Trans-Hex
Diamants

Metcor
Acier / Ingéniérie

Rothmans
Produits de tabac / Pétrole
Bière / Gaz
Vin / Appareils ménagers
Spiritueux / Expositions d'art
Articles de luxe

Cape Wine & Distillers
Vin / Spiritueux

W & A Gilbey
Vin / Spiritueux

Henkel South Africa
Détergents / Adhésifs

Stewarts & Lloyds
Compagnie maritime

Volkskas
Banque

Boland Bank
Banque

Legal & General Volkskas Insurance
Compagnie d'assurance

Momentum Life Assurers
Compagnie d'assurance

Sage Holdings
Compagnie d'investissement

Rembrandt van Rijn Art Foundation
Expositions d'art

Partnership in Industrie
Holding (Luxembourg)

Partnership in Industrie
Holding (Suisse)

Rupert Foundation
Holding (Luxembourg)

REMBRANDT GROUP
Afrique du Sud

Les must de Cartier
Accessoires YSL
Fondation Cartier
Accessoires Ferrari

Total

Ambassador	Muratti
Belga	Number 7
Caballero	Peer
Carrols	Peter Stuyvesant
Carreras	Privileg
Cartier	Rembrandt
Craven	Rothmans
Dunhill	Schimmelpenninck
Laurens	Sportsman
Lexington	St. Moritz
Le "Khedive"	Windsor
Lord	Winfield
Lux	van Dijk
Madison	

Beamish & Crawford	Carling Black Label
Carlsberg Family	Colt 45
Louis Luyt	Miller High Life
O'Keefe Ale	Old Vienna

W & A Gilbey

Chateau Libertas
Fleur du Cap
Grünberger
Henry Tayler & Ries
Jordan Valley
La Gratitude
Lancerac Rosé
Oude Meester
Ste-Michelle
Tasheimer Goldtröpchen

Rowenta

Le Club de Hockey Les Nordiques
The Argonaut Football Club

Rembrandt van Rijn Art Foundation

built in the park by the German army during the Second World War, when its officers occupied the chateau. Today the chateau is used for conferences and as a guest house by Cartier. Exhibitions are organized under the direction of Marie-Claude Beaud, previously associated with the museums in Grenoble and Toulon. Recent exhibitions have included a survey of contemporary sculpture, one-person shows of the French artists Jean-Pierre Reynaud and Raymond Hains, and, in May 1986, a presentation under the title *Les années 60* (The Sixties). In this last show, a significant place was given to the development, in 1968, of a luxury cigarette lighter by Robert Hocq (the beginning of "les must de Cartier"). Robert Hocq is the father of Nathalie Hocq, who today presides over Cartier International. Commemorating the political events of May '68 was a fake barricade of cobblestones erected on the parking lot of the Fondation Cartier. The central exhibition space of the bunker featured a display of creations by famous Parisian fashion houses, while several Rolls-Royces and other luxury cars driven by pop stars of the sixties were lined up on the park's lawn.

Cartier's Alain Perrin is a vigorous supporter of business sponsorship of the arts. He is a member of ADMICAL (Association pour le Développement du Mécénat Industriel et Commercial), which is proselytizing for greater involvement of French corporations in culture. It takes the United States as its model and follows in particular the example of the Business Committee for the Arts in New York. ADMICAL is headed by Jacques Rigaud of RTL (Radio Télévision Luxembourg), one of the few commercial stations in an environment that has traditionally been dominated by public institutions. The French advertising industry is enthusiastically backing ADMICAL's efforts. They have also been well-received by Jack Lang, the former socialist minister of culture and communication, as well as by François Léotard, his successor in the conservative government of Jacques Chirac. Léotard appointed Alain Perrin to an advisory position on business sponsorship of culture in his ministry.

The Rembrandt Group and Anton Rupert personally have been supporting art exhibitions also through the Rembrandt van Rijn Art Foundation and other subsidiaries of Rothmans, such as Rothmans of Pall Mall in Canada, Peter Stuyvesant, and Dunhill. The annual report of the Rembrandt Group traditionally carries the Dutch artist's self-portrait of 1634 on its cover. His image also embellishes the packages of the cigarettes that are sold under his name in South Africa. Philip Morris, Rupert's partner in the cigarette industry, is equally known for its sponsorship of art exhibitions. It announces them with the motto "It takes art to make a company great."

According to *Fortune*, Anton Rupert is a member of Pieter Botha's Nationalist Party, which has been in power for decades in South Africa. He is also a member of the Broederbond (League of Brothers). *Fortune* has also related rumors that Rupert received starting capital from the Broederbond for the purpose of building an Afrikaner business establishment that could rival the British-oriented South African corporate world. The Broederbond is a secret society which counts the Afrikaner power elite among its members. It has a long history of fervent support for the country's apartheid policies. A number of prominent members of the Broederbond had close links to the Nazis.

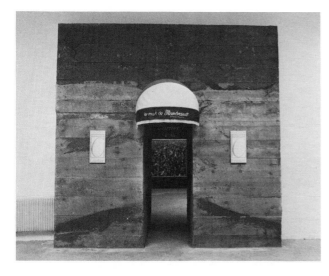
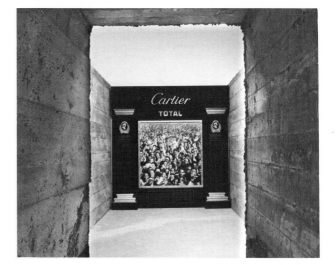
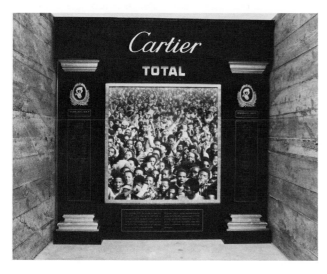

Sequence of views as one passes
through the installation.

Bibliography

1. One-person exhibitions: catalogues and related publications

1962

Wittenborn One-Wall Gallery, New York, N.Y. *Hans Haacke: Lithographs, Relief Prints,* September 6-September 30, 1962. Announcement, with statement by Haacke.

Gallery 105, School of the Arts, Pennsylvania State University, State College, Pa. *Hans Haacke: Exhibition of Prints and Constructions,* October 8-October 24, 1962. Announcement, with statement by Haacke.

Avery Hall, School of Architecture, Columbia University, New York, N.Y. *Sculpture & Graphics by Hans Haacke,* November 12-December 7, 1962.

1965

Galerie Schmela, Düsseldorf. *Hans Haacke: "Wind und Wasser,"* May 1965. Announcement, with statement by Haacke.

Galerie im 3. Stock, Haus am Lützowplatz, Berlin. *Hans Haacke: Wind und Wasser,* August-September 1965. Catalogue, 12 p.

1966

Howard Wise Gallery, New York, N.Y. *Hans Haacke: Wind and Water,* January 4-January 22, 1966. Announcement, with statement by Haacke.

1967

Hayden Gallery, Massachusetts Institute of Technology, Cambridge, Mass. *Hans Haacke,* October 24-November 26, 1967. Announcement.

1968

Howard Wise Gallery, New York, N.Y. *Hans Haacke,* January 13-February 3, 1968. Announcement, with statement by Haacke.

95 East Houston Street, New York, N.Y. *Hans Haacke: Water in Wind,* December 14-December 15, 1968. Announcement.

1969

Howard Wise Gallery, New York, N.Y. *Hans Haacke at Howard Wise Gallery,* November 1-November 29, 1969. Announcement, with statement by Haacke.

1971

Galerie Paul Maenz, Cologne. *Hans Haacke,* January 16-February 13, 1971. Published in *Paul Maenz Köln Jahresbericht 1971* (Cologne: Paul Maenz, 1971), pp. 3-6.

1972

Galleria Françoise Lambert, Milan. *Hans Haacke,* January 1972. Announcement.

Museum Haus Lange, Krefeld. *Hans Haacke, New York: Demonstrationen der physikalischen Welt; Biologische und gesellschaftliche Systeme,* May 22-July 16, 1972. Catalogue, introduction by Paul Wember, [28] p.; plus supplement: *Hans Haacke: Auswertung der Ausstellung; Dokumentation; Ausstellung + Besucher,* [18] p.

1973

John Weber Gallery, New York, N.Y. *Hans Haacke,* April 28-May 17, 1973. Photocopied catalogue, "Visitors' Profile: Results."

Galerie Paul Maenz, Brussels. *Hans Haacke,* May 19-June 9, 1973. Published in *Paul Maenz Jahresbericht 1973 Köln & Brussel* (Cologne: Paul Maenz, 1973), pp. 41-44.

1974

Galerie Paul Maenz, Cologne. *Hans Haacke,* July 4-July 31, 1974. Published in *Paul Maenz Jahresbericht 1974* (Cologne: Paul Maenz, 1974). Poster, *Zensur meiner Arbeit für Projekt '74 durch das Wallraf-Richartz-Museum* (reproduces correspondence between Haacke and Dr. Horst Keller, Director of the Wallraf-Richartz-Museum).

1975

John Weber Gallery, New York, N.Y. *Hans Haacke: "Seurat's 'Les Poseuses' (small version), 1888-1975,"* May 3-May 28, 1975. Photocopied artists' book, [14] p.

1976

Lisson Gallery, London. *Hans Haacke,* April 6-April 24, 1976. Announcement.

Max Protetch Gallery, Washington, D.C. *Mobilization,* May 4-May 29, 1976. Artists' book, 20 p.

Frankfurter Kunstverein, Frankfurt. *Hans Haacke,* September 10-October 24, 1976. Catalogue, introduction by G[eorg] Bussmann, statements by Haacke and interview with Haacke by Margaret Sheffield, [94] p.

Galleria Françoise Lambert, Milan. *Hans Haacke,* October 15-October 30, 1976. Announcement.

1977

Galerie Durand-Dessert, Paris. *Hans Haacke,* January 7-February 9, 1977. Photocopied artists' book, "Hans Haacke: Seurat's Les Poseuses (small version), 1888-1975" (in French), [14] p.

John Weber Gallery, New York, N.Y. *Hans Haacke: "The Good Will Umbrella,"* January 19-February 5, 1977. Photocopied artists' book, [22] p.

Amherst College, Amherst, Mass. *Hans Haacke,* March-April 1977.

Badischer Kunstverein, Karlsruhe. *Hans Haacke,* March 8-April 17, 1977.

Wadsworth Atheneum, Hartford, Conn. *Matrix 31: Hans Haacke,* April 19-June 6, 1977. Brochure, essay by A[ndrea] M[iller-] K[eller], [4] p.

The Arts Cafe, Hartford, Conn. *Hans Haacke: The Good Will Umbrella,* April 4-April 30, 1977.

Mary Porter Sesnon Gallery, University of California, Santa Cruz. *Hans Haacke,* September 19-October 22, 1977. Catalogue, text by Nan Rosenthal, 32 p.

1978

Galerie Durand-Dessert, Paris. *Hans Haacke,* January 7-February 11, 1978. Photocopied catalogue, "Hans Haacke: The Good Will Umbrella (Le bouclier de bonne volonté)," 34 p.

Baxter Art Gallery, California Institute of Technology, Pasadena, Calif. *Hans Haacke,* May 25-July 2, 1978. Catalogue, text by Nan Rosenthal, 48 p.

Museum of Modern Art, Oxford. *Hans Haacke,* November 18-December 24, 1978. Catalogue, *Hans Haacke: Volume 1,* texts by Haacke and an interview with Haacke by Margaret Sheffield, 83 p. Catalogue insert, *A Breed Apart,* [11] p.

1979

Arnolfini Gallery, Bristol. *Hans Haacke,* January 6-February 24, 1979. Traveled to Spectro Arts Workshop, Newcastle-upon-Tyne, March 10-April 4, 1979; New 57 Gallery, Edinburgh, April 7-May 5, 1979; South Hill Park Arts Centre, Bracknell, June 30-July 22, 1979; Midland Group Nottingham, August 11-September 29, 1979; and South Yorkshire Photographic Project, Sheffield, August 1-August 31, 1980.

Stedelijk Van Abbemuseum, Eindhoven. *Hans Haacke,* January 19-February 18, 1979. Catalogue, *Hans Haacke: Volume 1,* texts by Haacke and an interview with Haacke by Margaret Sheffield, 83 p. Photocopied artists' book, *Hans Haacke: The Philips Pieces,* [7] p.

The Renaissance Society at the University of Chicago, Chicago, Ill. *Hans Haacke: Recent Work,* February 4-March 10, 1979. Catalogue, essay by Jack Burnham, 51 p.

Katholieke Hogeschool, Tilburg, The Netherlands, February 23-March 30, 1979. Traveled to Gemeentelijke Culturale Dienst, Middelburg, The Netherlands, April 4-April 28, 1979.

John Weber Gallery, New York, N.Y. *Hans Haacke: 4 works 1978-79,* May 5-May 29, 1979. Photocopied catalogue, [13] p.

1980

Galerija Suvremene Umjetnosti, Zagreb. *Hans Haacke,* January 10-February 3, 1980. Catalogue, introduction by Davor Matičević, and texts by Haacke, [32] p.

Saman Gallery, Genoa. *Hans Haacke: quattro Lavori,* April 8-May 8, 1980. Photocopied catalogue, 24 p.

1981

John Weber Gallery, New York, N.Y. *Hans Haacke: Upstairs at Mobil,* February 7-March 4, 1981. Announcement, designed by Haacke. Photocopied artists' book, 18 p.

Galerie Paul Maenz, Cologne. *Der Pralinenmeister,* May 29-June 27, 1981. Announcement, designed by Haacke. Catalogue, [16] p.

and/or, Seattle, Wash. *Hans Haacke: Mobil Observations,* July 3-July 23, 1981. Catalogue, [30] p.

Walter Phillips Gallery, The Banff Centre–School of Fine Arts, Banff, Alberta. *Hans Haacke: The Key to an Integrated Lifestyle at the Top: Vocation/Vacation Project,* November 19-November 29, 1981. Photocopied brochure, [4] p. Catalogue, *Vocation/Vacation,* texts by Tom Sherman and Jan Pottie, and Benjamin H. D. Buchloh, 2 vols., [80] p.

1982

Bread and Roses Gallery, District 1199 Cultural Center, New York, N.Y. March 11-April 23, 1982. Announcement, designed by Haacke.

S.U.B. Art Gallery, University of Alberta, Edmonton. *Hans Haacke: Mobil Observations,* March 11-March 28, 1982. Traveled to Mendel Art Gallery, Saskatoon, Saskatchewan, April 8-May 16, 1982; and South Alberta Art Gallery, Lethbridge, Alberta, June 5-July 11, 1982. Catalogue, [32] p.

1983

Galerie France Morin, Montreal. *Hans Haacke,* February 5-February 26, 1983. Announcement.

John Weber Gallery, New York, N.Y. *Hans Haacke,* April 30-May 21, 1983. Announcement, designed by Haacke.

1984

The Tate Gallery, London. *Hans Haacke,* January 25-March 4, 1984. Catalogue, *Hans Haacke: Volume II, Works 1978-1983,* texts by Haacke and interviews with Haacke by Tony Brown and Walter Grasskamp, 124 p. Brochure, text by Catherine Lacey, [8] p. Announcement, designed by Haacke.

Neue Gesellschaft für Bildende Kunst/Realismusstudio, held at the Künstlerhaus Bethanien, Berlin. *Hans Haacke: Nach allen Regeln der Kunst,* September 2-October 14,

1984. Catalogue, texts by Ulrich Giersch, Jean-Hubert Martin, Barbara Straka, and Hans Haacke; interview with Haacke by Jeanne Siegel, 128 p.

1985

Kunsthalle, Bern. *Hans Haacke: Nach allen Regeln der Kunst,* March 1-March 31, 1985. Catalogue, texts by Ulrich Giersch, Jean-Hubert Martin, Barbara Straka, and Hans Haacke; interview with Haacke by Jeanne Siegel, 128 p.

John Weber Gallery, New York, N.Y. *Hans Haacke: 4 Works: 1983-1985,* May 4-May 25, 1985. Catalogue, [22] p. Announcement, designed by Haacke.

Raum für Kunst, Hamburg. *Weite und Vielfalt der Brigade Ludwig,* June 3-July 3, 1985. Catalogue (supplement to Berlin catalogue), *Weite und Vielfalt der Brigade Ludwig: Materialien zur Werkentstehung und Rezeption,* texts by Walter Grasskamp et al., 16 p.

1986

Le Consortium, Dijon. *Hans Haacke: Les Must de Rembrandt,* June 12-August 1986. Announcement, designed by Haacke.

2. Group exhibitions (selected): published catalogues

1962

Stedelijk Museum, Amsterdam. *nul,* March 9-March 25, 1962. Large folded poster.

Museum of Modern Art, New York, N.Y. *European Print Acquisitions: New Prints from Germany, Poland, and Russia,* October 18-November 25, 1962. Offset catalogue, 17 p. (4 works)

1964

Signals Gallery, London. *Second Pilot Show for Tomorrow Today,* July 16-August 27, 1964.

Institute of Contemporary Art, University of Pennsylvania, Philadelphia. *Group Zero,* October 30-December 11, 1964. Foreword by Samuel Adams Green, [76] p. (3 works)

1965

Stedelijk Museum, Amsterdam. *nul,* April 15-June 8, 1965. Catalogue, texts by artists, 2 vols., [64] p.

Kunsthalle, Bern. *Licht und Bewegung: Kinetische Kunst,* July 3-September 5, 1965. Traveled to Palais des Beaux-Arts, Brussels, October 14-November 14, 1965; Staatliche Kunsthalle, Baden-Baden, December 3, 1965-January 9, 1966; and Kunsthalle, Düsseldorf, February 2-March 13, 1966. Catalogue, [52] p. (4 works)

1966

University Art Gallery, University of California, Berkeley. *Directions in Kinetic Sculpture,* March 18-May 1, 1966. Traveled to Museum of Art, Santa Barbara, June 5-July 10, 1966. Catalogue, essay by Peter Selz, introduction by George Rickey, statement by Haacke, 78 p. (1 work)

Institute of Contemporary Art, Boston. *as found,* March 5-April 10, 1966. Brochure, text by Ulfert Wilke, [8] p. (1 work)

Hayden Gallery, Massachusetts Institute of Technology, Cambridge, Mass. *Miscellaneous Notions of Kinetic Sculpture,* April 4-May 2, 1967. (4 works)

Central Park, New York, N.Y. *Kinetic Environment 1 and 2,* July 23, 1967, and October 29, 1967. Organized by Willoughby Sharp.

1968

Wallraf-Richartz-Museum, Cologne (held Kunsthalle, Cologne). *ars multiplicata: vervielfältigte Kunst seit 1945,* January 13-April 15, 1968. Catalogue, essays by Gert von der Osten, Erhart Kastner, Horst Keller et al., 232 p. (2 works)

Arts Council YM/YWHA, Philadelphia. *Air Art,* March 14-March 31, 1968. Traveled to Contemporary Arts Center, Cincinnati, April 25-May 19, 1968; and Lakeview Center for the Arts and Sciences, Peoria, Ill., June 7-July 28, 1968. Catalogue, introduction by Willoughby Sharp, statements by the artists, 36 p.

Albright-Knox Art Gallery, Buffalo. *Plus by Minus: Today's Half-Century,* March 3-April 14, 1968. Catalogue, essay by Douglas MacAgy, [62] p. (1 work)

Fondation Maeght, St.-Paul-de-Vence. *Art vivant, 1965-68,* April 13-June 30, 1968. Catalogue, text by François Wehrlin, [112] p. (2 works)

Milwaukee Art Center, Milwaukee. *Directions 1: OPTIONS,* June 22-August 18, 1968. Traveled to Museum of Modern Art, Chicago, September 14-October 20, 1968. Catalogue, essay by Lawrence Alloway, 85 p. (3 works)

Wilhelm-Lehmbruck Museum, Duisburg. *Junge deutsche Plastik,* June 29-September 22, 1968. Catalogue, essay by G. Händler; [52] p. (3 works)

Museum of Modern Art, New York, N.Y. *The Machine as Seen at the End of the Mechanical Age,* November 25, 1968-February 9, 1969. Traveled to University of St. Thomas, Houston, March 25-May 18, 1969; and San Francisco Museum of Modern Art, June 23-August 24, 1969. Catalogue by K. G. Pontus Hultén, 216 p. (1 work)

1969

Andrew Dickson White Museum of Art, Cornell University, Ithaca, N.Y.

Earth Art, February 11-March 6, 1969. Organized by Willoughby Sharp. Catalogue, foreword by Thomas Leavitt and texts by Willoughby Sharp and William C. Lipke; includes statements by the artists and excerpts from a symposium held at Cornell University, February 16, 1969, 88 p. (2 works)

Kunsthalle, Bern. *Live in Your Head. When Attitudes Become Form: Works-Concepts-Processes-Situations-Information,* March 22-April 27, 1969. Traveled to Museum Haus Lange, Krefeld, May 10-June 15, 1969; and to the Institute of Contemporary Arts, London, September 28-October 27, 1969. Organized by Harald Szeemann. Catalogue, essays by Scott Burton, Grégoire Müller, and Tommaso Trini, [206] p. (1 work)

Institute of Arts, Detroit. *Other ideas,* September 30-October 12, 1969. Catalogue, essay by Sam Wagstaff, Jr., [43] p. (3 works)

Städtische Kunsthalle, Düsseldorf. *Prospect 69,* September 30-October 12, 1969. Organized by Konrad Fischer and Hans Strelow. Catalogue, interviews and statements by the artists, 56 p. (2 works)

Seattle Art Museum, Seattle. *557,087,* September 5-October 5, 1969. Traveled to Vancouver Art Gallery, Vancouver, as *955,000,* January 13-February 8, 1970. Organized by Lucy R. Lippard. Catalogue, 95 loose index cards in envelope. (1 work)

Art Gallery of Ontario, Toronto. *New Alchemy: Elements, Systems, Forces,* September 27-October 26, 1969. Traveled to Musée d'Art Contemporain, Montreal, November 5-December 14, 1969. Organized by Dennis Young. Catalogue, essays by Dennis Young and statements by Haacke, [68] p. (15 works)

Kunsthalle, Bern. *Pläne und Projekte als Kunst/Plans and Projects as Art,* November 8-December 7, 1969. Traveled to Aktionsraum 1, Munich, November 19-December 11, 1969; and as *Künstler machen Pläne, andere auch,* to Kunsthaus Hamburg, February 14-March 15, 1970.

Catalogue, 3 vols., essays by Bazon Brock and Marshal McLuhan et al. (2 works)

Museum of Contemporary Art, Chicago. *Art by Telephone,* November 1-December 14, 1969. Organized by Jan van der Marck. Catalogue is a 12″ LP record, 33⅓ rpm, with sleeve notes.

1970

New York Cultural Center, New York, N.Y. *Conceptual Art and Conceptual Aspects,* April 10-August 25, 1970. Catalogue by Donald Karshan, includes statements by Haacke, 100 p. (1 work)

Metropolitan Art Gallery, Tokyo. *Tokyo Biennale '70: Between Man and Matter,* May 10-May 30, 1970. Traveled to Kyoto Municipal Art Museum, Kyoto, June 6-June 28, 1970; and Aichi Prefectural Art Gallery, Nagoya, July 15-July 26, 1970. Catalogue, anonymous text, 2 vols. (2 works)

National Gallery of Victoria, Melbourne. *Air,* June 17-July 19, 1970. Traveled to The Art Gallery of South Australia, August 7-August 29, 1970; Ford Pavilion, Sydney, September 15-September 26, 1970; and Stedelijk Museum, Amsterdam, April 30-June 6, 1971 (as *Lucht-Kunst*). Catalogue, essays by James Harithas, 48 p. (5 works)

Galleria Civica d'Arte Moderna, Turin. *Conceptual Art—Arte Povera—Land Art,* June 12-July 12, 1970. Organized by Germano Celant. Catalogue, texts by Germano Celant, Lucy R. Lippard et al., [224] p.

Museum of Modern Art, New York, N.Y. *Information,* July 2-September 30, 1970. Catalogue, edited and with an introduction by Kynaston L. McShine, 207 p. (1 work)

Fondation Maeght, St.-Paul-de-Vence. *L'art vivant aux États-Unis,* July 16-September 30, 1970. Essay by Dore Ashton, 164 p. (4 works)

Jewish Museum, New York, N.Y. *Software,* September 16-November 8, 1970. Traveled to Smithsonian Institution, Washington, D.C., December 16-February 14, 1970. Catalogue, text by Jack Burnham, 72 p. (1 work)

1971

University of California Art Galleries, Santa Barbara. *Constructivist Tendencies from the Collection of Mr. and Mrs. George Rickey,* January 5-February 14, 1971. Earlier held at State University of New York, Albany, August 31-September 27, 1970; and the University Art Museum, University of New Mexico, Albuquerque, October 19-November 22, 1970; traveled in the United States. Catalogue by Ala Story, introduction by George Rickey; includes statement by Haacke, 135 p. (1 work)

Museum of Fine Arts, Boston. *earth air fire water: elements of art,* February 5-April 4, 1971. Organized by Virginia Gunter. Catalogue, texts by Virginia Gunter and David Antin, 2 vols., 117 p. (5 works)

Galerie Onnasch, Cologne. *20 Deutsche,* March 1971. Text by Klaus Honnef in German and English, [150] p. (3 works)

Philadelphia Museum of Art, Philadelphia. *Multiples: The First Decade,* March 5-April 4, 1971. Catalogue by John L. Tancock, [144] p. (2 works)

Galerie Nächst St. Stephan, Vienna. *Situation Concepts,* March 16-April 8, 1971. Catalogue, 132 p. (1 work)

Milwaukee Art Center, Milwaukee. *Directions 3: Eight Artists,* June 19-August 8, 1971. Catalogue, introduction by John Lloyd Taylor, [10 double leaves].

Museo de Arte Moderno, Buenos Aires. *Arte de sistemas,* July-August 1971. Organized by C.A.Y.C. Catalogue, essay by Jorge Glusberg, 106 loose cards in portfolio. (1 work)

Städtische Kunsthalle, Düsseldorf. *Prospect 71.* Traveled to Louisiana Museum, Humlebaek, Denmark, January 22-February 14, 1972. Catalogue: Konrad Fischer, Jürgen

Harten, and Hans Strelow, *Project 71/Projection*. Düsseldorf: Art Press, 1971, [150] p.

1972

Kunstmuseum, Basel. *"Konzept"–Kunst*, March 18-April 23, 1972. Catalogue, edited by Zdenek Felix, [66] p.; text in German and English. (1 work)

Memorial Art Gallery of the University of Rochester, Rochester, N.Y. *Art Without Limit*, April 7-May 7, 1972. Catalogue, duplicated typescript, [4] p. (full catalogue planned but never printed). (1 work)

High Art Museum, Atlanta. *The Modern Image*, April 14-June 11, 1972. (4 works)

Centro Coltejer, Medellín, Colombia. *Tercera bienal de arte coltejer*, May 1-June 15, 1972. Catalogue, essays by Rodrigo Uribe Echavarria, Leonel Estrada et al., 291 p. (1 work)

Neue Galerie and Museum Friedericianum, Kassel. *Documenta 5: Befragung der Realität: Bildwelten heute*, June 30-October 8, 1972. Catalogue, essays by Harald Szeemann et al., 2 vols. (1 work)

John Weber Gallery, New York, N.Y. *Andre, Haacke, Holt, James, Miller, Obering*, October 7-October 24, 1972. Published *John Weber Gallery Visitors' Profile 1*, photocopied artists' book, [23] p. (1 work)

The New York Cultural Center, New York, N.Y. *Making Megalopolis Matter*, October 12-November 9, 1972. (2 works)

Museo Civico, Bologna. *Tra rivolta e revoluzione: immagine e progetto*, November 1972-January 1973. Catalogue, edited by Concetto Pozzati, 784 p. (1 work)

1973

Kunstverein, Hannover. *Kunst im politischen Kampf*, March 31-May 13, 1973. Catalogue, essay by Christos M. Joachimides; colloquium with the artists (not Haacke) by Helmut R. Leppien; artists' responses to five questions (Haacke included), 88 p. (1 work)

John Weber Gallery, New York, N.Y. *Group Show*, September 1973. (1 work)

Moderna Museet, Stockholm. *New York Collection for Stockholm*, October 27-December 2, 1973. Catalogue, essays by Pontus Hultén and Emile de Antonio; statement by Haacke, [78] p. (1 work)

Parcheggio di Villa Borghese, Rome. *Contemporanea*, November 1973-February 1974. Catalogue, edited by Achille Bonito Oliva, 574 p. (1 work)

1974

Stefanotty Gallery, New York, N.Y. *Live!*, March 12-April 13, 1974 (with Allan Kaprow, Les Levine, and Dennis Oppenheim). (1 work)

Hayden Gallery, Massachusetts Institute of Technology, Cambridge, Mass. *Interventions in Landscape*, April 12-May 11, 1974. (3 works)

Galerie Paul Maenz, Cologne. *13 'Projekt 74' Artists*, July 1974. Catalogue, [24] p. (1 work)

Institute of Contemporary Arts, London. *Art into Society—Society into Art: Seven German Artists*, October 30-November 24, 1974. Catalogue, essays by Norman Rosenthal and Christos M. Joachimides; includes text by Haacke, 94 p. (1 work)

Galerie Magers, Bonn. *28 Selbstportraits*, December 7, 1974-January 30, 1975. Catalogue, essay by Werner Lippert, [76] p. (1 work)

1975

Rutgers University Art Gallery, New Brunswick, N.J. *A Response to the Environment*, March 16-April 26, 1975. Catalogue, essay by Jeffrey Wechsler, [40] p. (1 work)

Musée d'Ixelles, Brussels. *Je nous, art d'aujourdhui*, May 24-July 13, 1975. Boxed catalogue with multiples. (1 work)

Palais des Beaux-Arts, Brussels. *JPI (Jeune peinture I): Art international (internationale kunst)*, July 18-August 31, 1975. Catalogue, essays by Pierre E. Crowet et al., 88 p. (1 work)

High Museum of Art, Atlanta. *The New Image*, October 18, 1975-June 27, 1976. Catalogue, essays by John Howett and Paula Hancock, [16] p. (1 work)

1976

Wright State University Art Gallery, Dayton, Ohio. *Some Contemporary Concerns in the Visual Arts: Carl Andre, Hans Haacke, Robert Mangold, Lucio Pozzi, Stephen Rosenthal*, January 26-February 15, 1976. Offset catalogue, introduction by William H. Spurlock, [31] p. (1 work)

Ex Cantieri Navali alla Giudecca, Venice. *La Biennale di Venezia: Attualità internazionale '72-'76*, July 18-October 10, 1975. Catalogue: *La Biennale di Venezia: catalogo generale*, 2 vols. (1 work)

Lerner-Heller Gallery, New York, N.Y. *A Patriotic Show*, September 11-October 7, 1976. Traveled to Moravian College, Bethlehem, Pennsylvania, February 8-March 3, 1977; and Wright State University, Dayton, Ohio, April 6-April 27, 1977. Catalogue, introduction by Richard Martin, [40] p. (1 work)

Städtische Kunsthalle, Düsseldorf. *Prospectretrospect: Europa 1946-1976*, October 20-October 31, 1976. Catalogue, edited by Jürgen Harten; essays by Benjamin Buchloh et al., 175 p.

1977

Fruitmarket Gallery, Edinburgh. *Robert Barry, Victor Burgin, Hamish Fulton, Gilbert and George, Hans Haacke, John Hilliard, Kosuth/Charlesworth, David Tremlett, Lawrence Weiner*, April 3-April 24, 1976. Catalogue, introduction by Barry Barker, [28] p. (1 work)

Szépművészeti Museum, Budapest. *Tendenzen der Kunst in der Bundesrepublik Deutschland nach 1945*, November 19-December 31, 1977. Catalogue, essays by Paul Vogt and Zdenek Felix, 141 p. (1 work)

Museum of Contemporary Art, Chicago. *Words at Liberty*, May 7-July 3, 1977. Catalogue, introduction by Judith Russi Kirshner, [20] p. (1 work)

Philadelphia College of Art, Philadelphia. *Time*, April 24-May 21, 1977. Essay by Janet Kardon, 48 p. (1 work)

San Francisco Art Institute, San Francisco. *Social Criticism and Art Practice*, July 8-August 21, 1977. (4 works)

Whitney Downtown, New York, N.Y. *Words: A Look at the Use of Language in Art, 1967-1977*, March 10-April 13, 1977. Photocopied catalogue, unsigned essay, [10] p. (1 work)

Art Net, London. *Radical Attitudes to the Gallery*, June-July 1977. Catalogue published in *Studio International* 195, no. 990 (1980): 20-52, ills. Introduction by Tony Rickaby; includes text by Haacke.

Galerie Magers, Bonn. *Kunst und Architektur*, December 9, 1977-January 31, 1978. Catalogue, foreword by Walter Lippert, [52] p. (1 work)

1978

La Biennale di Venezia, Venice. *Artenatura: saggi di Jean-Christophe Ammann . . . [et al.]*, 1978. Catalogue, organized by Achille Bonita Oliva, 196 p.

La Biennale di Venezia, Venice. *Dalla natura all'arte, dall'arte alla natura: catalogo generale*, 1978. Edited by Živa Kraus, 283 p. (1 work)

Galerie m, Bochum. *Daniel Buren, Victor Burgin, Braco Dimitrijević, Hans Haacke, Red Herring, Katharina Sieverding*, January 13-February 27, 1978. Catalogue, includes text by Haacke, [16] p. (3 works)

Helen Foresman Spencer Museum of Art, University of Kansas, Lawrence. *Artists Look at Art*, January 15-March 12, 1978. Catalogue, essay by William Hennessey, [64] p. (1 work)

Kölnischer Kunstverein, Cologne. *Feldforschung*, April 22-May 28, 1978. Catalogue, introduction by Wulf Herzogenrath; includes text by Haacke, 90 p. (3 works)

Bonner Kunstverein and Städtisches Kunstmuseum, Bonn (held Haus an der Redoute, Bonn-Bad Godesberg). *Prozesse: physikalische, biologische, chemische*, September 22-October 22, 1978. Catalogue, essay by Margarethe Jochimsen, [98] p. (10 works)

Städtische Kunsthalle, Düsseldorf. *Museum des Geldes: Über die seltsame Natur des Geldes in Kunst, Wissenschaft und Leben*, November 18, 1978-February 4, 1979. Traveled to Stedelijk Van Abbemuseum, Eindhoven, February 16-April 8, 1979; and Musée National d'Art Moderne, Paris, June 27-September 10, 1979. Catalogue, edited and conceived by Jürgen Harten and Horst Kurnitzky; includes text by Haacke, 2 vols. (1 work)

1979

Kunstverein, Hamburg. *Eremit? Forscher? Sozialarbeiter? Das veränderte Selbstverständnis von Künstlern*, July 14-August 26, 1979. Traveled to Kunstverein, Munich, January 18-March 2, 1980. Catalogue, edited by Uwe M. Schneede, 167 p. (2 works)

1980

Museum van Hedendaagse Kunst, Ghent. *Kunst in Europa na '68*, June 21-August 31, 1980. Catalogue, essays by Jan Hoet, Germano Celant et al., 204 p. (4 works)

University Gallery, Wright State University, Dayton, Ohio. *Art of Conscience: The Last Decade*, October 13-October 30, 1980. Traveled to Freedman Gallery, Albright College, Reading, Pa., September 1-October 1, 1981; Joe and Emily Lowe Art Gallery, Syracuse University, Syracuse, N.Y., November 15, 1981-January 10, 1982; Emily Davis Gallery, University of Akron, Akron, Ohio, January 17-February 28, 1982; and Doane Hall, Allegheny College,

Meadville, Pa., April 1-April 23, 1982. Catalogue, essay by Donald B. Kuspit and statements by the artists, [28] p. (2 works)

Ben Shahn Gallery, William Paterson College, Wayne, N.J. *Language in the Visual Arts*, October 27-November 26, 1980. Catalogue, essay by Nancy Einreinhofer, 30 p. (1 work)

1981

Freedman Gallery, Albright College, Reading, Pa. *Messages: Words and Images*, March 20-April 24, 1981. Traveled to Lehigh University, Bethlehem, Pa., September 13-October 13, 1981; Anderson Gallery, Virginia Commonwealth University, Richmond, Va., February 9-March 5, 1982. Catalogue, essay by Marilyn A. Zeitlin, [52] p.

Badischer Kunstverein, Karlsruhe. *Politische Konzeptkunst*, January 13-March 1, 1981. Catalogue published under the title "Kunst im sozialen Kontext" in *Kunstforum International* (Mainz), no. 42 (June 1980), entire issue. (1 work)

ARC/Musée d'Art Moderne de la Ville de Paris. *Art Allemagne aujourd'hui*, January 17-March 8, 1981. Catalogue, essays by Suzanne Pagé, Wolfgang Siano, René Block et al.; includes text by Haacke, 315 p. (2 works)

Bonner Kunstverein, Bonn. *Die Kehrseite der Wunschbilder*, May 1981. (1 work)

Wesleyan University Art Gallery, Middletown, Conn. *No Title: The Collection of Sol LeWitt*, October 21-December 20, 1981. Catalogue, edited and introduced by John T. Paoletti; includes edited transcript of interview with Haacke by Ralph Emmerich, 116 p. (5 works)

Walter Phillips Gallery, The Banff Centre–School of Fine Arts, Banff, Alberta. *Vocation/Vacation*, November 5-December 13, 1981. Catalogue, texts by Tom Sherman and Jan Pottie, and Benjamin H. D. Buchloh, 2 vols., [80] p. (1 work: Haacke's contribution, *The Key to an Integrated Lifestyle at the Top*, was presented November 19-November 29, 1981.)

1982

Crown Point Gallery, Oakland, Calif. *Artists' Photographs*, January 10-February 27, 1982. Boxed exhibition catalogue [*Vision*, no. 5]. (1 work)

Stedelijk Museum, Amsterdam. *'60 '80: Attitudes/Concepts/Images*, April 9-July 11, 1982. Catalogue, essays by E. de Wilde, Ad Petersen, Gijs van Tuyl et al.; includes statements by Haacke, 248 p. (1 work)

Neue Galerie, Orangerie, and Museum Friedericianum, Kassel. *Documenta 7*, June 19-September 28, 1982. Catalogue, essays by Rudi Fuchs, Saskia Bos, Coosje van Bruggen et al., 2 vols. (3 works)

Kunstmuseum Düsseldorf and Kunstpalast Ehrenhof, Düsseldorf. *Gegen das Kriegsrecht in Polen–für Solidarność*, October 22-November 13, 1982. Catalogue, essay by Iring Fetscher, 72 p. (1 work)

1983

Art Gallery of Ontario, Toronto. *Museums by Artists*, April 2-May 15, 1983. Traveled to Musée d'Art Contemporain, Montreal, September 15-October 30, 1983; and Glenbow Museum, Calgary, November 18, 1983-January 7, 1984. Catalogue, edited by A. A. Bronson and Peggy Gale; includes text by Haacke. (1 work)

Alternative Museum, New York, N.Y. *Contra Media: Hans Haacke, Barbara Kruger, Michael Lebron, Erika Rothenberg*, January 29-February 26, 1983. Catalogue, includes statement by Haacke, 16 p. (4 works)

Musée National d'Art Moderne, Centre Georges Pompidou, Paris. *Bonjour Monsieur Manet*, June 8-October 3, 1983. Catalogue, essays by Jean Clay and Dominique Fourcade et al., 111 p. (1 work)

National Museum of Modern Art, Tokyo. *Photography in Contemporary Art*, October 7-December 4, 1983. Traveled National Museum of Modern Art, Kyoto, December 13, 1983-January 22, 1984. Catalogue, essay by Hisae Fujii, 139 p. (mainly Japanese text). (2 works)

1984

The Graduate School and University Center of the City University of New York, New York, N.Y. *Artists' Call Against U.S. Intervention in Central America*, January 22-March 6, 1984. (1 work)

Edith C. Blum Art Institute, Bard College, Annandale-on-Hudson, N.Y. *Art as Social Conscience*, February 9-March 28, 1984. Poster catalogue. (2 works)

Art Gallery of New South Wales, Sydney, Australia. *Fifth Biennale of Sydney: "Private Symbol: Social Metaphor,"* April 11-June 17, 1984. Catalogue, essays by Leon Paroissien et al. (2 works)

Museum Haus Lange, Krefeld. *Als Bewegung in die Kunst kam*, September 9-November 25, 1984. (1 work)

The Contemporary Arts Center, Cincinnati, Ohio. *Disarming Images: Art for Nuclear Disarmament*, September 14-October 27, 1984. Traveled to University Art Gallery, San Diego State University, San Diego, Calif., November 23-December 22, 1984; Museum of Art, Washington State University, Pullman, Wash., February 11-March 3, 1985; New York State Museum, Albany, N.Y., March 24-June 2, 1985; University Art Museum, University of California, Santa Barbara, Calif., June 25-August 4, 1985; Munson-Williams-Proctor Institute, Utica, N.Y., September 1985; Oberlin College, Oberlin, Ohio, October 27-November 24, 1985; Baxter Art Gallery, California Institute of Technology, Pasadena, Calif., March 2-March 30, 1986; Yellowstone Arts Center, Billings, Mont., April 28-June 9, 1986; Bronx Museum of Arts, Bronx, N.Y., September 11-November 20, 1986. Catalogue, edited by Nina Felshin, 71 p. (1 work)

Hirshhorn Museum and Sculpture Garden, Washington, D.C. *Content: A Contemporary Focus, 1974-1984*, October 4, 1984-January 6, 1985. Catalogue, essays by Howard N. Fox, Miranda McClintic, and Phyllis Rosenzweig, 184 p. (1 work)

Independent Curators Incorporated, New York, N.Y. *From the Collection of Sol LeWitt*. Traveled to The University Art Museum, California State University, Long Beach, Calif., October 16-November 11, 1984; Ackland Art Museum, University of North Carolina, Chapel Hill, N.C., January 26-March 3, 1985; Everhart Museum, Scranton, Pa., April 27-June 8, 1985; The Grey Art Gallery and Study Center, New York University, New York, N.Y., July 9-August 26, 1985; and Museum of Art, Fort Lauderdale, Fla., March 5-April 16, 1985. Catalogue, essays by Andrea Miller-Keller and John B. Ravenal, [48] p. (2 works)

Palais des Beaux-Arts, Brussels. *L'Art et le temps: Regards sur la quatrième dimension*, November 22, 1984-January 20, 1985. Traveled to Musée Rath, Geneva, February 15-April 14, 1985; Städtische Kunsthalle, Mannheim, July 11-September 1, 1985; Museum des 20. Jahrhunderts, Vienna, September 9-November 11, 1985; and Barbican Art Gallery, London, February 20-April 27, 1986. Catalogue, edited by Michel Baudson, 270 p. (1 work)

The New Museum of Contemporary Art, New York, N.Y. *Difference: On Representation and Sexuality*, December 8, 1984-February 10, 1985. Traveled to The Renaissance Society at the University of Chicago, March 3-April 7, 1985; and to the Institute of Contemporary Arts, London, July 19-September 1, 1985. Catalogue, essays by Craig Owens, Jacqueline Rose, Peter Wollen et al., 48 p. (1 work)

1985

Milwaukee Art Museum, Milwaukee, Wis. *Currents 7: Words in Action*, March 7-June 2, 1985. Catalogue. (1 work)

Milton and Sally Avery Center for the Arts, Bard College, Annandale-on-Hudson, N.Y. *The Maximal Implications of the Minimal Line*, March 24-April 28, 1985. Catalogue, essays by Linda Weintraub, Donald Kuspit, and Phyllis Tuchman, 90 p. (1 work)

Nationalgalerie, Berlin. *1945-1985: Kunst in der Bundesrepublik Deutschland*, September 27, 1985-January 21, 1986. Catalogue, essays by Dieter Honisch, Eduard Trier, Lucius Grisebach et al., 732 p. (1 work)

São Paulo Biennale, São Paulo, Brazil. *Between Science and Fiction*, October 4-December 15, 1985. Catalogue. (1 work)

Auckland City Art Gallery, Auckland, New Zealand. *Chance and Change: A Century of the Avant-Garde*, October 25-December 8, 1985. Catalogue, essay by Andrew Bogle, loose cards, poster, etc. (1 work)

Nexus Contemporary Art Center, Atlanta. *Public Art*, November 1985. Catalogue, ill.

Henry Art Gallery, University of Washington, Seattle. *No! Contemporary American DADA*, November 8, 1985-January 19, 1986. Catalogue, essays by Ileana B. Leavins and Chris Bruce, 2 vols., 108 p. (1 work)

1986

Museum of Art, Fort Lauderdale, Fla. *An American Renaissance: Painting and Sculpture since 1940*, January 12-March 30, 1986. Catalogue, essays by Malcolm K. Daniel, Kim Levin, Sam Hunter et al. (1 work)

Queens Museum, Flushing Meadows, N.Y. *The Real Big Picture*, February-March 1986.

Kunsthalle Bremen. *Bodenskulptur*, April 29-June 15, 1986. Catalogue, essays by Bernhard Kerber and Siegfried Salzmann, [130] p. (1 work)

Stedelijk Van Abbemuseum, Eindhoven. *eye level / ooghoogte: Stedelijk Van Abbemuseum 1936-1986*, June 14-November 9, 1986. Catalogue, 2 vols., unpag. (1 work)

Städtische Galerie im Lenbachhaus, Munich. *Beuys zu Ehren*, July 16-September 28, 1986. Catalogue, [500] p. (1 work)

3. Writings, interviews, and statements by the artist

(Additional texts and statements may be found in section 6.)

Haacke, Hans. Letter to David Medalla (extract). *Signals* (London) 1, no. 8 (June-July 1965): 15.

Burnham, Jack. "Questions to the Artist." *Tri-Quarterly Supplement* (Evanston, Ill.), no. 1 (Spring 1967): 16-24.
 French translation: "Questions à Hans Haacke," *Robho* (Paris), no. 2 (November-December 1967): 9-10. German translation in: Edward Fry, ed., *Hans Haacke: Werkmonographie*. Cologne: DuMont Schauberg, 1972, pp. 26-31.

Siegel, Jeanne. "An Interview with Hans Haacke." *Arts Magazine* (New York) 45, no. 7 (May 1971): 18-21, ill.
 Reprinted in: Jeanne Siegel, *Artwords: Discourse on the 60s and 70s*. Ann Arbor, Michigan: UMI Research Press, 1985, pp. 211-218. German translation in: Edward Fry, ed., *Hans Haacke: Werkmonographie*. Cologne: DuMont Schauberg, 1972, pp. 26-31.

Haacke, Hans. "Correspondence: Guggenheim 1." *Studio International* (London) 182, no. 936 (September 1971): 61.

Haacke, Hans. "Pour Aubertin." In *CNAC Archives 3: Aubertin, Deux, Schauer*. Paris: Centre National d'Art Contemporain, 1972, p. 6. [Catalogue for exhibition, *Bernard Aubertin*, March 14-April 10, 1972.]

Thwaites, John Anthony. "Hans Haacke: An Interview." *Art and Artists* (London) 7, no. 8 (November 1972): 32-35, ills.

Thomas, Karin. Interview with Hans Haacke. In *Kunst-Praxis heute: eine Dokumentation der aktuellen Ästhetik*. Cologne: DuMont Schauberg, 1972.

Haacke, Hans. Transcript of talk by Hans Haacke at Museum Folkwang, Essen, June 1973. In *Selbstdarstellung: Künstler über sich*, edited by Wulf Herzogenrath. Düsseldorf: Droste, 1973, pp. 60-71, ills.

Haacke, Hans. "The Role of the Artist in Today's Society: A Symposium at Oberlin." Supplement to *Allen Memorial Art Museum Bulletin* (Oberlin, Ohio) 30, no. 3 (Spring 1973): 2-3.
 Reprinted in: *Art Journal* (New York) 34, no. 4 (Summer 1975): 327-331.

Haacke, Hans. Untitled text. In *Art into Society, Society into Art*. London: Institute of Contemporary Arts, 1974.
 Reprinted in *Hans Haacke, Vol. 1*. Oxford: Museum of Modern Art; Eindhoven: Stedelijk Van Abbemuseum, 1978, p. 77. Reprinted under title: "All the Art That's Fit to Show," in *Museums by Artists*, edited by A. A. Bronson and Peggy Gale. Toronto: Art Metropole, 1983, pp. 151-152. German translation in: *Hans Haacke*, Frankfurt, Frankfurter Kunstverein, 1976. Dutch translation in: Carel Blotkamp, ed., *Museum in Motion? = Museum in Beweging?* The Hague: Staatsuitgeverij, 1979, pp. 262-265. Serbo-Croatian translation in: *Hans Haacke*, Zagreb, Galerija Suvremene Umjetnosti, 1980, n.p.

Gordon, Mary. "Art and Politics. Five Interviews with: Carl Baldwin, Hans Haacke, Alice Neel, May Stevens, Leon Golub." *Strata: A Publication of the School of Visual Arts* (New York) 1, no. 2 (1975): 6-11, ills.

Sheffield, Margaret. "Hans Haacke: Interview." *Studio International* (London) 191, no. 980 (March-April 1976): 117-123, ills.
 Reprinted in: *Hans Haacke, Volume 1*. Oxford: Museum of Modern Art; Eindhoven: Stedelijk Van Abbemuseum, 1978, pp. 69-76. German translation in: *Hans Haacke*, Frankfurt, Frankfurter Kunstverein, 1976. Serbo-Croatian translation in: *Studenski list* (Zagreb) 35, no. 760 (February 8, 1980): 9, ill.

Haacke, Hans. "Les adhérents." In *Art actuel: Skira annuel 77* (Geneva), no. 3 (1977): 141-143.

English translation: "The Constituency," *Tracks* (New York) 3, no. 3 (Fall 1977): 101-105. Reprinted in: *Hans Haacke, Volume 1*. Oxford: Museum of Modern Art; Eindhoven: Stedelijk Van Abbemuseum, 1978, pp. 78-81. German translation in: *Feldforschung*. Cologne: Kölnischer Kunstverein, 1978, pp. 45-46.

Haacke, Hans. "Der Agent." In *What do you expect?/Was erwartet Du?*, edited by Christine Bernhardt. Cologne: Paul Maenz, 1977, [pp. 19-20].

Reprinted in: *Kunstmagazin* (Mainz) 18, no. 2 (1978): 45-46. English translation: "The Agent," in *Studio International* (London) 195, no. 990 (1980): 36-37, ill. Also in: *Hans Haacke, Volume 1*. Oxford: Museum of Modern Art; Eindhoven: Stedelijk Van Abbemuseum, 1978, p. 83. Also in: *Studio International* (London) 195, no. 990 (1980): 36-37, ill. Serbo-Croatian translation in: *Hans Haacke*, Zagreb, Galerija Suvremene Umjetnosti, 1980, n.p.

White, Robin. "Hans Haacke." Interview. *View* (Oakland, Calif.) 1, no. 6 (November 1978), entire issue, ills.

Haacke, Hans. "Arbeitsbedingungen." *Kunstforum International* (Mainz), no. 42 (1980): 214-227.

Revised English version: "Working Conditions," *Artforum* (New York) 19, no. 10 (Summer 1981): 56-61. Reprinted in: *Urban Skinner* (Melbourne) (August 1983): [5-7], ills. Also in: *Hans Haacke: Volume II, Works 1978-1983*. London: Tate Gallery; Eindhoven: Stedelijk Van Abbemuseum, 1984, pp. 88-95.

Patterson, Michele. "Hans Haacke: Interviewed by Michele Patterson." *Journal of Fine Arts* (Chapel Hill, N.C.) 1, no. 2 (Spring-Summer 1980): 48-59, 85-87, ills.

Haacke, Hans. Untitled text. In *Art Allemagne aujourd'hui*, ARC/Musée d'Art Moderne de la Ville de Paris, 1981, pp. 166-167.

Emmerich, Ralph. "Interview with Hans Haacke." In *No Title: The Collection of Sol LeWitt*, edited by John T. Paoletti. Middletown: Wesleyan University, in association with Wadsworth Atheneum, 1981, pp. 58-63, ills.

Grasskamp, Walter. "Ein schöner Mäzen! Ein Gespräch mit Hans Haacke über den 'Trumpf-Pralinenmeister.'" *Kunstforum International* (Mainz), nos. 44-45 (May-August 1981): 152-173, ills.

English translation: "Information Magic," in *Hans Haacke: Volume II, Works 1978-1983*. London: Tate Gallery; Eindhoven: Stedelijk Van Abbemuseum, 1984, pp. 96-100.

Brown, Tony. "Artist as Corporate Critic: An Interview with Hans Haacke." *Parachute* (Montreal), no. 23 (Summer 1981): 12-17, ills.

Reprinted in: *Hans Haacke: Volume II, Works 1978-1983*. London: Tate Gallery; Eindhoven: Stedelijk Van Abbemuseum, 1984, pp. 101-104.

Haacke, Hans. "Letters." [Letter to the editor; reply to letter by William Rubin.] *Artforum* (New York) 20, no. 1 (September 1981): 2.

Haacke, Hans. "Letters." [Letter to the editor, regarding Hans Jürgen Syberberg.] *Artforum* (New York) 21, no. 4 (December 1982): 3-4.

Haacke, Hans. "Sur Yves Klein, vingt ans après." *Art Press* (Paris), no. 67 (February 1983): 10-11.

Haacke, Hans. Statement. *Upfront* (New York), no. 5 (February 1983): 9-10.

Haacke, Hans. "Letters." [Reply to a letter to the editor by Hans Jürgen Syberberg.] *Artforum* (New York) 21, no. 7 (March 1983): 2.

Britton, Stephanie. "I Have to Get my Rocks Off: An interview with Hans Haacke." *Art Link* (Adelaide) 3, no. 5 (November-December 1983): 8.

Haacke, Hans, and Thomas Woodruff. Letter to the editor. *The Wall Street Journal* (New York), March 13, 1984, p. 31.

Siegel, Jeanne. "Leon Golub/Hans Haacke: What Makes Art Political?" *Arts Magazine* (New York) 58, no. 8 (April 1984): 107-113, ills.

Morgan, Robert C. "A Conversation with Hans Haacke." *Real Life Magazine* (New York), no. 13 (Fall 1984): 5-11, ills.

Bois, Yve-Alain, Douglas Crimp, and Rosalind Krauss. "A Conversation with Hans Haacke." *October* (New York), no. 30 (Fall 1984): 23-48, ills.

Haacke, Hans. "Mit Glanz und Gloria." In *documenta: trendmaker im internationalen Kunstbetrieb?*, edited by Volker Rattemeyer. Kassel: Johannes Stauda Verlag, 1984, pp. 99-104, ills.

Haacke, Hans. "Museums, Managers of Consciousness." In *Art museums and big business*, edited by Ian North. Kingston: Art Museums Association of Australia, 1984, pp. 33-40.

Reprinted in: *Art in America* (New York) 72, no. 2 (February 1984): 9-17. Also in: *Hans Haacke: Volume II, Works 1978-1983*. London: Tate Gallery; Eindhoven: Stedelijk Van Abbemuseum, 1984, pp. 105-109. Excerpts in: *Art Link* (Adelaide) 3, no. 5 (November-December 1983): 7. German translation: "Museen: Manager des Bewusstseins," in *Hans Haacke = Nach allen Regeln der Kunst*. Berlin: Neue Gesellschaft für Bildende Kunst, 1984, pp. 92-96. Reprinted in: *Illustrierte Stadtzeitung Zitty* (Berlin) 8, no. 19 (August 31-September 9, 1984): 39, ill.

Haacke, Hans. Letter to the editor. *Flash Art* (Milan), no. 121 (March 1985): 38.

Samaras, Connie. "Sponsorship or Censorship?" [Interview with Hans Haacke.] *New Art Examiner* (Chicago) 13, no. 3 (November 1985): 20-25, ill.

Reprinted in: *Utne Reader* (Marion, Ohio), no. 15 (April-May 1986): 106-114, ills.

Haacke, Hans. "Letters: Saatchi/South Africa Update." [Letter to the editor.] *Art in America* (New York) 73, no. 12 (December 1985): 9.

Tilroe, Anna. "Kwelgeest van de kunstsponsors." [Interview with Hans Haacke.] *De Volkskrant* (Amsterdam) (December 20, 1985): 21, ills.

Lord, Catherine. "Hans Haacke: Where the Consciousness Industry is Concentrated." In *Cultures in Contention*, edited by Douglas Kahn and Diane Neumaier. Seattle: The Real Comet Press, 1985, pp. 204-235, ills.

Haacke, Hans. "Letters: Political Art, Political Value." [Reply to letter to the editor by T. Gasloli.] *New Art Examiner* (Chicago) 13, no. 5 (January 1986): 1.

Taylor, Paul. "Interview with Hans Haacke." *Flash Art* (Milan), no. 126 (February-March 1986): 39-41, ills.

Smolik, Noemi. "Hans Haacke: Provokation gehört zum Geschäft." *Wolkenkratzer Art Journal* (Frankfurt), no. 13 (June-July-August 1986): 38-41, ills.

4. Monographs on the artist and books by the artist

Burnham, Jack W. *Hans Haacke: Wind and Water Sculpture*. Evanston, Ill.: Northwestern University Press, 1967, 24 p. (*Tri-Quarterly Supplement*, no. 1 [Spring 1967]).

Haacke, Hans. Untitled typescript regarding cancellation of Haacke exhibition at Guggenheim Museum. Dated April 3, 1971, New York, typescript, [5] p.

Fry, Edward F., ed. *Hans Haacke: Werkmonographie*. Introduction by Edward F. Fry. Cologne: DuMont Schauberg, 1972, [80] p., plus ills. [Includes statements by the artist, and interviews.]

Haacke, Hans. *John Weber Gallery Visitors' Profile 1*. New York, 1973. Photocopied, [24] p., ills. [Results of a survey carried out during a group exhibition held at John Weber Gallery, October 7-October 24, 1972.]

Haacke, Hans. *John Weber Gallery Visitors' Profile 2*. New York, 1973. Photocopied, [30] p., ills. [Results of a survey carried out during one-person exhibition at John Weber Gallery, April 28-May 17, 1973.]

Haacke, Hans. *Solomon R. Guggenheim Museum Board of Trustees*. New York, 1974. Photocopied, [8] p., ills. [Reproduction of work exhibited in *Live!* at the Stefanotty Gallery, March 12-April 13, 1974.]

Haacke, Hans. *Framing and Being Framed: 7 Works 1970-75*. Essays by Jack Burnham, Howard S. Becker, and John Walton. Halifax: Press of the Nova Scotia College of Art and Design; New York: New York University Press, 1975, 154 p., ill.

Haacke, Hans. *The Philips Pieces*. New York, 1979. Photocopied, 7 p., ills.

Haacke, Hans. *Wij geloven aan de macht van de creative verbeeldings-kracht*. Ghent, 1980. Duplicated [10] p., ills. [Published on the occasion of the exhibition *Kunst in Europa na '68*, Museum van Hedendaagse Kunst, Ghent, June 21-August 31, 1980.]

Haacke, Hans. *Der Pralinenmeister; The Chocolate Master*. Toronto: Art Metropole, 1982. [Reproduction of work first exhibited at Galerie Paul Maenz, Cologne, May 29-June 27, 1981. Includes English translation of text.]

5. General books and sections in books

Abel, Sabine. "Hans Haacke—Biographie, Werk und Dokumenta-beiträge: Politische Kunst als Alibi der D 7?" In *Materialien zur Documenta 7*, edited by Werner Stehr and Johannes Kirschenmann. Kassel: Hessisches Institut für Lehrerfortbildung, 1982, pp. 43-47, ills.

Arnason, H. H. *A History of Modern Art*. Edited and enlarged edition. London: Thames and Hudson, 1977, p. 740, ills.

Ashton, Dore. *American Art Since 1945*. New York: Oxford University Press, 1982, pp. 194-197, ills.

Aue, Walter, ed. *P.C.A.–Projekte, Konzepte & Actionen*. Cologne: DuMont Schauberg Verlag, 1971, ills.

Benthall, Jonathan. *Science and technology in art today*. London: Studio Vista, 1972, pp. 125, 129-130, 134, 138, ills.

Brock, Bazon. *Besucherschule zur documenta 7: "Die Hässlichkeit des Schönen."* Kassel: Bazon Brock's Besucherschule, 1982, pp. 70-71, ills. Includes text by Haacke.

Bronson, A. A., and Peggy Gale, eds. *Museums by Artists*. Toronto: Art Metropole, 1983, pp. 149-184, ills.

Burnham, Jack. "The Aesthetics of Intelligent Systems." In *On the Future of Art*, edited by Edward F. Fry. New York: Viking Press, 1970.

Burnham, Jack. *Beyond Modern Sculpture*. New York: George Braziller, 1968, pp. 279-280, 346-349, ills.

Burnham, Jack. *The Structure of Art*. New York: George Braziller, 1971, pp. 142-143, ills.

Burnham, Jack. *Great Western Salt Works: Essays on the Meaning of Post-Formalist Art*. New York: George Braziller, 1974, pp. 30-33, ills.

Burnham, Jack. "Hans Haacke: Wind and Water Sculpture." In *Art in the Land: A Critical Anthology of Environmental Art*, edited by Alan Sonfist. New York: E. P. Dutton, 1983, pp. 105-124, ills.

Calas, Nicolas, and Elena Calas. *Icons and Images of the Sixties*. New York: E. P. Dutton, 1971, pp. 297-300, ills.

Cavaliere, Barbara. "Hans Haacke." In *Contemporary Artists*, edited by Colin Naylor and Genesis P-Orridge. 2d ed. New York: St. Martin's Press, 1983, pp. 375-376.

Celant, Germano. *Arte povera*. Milan: Mazzotta, 1969, pp. 179-184, ills. English edition, New York: Praeger Publishers, 1969.

Celant, Germano. "Untitled, 1975." In *1970-1975 Paul Maenz Köln*. Cologne: Paul Maenz, 1975, pp. 62-63, ills. Text in German and English.

Celant, Germano. *Precronistoria 1966-69*. Florence: Centro Di, 1976, (Segni 2), pp. 56, 57, 111, 151, 152, ills.

Czartoryska, Urszula. *Od pop-artu do sztuki konceptualnej*. Warsaw: Artystyczne i Filmowe, 1973.

Dienst, Rolf-Gunter. *Deutsche Kunst: eine neue Generation*. Cologne: DuMont Schauberg, 1970, ills.

Gottlieb, Carla. *Beyond Modern Art*. New York: E. P. Dutton, 1976.

Grasskamp, Walter. "Hans Haacke." In *Von hier aus*. Cologne: DuMont Buchverlag, 1984, pp. 120-125.

Green, Jonathan. *American Photography: A Critical History Since 1945*. New York: Harry N. Abrams, 1984, pp. 202, 205-206, ills.

Gutzmer, Manfred. "Die Kunst und das Abwässer-Problem." In *Kunst-jahrbuch 3*. Hannover: Fackelträger, 1973, pp. 144-145. [Reprinted from *Rheinische Post*, May 19, 1972.]

Hacker, Dieter, and Bernhard Sandfort, eds. *Die Schönheit muss auch manchmal wahr sein: Beiträge zu Kunst und Politik*. Berlin: 7. Produzentengalerie, 1982, pp. 47-53, ills.

Haryu, Ichiro. *Art as Action and Concept*. Tokyo: Kodansha, 1972, pp. 55, 100, ills. Japanese text.

Henri, Adrian. *Total Art: Environments, Happenings, and Performance*. London: Thames and Hudson, 1974, pp. 78-79, 178, ills.

Hohmeyer, Jürgen. "Rede, Künstler." In *Kunstjahrbuch 3*. Hannover: Fackelträger, 1973, pp. 23-25.

Honnef, Klaus. *Concept Art*. Cologne: Phaidon, 1972, pp. 17-19, 71-75, ills.

Hunter, Sam. *American Art of the 20th Century*. New York: Harry N. Abrams, 1972, pp. 391-392, 434-436, ills.

Janis, Harriet, and Rudi Blesh. *Collage*. Philadelphia: Chilton Book Co., 1967, pp. 284, 286-288, ills.

Kelly, James J. *The Sculptural Idea*. Minneapolis: Burgess Publishing Co., 1970, p. 151, ills.

Kultermann, Udo. *Neue Dimensionen der Plastik*. Tübingen: Wasmuth, 1967. English edition: *The New Sculpture: Environments and Assemblages*. London: Thames and Hudson, 1968, p. 173, ills.

Lippard, Lucy R., ed. *Six Years: The Dematerialization of the Art Object from 1966 to 1972*. New York: Praeger Publishers, 1973, pp. 37-38, 64, 78, 122-123, 227-229, 240, ills.

Lippard, Lucy R. *Get the Message?: A Decade of Art for Social Change*. New York: E. P. Dutton, 1984, ill.

Los Angeles County Museum of Art, Los Angeles. *A & T: A Report on the Art and Techology Program of the Los Angeles County Museum of Art, 1967-1971*. Introduction by Maurice Tuchman, 387 p.

Menna, Filiberto. "L'arte concep-tuale." In *L'arte moderna*, no. 109. Milan: Fabbri, 1978.

Merriman, John Henry, and Albert E. Elsen. *Law, Ethics and the Visual Arts: Cases and Materials*. New York: Matthew Bender, 1979, 2 vols.

Meyer, Ursula. *Conceptual Art*. New York: E. P. Dutton, 1972, pp. 132-136, ills.

Mogelon, Alex, and Norman Laliberté. *Art in Boxes*. New York: Van Nostrand Reinhold, 1974, pp. 190, 204-206, ills.

Morschel, Jürgen. *Deutsche Kunst der 60er Jahre. Teil II. Plastik, Objekte, Aktionen*. Munich: Bruckmann, 1972, pp. 108, 285, ills.

Popper, Frank. *Naissance de l'art cinétique*. Paris: Gauthier-Villars, 1967, pp. 148-149, 201, 218, ills. English edition: *Origins and Development of Kinetic Art*. London: Studio Vista, 1967.

Rickey, George. *Constructivism: Origins and Evolution*. New York: George Braziller, 1967, pp. 205-207, ills.

Rogoff, Irit. "Representations of Politics: Critics, Pessimists, Radicals." In *German Art in the 20th Century: Painting and Sculpture 1905-1985*, edited by Christos M. Joachimides, Norman Rosenthal, and Wieland Schmied. Munich: Prestel Verlag; London: Royal Academy of Arts, 1985, pp. 125-136, ills.

Robins, Corrine. *The Pluralist Era: American Art 1968-1981*. New York: Harper & Row, 1984.

Schwarze, Dirk. "Die Überhöhung der Aura." In *Künstler zur Documenta 7, Eine Serie von Dirk Schwarze*. Kassel: Hessische Niedersächsische Allgemeine, 1982, p. 26, ills.

Selz, Peter. *Art in Our Times*. New York: Harry N. Abrams, 1981, pp. 492, 557, ills.

Sharp, Willoughby. "Luminism and Kineticism." In *Minimal Art*, edited by Gregory Battcock. New York: E. P. Dutton, 1968, pp. 317-358, ills.

Staeck, Klaus, ed. *Ohne die Rose tun wirs nicht. Für Joseph Beuys*. Heidelberg: Edition Staeck, 1986, 353 p. ills.

6. Periodical and newspaper articles

1962

T[illim], S[idney]. "In the Galleries: Hans Haacke." *Arts Magazine* (New York) 37, no. 1 (October 1962): 57-58.

1965

Strelow, Hans. "Die Künstler als Erfinder." *Rheinische Post* (Düsseldorf), no. 114, May 17, 1965, n.p.

[Strelow, Hans.] "Kinetik mit Wasser und Luft." *Rheinische Post* (Düsseldorf), no. 122, May 25, 1965, n.p.

Thwaites, John Anthony. "The Story of Zero." *Studio International* (London) 170, no. 867 (July 1965): 2-9, ill.

Winkler, Gerd. "Atelierbesuch." *Kunst* (Mainz), no. 6-7 (August-September 1965): 120-121, ill.

Thwaites, John Anthony. "Younger German artists: Hans Haacke's creations require the viewer to lend a hand." *The Bulletin* (Bonn) 13, no. 40 (October 26, 1965): 7-8, ill.

1966

Rickey, George. "Kinesis Continued." *Art in America* (New York) 53, no. 6 (December 1965-January 1966): 45-55, ills.

Piene, Nan R. "New York: Gallery Notes." *Art in America* (New York) 54, no. 1 (January-February 1966): 120.

"Styles: The Movement Movement." *Time* (New York) 87, no. 4 (January 28, 1966): 64-69, ill.

B[ochner], M[el]. "In the Galleries: Hans Haacke, Gerald Oster." *Arts Magazine* (New York) 40, no. 5 (March 1966): 58.

Leider, Philip. "Kinetic Sculpture at Berkeley." *Artforum* (Los Angeles) 4, no. 9 (May 1966): 40-44, ills.

Metcalf, Katherine. "Kinetic Sculpture." *Arts and Architecture* (Los Angeles) 83, no. 5 (June 1966): 29-30, ills.

1967

Rickey, George. "Origins of Kinetic Art." *Studio International* (London) 173, no. 886 (February 1967): 65-69, ills.

Glusberg, Jorge. "La technica, herramienta del arte nuevo." *Analisis* (Buenos Aires), no. 318 (April 17, 1967): 42-43, ills.

C[lay], J[ean]. "Spécial Hans Haacke: Art signe et art piège." *Robho* (Paris), no. 2 (November-December 1967): cover, 6-8, ills.

Sharp, Willoughby. "Kineticism: Bursting into Open Space." *Robho* (Paris), no. 2 (November-December 1967): 11, ills.

Spear, Athena Tacha. "Sculptured Light." *Art International* (Lugano) 11, no. 10 (December 1967): 29-49, ills.

1968

Perreault, John. "Now There's Hans Haacke." *The Village Voice* (New York) 13, no. 15 (January 25, 1968): 18-19.

Lippard, Lucy, and John Chandler. "The Dematerialization of Art." *Art International* (Lugano) 12, no. 2 (February 1968): 31-36.

"Kinetics: Big Brother." *Time* (New York) 91, no. 6 (February 9, 1968): 45.

B[urton], S[cott]. "Hans Haacke." *Art News* (New York) 67, no. 1 (March 1968): 14.

S[iegel], J[eanne]. "In the Galleries: Hans Haacke." *Arts Magazine* (New York) 42, no. 5 (March 1968): 58, ills.

Glusberg, Jorge. "Los globos artisticos." *Analisis* (Buenos Aires), no. 368 (April 1, 1968): 40-41, ills.

Palazzoli, Daniela. "L'aria e le strutture gonfiabili/The Air and Inflatable Structures." *Bit* (Milan) 2, no. 1 (March-April 1968): 6-11, ills. Text in Italian and English.

Burnham, Jack. "Systems Esthetics." *Artforum* (New York) 7, no. 1 (September 1968): 30-35, ills.

1969

Glusberg, Jorge. "Air Art. One: The Dialectic Between Container and Content." *Art and Artists* (London) 3, no. 10 (January 1969): 42-45, ills.

Perreault, John. "Earth Show." *The Village Voice* (New York) 14, no. 20 (February 27, 1969): 16, 18, 20.

Junker, Howard. "Down to Earth." *Newsweek* (New York) 73, no. 12 (March 24, 1969): 101, ills.

Ashton, Dore. "Exercises in Anti-Style." *Arts Magazine* (New York) 43, no. 6 (April 1969): 45-46.

Lindgren, Nilo. "Art and Technology." *IEEE Spectrum* (New York) 6, no. 4 (April 1969): 59-68, ill.

Bourdon, David. "What on Earth!" *Life* (New York) 66, no. 16 (April 25, 1969): 80-86, ills.

Pierre, José. "Les Grandes Vacances de l'art moderne." *L'Oeil* (Paris), no. 173 (May 1969): 10-18, 72, ills.

Neugass, Fritz. "Die Kontinente durchpflügen." *Frankfurter Allgemeine Zeitung*, no. 120, May 27, 1969, p. 9, ill.

Chandler, John Noël. "Hans Haacke: The Continuity of Change." *Artscanada* (Toronto) 26, no. 3 (June 1969): 8-11, ills.

Vinklers, Bitite. "Hans Haacke." *Art International* (Lugano) 13, no. 7 (September 1969): 44-49, 56, ill.

Burnham, Jack. "Real Time Systems." *Artforum* (New York) 8, no. 1 (September 1969): 49-55, ills. [Reprinted in: Jack Burnham, *Great Western Salt Works: Essays on the Meaning of Post-Formalist Art* (New York: George Braziller, 1974), pp. 27-38.]

Thwaites, John Anthony. "Vom Baum der Kunsterkenntnis." *Saarbrücker Zeitung*, October 14, 1969.

Engelhard, Ernst Günter. "Kommt'ne Taube: Ernsthafte Gedanken zu 'prospect 69' in Düsseldorf." *Christ und Welt* (Stuttgart) 22, no. 41, October 10, 1969, p. 17, ill.

Sello, Gottfried. "Ein Bett ist ein Bett ist . . .: Denkspiel und Denkfehler–'Prospect 69' in Düsseldorf." *Die Zeit* (Hamburg), no. 41, October 10, 1969, p. 15.

Sharp, Willoughby. "Place and Process." *Artforum* (New York) 8, no. 3 (November 1969): 46-49, ills.

Bonin, Wibke von. "Germany: October 1969." *Arts Magazine* (New York) 44, no. 2 (November 1969): 51-52, ills.

Thériault, Normand. "Alchimistes au XXe siècle." *La Presse* (Montreal), November 8, 1969, p. 40, ill.

Andrea, Christopher. "Haacke Explains his 'Astonishing' Show." *The Christian Science Monitor* (Boston), November 24, 1969, p. 10, ills.

Perreault, John. "Systems." *The Village Voice* (New York) 14, no. 58 (November 20, 1969): 19, 34, 36.

Glueck, Grace. "'Tis the month before Christmas." *Art in America* (New York) 57, no. 6 (November-December 1969): 156, 159-160, ill.

J[ohnson], W[illiam]. "Reviews and Previews: Hans Haacke." *Art News* (New York) 68, no. 8 (December 1969): 14.

Greenwood, Michael. "The Open Alembic." *Artscanada* (Toronto) 26, no. 6 (December 1969): 57-58, ill.

Thériault, Normand. "Tout n'est pas dans le visuel." *La Presse* (Montreal), December 6, 1969, p. 41, ill.

M[üller], G[régoire]. "In the Galleries: Hans Haacke." *Arts Magazine* (New York) 44, no. 3 (December 1969-January 1970): 61.

1970

Ratcliff, Carter. "New York Letter." *Art International* (Lugano) 14, no. 1 (January 1970): 94.

Bourgeois, Jean-Louis. "New York." *Artforum* (New York) 8, no. 5 (January 1970): 71-72, ills.

Ashton, Dore. "Les systèmes de Hans Haacke." *Opus International* (Paris) 17, no. 12 (April 1970): 42-44.

Love, Joseph P. "The Tenth Tokyo Biennale of Contemporary Art." *Art International* (Lugano) 14, no. 6 (Summer 1970): 70-75, ills.

Ashton, Dore. "Monuments pour nulle part ou pour n'importe où." *Chroniques de l'Art Vivant* (Paris), no. 12 (July 1970): 8-9, ills.

Kramer, Hilton. "Show at the Modern Raises Questions." *The New York Times*, July 2, 1970, p. C26, ill.

Genauer, Emily. "Some Explanations of Information." *Newsday* (Garden City, N.Y.), July 11, 1970, Section W, pp. 25-26.

Perreault, John. "Information." *The Village Voice* (New York) 15, no. 29 (July 16, 1970): 14, 31.

Albert-Levin, Marc. "À la Fondation Maeght: L'art américain peut-il vivre en France?" *Les Lettres Françaises* (Paris), no. 1345 (July 29, 1970): 24-26, ills.

Strelow, Hans. "Das grosse Spiel mit den Medien: 'Information'–eine Schau im Museum of Modern Art in New York." *Frankfurter Allgemeine Zeitung*, no. 182, August 10, 1970, p. 16.

Schneider, Pierre. "Paris: Tarzan Returns in Full Swing." *The New York Times*, August 24, 1970, p. 36.

Ammann, Jean-Christophe, Theo Kneubühler, and Rolf Winnewisser. "Aspekte der aktuellen Kunstszene." *Werk* (Winterthur, Switz.) 57, no. 9 (September 1970): 600-610, ills. Includes resumés in French and English.

Ashton, Dore. "Intercultural Gaps on the Côte d'Azur: Maeght Foundation Shows American Art." *Arts Magazine* (New York) 45, no. 1 (September-October 1970): 38-41.

Vinklers, Bitite. "Art and Information: 'Software' at the Jewish Museum." *Arts Magazine* (New York) 45, no. 1 (September-October 1970): 46-49, ills.

Jappe, Georg. "Kinetic Art in Germany." *Studio International* (London) 180, no. 926 (October 1970): 123-129, ills.

Baker, Kenneth. "New York." *Artforum* (New York) 9, no. 4 (December 1970): 80, ills.

Clay, Jean. "Aspects of Bourgeois Art: The World as It Is." *Studio International* (London) 180, no. 928 (December 1970): 254-255.

1971

"Haacke interdit." *Robho* (Paris), nos. 5/6 (1971).

Vitt, Walter. "Wünsche und Witze?: Ausstellung Hans Haacke in der Kölner Galerie Maenz." *Kölner Stadt-Anzeiger*, no. 17, January 21, 1971, p. 16.

Ott, Günther. "Kennen Sie Manhattan?–Neue Galerie zeigt 720 Fotos von Hans Haacke." *Kölnische Rundschau*, January 23, 1971.

Young, Dennis. "The New Alchemists: Hans Haacke, John van Saun, Takis, Charles Ross." *Art and Artists* (London) 5, no. 11 (February 1971): 46-49, ills.

Pfeiffer, Günter. "Die Front der Puristen: Das Galerieprogramm in der Kölner Lindenstrasse." *Frankfurter Allgemeine Zeitung*, no. 33, February 9, 1971, p. 19.

Loercher, Diana. "Elements of Art: earth, air, fire, and water." *The Christian Science Monitor* (Boston), February 11, 1971, p. 9, ills.

"Hans Haacke." *Flash Art* (Milan), no. 22 (February-March 1971): 4, ills.

Honnef, Klaus. "Kunst-Bericht aus dem Rheinland." *Magazin Kunst* 11, no. 41 (Winter 1971): 2159-2162, ill.

Baker, Kenneth. "Boston." *Artforum* (New York) 9, no. 7 (March 1971): 72-74, ill.

Pfeiffer, Günter. "Ausstellungen: Hans Haacke." *Das Kunstwerk* (Stuttgart) 24, no. 2 (March 1971): 115.

Parent, Béatrice. "Land Art." *Opus International* (Paris), no. 23 (March 1971): 22-27, ills.

Benthall, Jonathan. "Haacke, Sonfist and Nature." *Studio International* (London) 181, no. 931 (March 1971): 95-96.

Glueck, Grace. "The Guggenheim Cancels Haacke's Show." *The New York Times*, April 7, 1971, p. 52.

Gratz, Roberta. "The Guggenheim Refuses to Hang Slumlords." *New York Post*, April 8, 1971, p. 18.

Herzig, Doris. "Art Show Scrubbed as Politically Dirty." *Newsday* (Garden City, N.Y.), April 9, 1971, p. 15A, ills.

Perreault, John. "Art: Political Items." *The Village Voice* (New York) 16, no. 15 (April 15, 1971): 21-22.

"Haacke-Ausstellung: Fehler im System." *Der Spiegel* (Hamburg) 25, no. 18 (April 26, 1971): 196-197, ills.

Genauer, Emily. "Art and the Artists." *New York Post*, April 24, 1971, p. 34.

McFadden, Robert D. "Guggenheim Aide Ousted in Dispute: Edward Fry Set Up a Show by Haacke on Slums." *The New York Times*, April 27, 1971, p. 48.

"On the Blink." *The Guardian* (London), April 30, 1971, p. 13.

B[aker], E[lizabeth] C. "Editorial: Artists vs. Museums." *Art News* (New York) 70, no. 3 (May 1971): 25, 66.

Akston, Joseph James. "Editorial." *Arts Magazine* (New York) 45, no. 7 (May 1971): 5.

Fry, Edward. "Hans Haacke, the Guggenheim: The Issues." *Arts Magazine* (New York) 45, no. 7 (May 1971): 17.

"Actualité: On décroche (toujours) au Guggenheim." *Chroniques de l'Art Vivant* (Paris), no. 20 (May 1971): 13.

Haacke, Hans, Thomas Messer, and Edward Fry. [Statements on Guggenheim cancellation.] *Flash Art* (Milan), no. 24 (May 1971): 3.

Glueck, Grace. "Ousted Curator Assails Guggenheim." *The New York Times*, May 1, 1971, p. 22.

Battcock, Gregory. "New York-One." *Art and Artists* (London) 6, no. 3 (June 1971): 58-59, ills.

Burnham, Jack. "Hans Haacke's Cancelled Show at the Guggenheim." *Artforum* (New York) 9, no. 10 (June 1971): 67-71, ills. [Reprinted in: Amy Baker Sandback, ed., *Looking Critically: 21 Years of Artforum Magazine.* Ann Arbor, Mich: UMI Research Press, 1984, pp. 105-109, ill.]

Akston, Joseph James. "Editorial." *Arts Magazine* (New York) 45, no. 8 (Summer 1971): 4.

Messer, Thomas. "Guest editorial." *Arts Magazine* (New York) 45, no. 8 (Summer 1971): 4-5.

Abish, Cecile, et al. "Artists' Statement." [Petition in support of Hans Haacke.] *Arts Magazine* (New York) 45, no. 8 (Summer 1971): 5.

"Gurgles Around the Guggenheim. Statements and comments by Daniel Buren, Diane Waldman, Thomas M. Messer, and Hans Haacke." *Studio International* (London) 181, no. 934 (June 1971): 246-250.

Reise, Barbara. "A tail of two exhibitions: The aborted Haacke and Robert Morris shows." *Studio International* (London) 182, no. 935 (July-August 1971): 30.

Reise, Barbara. "Background to the Foreground: The Haacke Exhibition History." [Interview with Edward Fry and Thomas Messer.] *Studio International* (London) 182, no. 935 (July-August 1971): 30-34, ills.

Reise, Barbara. "'Which is in fact what happened': Thomas M. Messer in an Interview with Barbara Reise, 25 April, 1971." *Studio International* (London) 182, no. 935 (July-August 1971): 34-37.

Alloway, Lawrence. "Art." *The Nation* (New York) 213, no. 3 (August 2, 1971): 93-94.

B[aker], E[lizabeth] C. "Editorial: Artists vs. Museums, Continued." *Art News* (New York) 70, no. 5 (September 1971): 21, 58-59. Includes letter to the editor by Hans Haacke.

"Buren, Haacke, chi altro?" *Data* (Milan) 1, no. 1 (September 1971): 31, ill.

Borgeaud, Bernard. "Art et nature: Hans Haacke et l'Écologie." *Chroniques de l'Art Vivant* (Paris), no. 26 (December 1971-January 1972): 18-19, ills.

1972

Haacke, Hans. "Shapolsky et al. Manhattan Immobilienbesitz, ein gesellschaftliches Realzeitsystem, Stand 1/3/1972." *Interfunktionen* (Cologne), no. 9 (1972): 95-109, ills.

Smith, Terry. "Evaluating Photographs: Investing in Some Real Estate." *The Review* (Sydney), January 29-February 4, 1972, p. 425, ill.

Fry, Edward. "The Post-Liberal Artist." *Art and Artists* (London) 6, no. 11 (February 1972): 32-35, ills.

Trini, Tommaso. "Mostre: Hans Haacke." *Domus* (Milan), no. 507 (February 1972): 52, ill.

Altamira, A. "Milano: Hans Haacke." *Notiziario Arte Contemporanea* (Milan), March 1972, pp. 18-19, ills.

Nemser, Cindy. "Hans Haacke and the Guggenheim." *Feminist Art Journal* (New York) 1, no. 1 (April 1972): 24.

Newbold, Leroy. [Letter in response to Edward Fry's article in February 1972 issue.] *Art and Artists* (London) 7, no. 2 (May 1972): 12.

[Gutzmer, Manfred.] "Die Kunst und das Abwässer-Problem." *Rheinische Post* (Düsseldorf), no. 115, May 19, 1972, n.p., ill. [Reprinted in: *Kunstjahrbuch 3.* Hannover, 1973.]

Frese, Hans M. "Hans Haacke hat es mit dem Wasser." *NRZ* (Düsseldorf), no. 115, May 19, 1972, n.p., ill.

Frese, Hans M. "Kunst und Abwässer: 'Wer geht da schon hin?'" *NRZ* (Düsseldorf), no. 119, May 25, 1972, n.p., ill.

Haacke, Hans. [Visitors' Profile. Milwaukee Art Center.] *Flash Art* (Milan), no. 32-34 (May-July 1972): cover, 14, ill. Includes statement by Haacke.

Sello, Gottfried. "Kunstkalender." *Die Zeit* (Hamburg), no. 26, June 30, 1972, p. 12.

Krüger, Werner. "Hans Haacke in Köln." *Neues Rheinland* (Cologne) 15, no. 7 (July 1972): 36.

"Mickey Mouse befragt die Wirklichkeit." *Der Spiegel* (Hamburg) 26, no. 28 (July 3, 1972): 104-105, ills.

Krüger, Werner. "Bohnen wachsen im Museum." *Kölner Stadt-Anzeiger,* July 7, 1972.

"Documenta: jung, arm, links." *Der Spiegel* (Hamburg) 26, no. 35 (August 21, 1972): 104-106, ills.

Dickson, David. "Art Politic." *Art and Artists* (London) 7, no. 6 (September 1972): 18-21, ills.

Riese, Hans Peter. "Schmutzaufwühlend?: Hans Haacke: 'Werkmonographie.'" *Frankfurter Allgemeine Zeitung,* no. 211, September 12, 1972, p. 27.

Kerber, Bernhard. "Documenta und Szene Rhein-Ruhr." *Art International* (Lugano) 16, no. 8 (October 1972): 68-77, ills.

Loetterle, Fred. "'Megalopolis' Hits Columbus Circle." *Sunday News* (New York), October 15, 1972, p. M12.

Huxtable, Ada Louise. "'Megalopolis' Show: Artists and the Urban Scene." *The New York Times,* October 31, 1972, p. 54.

Thwaites, John Anthony. "Cologne." *Art and Artists* (London) 7, no. 8 (November 1972): 50-51.

D[avis], D[ouglas]. "Art of the Real (Estate)." *Newsweek* (New York) 80, no. 19 (November 6, 1972): 77-78.

Meyer, Rosemary. "Andre, Haacke, Holt, James, Obering: John Weber Gallery." *Arts Magazine* (New York) 47, no. 3 (December 1972): 76.

Kuhn, Annette. "Haacke and the landlords: The art that exposed patterns of property." *The Village Voice* (New York) 17, no. 50 (December 14, 1972): 13, 16.

Lebeer, Irmeline. "Le profil des visiteur de musée 1972: un projet de Hans Haacke." *Chroniques de l'Art Vivant* (Paris), no. 35 (December 1972-January 1973): 22-23, ill.

1973

Winter, Peter. "Kunst im politischen Kampf." *Kunstforum International* (Mainz), no. 1 (1973): 98-107.

Haacke, Hans. "Profil de l'habitat des visiteurs de la galerie." *Art Press* (Paris), no. 1 (December-January 1973): 16-17.

Boice, Bruce. "Reviews." *Artforum* (New York) 11, no. 5 (January 1973): 85.

Glozer, Laszlo. "Acht Modelle politischer Kunst." *Süddeutsche Zeitung* (Munich), April 1973.

Perreault, John. "Documenting an art-world inside job." *The Village Voice* (New York) 18, no. 19 (May 10, 1973): 40.

Haacke, Hans, and Bruce Boice. "Hans Haacke's Gallery Visitors' Profile." *Artforum* (New York) 11, no. 10 (June 1973): 44-46, ills.

Frank, Peter. "Manifestations internationales: New York." *arTitudes* (Paris), no. 5 (June-July-August 1973): 38-41, ills.

Battcock, Gregory. "New York." *Art and Artists* (London) 8, no. 5 (August 1973): 48-49, ills.

Anderson, Laurie. "Reviews and Previews: Ten Artists (John Weber Gallery)." *Art News* (New York) 72, no. 9 (November 1973): 101-102.

Stitelman, Paul. "New York Galleries." *Arts Magazine* (New York) 48, no. 2 (November 1973): 59.

1974

Haacke, Hans. "Profile." *Studio International* (London) 187, no. 963 (February 1974): 61-64, ills.

Kuhn, Annette. "Culture Shock." *The Village Voice* (New York) 19, no. 13 (March 28, 1974): 35.

Perreault, John. "It says so on the door!" *The Village Voice* (New York) 19, no. 3 (March 28, 1974): 35-36.

Albright, Thomas. "Hans Haacke's Work is 'Another Level of Reality.'" *San Francisco Chronicle*, March 30, 1974, p. 33.

Olson, Roberta J. M. "Live!" *Arts Magazine* (New York) 48, no. 8 (May 1974): 64-65, ill.

"Projekt '74 (Kunst bleibt Kunst)." *Data* (Milan) 4, no. 12 (Summer 1974): 34-35, ills.

Haacke, Hans. "Manet Projekt '74/Hans Haacke sulla censura del Wallraf-Richartz-Museum al suo lavoro per Projekt '74." *Data* (Milan) 4, no. 12 (Summer 1974): 36-37, ills.

Tomic, Biljana. "On Projekt '74." *Moment* (Belgrade), no. 4 (Summer 1974): n.p.

Haacke, Hans. "Manet—Projekt '74." *Extra* (Cologne), no. 1 (June 1974): 6-18, ills.

Stachelhaus, Heiner. "Kunstkrach um ein Gemälde von Manet aus dem Jahre 1880: 'Spargelstilleben' mit Hermann J. Abs." *NRZ* (Düsseldorf), July 4, 1974.

Plunien, Eo. "Viel Lärm um ein Spargelbündel." *Die Welt* (Hamburg), July 5, 1974, p. 28.

Ohff, Heinz. "Schwierigkeiten mit den siebziger Jahren. *Der Tagesspiegel* (Berlin), July 9, 1974, p. 4.

Staeck, Klaus. "Der Leimtopf als Argument." *Der Tagesspiegel* (Berlin), July 12, 1974, p. 4.

Krüger, Werner. "Bemerkungen: Briefe, Vorwürfe, Krach." *Kölner Stadt-Anzeiger*, July 13-14, 1974.

Hohmeyer, Jürgen. "Kunst auf der Kippe." *Der Spiegel* (Hamburg) 28, no. 29 (July 15, 1974): 90-91, ills.

Plunien, Eo. "Der Kulturbetrieb gebar eine Maus." *Die Welt* (Hamburg), July 16, 1974, p. 17.

Trappschuh, Elke. "'Spurensuche' nach der Verbindlichkeit der Kunst." *Handelsblatt* (Düsseldorf), August 13, 1974.

Macaire, Alain. "Cologne: Projekt '74." *+ - 0* (Brussels), no. 5 (September 1974): 10-18, ills. Includes statements by Haacke.

Frank, Peter. "Live!" *Art News* (New York) 73, no. 7 (September 1974): 118.

Honnef, Klaus. "Projekt '74 a Colonia." *Domus* (Milan), no. 538 (September 1974): 41-43, ill. In Italian and German.

Harrison, Charles, and Lynda Morris. "Projekt '74." *Studio International* (London) 188, no. 969 (September 1974): Review supp. 6-8.

Frank, Peter. "Reviews: Art Now–Projekt." *Architecture Plus* (New York) 2, no. 5 (September-October 1974): 127-129, ill.

Graevenitz, Antje von. "Kunsthalle und Kunstverein-Römisch–Germanisches Museum-Wallraf-Richartz-Museum: Ausstellung Kunst bleibt Kunst, Projekt '74. Aspekte internationaler Kunst am Anfang der 70er Jahre." *Pantheon* (Munich) 32, no. 4 (October-December 1974): 413-416, ills.

Tisdall, Caroline. "Unstill Life." *The Guardian* (London), November 1, 1974, p. 10.

Vaizey, Marina. "Drawing the Lessons of History." *Sunday Times* (London), November 3, 1974, p. 31.

Cork, Richard. "The Real Life Brigade." *Evening Standard* (London), November 7, 1974.

Overy, Paul. "Should Artists Go On Strike?" *The Times* (London), November 12, 1974, p. 9.

Baldwin, Carl R. "Haacke: *Refusé* in Cologne." *Art in America* (New York) 62, no. 6 (November-December 1974): 36-37, ill.

Haacke, Hans. "Manet-Projekt '74." *Avalanche* (New York) (December 1974): 16-17, ills.

Buren, Daniel, and Liza Bear. "Daniel Buren . . . Kunst bleibt Politik." *Avalanche* (New York) (December 1974): 18-19, ills.

1975

Ramsden, Mel. "Perimeters of Protest." [Review of panel discussion at Artists Space, February 18, 1975; Haacke was one of eight panelists.] *The Fox* (New York) 1, no. 1 (1975): 133-135.

Morris, Lynda. "Art into Society–Society into Art: Seven German Artists at the I.C.A., London." *Studio International* (London) 189, no. 973 (January-February 1975): Review supp. 16-17.

Burnham, Jack. "Meditations on a Bunch of Asparagus." *Arts Magazine* (New York) 49, no. 6 (February 1975): 72-75, ills.

Joachimides, Christos M. "Art into Society: Society into Art." *Kunstforum International* (Mainz), no. 13 (February-April 1975): 167-175, ills.

"Nancy Spero." [Excerpts from the panel "Perimeters of Protest," including Hans Haacke, Nancy Spero, Carl Andre, Rudolf Baranik, Mel Edwards.] *Art-Rite* (New York), no. 9 (Spring 1975): 18.

Teyssedre, Bernard. "L'art sociologique." *Opus International* (Paris), no. 55 (April 1975): 16-28, ills.

Da Vinci, Mona. "More than Meets the Eye." *The Soho Weekly News* (New York) 2, no. 33 (May 22, 1975): 25, ill.

Burnham, Jack. "Hans Haacke's Seurat Exhibition: The Perils of Radicalism." *New Art Examiner* (Chicago), 2, no. 9 (June 1975): 3, ill.

Beaucamp, Eduard. "Avantgarde im Glockenturm." *Frankfurter Allgemeine Zeitung*, no. 124, June 2, 1975, p. 21, ill.

Davis, Douglas. "Spring Fashions." *Newsweek* (New York) 85, no. 22 (June 2, 1975): 66, ill.

Michael, Andre. "New York Reviews." *Art News* (New York) 74, no. 7 (September 1975): 116.

Kozloff, Max. "Painting and Anti-Painting: A Family Quarrel." *Artforum* (New York) 14, no. 1 (September 1975): 42-43, ills.

Heinemann, Susan. "Reviews: Hans Haacke, John Weber Gallery." *Artforum* (New York) 14, no. 1 (September 1975): 75.

Collins, Tara. "Hans Haacke." *Arts Magazine* (New York) 50, no. 2 (October 1975): 6, ill.

Haacke, Hans. "Solomon R. Guggenheim Museum Board of Trustees." *TriQuarterly* (Evanston, Ill.), no. 32 (Winter 1975): [67-73], ills.

1976

Ramsden, Mel. "Review: Framing and Being Framed–Or, Are We Going to Let Barbara Rose Get Away with 'Dialectics' this Year?" *The Fox* (New York), no. 3 (1976): 64-74, ills.

Hunt, Ron. "For Factography!" *Studio International* (London) 191, no. 980 (March-April 1976): 96-99, ills.

Smith, Terry. "Without Revolutionary Theory . . ." *Studio International* (London) 191, no. 980 (March-April 1976): 134-137.

Brooks, Rosetta. "Please No Slogans." *Studio International* (London) 191, no. 980 (March-April 1976): 155-161, ills.

Cork, Richard. "Masterpiece–or a million dollar pawn?" *Evening Standard* (London), April 15, 1976, p. 16, ill.

Richard, Paul. "For Hans Haacke, the Medium Is the Message." *The Washington Post*, May 6, 1976, p. C15, ill.

Fuller, Peter. "Hans Haacke." *Studio International* (London) 192, no. 982 (July-August 1976): 88-89, ill.

Oliva, Achille Bonito. "Sull'ideologia in arte, spostare il problema in avanti dall'"io' al 'noi' all'anonimo." *Domus* (Milan), no. 561 (August 1976): 50. Text in Italian and French.

Iden, Peter. "Der grosse Bruch: Arbeiten von Hans Haacke im Kunstverein." *Frankfurter Rundschau*, September 17, 1976.

Macaire, Alain. "De l'art comme marchandise, du musée comme lieu politique." *arTitudes* (Paris), no. 11 (October 1976): 6, ills.

Morschel, Jürgen. "Ein Querdenker: Hans Haacke stellt im Frankfurter Kunstverein aus." *Süddeutsche Zeitung* (Munich), no. 243, October 19, 1976, p. 16, ill.

Beaucamp, Eduard. "Haackes trockene Kunst der Fakten." *Frankfurter Allgemeine Zeitung*, October 20, 1976, p. 25.

Haacke, Hans. [Reproduction of *The Good Will Umbrella*.] *Vision* (Oakland), no. 3 (November 1976): 68-73, ills.

Hobbs, Robert C. "Books in Review: Hans Haacke: Framing and Being Framed: 7 Works, 1970-75." *Art Journal* (New York) 36, no. 2 (Winter 1976-1977): 176-180.

1977

Boelema, Ida, Saskia Bos, Antje von Graevenitz, and Gijs van Tuyl. "Kunst en tijd." *Openbaar Kunstbezit* (Amsterdam/Weesp) 1, no. 1 (1977): 1-45, ills.

P[onti], L[isa] L. "Hans Haacke si repete: une exposition à Milan: *On Seurat's 'Les Poseuses.'*" *Domus* (Milan), no. 566 (January 1977): 51, ills.

Hervé, Jocelyne. "Hans Haacke: la dénonciation des mécanismes cachés de l'art." *Les Cahiers de la Peinture* (Paris), no. 47 (February 1977): 3.

Perreault, John. "On Art: Hans Haacke." *The Soho Weekly News* (New York) 4, no. 18 (February 3, 1977): 18.

Bourdon, David. "Sniffing the Corporate Carrot." *The Village Voice* (New York) 22, no. 6 (February 7, 1977): 71, ills.

Rickelt, Michael. "Real-Zeit-Dokument ein zeitloses Kunstwerk?" *Badische Neue Nachrichten* (Karlsruhe), March 21, 1977, n.p.

Haas, Patrick de. "Hans Haacke: Galerie Durand-Dessert." *Art Press* (Paris), n.s. no. 6 (April 1977): 37.

Lubell, Ellen. "Art Reviews: Hans Haacke." *Arts Magazine* (New York) 51, no. 8 (April 1977): 36, ills.

Busche, Ernst. "Ausstellungen: Bericht aus New York (Januar 77)." *Das Kunstwerk* (Stuttgart) 30, no. 2 (April 1977): 38-40.

Morschel, Jürgen. "'Jede Kunst ist politisch': Hans Haackes Entwurf des Kunstwerks als 'System.'" *Kunst Nachrichten* (Lucerne) 13, no. 4 (May 1977): 90-96, ills.

Willson, V. P. "Atheneum Exhibit Explores Evolving Business of Art." *Greater Hartford Business Review* (Hartford, Conn.) 1, no. 10 (June 1977): 2, 21.

Herrera, Hayden. "Manhattan Seven." *Art in America* (New York) 65, no. 4 (July-August 1977): 50-63, ills.

Keil, Bob. "Social Criticism as Art." *Artweek* (Oakland) 8, no. 27 (August 13, 1977): 1, 16, ill.

1978

Wick-Kmoch, Astrid. "Kunst + Systemtheorie + Sozialwissenschaften: Zu den Arbeiten von Hans Haacke." *Kunstforum International* (Mainz), no. 27 (1978): 125-142, ills.

Carroll, Maryrose. "Hans Haacke: Politicism vs. Formalism." *New Art Examiner* (Chicago) 5, no. 4 (January 1978): 9.

B[ouisset], M[aïten]. "Hans Haacke: une certain idée de l'art." *Le Matin* (Paris), January 27, 1978, p. 27.

Schoor, Frank van de. "Moderne Kunst en maatschappelijke relevantie." *Museumjournaal* (Amsterdam) 23, no. 1 (February 1978): 2-10, ills.

Grosskopf, Annegret. "Jedermann ist ein Sonnenkönig: Der Kölner Kunstverein zeigt die Ausstellung 'Feldforschung.'" *Kölner Stadt-Anzeiger*, April 22-23, 1978.

Haacke, Hans. "The Good Will Umbrella." *Qualitative Sociology* (Syracuse, N.Y.) 1, no. 1 (May 1978): 108-121, ills.

Reuther, Hanno. "Nur Zeigen: 'Feldforschung,' auch politische, im Kölnischen Kunstverein." *Frankfurter Rundschau*, May 26, 1978, p. 17.

Muchnic, Suzanne. "Creative Questioning." *Los Angeles Times*, June 5, 1978, Section 4, pp. 1, 5, ill.

Wortz, Melinda. "Hans Haacke's Political Paradoxes." *Artweek* (Oakland) 9, no. 23 (June 17, 1978): 1, 16, ills.

Haacke, Hans. [Advertisements: *A Breed Apart*.] *Oxford Mail*, November 17, 1978, p. 10, ill.; November 24, 1978, p. 6, ill.; and December 1, 1978, p. 23, ill.

Tisdall, Caroline. "Associative Guilt." *The Guardian* (London), November 24, 1978, p. 11, ill.

"Truly modern museum." *Oxford Star*, December 7, 1978, n.p., ill.

Burnham, Jack. "Jack Burnham on the Political Art of Hans Haacke: A Transcript." *Wordworks* (San Jose, Calif.), December 10, 1978, n.p.

Domingo, Willis. "Hans Haacke." *Art Monthly* (London), no. 22 (December 1978-January 1979): 19-20, ills.

1979

Picard, Lil. "Brief aus New York: A New Taste = Ein neuer Geschmack." *Kunstforum International* (Mainz), no. 34 (1979): 169.

Ginneken, Lily van. "Kunst als dekmantel: Hans Haacke in Van Abbe." *De Volkskrant* (Amsterdam), January 23, 1979, p. 17, ill.

Tuyl, Gijs van. "Philips op een Perzisch tapijt: Hans Haacke in het Van Abbemuseum." *Vrij Nederland* (Amsterdam), January 27, 1979, n.p., ill.

"News: Hans Haacke." *Flash Art/Heute Kunst* (Milan), nos. 86-87/no. 24 (January-February 1979): 4.

"Prints & photographs published: Hans Haacke, *Tiffany Cares* (1978)." *Print Collector's Newsletter* (New York) 9, no. 6 (January-February 1979): 193.

Brouwer, Marianne. "De politieke kunst van Hans Haacke: 'Ik wil de dingen spannend houden.'" *Haagse Post* (Amsterdam) February 3, 1979, pp. 56-59, ills.

Beks, Maarten. "'t is de kunst van het kapitaal." *Eindhovens Dagblad*, February 7, 1979, n.p.

B[less], F[rits]. "Beijk't maar." *De Tijd* (Amsterdam), February 7, 1979, p. 50.

Fisher, Jean. "Hans Haacke." *Aspects* (Newcastle-upon-Tyne), no. 6 (Spring 1979): n.p.

Artner, Alan G. "European Attitude Essential in Judging Works of Hans Haacke." *Chicago Tribune*, March 2, 1979, Section 4, p. 12, ills.

Peters, Philip. "De politieke kunst van Hans Haacke: 'Kunstenaars zijn narren aan het hof van de machts elite.'" *De Tijd* (Amsterdam), March 23, 1979, pp. 50-53, ill.

Oosthoek, André. "Hans Haacke." *Provinciale Zeeuwse Courant* (Middelburg), April 21, 1979.

Miller, Donald. "Using Art to Stress Wrongs in Society." *Pittsburgh Post-Gazette*, June 4, 1979.

Hess, Elizabeth. "Works by Hans Haacke." *Seven Days* (New York) 3, no. 8 (June 29, 1979): 32-33, ills.

Morgan, Robert C. "Conceptual Art and the Continuing Quest for a New Social Context." *Journal: Southern California Art Magazine* (Los Angeles), no. 23 (June-July 1979): 30-36, ills.

Skiles, Jacqueline. "The Big Bad Businessman." *Women Artists News* (New York) 5, nos. 6-7 (December 1979-January 1980): 4.

1980

Zutter, Jörg. "Europäische Kunst der 70er Jahre formt ein einheitliches Bild." *Kunstforum International* (Mainz), no. 41 (1980): 279.

Schwarz, Michael. "Über den Realismus politischer Konzeptkunst." *Kunstforum International* (Mainz), no. 42 (1980): 14-34, ills.

Haacke, Hans. [*A Breed Apart.*] *Kunstforum International* (Mainz), no. 42 (1980): 110-112, ills.

Grasskamp, Walter. "Ästhetik für Produzenten." [Introduction to Haacke's article "Arbeitsbedingungen."] *Kunstforum International* (Mainz), no. 42 (1980): 213.

Matičević, Davor. "Tko je Hans Haacke?" *Start* (Zagreb), no. 287 (January 23-February 6, 1980): 8-9, ill.

M[atičević], D[avor]. "Točno pogadja cilj." *Polet* (Zagreb), no. 118, January 23, 1980, p. 19, ill.

Maleković, Vladimir. "Kritika sistema manipulacije." *Vjesnik* (Zagreb), January 26, 1980, p. 13, ill.

Plisnier, Lucienne. "Europalia 80 à Gand: pas de tout repos." *Pourquoi Pas?* (Brussels), June 19, 1980, n.p.

Ranson, Jean. "Haacke pakt fn aan: kunst die zich intelligent met politiek inlaat." *De Morgen* (Brussels), June 27, 1980, p. 19, ill.

Brouwer, Marianne. "Gent is de grootste verrassing van het jaar." *Vrije Nederland* (Amsterdam), July 12, 1980, p. 16, ills.

Carnier, Luk. "Een nieuwe manier van kijken: Europese kunst na '68." *De Rode Vaan* (Brussels), July 24, 1980, pp. 21-22, ill.

Barten, Walter. "Wat is er van de jaren zeventig terechtgekomen?" *De Groene Amsterdammer*, July 30, 1980, pp. 16-17, ills.

Waterschoot, Hektor. "Wat men '68 al niet in de schoenen gooit." *Knack* (Brussels), July 19, 1980, p. 46, ills.

Glozer, Laszlo. "Rauchspuren im Museum." *Süddeutsche Zeitung* (Munich), August 9-10, 1980, n.p.

Winter, Peter. "Planetarium der Phantasie." *Frankfurter Allgemeine Zeitung*, August 22, 1980, p. 21.

Kuspit, Donald B. "Art of Conscience: The Last Decade." *Dialogue: The Ohio Arts Journal* (Munroe Falls, Ohio) 3, no. 2 (September-October 1980): 19-21, ills.

White, James A. "Artist's quandary: Do corporate sales sell out creativity?" *Daily News* (New York), October 23, 1980, p. 45.

Dimitrijević, Nena. "Reviews: Art in Europe after '68." *Aspects* (Newcastle-upon-Tyne), no. 13 (Winter 1980-1981): n.p.

1981

Corris, Michael. "News from the Front." *Artery* (Wayne, N.J.) 4, no. 3 (1981): 12-13, ills.

[Hohmeyer, Jürgen.] "Kunst: Geheimer Strom." *Der Spiegel* (Hamburg) 35, no. 5 (January 26, 1981): 165-166, ills.

Braxmeier, Rainer. "Politische Konzeptkunst." *Das Kunstwerk* (Stuttgart) 34, no. 2 (February 1981): 92-93, ill.

Perreault, John. "Art Attacks." *The Soho Weekly News* (New York) 8, no. 21 (February 18-24, 1981): 48, ill.

Lippard, Lucy R. "Power Plays." *The Village Voice* (New York) 26, no. 9 (February 25-March 3, 1981): 72, ills.

Larson, Kay. "Drawing on Strength." *New York* (New York) 14, no. 10 (March 9, 1981): 58-61, ill.

Kahn, Doug. "Monkey Wrenches." *And/or Notes* (Seattle) (April 1981): 14.

Lawson, Thomas. "Reviews." *Artforum* (New York) 19, no. 9 (May 1981): 70-72, ill.

Schön, Jürgen. "Maler nimmt Kunst-Ludwig aufs Korn." *Express* (Cologne), May 23, 1981, p. 7, ill.

"Szene: Kunst gegen Ludwig." *Der Spiegel* (Hamburg) 35, no. 22 (May 25, 1981): 189, ill.

Pontbriand, Chantal. "L'art dans un contexte social." *Parachute* (Montreal), no. 23 (Summer 1981): 4.

Craven, David. "Hans Haacke and the Aesthetics of Legitimation." *Parachute* (Montreal), no. 23 (Summer 1981): 5-11, ills.

S[chneider], B[runo] F. "Saures für den Pralinenmeister." *Kölnische Rundschau*, no. 125, June 1, 1981, p. 12, ill.

Reuther, Hanno. "Kunstchronik: Hans Haacke: Der Pralinenmeister." *Vorwärts* (Bonn), July 2, 1981.

Fry, Jacqueline. "Le musée dans quelques oeuvres récentes." *Parachute* (Montreal), no. 24 (Fall 1981): 33-45, ills.

Morrison, C. L., and William Rubin. "Letters." [Letters to the editor, following Haacke's article "Working Conditions." Response by Haacke, same page.] *Artforum* (New York) 20, no. 1 (September 1981): 2.

Overath, Angelika. "Kunst ist Trumpf. Peter Ludwig: der Bilder- und Unruhestifter." *Transatlantik* (Munich) (September 1981) 64-73, ills.

Whyte, Jon. "Vocation/Vacation." *Banff Crag and Canyon*, November 25, 1981, p. 12.

Tousley, Nancy. "Artist's medium in society's hidden meanings, motives." *The Calgary Herald*, November 28, 1981, p. D5, ill.

Millet, Catherine. "L'art de la fin de l'art . . . 10 ans après." *Art Press* (Paris), no. 54 (December 1981): 6-9, ills.

Payant, René. "Hans Haacke: l'art contre la politique." *Art Press* (Paris), no. 54 (December 1981): 20-21, ills.

Passel, Bernhard, and Wolfgang Max Faust. "Worüber zu sprechen ist: Ein Florilegium aus Kritiken und Rezensionen zum Zeitschnitt: 30 Deutsche." *Kunstforum International* (Cologne), no. 47 (December 1981-January 1982): 129-180, ills.

1982

Craven, David. "Hans Haackes 'Schlaue Verwicklung.'" *Kritische Berichte* (Giessen) 10, no. 1 (1982): 28-39, ills. [English translation: "Hans Haacke's 'Cunning Involvement.'" In *The UnNecessary Image*, edited by Peter D'Agostino and Antonio Muntadas. New York: Tanam Press, 1982, pp. 21-25.]

Craven, David. "Art Goes Public: Recent Work by Hans Haacke and Marc Blane." *Kritische Berichte* (Giessen) 10, no. 4 (1982): 77-80, ills.

Morgan, Marie. "The Dark Side of Patronage." *Banff Letters* 1, no. 1 (Spring 1982): 2-4, ills.

Smith, Michael. "Mr. Smith Goes to the Airport." *Journal: A Contemporary Art Magazine* (Los Angeles), no. 32 (Spring 1982): 27-34, ills.

"Haacke's 'Safety Net' at Gallery 1199." *1199 News* (New York) 17, no. 3 (March 1982): 22, ill.

Carducci, Vincent A. "Re: Contemporary Art in Detroit Collections." *Detroit Focus Quarterly* 1, no. 2 (April 1982): 1-3.

Gault, Charlotte Townsend. "Vocation/Vacation." *Vanguard* (Vancouver) 11, no. 3 (April 1982): 22-25, ills.

Haacke, Hans. "On Social Grease." *Art Journal* (New York) 42, no. 2 (Summer 1982): 137-143, ills.

Buchloh, Benjamin H. D. "Documenta 7: A Dictionary of Received Ideas." *October* (New York), no. 22 (Fall 1982): 104-126, ills.

Owens, Craig. "Bayreuth '82." *Art in America* (New York) 70, no. 8 (September 1982): 132-139, 191, ills.

Buchloh, Benjamin H. D. "Allegorical Procedures: Appropriation and Montage in Contemporary Art." *Artforum* (New York) 21, no. 1 (September 1982): 43-56, ill.

"Prints & photographs published: Hans Haacke, *Upstairs at Mobil* (1982)." *Print Collector's Newsletter* (New York) 13, no. 4 (September-October 1982): 135.

Schuldt. "Documenta: Hans Haacke; Marcel Broodthaers." *Artforum* (New York) 21, no. 2 (October 1982): 85-86.

L[ord], C[atherine]. "Received and Noted: *Der Pralinenmeister.*" *Afterimage* (Rochester, N.Y.) 10, no. 5 (December 1982): 20, ills.

1983

Haacke, Hans. "'Wij geloven aan de macht van de kreatieve verbeeldingskracht.'" *DWARS* (Breda), no. 1 (June 1983): 24-25, ill.

Ruhloff, Marianne. "Zu Hans Haackes Arbeit 'The Right to Life (Das Recht zum Leben).'" *Kunstpädagogik* (Düsseldorf), no. 2 (1982), ills.

Daigneault, Gilles. "Des fenêtres ouvertes sur le monde . . . d'Alcan." *Le Devoir* (Montreal), February 12, 1983, pp. 17, 32, ill.

Toupin, Gilles. "Ce qui se cache derrière les nuages idéologiques: Hans Haacke et la compagnie Alcan." *La Presse* (Montreal), February 12, 1983, p. E1, ills. Includes interview with Haacke.

Galloway, David. "Report from Germany: Peter Ludwig: Appetite for Art." *Art in America* (New York) 71, no. 6 (Summer 1983): 35-41, ills.

"The Tate: Spart Gallery." *Private Eye* (London), no. 564, July 29, 1983, p. 20.

A Friend of the Tate. "Advertising." [Letter to the editor.] *Private Eye* (London), no. 566, August 26, 1983, p. 10.

Haacke, Hans. "Voici Alcan." *Impulse Magazine* (Toronto) 10, no. 4 (Fall 1983): 21-23, ills.

Gilmour, Pat. "Art as Social Grease: Culture a casualty on the road to profit." *The Age Monthly Review* (Melbourne) 4, no. 5 (September 1983): 21-23, ills.

Monk, Philip. "Reviews: Museums by Artists." *Parachute* (Montreal), no. 32 (September-November 1983): 44-45, ill.

Linker, Kate. "Reviews: Hans Haacke, John Weber Gallery." *Artforum* (New York) 22, no. 2 (October 1983): 72, ill.

Gilmour, Pat. "The Museum and the Private Sector." *Art Monthly* (London), no. 71 (November 1983): 26-27.

Gilmour, Pat. "Corporate Sponsorship—The Facts: The Museum and the Private Sector." *Art Link* (Adelaide) 3, no. 5 (November-December 1983): 4-6.

1984

Ruhloff, Marianne. "Das Bild als Lehrstück über den Kunstgebrauch in unserer Gesellschaft." *Kunstpädagogik* (Düsseldorf), no. 2 (1984): 56-57, plus back cover, ill.

Januszczak, Waldemar. "A talent to abuse." *The Guardian* (London), January 25, 1984, p. 11, ill.

Express Staff Reporter. "The Victoria Line for Maggie." *Daily Express* (London), January 25, 1984, p. 7, ill.

Beattie, Dr. Susan. "Letters to the Editor: A symbol of Thatcherism." *The Guardian* (London), January 27, 1984, p. 14.

Feaver, William. "Thoughts of a saboteur." *The Observer* (London), January 29, 1984, p. 55, ill.

Miller, Roland. "Strictures at an exhibition." [Letter to the editor.] *The Guardian* (London), January 31, 1984, p. 10, ill.

Beaumont, Mary Rose. "London—Hans Haacke—Tate Gallery." *Arts Review* (London) 36, no. 3 (February 1984): 70.

"Key to the Cover." *Art Monthly* (London), no. 73 (February 1984): cover, 1-3, ill.

Glueck, Grace. "Art 'Interventions' on U.S. Latin Role." *The New York Times*, February 3, 1984, p. C23.

Thorn, F. "Massvolle Provokation: Der Kölner Konzeptkünstler Hans Haacke in der Londoner Tate Gallery." *Süddeutsche Zeitung* (Munich), no. 28, February 3, 1984, p. 15, ill.

"Haacke blows the adman's image." *The News Line* (London), February 4, 1984, p. 12, ill.

Vaizey, Marina. "Portrait of a Nation." *The Sunday Times* (London), February 5, 1984, p. 37.

Gehren, Georg von. "Schützenhilfe für Arrivierte." *Handelsblatt* (Düsseldorf), February 7, 1984, p. 16.

Beaumont, Mary Rose. "London: Hans Haacke." *Arts Review* (London) (February 17, 1984): 70, ill.

Cooper, Emmanuel. "Biting the Hand that Feeds?" *Tribune* (London), February 17, 1984, ill.

Cendre, Anne. "Maggie et Pandore." *Tribune de Genève*, February 18-19, 1984, p. T5, ill.

"Artists for Old Grenada." [Editorial.] *The Wall Street Journal* (New York), February 21, 1984, p. 32. [Response by Haacke and Thomas Woodruff, *The Wall Street Journal*, March 13, 1984, p. 31.]

Kent, Sarah. "Articles of Faith." *Time Out* (London), February 23-29, 1984, pp. 14-15, ills.

Seiler-Franklin, Andreas. "Ein fast Refüsierter und Erfolgreiche." *Tages-Anzeiger* (Zurich), February 25, 1984.

Exner, Julian. "Thatcher von Haacke gehängt." *Frankfurter Rundschau*, no. 49, February 27, 1984, ill.

Edmonds, Angela. "Hans Haacke at the Tate." *Focus* (London), February 27, 1984, ill.

Bird, Jon. "Hans Haacke: 'The Limits of Tolerance.'" *Art Monthly* (London), no. 74 (March 1984): 15-16.

"Tate Gallery Surprise." *Anti-Apartheid News* (London), March 1984, p. 11.

Reichardt, Jasia. "Hans Haacke—The London Target." *Artefactum* (Antwerp), no. 3 (April-May 1984): 25-27, ill.

Kramer, Hilton. "Turning Back the Clock: Art and Politics in 1984." *The New Criterion* (New York) 2, no. 8 (April 1984): 68-73. [Reprinted in: Hilton Kramer, *Revenge of the Philistines* (New York: The Free Press, 1985), pp. 386-394.]

Brenson, Michael. "Can Political Passion Inspire Great Art?" *The New York Times*, April 29, 1984, pp. H1, H22, ills.

Collier, Caroline. "London: Hans Haacke—Tate." *Flash Art* (Milan), no. 117 (April-May 1984): 39-40, ill.

"Hans Haacke at the Tate Gallery." *Performance Magazine* (London) (April-May 1984): n.p., ill.

Feaver, William. "London: Learning to Love Big Brother." *Art News* (New York) 83, no. 5 (May 1984): 137-143, ill.

Gambrell, Jamey. "Art Against Intervention." *Art in America* (New York) 72, no. 5 (May 1984): 9-14, ills.

Arksey, Neil. "Hans Haacke at the Tate." *Artscribe* (London), no. 46 (May-July 1984): 56-57, ill.

Winkler, Lisa K. "The Incredible, Invisible Saatchi Brothers: Advertising May Never be the Same Again." *International Management/Europe* (London) 39, no. 6 (June 1984): 32-35, ills.

Atha, Amanda. "The Saatchi Picture Show." *Harpers & Queen* (London) 84, no. 8 (August 1984): 66-69, ill.

Schmid, Peter. "Notfalls fliegt New York in die Luft." *Die Weltwoche* (Zurich), no. 32, August 9, 1984, p. 39, ill.

Stepken, Angelika. "Kunst ist eine Frage des Konsensus: Hans Haacke im 'Künstlerhaus Bethanien.'" *Illustrierte Stadtzeitung Zitty* (Berlin) 8, no. 19 (August 31-September 9, 1984): 36-37, ills.

Grasskamp, Walter. "An Unpublished Text for an Unpainted Picture." *October* (New York), no. 30 (Fall 1984): 17-22, ills.

Crimp, Douglas. "The Art of Exhibition." *October* (New York), no. 30 (Fall 1984): 49-81, ills.

Stepken, Angelika. "Berlin: Hans Haacke: Fakten sorgen für Verdruss." *Art* (Hamburg), no. 9 (September 1984): 98-100, ill.

Wulffen, Thomas. "Kunst im Dienst der Aufklärung." *Der Tagesspiegel* (Berlin), no. 11840, September 2, 1984, p. 4, ills.

"Hier und Dort: 'Brigade Ludwig.'" *Der Spiegel* (Hamburg) 38, no. 37 (September 10, 1984): 198, ill.

Rhode, Werner. "Ein Querkopf: Hans Haacke in Berliner 'Künstlerhaus Bethanien.'" *Frankfurter Rundschau*, September 24, 1984.

Schultz, Bernhard. "Thema Kunstpolitik: Hans Haacke in Berlin." *Handelsblatt* (Düsseldorf), no. 182, September 25, 1984, p. 18.

Schultz, Bernhard. "V-Effekt im Kunstbetrieb." *Die Zeit* (Hamburg), no. 40, September 28, 1984, p. 51.

Rhode, Werner. "Pralinenmeister und Eiserne Lady: Sinnliche Bilder mit politischen Hintersinn." *Kölner Stadt-Anzeiger*, no. 225, September 27, 1984, p. 9, ill.

Göpfert, Peter Hans. Spargel und Schokolade scharf aufs Korrn genommen." *Berliner Morgenpost*, no. 298, October 10, 1984.

Lewis, Mark. "Covering Up Some Old Wounds." *Parachute* (Montreal), no. 36 (September-October-November 1984): 66-69, ills.

Zelevansky, Lynn. "Art that Corporations Can't Buy." *Art and Auction* (New York) 7, no. 3 (October 1984): 145-147, ills.

Nungesser, Michael. "Anweisung aus Berlin—Nach allen Regeln der Kunstszene." *Kunstforum International* (Cologne), no. 76 (November-December 1984): 158-166, ills.

Staeck, Klaus, et al. "Die aktuelle Diskussion: Geld und Kunst—Kommen die Mäzene?" *Westermanns Monatshefte* (Braunschweig), no. 12 (December 1984): 136-142, ill.

Raithel, Helmut. "Brüder im Glauben." *Manager Magazin* (Hamburg) (December 1984)· 160-169.

1985

Fleming, Lee. "Issues Are the Issue." *Art News* (New York) 84, no. 1 (January 1985): 84-89, ills.

Tobler, Konrad, and Hansruedi Reust. "Imperiale Kunstform gebrochen." *Kultur Magazin* (Bern), nos. 49-51 (January-February-March 1985): 35-38, ill.

"Politische Konzepte: Hans Haacke in der Berner Kunsthalle." *Der Bund* (Bern), March 1, 1985, p. 33, ill.

Zimmermann, Marie-Louise. "'Mit meiner Kunst diene ich dem Souverän': Politische Installationen von Hans Haacke in der Kunsthalle Bern." *Berner Zeitung*, March 4, 1985, n.p., ill.

Hollenstein, Roman. "'Jede Kunst ist politisch': Hans Haacke in der Berner Kunsthalle." *Neue Zürcher Zeitung* (Zurich), no. 52, March 4, 1985, p. 17.

"Mit einem Sprengkopf im Interieur: Zur Austellung von Hans Haacke 'Nach allen Regeln der Kunst' in der Berner Kunsthalle." *Der Bund* (Bern), March 5, 1985, p. 27, ill.

Marek, Jan. "Der Journalist mit dem Malpinsel: Der deutsche Künstler Hans Haacke stellt in der Kunsthalle Bern aus." *Die Weltwoche* (Zurich), no. 11, March 14, 1985, p. 51, ill.

Kuhn, Marie-Josée. "Blut im Bally-Schuh: Zur Hans Haacke-

Austellung in der Berner Kunsthalle." *Die Wochenzeitung* (Zurich), no. 11, March 15, 1985, p. 13, ills.

Gassert, Siegmar. Wolf im Schafspelz: Der Mäzen." *Basler Zeitung* (Basel), March 20, 1985, p. 34, ill.

Brunell, Janice. "Hans Haacke on Art Industry." *The Cooper Pioneer* (New York), March 21, 1985, p. 4.

Argence, Guy. "Expositions: Hans Haacke, Kunsthalle, Bern." *Art Press* (Paris), no. 92 (May 1985): 56, ill.

Raynor, Vivien. "Art: Hans Haacke Show at John Weber Gallery." *The New York Times*, May 17, 1985, p. C21, ill.

Indiana, Gary. "Art Objects." *The Village Voice* (New York) 30, no. 21 (May 21, 1985): 109, ill.

Hawthorne, Don. "Saatchi & Saatchi Go Public." *Art News* (New York) 84, no. 5 (May 1985): 72-81.

"Charles Saatchi: The Man and the Museum." *Art and Auction* (New York) 7, no. 10 (May 1985): 104-109, ills.

Wechsler, Max. "Reviews: Bonn: Hans Haacke." *Artforum* (New York) 23, no. 10 (Summer 1985): 118-119, ill.

Baker, Kenneth. "Report from London: The Saatchi Museum Opens." *Art in America* (New York) 73, no. 7 (July 1985): 23-27, ills.

Evans-Clark, Phillip. "Hans Haacke: Galerie John Weber." *Art Press* (Paris), no. 94 (July-August 1985): 54, ill.

Tully, Judd. "Reviews—New York: Hans Haacke." *New Art Examiner* (Chicago) 12, no. 10 (Summer 1985): 71, ill.

Harris, William. "Corporate Culture: The Grant Givers." *Manhattan, Inc.* (New York) 2, no. 9 (September 1985): 147-151, ills.

Hawthorne, Don. "Was nicht passt wird verkauft: Die Sammlung Saatchi." *Art* (Hamburg), no. 9 (September 1985): 66-73, ills.

Bell, Jane. "New York Reviews: Hans Haacke at John Weber." *Art News* (New York) 84, no. 8 (October 1985): 128-129, ill.

Morgan, Robert C. "Hans Haacke: Working from the Inside Out." *Arts Magazine* (New York) 60, no. 2 (October 1985): 24-25, ills.

Lichtenstein, Therese. "Hans Haacke/John Weber." *Flash Art* (Milan), no. 124 (October-November 1985): 52, ill.

Tilroe, Anna. "Kwelgeest van de kunstsponsors." *De Volkskrant* (Amsterdam), December 20, 1985, p. 21, ill. [Includes interview with Haacke.]

"Mobil's Amusement and Concern." [Letter to the Tate Gallery, London, and the Stedelijk Van Abbemuseum, Eindhoven, from Mobil counsel, F. W. Dietmar Schaefer.] *Harper's Magazine* (New York) 271, no. 1627 (December 1985): 34-35, ill.

Glowen, Ron. "The Ongoing Paradoxes of Dada." *Artweek* (Los Angeles) 16, no. 42 (December 14, 1985): cover, 1-2, ills.

Haacke, Hans. "MetroMobiltan." *Impulse* (Toronto) 12, no. 2 (1985): 41-44, ills.

1986

Nemeczek, Alfred. "Das Bild macht sich der Betrachter." *Art* (Hamburg), no. 1 (January 1986): 32-35, ill.

Wallis, Brian. "The Art of Big Business." *Art in America* (New York) 74, no. 6 (June 1986): 28-33, ills.

Soutif, Daniel. "Haacke: Pas de Cartier." *Libération* (Paris), July 22, 1986, p. 24, ill. [Includes interview with Haacke.]

"Personalien: Hans Haacke." *Art* (Hamburg), no. 9 (September 1986): 17, ill.

Brenson, Michael. "Modern Masks, Ancient Treasures, and New Questions." *The New York Times*, September 7, 1986, p. 43.

Gilbert-Rolfe, Jeremy. "The Politics of Art." *Arts Magazine* 61, no. 1 (September 1986): 23-25.